Zentrum Paul Klee
Bern

KU-619-974

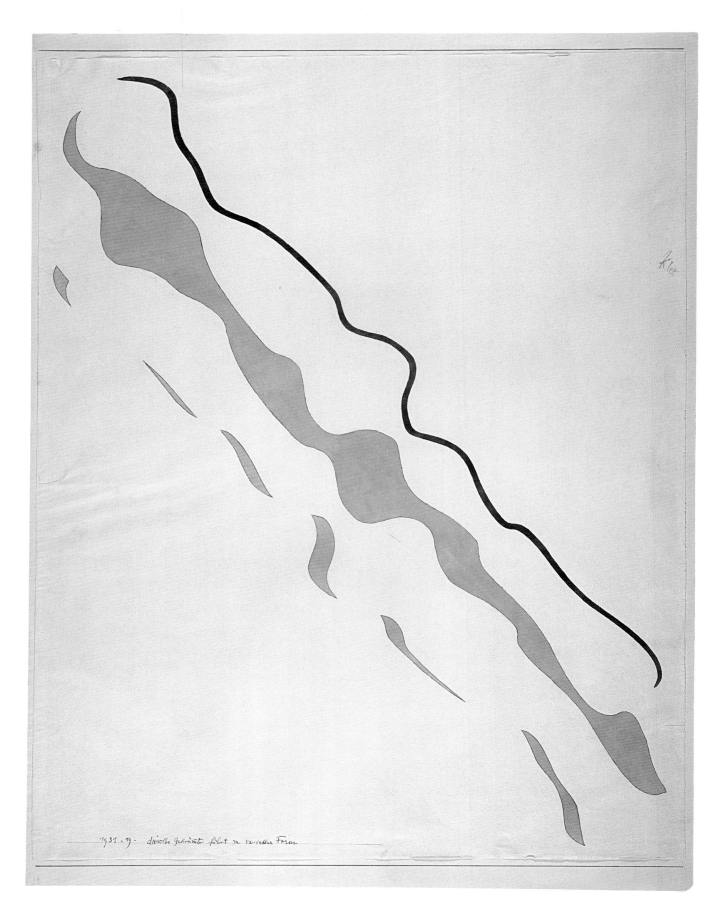

1931 - 19 · dieselbe Gekrümmte führt zu variablen Form

Zentrum Paul Klee
Bern

Hatje Cantz

LIVERPOOL JOHN MOORES UNIVERSITY
LEARNING SERVICES

Contents

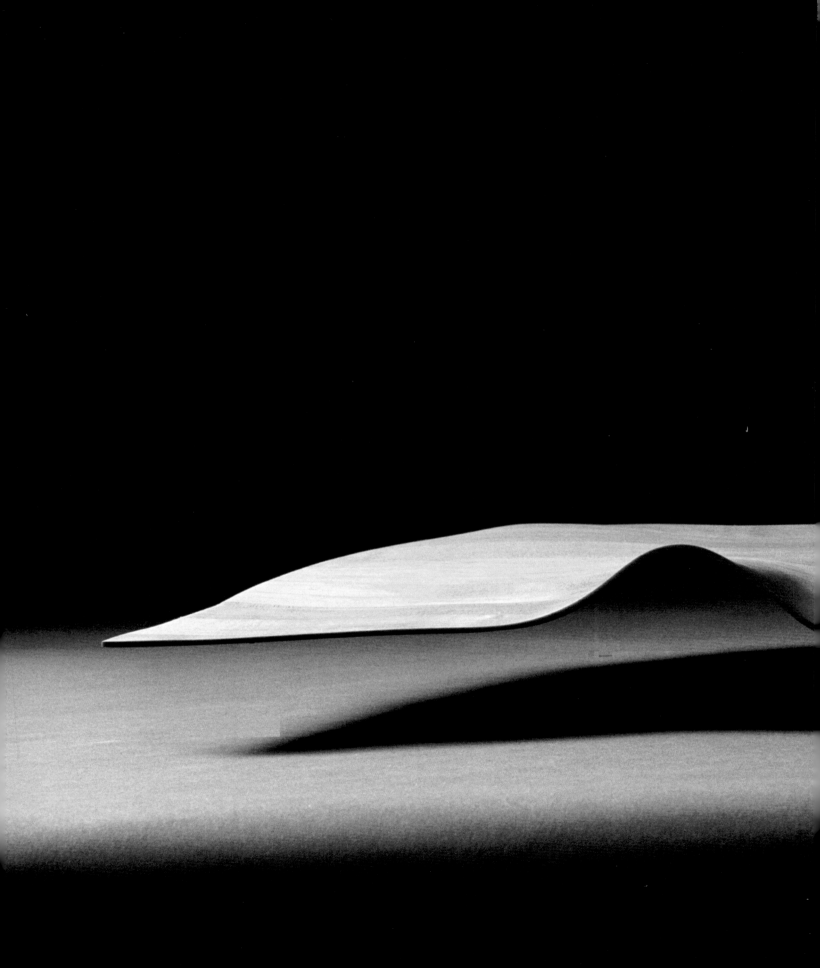

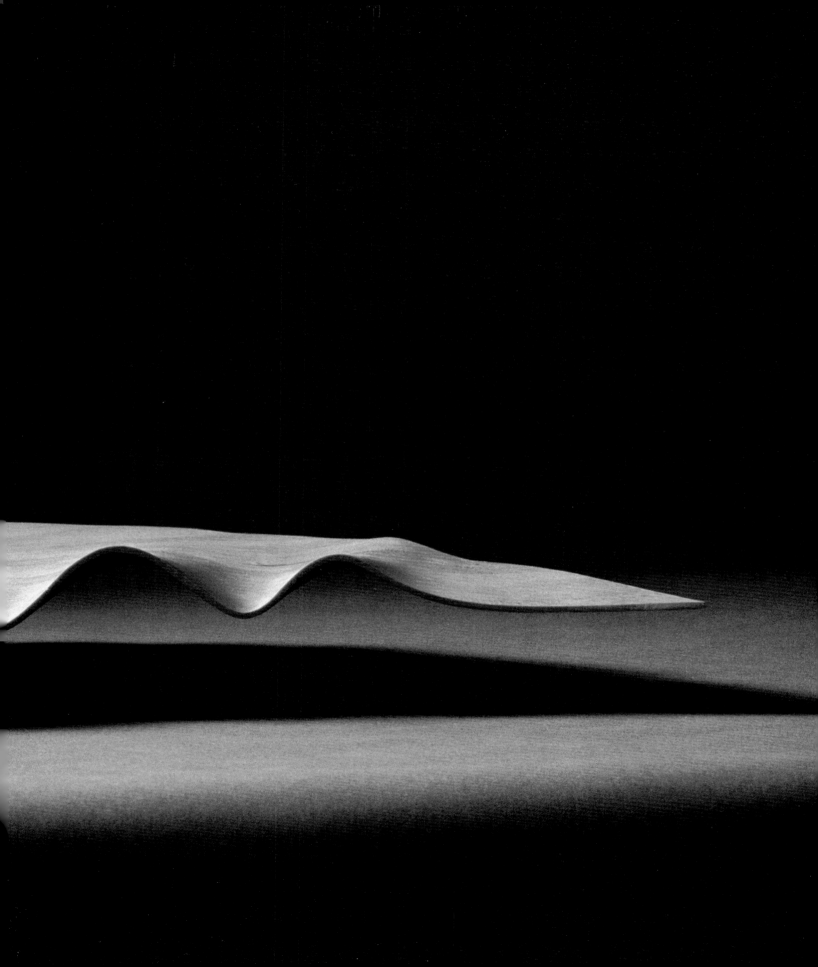

The Zentrum Paul Klee is a good example of what fertile cooperation between private and public institutions can produce—its street address, Monument im Fruchtland (Monument in the Fertile Country), aptly illustrates this.

The Maurice E. and Martha Müller Foundation (MMMF) undertook responsibility as a private developer and between 1998 and 2005 looked after the planning, realization, and financing of the building designed by Renzo Piano. On June 21, 2005, as scheduled, the foundation presented the completed building to the Stiftung Zentrum Paul Klee (Zentrum Paul Klee Foundation) for operation, thus achieving its most important goal.

The architecture realized by the MMMF for the Stiftung Zentrum Paul Klee and the public explodes traditional notions and outshines many a well-known precursor—or at least the one to be found in Riehen, near Basel, where Renzo Piano's other Swiss museum is located.
The three waves in the eastern part of Bern are, on the one hand, an autonomous work of art, a landscape sculpture; on the other, they establish excellent conditions for an operation that, setting out from Paul Klee's own interdisciplinary activity, will offer the public cultural events that cross the boundaries between genres. In this sense, the MMMF has provided the vital impetus—and startup capital—for a public enterprise that will greatly enhance Bern's attractiveness.

Over the past six and a half years, the MMMF has repeatedly profited from the generosity of its founders, Professor Maurice E. Müller and his wife, Martha Müller; from their partners in Bern and Swiss business; and from the lottery fund of the Canton of Bern. We owe them all profound thanks. Their early and generous commitment demonstrated both courage and vision, and for that they are ensured of public recognition.

The architecture of the Zentrum Paul Klee has caused a great surge of attention; my wish is that its operations will create a similar stir, and that the Zentrum Paul Klee will be able to count on the continued interest and long-term support of the public, of business, and politics.

Peter Schmid
President of the Maurice E. and Martha Müller Foundation, Bern

The Zentrum Paul Klee is opening its doors to the public. It is a historic day for the city, region, and canton of Bern. The people of Bern have long been waiting for this day, even though the time required to make the idea a reality was, in objective terms, atypically brief for Bern.

The political authorities of the City, Civic Community (Burgergemeinde), and Canton of Bern have greeted the project enthusiastically from the outset and have supported it with conviction and all available means. They were motivated, on the one hand, by the great economic significance of the new cultural institution and the expected boost for domestic and international tourism.

On the other hand, the public authorities have recognized the wide-reaching cultural significance of the Zentrum Paul Klee. The Zentrum Paul Klee provides a suitable place for the artistic legacy of one of the greatest visual artists that Bern has ever produced, a man of world renown. It is suitable not only in terms of its building, by the architect Renzo Piano, who has been decorated with the highest architectural awards; the idea of establishing an interdisciplinary center also suits Klee's spirit. The center in Bern's Schöngrün area should not be revered as a monument. Rather, the importance of ethical and aesthetic values to the individual and to society is something visitors to the Zentrum Paul Klee should experience through pleasurable encounters with art and culture when, for example, they apply their own hands in the children's museum. It lies in the nature of the matter that the networked idea behind the center, understood in this way, will radiate beyond its own physical boundaries. Through close cooperation with other cultural institutions in Bern, the Zentrum Paul Klee can and will make a substantial contribution to the art and museum landscape.

For the success of this project, I have the honor to express a threefold thanks in the name of the Stiftung Zentrum Paul Klee (Zentrum Paul Klee Foundation). First, I offer our gratitude to the founding family Klee, Ms. Livia Klee-Meyer and Mr. Alexander Klee, without whose gifts and loans the Zentrum Paul Klee would have remained but a beautiful dream. Next my thanks goes to the founding family Müller, whose vision made it possible to develop the idea of the center and whose donations made it possible to commission Renzo Piano for the building. Finally, my thanks go out to the businesses whose pioneering engagement contributed fundamentally to the realization of the Zentrum Paul Klee.

Regierungsrat Werner Luginbühl
Member of the Cantonal Government and
President of the Stiftung Zentrum Paul Klee, Bern

LIVERPOOL JOHN MOORES UNIVERSITY
LEARNING SERVICES

Dear Readers,

For the team that had the pleasure of directing and accompanying the planning and realization of the Zentrum Paul Klee on the operative level, the opening marks the end of an enjoyable period of hard work. It also means that a dream has become reality.
From the first initiative of the Klee family through the proposals and visions of Professor Maurice E. Müller and Martha Müller-Lüthi to the completion took a little more than ten years. A very brief time, by the standards of Bern, at least.

Work on the project was fascinating and varied, never monotonous, marked by highs and lows: from enthusiasm through disappointment to massive doubts on the political side, visionary thinking and unconditional, untiring support from the founding families, skepticism to brusque rejection from parts of the Bern art scene, and media reports continually searching for flies in the soup.
We found strength in a series of positive decisions on the part of the governments and parliaments of the city and canton of Bern, and we felt completely legitimated by the conclusive approval of Bern's voting population, given in spring 2001.

The present volume—surely quite rightly—places the focus on Paul Klee and his work. It is, however, also a progress report. It presents the history of the project, the visions of the founders, and the intellectual direction and the intended goals of the Zentrum Paul Klee.
Whether our goals have been achieved, whether we have managed to bring Paul Klee's œuvre closer to a large audience, and whether the Zentrum Paul Klee will transcend boundaries between the arts are questions that can only be answered after a few years have passed.

Today, my task is to express thanks: for the trust repeatedly shown me by the founding families, the Klees and the Müllers, by the Bern cantonal government, and the municipal government of the city of Bern. The same thanks is due to the councils of the Maurice E. and Martha Müller Foundation and of the Stiftung Zentrum Paul Klee with their presidents Peter Schmid and Werner Luginbühl. I also owe profound thanks to my wonderful team, who helped me build this unique cultural center—above all the members of the Gesamtprojektleitung (Overall Project Committee): Ursina Barandun, Dr. Lorenz Meyer, Christoph Reichenau, and Peter Tschanz as well as their managing director Elisabeth Ryter.

The Zentrum Paul Klee opens its doors to the public on June 20, 2005—before the official celebration. There is a deliberate symbolism in this. May it remind us that Paul Klee's œuvre belongs to all of us and inspires and satisfies us again and again.

Andreas Marti
Founding Director, Zentrum Paul Klee, Bern

Dear Readers,

You are holding in your hands the first major publication from the Zentrum Paul Klee. The authors represented in this "deluxe volume," as we like to call it, were all closely involved in the project. Beyond the project leaders and staff of the Zentrum Paul Klee, this includes many who followed and supported the development of this new house of culture from the very beginning.

Not represented are the voters of the city of Bern, though their decision at the ballot box made it possible to realize this project in the first place. It is to them, therefore, that this book is dedicated, and it is for them that the Zentrum Paul Klee first opens its doors on Monday, June 20, 2005, previous to the official opening.

The concept behind the Zentrum Paul Klee is just as varied as the authors of this volume. First and foremost, the Zentrum Paul Klee seeks to be a place of encounter and dialogue, a place where people engage with art, where people interested in culture come together, where various arts inspire one another—to the pleasure and the benefit of our visitors.

Our opening publication presents the collection of the Zentrum Paul Klee and its history. It offers an overview of the most important stages of the center's development and pays homage to the magnificent commitment of the founding families, the Klees and the Müllers, as well as our partners from government and business. The book is a thank you to everyone who made the Zentrum Paul Klee possible, to people and institutions too numerous to list separately. It is a thank you for their commitment, their enthusiasm, and their loyalty. They motivated us and spurred us on to manage our great task and to make the Zentrum Paul Klee a reality. We will continue to feel an obligation to the values they represent, and will constantly seek to optimize the activities of Bern's new cultural center in the spirit of Paul Klee and to the benefit of our visitors.

Ursina Barandun
Deputy Director and Director of Communication and Outreach,
Zentrum Paul Klee, Bern

LIVERPOOL JOHN MOORES UNIVERSITY
LEARNING SERVICES

"It is very rare to see such a creative genius express himself so clearly about the process of creation … He [Klee] never speaks of himself but lets us share in his studies, and helps us to study along with him."

Pierre Boulez, composer

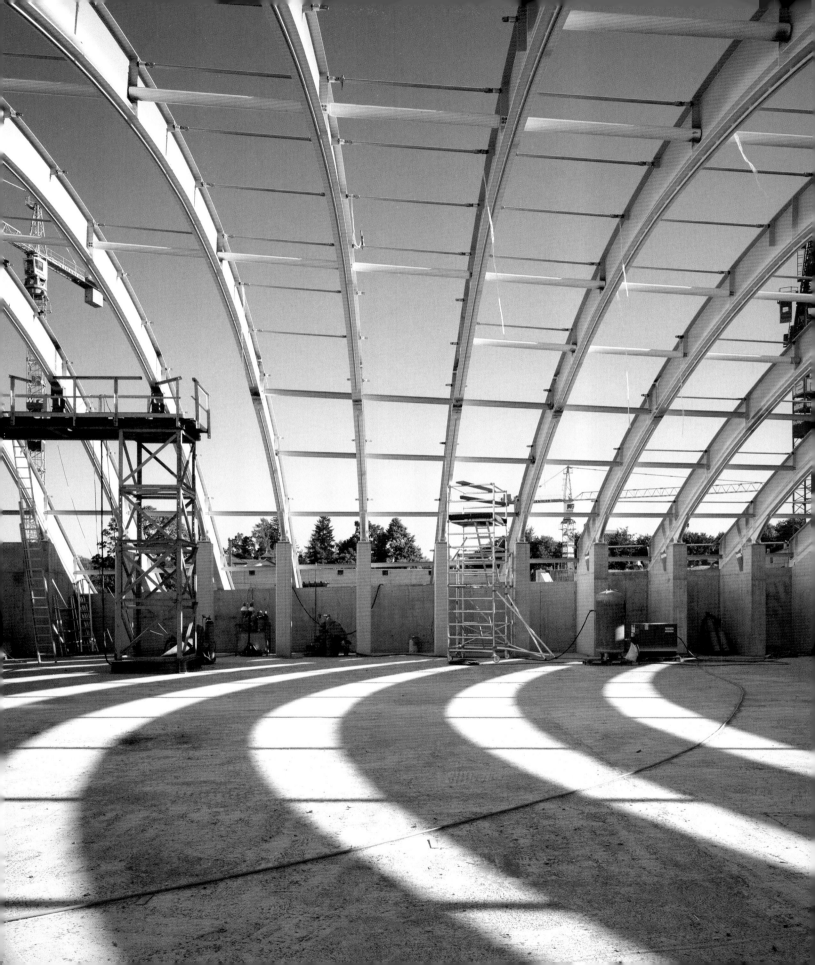

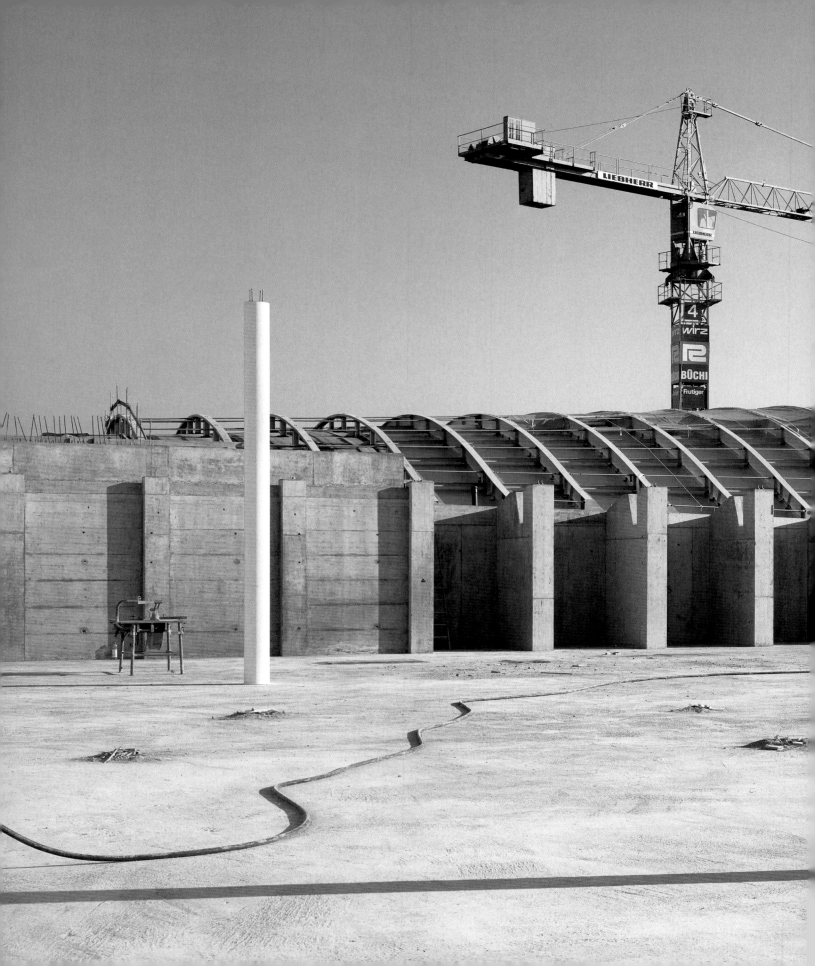

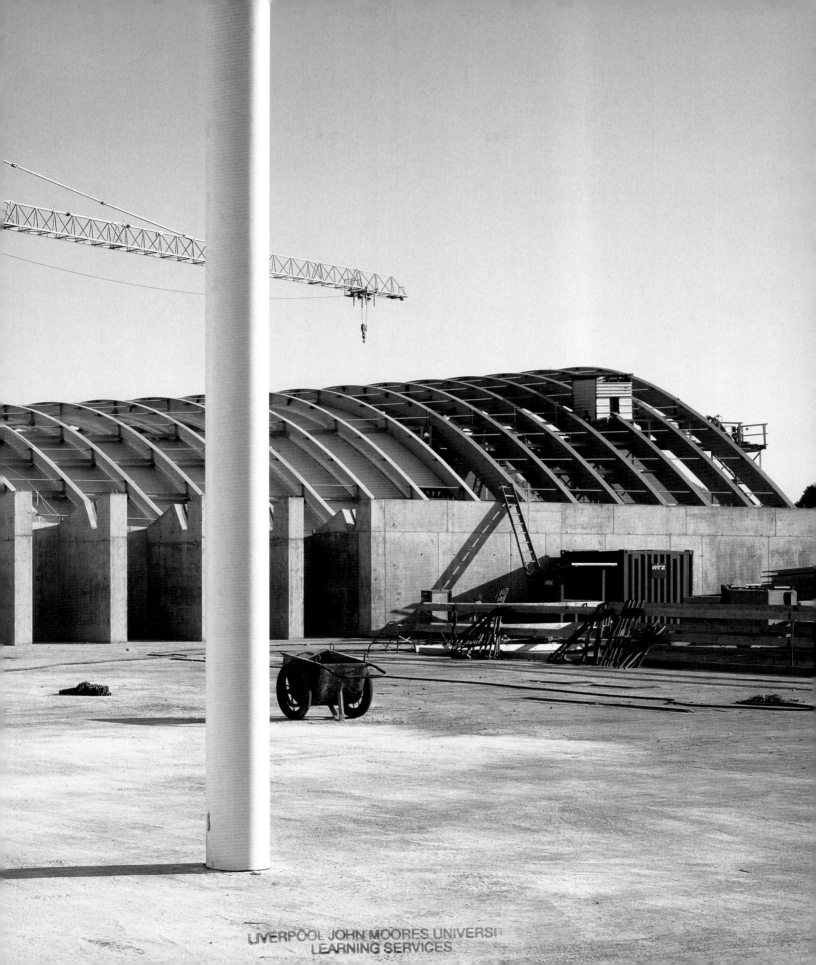

LIVERPOOL JOHN MOORES UNIVERSITY
LEARNING SERVICES

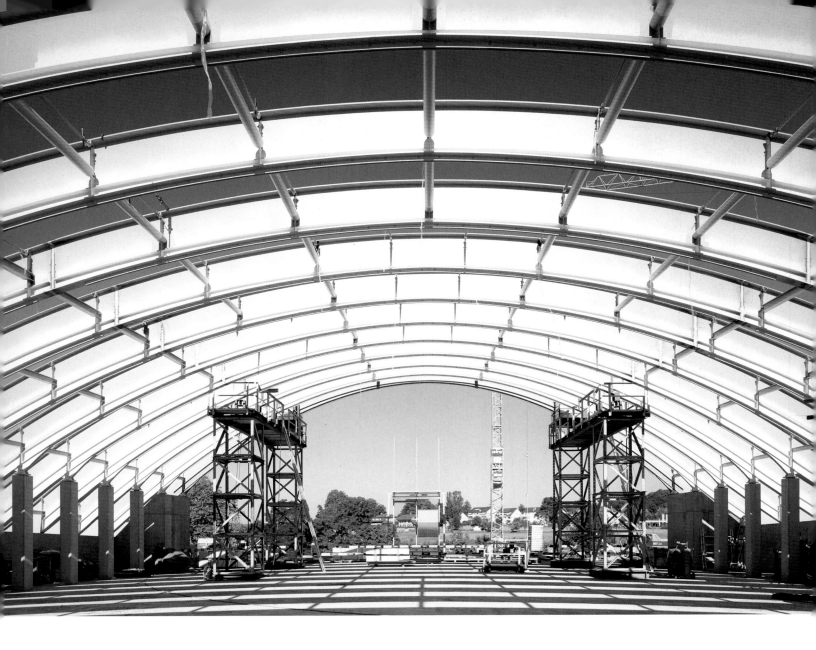

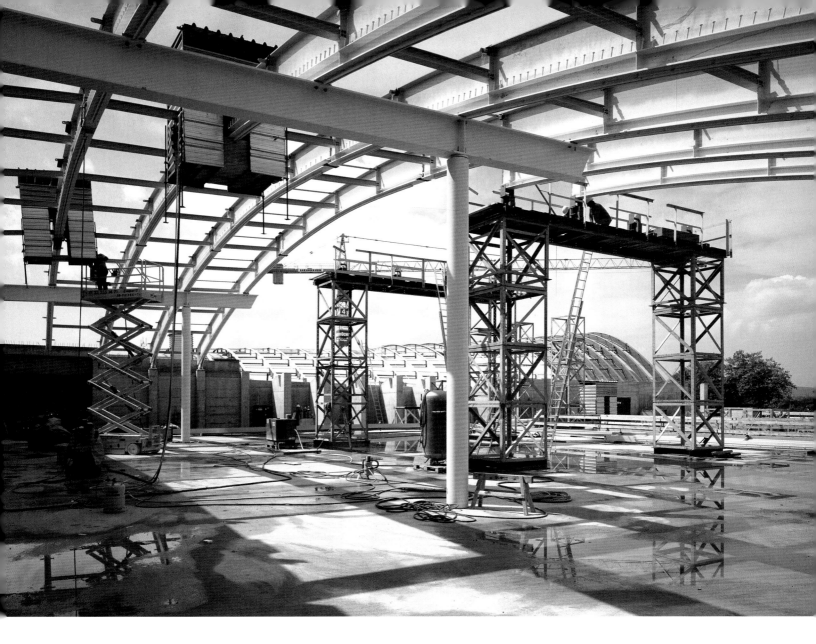

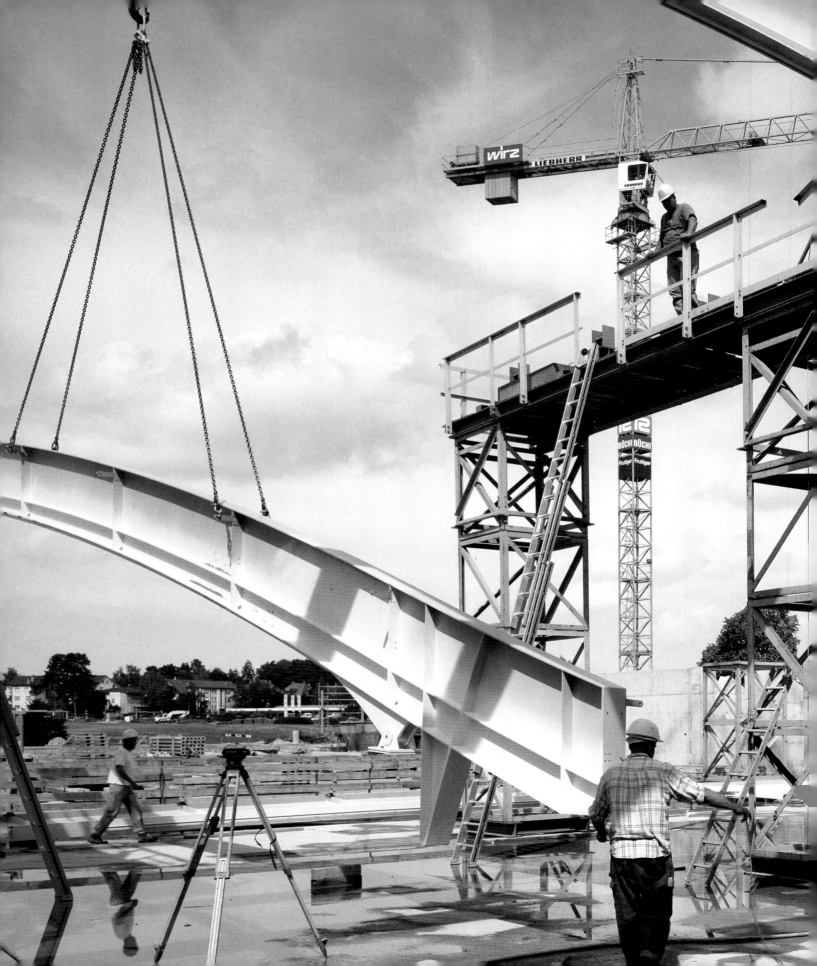

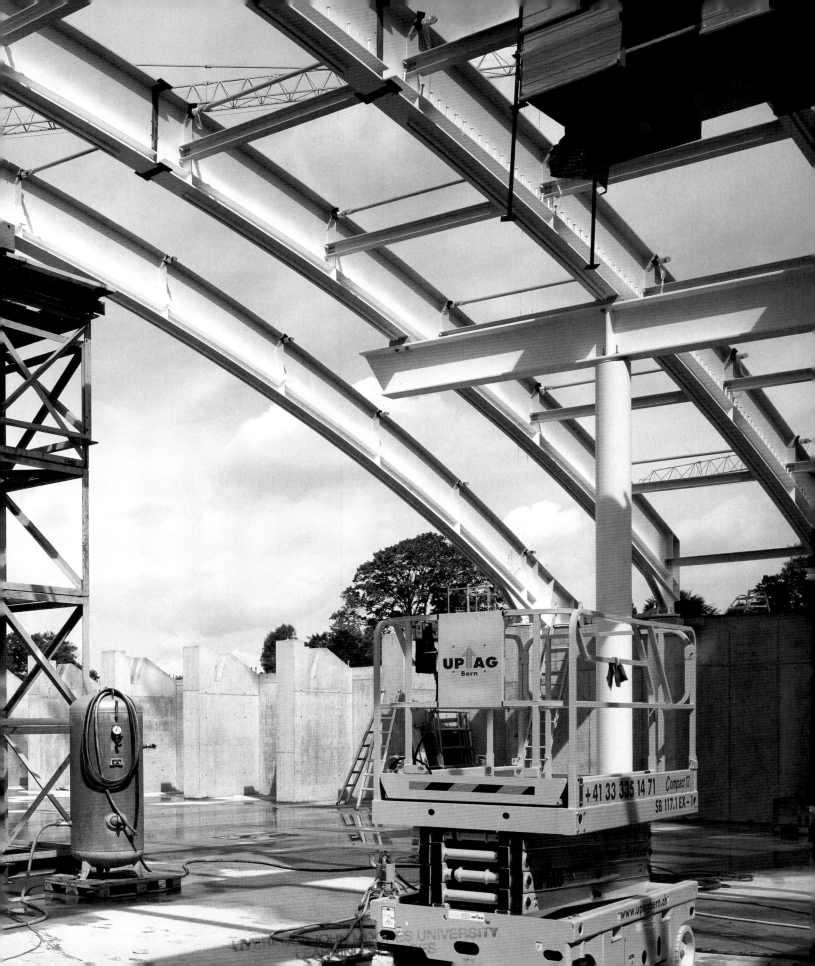

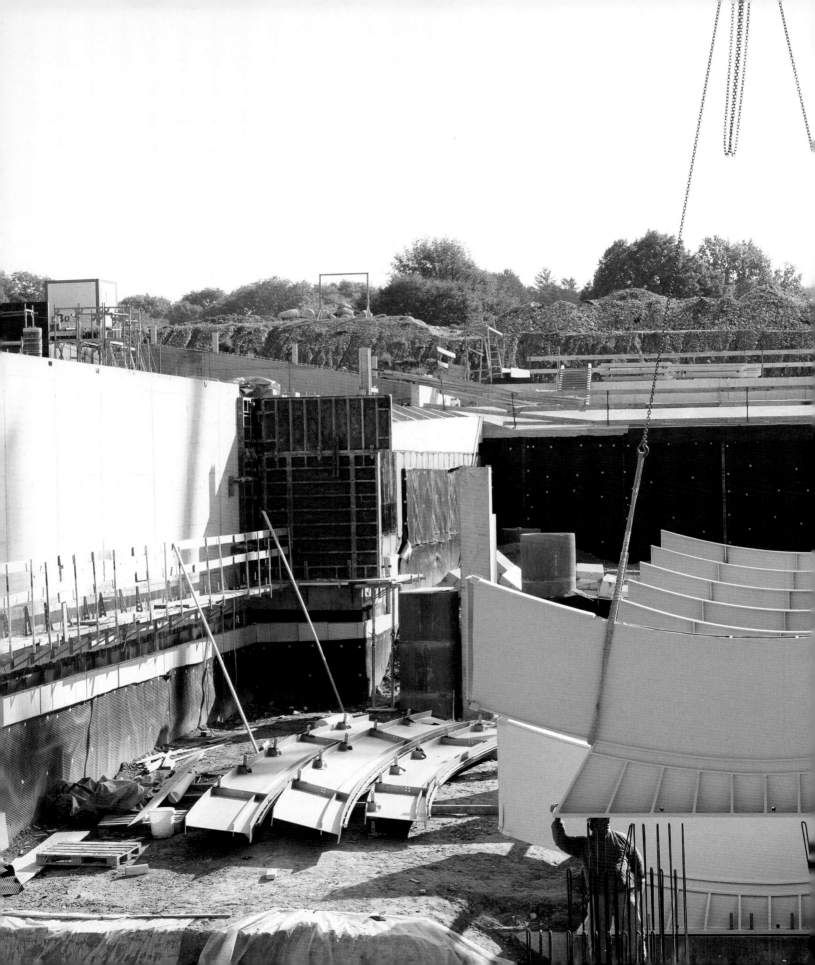

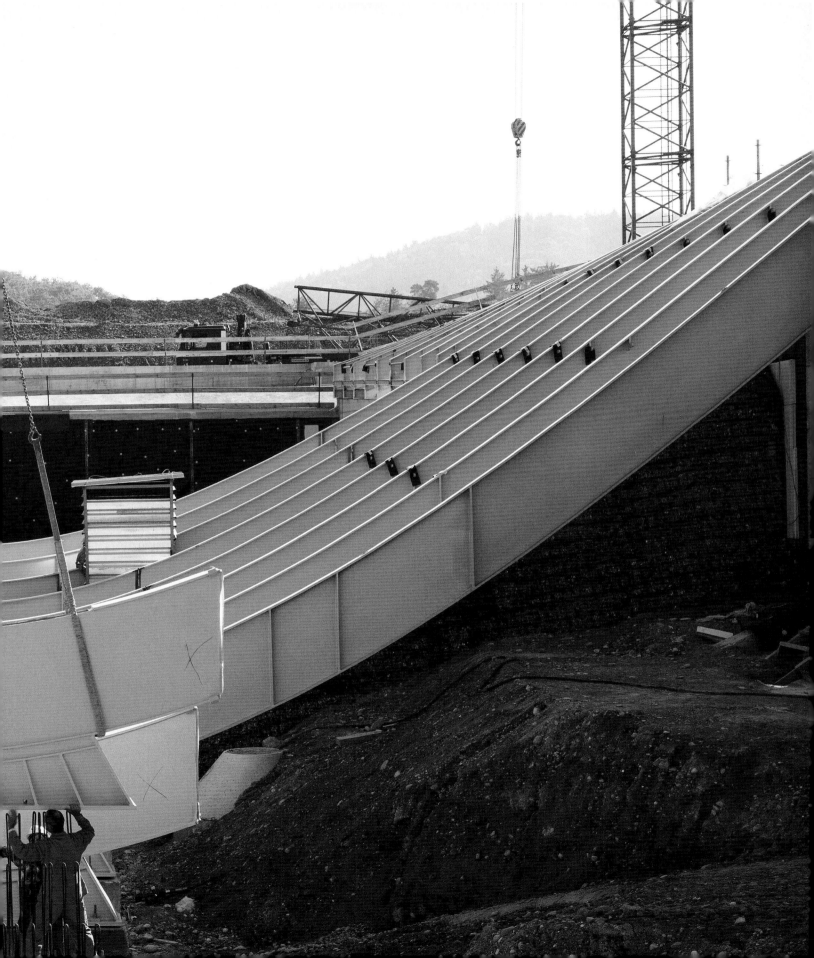

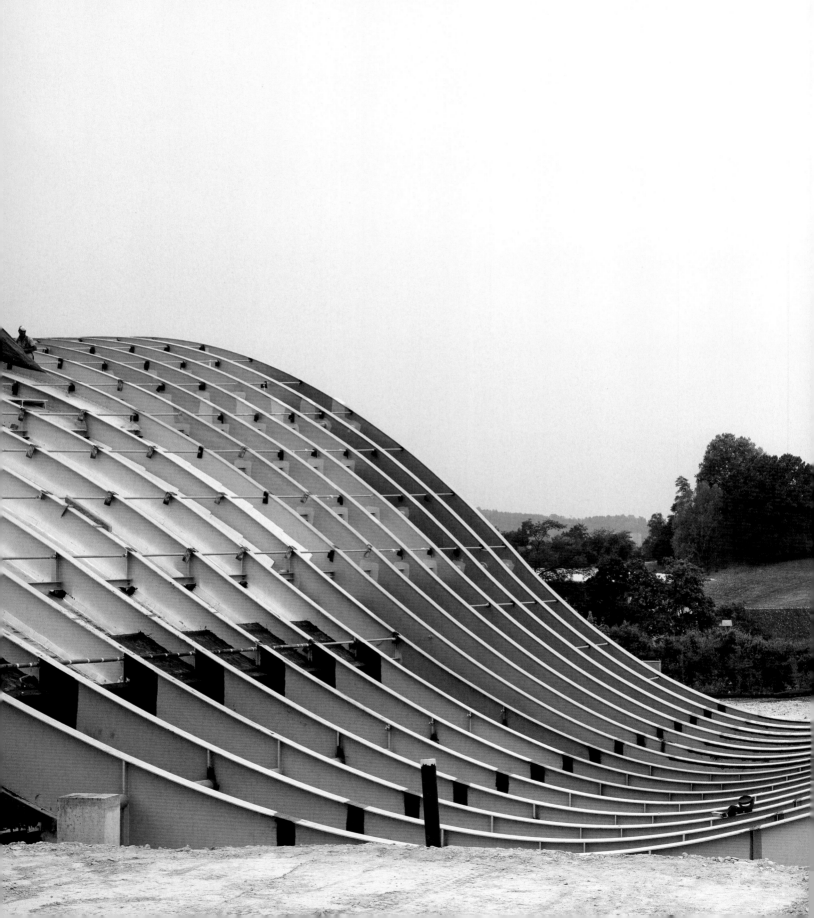

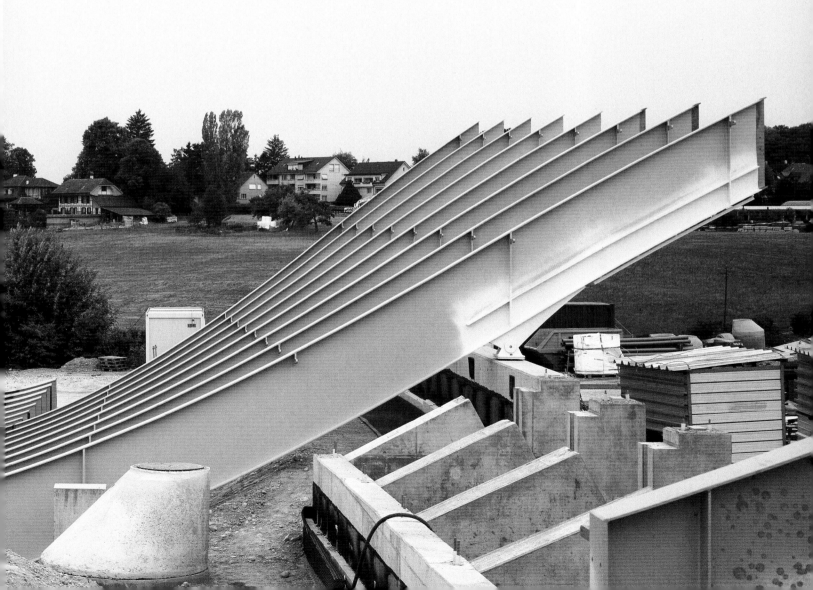

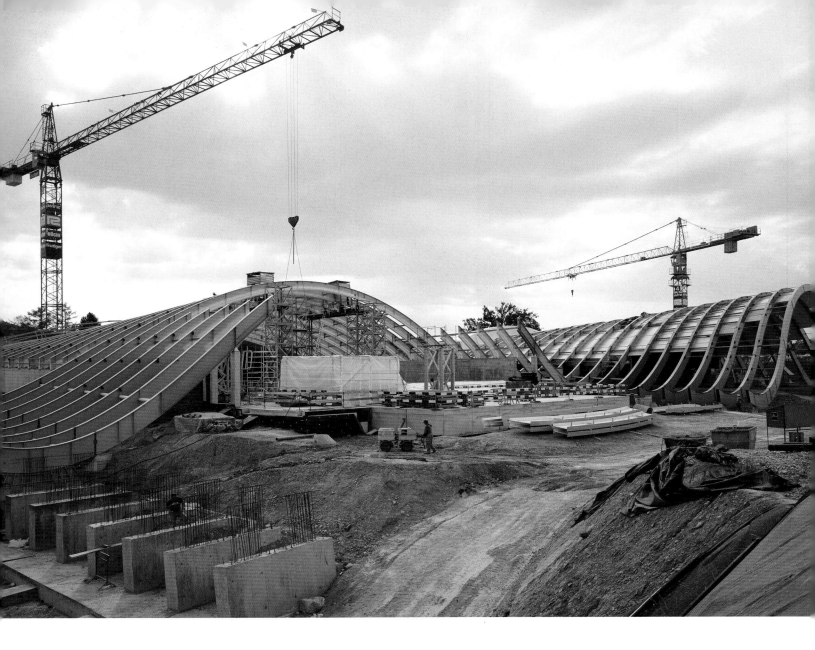

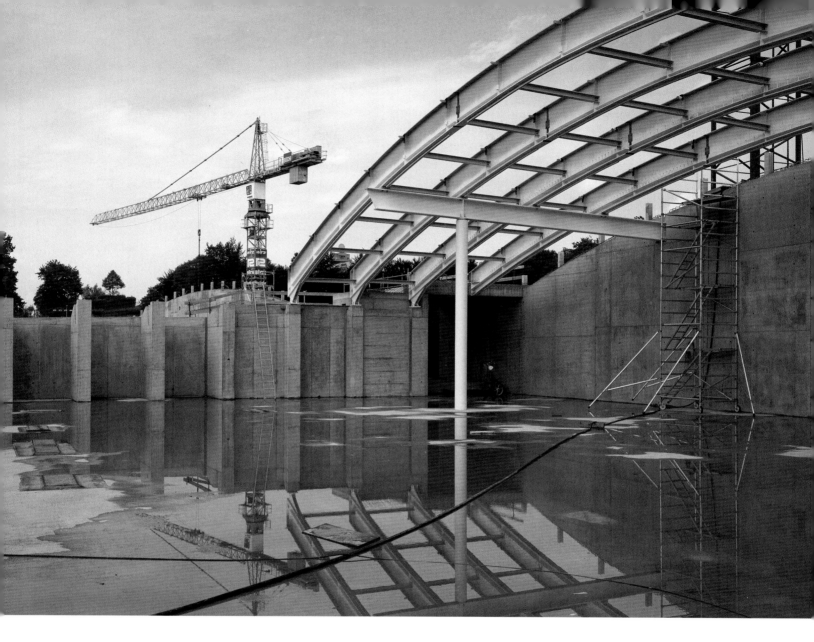

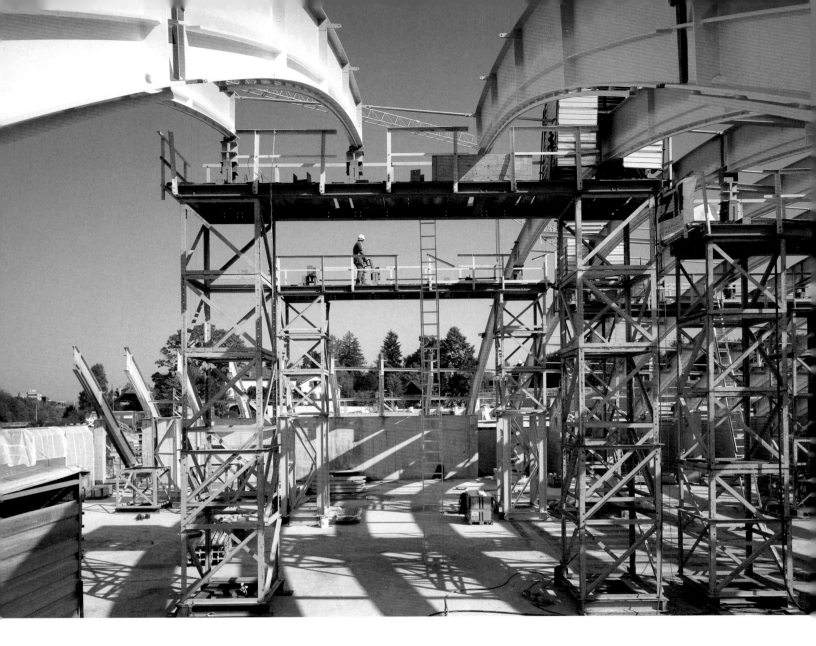

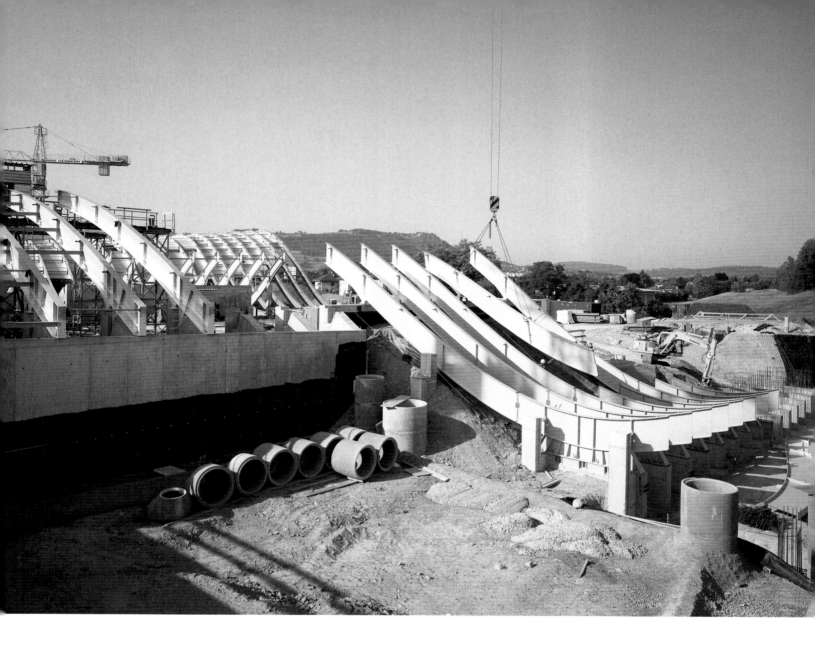

LIVERPOOL JOHN MOORES UNIVERSITY
LEARNING SERVICES

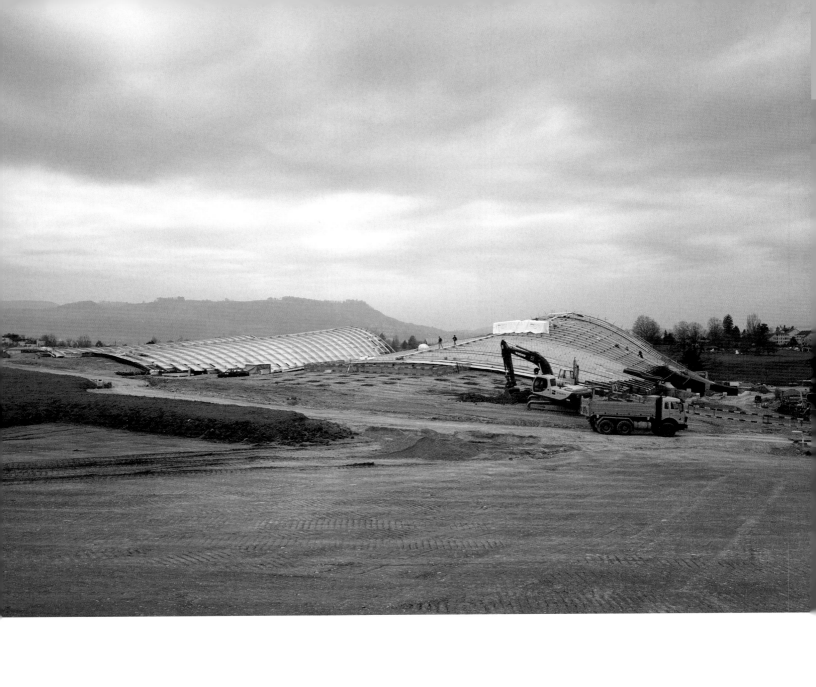

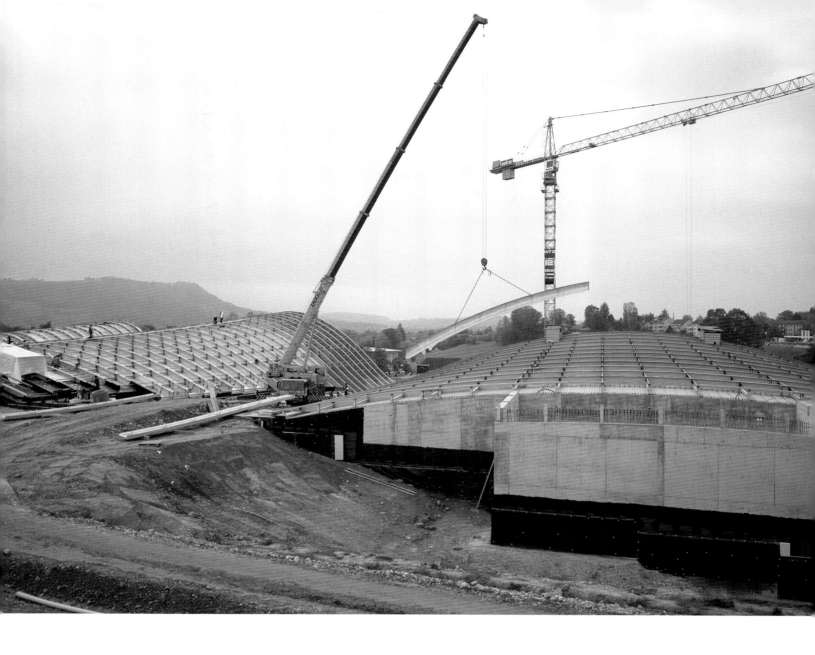

LIVERPOOL JOHN MOORES UNIVERSITY
LEARNING SERVICES

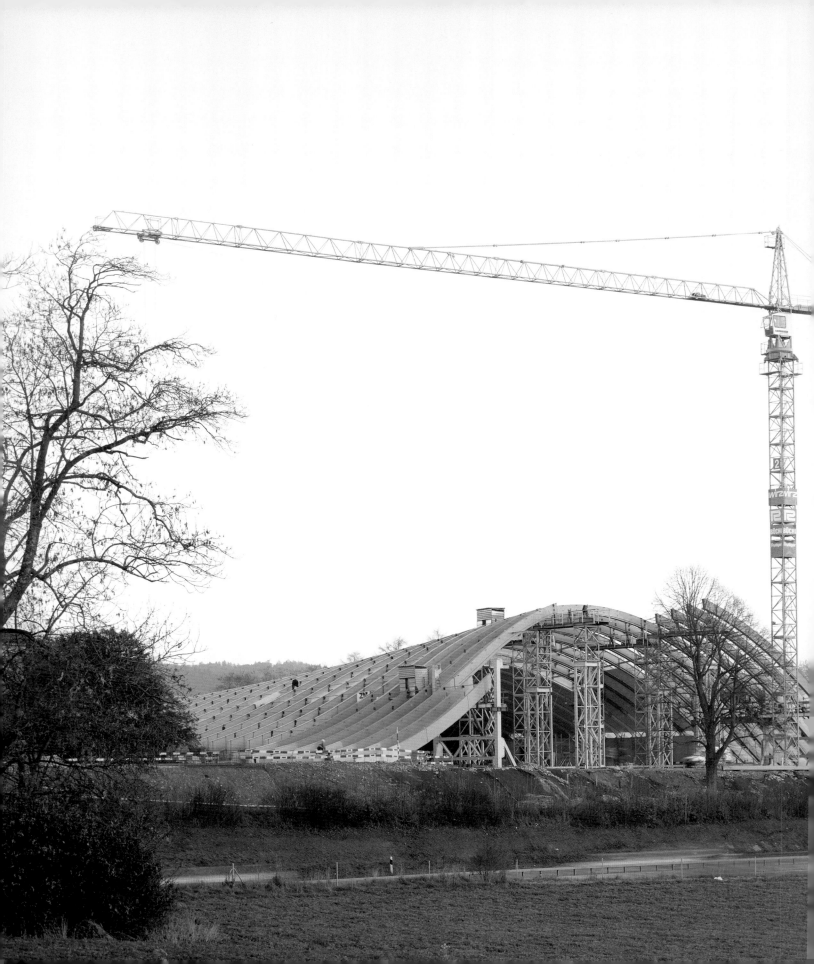

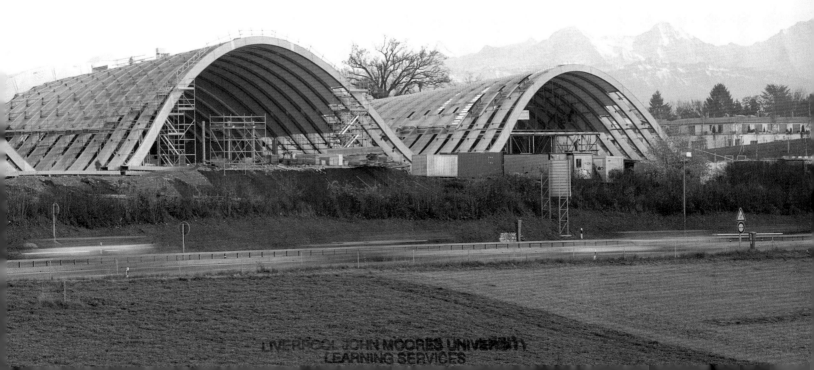
LIVERPOOL JOHN MOORES UNIVERSITY
LEARNING SERVICES

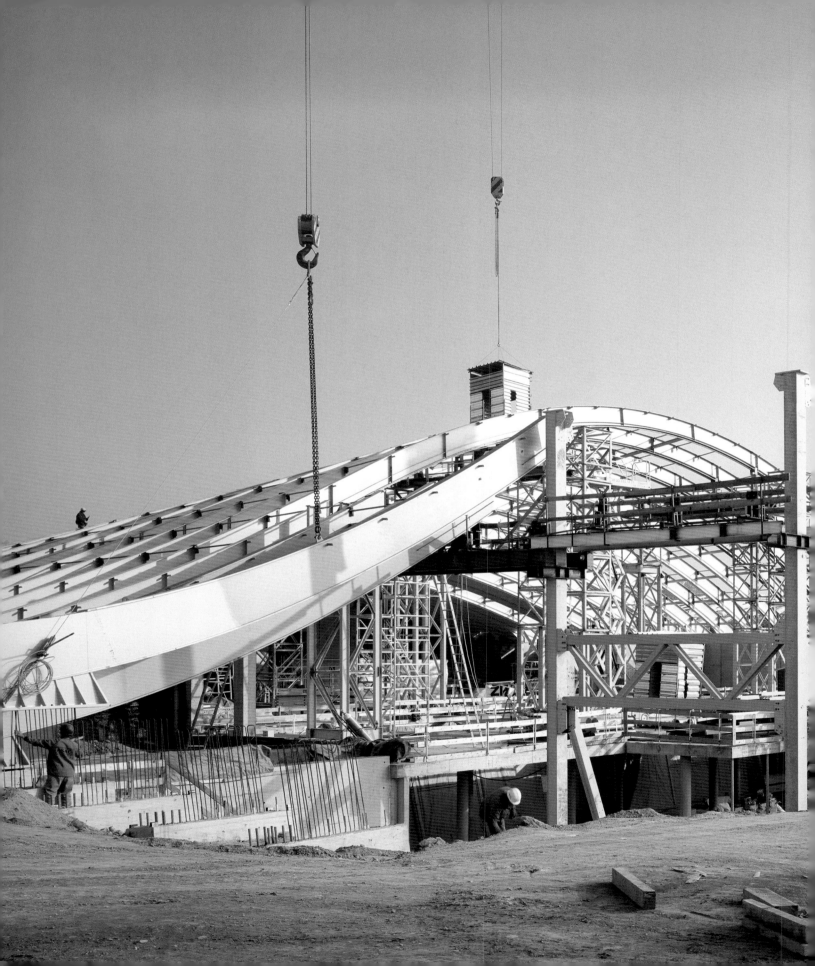

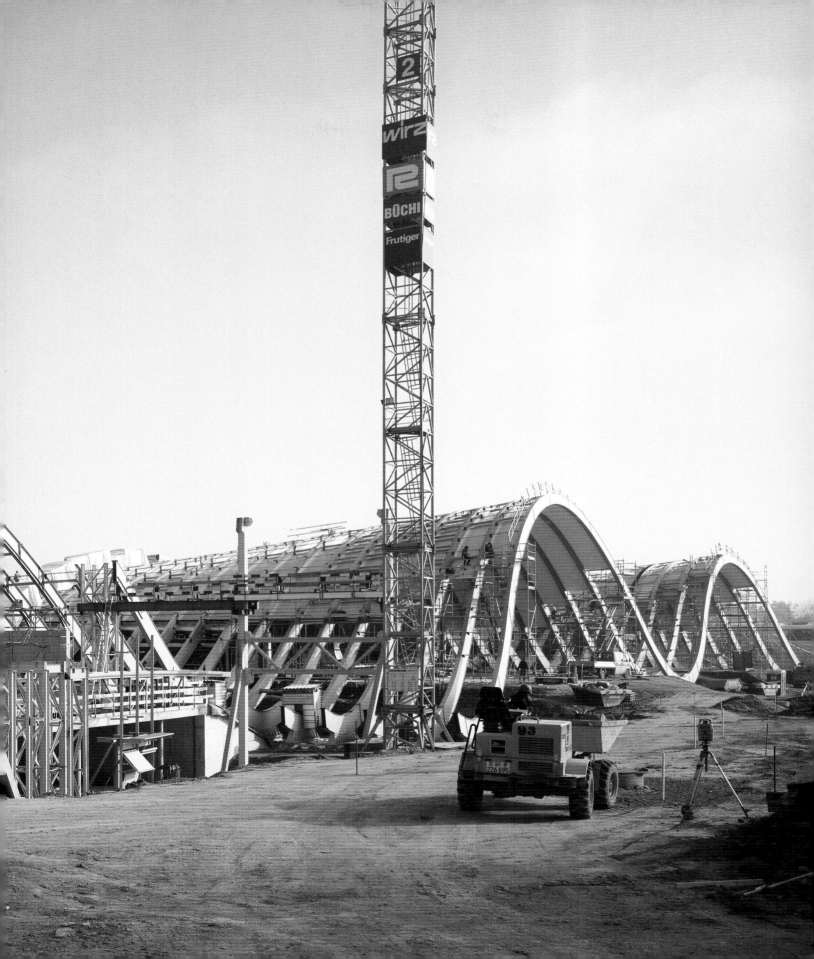

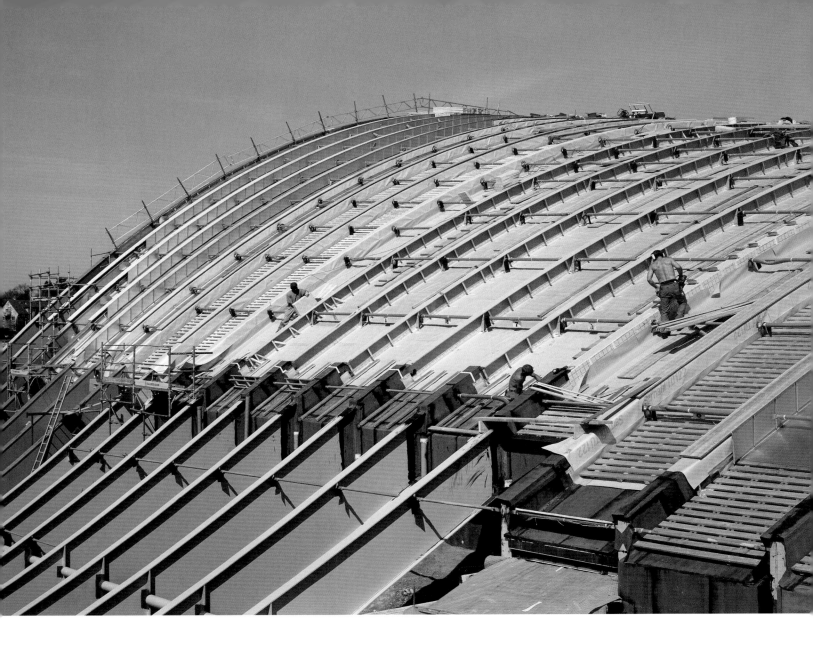

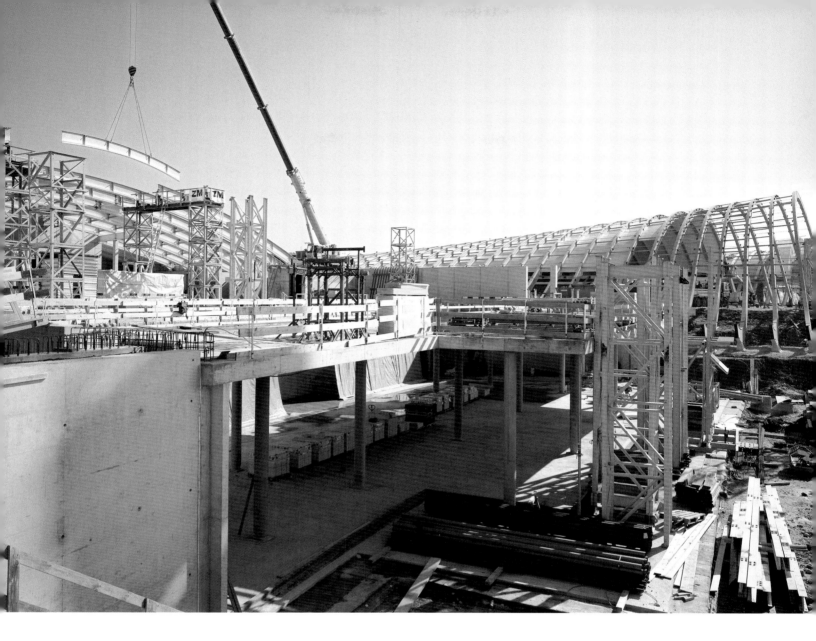

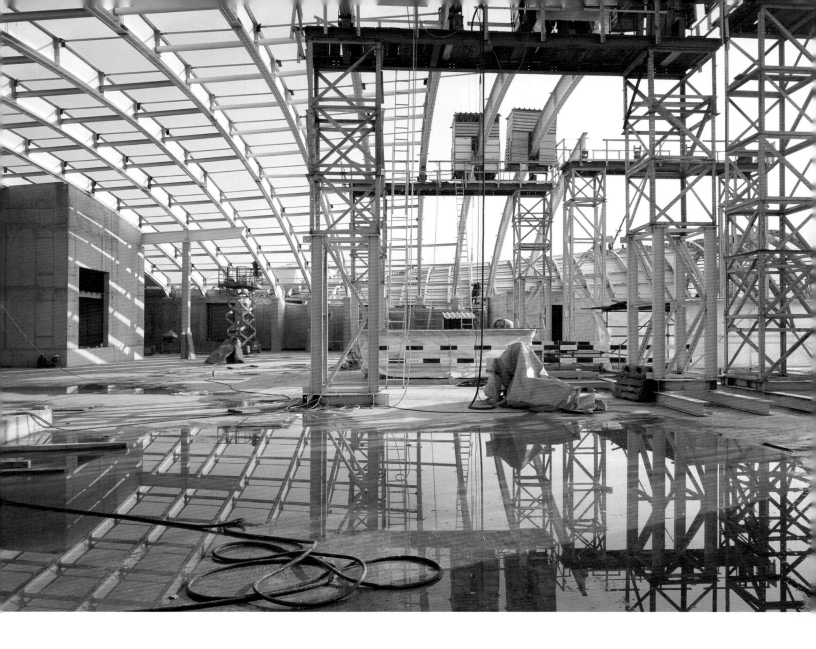

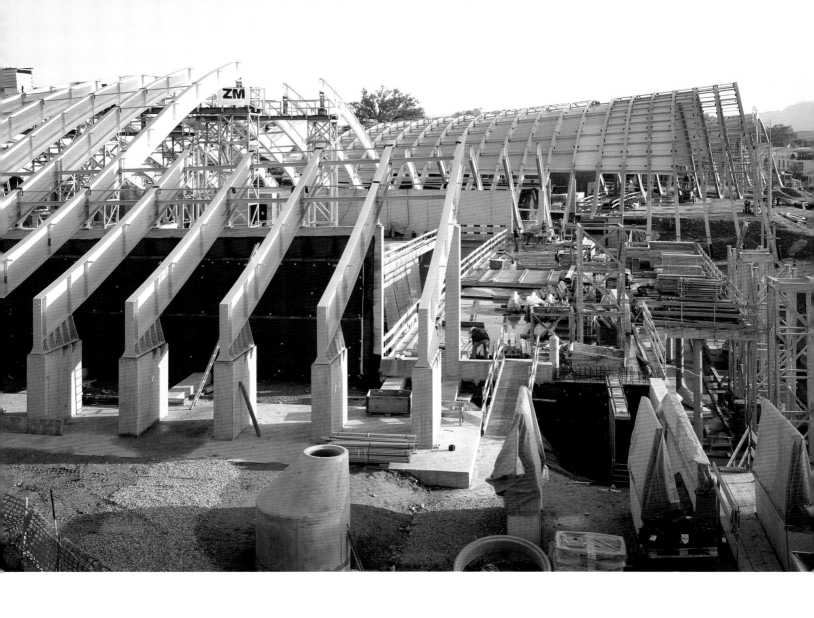

LIVERPOOL JOHN MOORES UNIVERSITY
LEARNING SERVICES

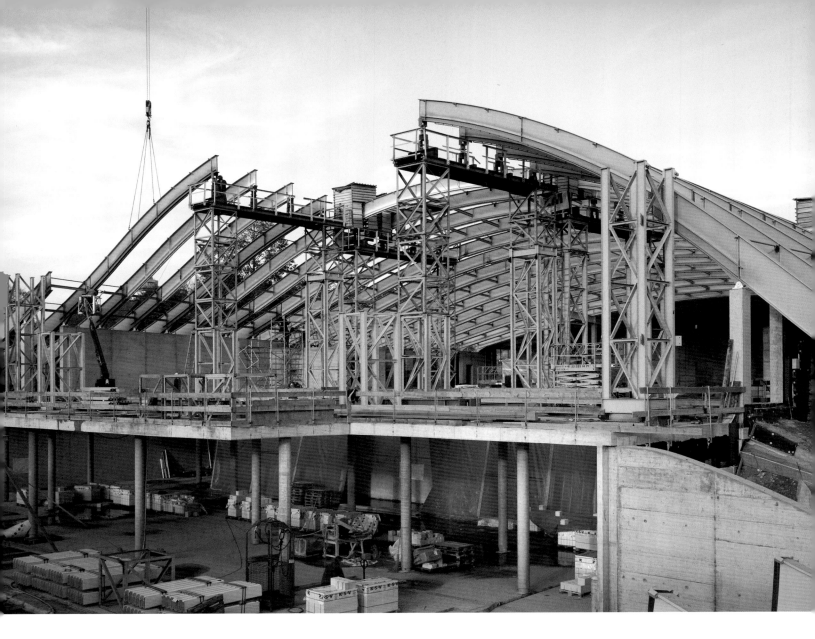

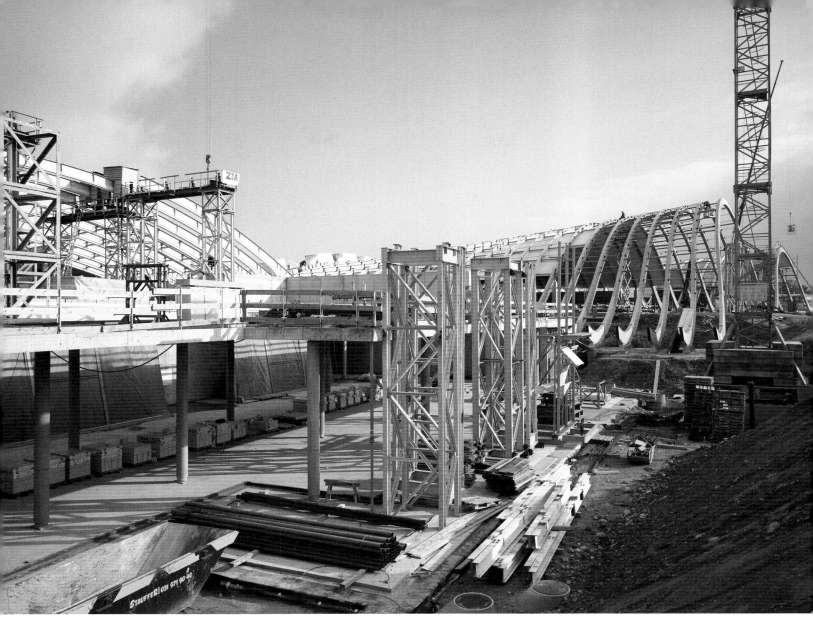

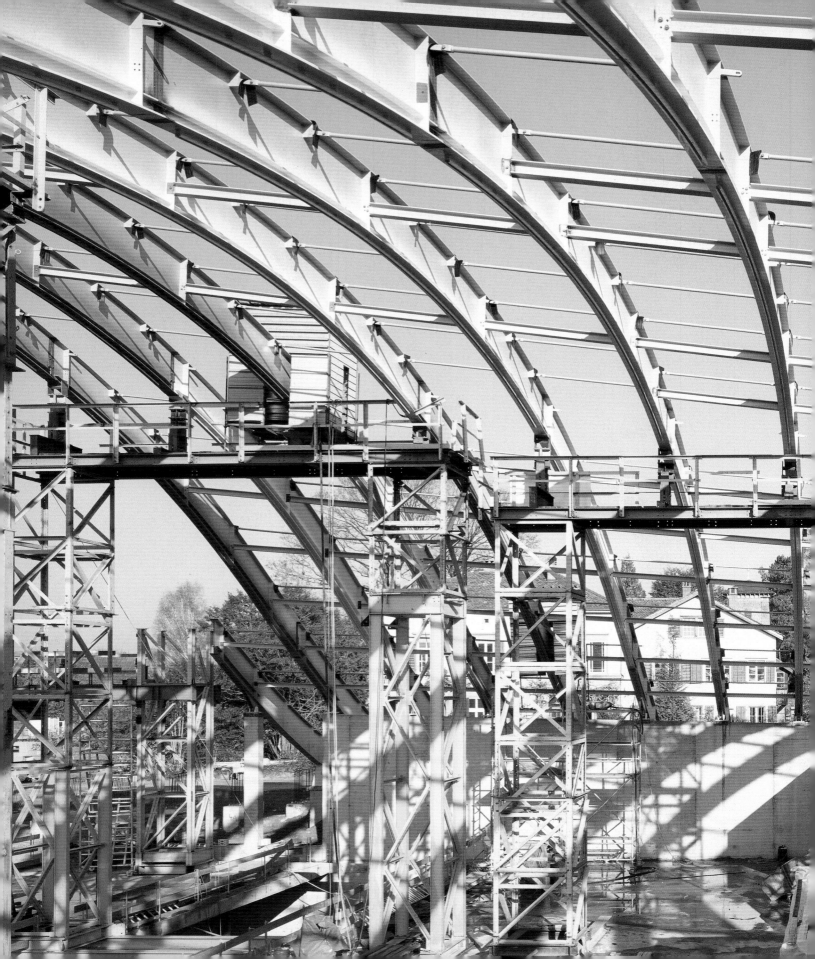

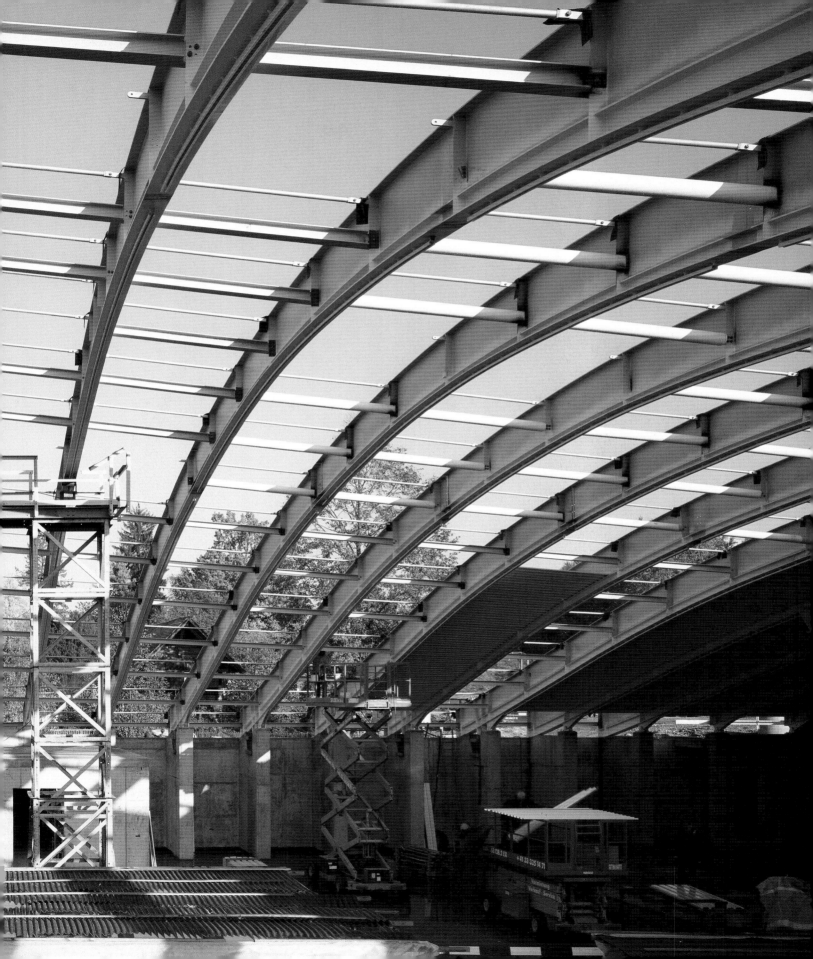

The Zentrum Paul Klee

LIVERPOOL JOHN MOORES UNIVERSITY
LEARNING SERVICES

A Dream for All of Us
An Appreciation of the Founding Family Klee

Dr. Klaus Baumgartner, former Mayor of Bern

Livia Klee-Meyer, co-founder of
the Zentrum Paul Klee

The Zentrum Paul Klee has opened. Our work is complete. Now it must prove its worth. Like every work on this scale, it owes its existence to the commitment of many people, in many places, in many ways. Their talent, their devotion, their care and precision, their enterprise and their patience have all contributed to its success. They have all earned our thanks! For deciding something is one thing; bringing it to life is another, and the more important one. We were fortunate in giving those involved in building the Zentrum Paul Klee this task, this opportunity.

We were fortunate. But we would not have had that good fortune had it not been for the initiative of Alexander Klee. He was the one who put out feelers in 1993 and, together with Hans Christoph von Tavel, then director of the Kunstmuseum Bern, presented the first, very general idea to the Canton and City of Bern to house important parts of the Felix Klee Estate Collection in a museum dedicated to Paul Klee. Many more talks took place before the idea was concrete and cogent enough for an agreement to be drafted and signed.

Without Livia Klee-Meyer and Alexander Klee, there would be no center. They continued the work of Lily Klee and her son, Felix, as well as that of the Klee-Gesellschaft (Klee Society) and the Paul-Klee-Stiftung (Paul Klee Foundation) with the goal of securing for Paul Klee's work the place in cultural and art history that it deserves. In 1997 Livia Klee-Meyer gave her share of Klee works from the Felix Klee Estate to the Canton and City of Bern. In doing so she enriched the public—all of us—in an exceptionally generous way. Her gift is the seed, the capital, the substance of the Zentrum Paul Klee. Finding himself in different circumstances, Alexander Klee agreed in 1998 to lend the City and Canton of Bern and the center a selection of works from his portion of the estate as permanent loans and to make the remaining works in his possession available as loans. In practical terms there is no difference. But the works remain his property.

Anyone who donates, gives. Livia Klee-Meyer gave her paintings away and with them not primarily assets but memories, feelings, a piece of her everyday, familiar sur-

roundings for many years—a piece of her history. We can only guess what effort it must have cost her and what conviction about the rightness of her action it needed. We can be sure, however, that the tremendous generosity of Livia Klee-Meyer's gift had its source in a great inner independence and a deep faith in the power of Paul Klee's work to communicate to the public.

Alexander Klee, co-founder of the Zentrum Paul Klee

Anyone who gives, wants something. Livia Klee-Meyer and Alexander Klee, together with the Paul-Klee-Stiftung, wanted a public place for Klee's œuvre in a museum dedicated to the artist. The place, the form, the size of the museum did not matter to them; however, the speed with which it would be constructed did. In the donation agreement with Livia Klee-Meyer precise deadlines were specified for the museum's opening. If we had not adhered to them, we would have lost the gift. Thanks to support from one patron of the arts in Bern, we were even able to come in ahead of schedule. The clarity of the demand gave vital impetus.

Anyone who receives a gift, accepts an obligation. The City and the Canton of Bern have, with the very generous support of Maurice E. and Martha Müller, created a home for the works of Paul Klee in public ownership. More than that, departing from original plans for a Klee museum, the Zentrum Paul Klee has been created, a cultural site that also integrates music and theater, seeks to awaken and develop creativity, and offers a place for research and communication in many contexts. As Pierre Boulez put it in *Le pays fertile* (The Fertile Country): "It is very rare to see such a creative genius express himself so clearly about the process of creation … He never speaks of himself but lets us share in his studies, and helps us to study along with him."[1]

But the obligation associated with the donation goes further. The public authorities must cultivate and support culture so that people can live and live together with self-confidence, self-determination, and dignity: "Where culture breaks off, violence breaks in," theater director August Everding warned. Paul Klee's fate is a case in point. His work is a "fertile country" for the individual's own development. The outstanding architecture of the Zentrum Paul Klee makes another important contribution to culture in our region, and culture is both a dimension of life and the basis of life. The donation also obliges us not to neglect existing cultural institutions and organizations. On the contrary, the cultural sphere of the city and the region, expanded as it now is, rightly expects our continued and increased support in all its variety. Its task, in turn, is to improve cooperation in a continuous endeavor to achieve ever more attractiveness, innovation, and quality, far beyond what has been achieved thus far, reaching out to the people.

Livia Klee-Meyer and Alexander Klee's initiative spurs us to do just that. They did not place their own interests first but instead acted with vision, unselfishness, humility,

Livia Klee-Meyer visiting the exhibition "Das Paul Klee-Zentrum im Gespräch" on Kornhausplatz in Bern, February 2002

and modesty. They sought not to fulfill themselves but to serve a task. They did not simply wish to tend their own gardens but to look beyond the fence. The Livia Klee Donation and everything that freely resulted from it is a model for all patrons, independent of their background, and warns donors against entertaining all too fixed ideas.

That model has already given tangible impetus. The Zentrum Paul Klee was fortunate to receive a number of important paintings as loans from private collections in Bern that had been assembled in the context of personal contact with Paul and Lily Klee. Now that the works from the Paul-Klee-Stiftung, the Felix Klee Estate, and from private collections have found a home at the Zentrum Paul Klee, a large section of the artistic estate of Paul and Lily Klee that the four Bern collectors Werner Allenbach, Rolf Bürgi, Hans Meyer-Benteli, and Hermann Rupf rescued from liquidation in 1946, and thus saved for the city, has been brought together again and is being presented for the first time in a place open to the public.

Livia Klee-Meyer had a dream. Modest and circumspect, giving and demanding, she brought it to light and to reality. Livia Klee-Meyer believes in the sense of possibility. That makes her a model for us all. Now the dream is being fulfilled. The Zentrum Paul Klee is giving Livia Klee-Meyer part of her gift back. And it enriches us all. Let us hope for other big dreams and courageous acts.

Note

1. "Il est très rare de voir un tel génie créateur s'exprimer lui-même de manière aussi claire sur le processus de la création ... Il ne parle jamais de lui, mais il étudie devant nous et nous aide à étudier avec lui." Pierre Boulez, *Le pays fertile* (Paris, 1989); our translation.

Lifework

In Honor of the Founders Maurice E. Müller and Martha Müller-Lüthi

Dr. Rolf Soiron, Basel

The idea of building a permanent home for Paul Klee's œuvre—designed by none other than Renzo Piano—in the Schöngrün area of Bern, just behind his own house, is one in a series of visions that have driven, accompanied, and even guided him throughout his life, Maurice Müller said when he first publicly announced his intention to establish a foundation. Some of these plans, he noted, disappeared into thin air. And even the dreams that would eventually become reality first met with obstacles, until, often suddenly and unexpectedly, an opportunity presented itself.[1]

In other words, Maurice Müller's lifetime achievements did not happen just like that. No, here is a man who has always followed his dreams—and been able to realize them, even when faced with difficulties. The ability not simply to envision but to translate vision into reality is a rare gift. Maurice Müller has been adept at recognizing people blessed with this gift and enjoyed surrounding himself with them, regardless of their field of expertise.

Even as a child Müller dreamed of becoming a surgeon. His father had also wished to pursue this career, emigrating to the United States at a young age and later becoming a physician. But in the end, he had had to return to Switzerland to take over the family business. By contrast, Maurice Müller was able to follow his dream, and in doing so found happiness. Indeed, as he himself has said, his life has been so interesting because he was able to perform surgery all over the world.

Of course he also dreamed of becoming a good surgeon. He headed large clinics in Sankt Gallen and Bern while also working as a university professor. When he set his instruments aside, past the age of eighty, he had performed a total of twenty thousand operations and four thousand hip replacements. There were many grateful patients, some of whom had given up all hope of living without pain or ever using their limbs again.

Had he also dreamed of being the best surgeon of his time? That was precisely the honorary title—Surgeon of the Twentieth Century—he was awarded by the Société International de Chirurgie d'Orthopédie et de Traumatologie (SICOT) in summer 2002.

Professor Maurice E. Müller, MD, Dr. h. c. mult., co-founder of the Zentrum Paul Klee

Martha Müller-Lüthi, co-founder of the Zentrum Paul Klee

Indeed, the Society's eulogy leaves no doubt about this distinction, proclaiming him "probably the greatest orthopedic surgeon who ever lived."[2] A dozen honorary doctorates and a long series of prestigious awards have only underscored this fact.

There are two accomplishments in particular that have secured him a place in the history of medicine: the dramatic improvement in the treatment of bone fractures, of which he was the driving force and guiding spirit; and progress in the operative treatment of hip and, later, other joint diseases, for which he and his friend Sir John Charnley developed the first reliable methods. These lifetime accomplishments did not simply happen. Starting in 1944, they became his vision and life purpose—one might even say his calling.

With the qualifying exam under his belt, he joined a practice in Bern as a stand-in physician. A patient whose femur had been severed by a falling tree during the Finnish-Russian War in 1940 came to see him for a consultation. A German military doctor by the name of Gerhard Küntscher had treated the injury by inserting an intramedullary pin, and after a mere two weeks the patient had been able to walk with crutches. Now, four years later, he had no complaints, but simply wanted to ask if his implant could be removed. Another patient impressed Maurice Müller as well. He could only walk with a cane, and even that required extreme effort, but he did not complain. On the contrary, the hip replacement he had received in Paris two years earlier had relieved him of the unbearable pain he had suffered day and night.

Both cases cast their spell on the twenty-six-year-old. For two weeks he dwelled upon what he had seen and then set out on his course: he wanted to achieve something in these fields. In the decades that followed he would change the world.

At the time, the field of surgery was on the verge of many breakthroughs, able to offer help in a growing number of increasingly difficult cases. But bone fractures remained of little interest, and, characteristically, in the leading hospitals they were typically left to assistants. Skeletal traction, casts, and immobilization were still the standard treatment in most cases. Complications were common, and enforced inactivity proved to be a burden to many patients. The results were entirely unsatisfactory. In 1945 the Swiss insurer SUVA had to pay out permanent disability in 40 percent of cases involving fractures to the lower leg, and in 70 percent of cases involving femur fractures.[3] The prospects for patients with degenerative joint disease were not much better, and more often than not, lifelong pain and severe disability loomed on the horizon. For some time, the medical establishment had experimented with various procedures, but these proved beneficial with only a limited number of patients. A reliable and widely applicable method had yet to be discovered. From this perspective, the course Maurice Müller chose makes perfect sense.

In 1944, however, it would have been hard to imagine the urgency with which the world would soon need a solution to these problems. Did Müller perhaps foresee that fractures and joint diseases would, before long, be counted among the world's most common medical problems? Did anyone predict their cause—namely, demographic and social change? Did Müller suspect that life expectancy would rise so dramatically, or that traditional modes of work, sports, leisure, and communications—and thus behavior and lifestyle—would undergo such fundamental transformations?

Today, respect and gratitude for Maurice Müller's lifetime achievements are universal and uncontested. But before reaching this point, he met with numerous obstacles—some of which were difficult to overcome. There was the envy and small-mindedness always encountered by those who accomplish great things. And the young man, as is so often the case, had to deal with the indifference, skepticism, and antagonism of those who had already become part of the establishment. Indeed, as self-evident as Müller's ideas appear to us today, they met with scientific opposition at least into the late 1950s.[4] For a long time, medical authorities in the Anglo-Saxon world stuck to their creed "a closed fracture remains closed." The situation in Switzerland was no better. When Sankt Gallen was recruiting a chief of surgery for the new orthopedic unit in its canton hospital in 1958, Maurice Müller was the only applicant to have become full professor and possess the title of specialist in both surgery and orthopedics. Nevertheless, opposition came from as far away as Zürich, and there were many who believed it necessary to warn against, or even scuttle, his candidacy. They were suspicious of this daring new physician, barely forty years old, with his unconventional methods.

The obstacles Maurice Müller encountered never caught him by surprise, however. This is why he always carried his ideas, discoveries, and plans around with him for a long time, ceaselessly questioning them until he was confident of his conclusions. Only occasionally has his bubbling enthusiasm led to a slip of the tongue, giving away a crucial phrase prematurely.

Maurice Müller's way of thinking is uncommon and unique. Of course, there were others in the medical profession who worked and took notes as prolifically as he. And naturally there were those who, like Müller, were never satisfied with their work and tirelessly proposed new improvements and experiments that, seen individually, might appear unimpressive at first glance. Nevertheless, Müller's particular skill at juggling a multitude of different ideas in his mind simultaneously is legendary. He can concentrate like no other. It is well known that, after a doze during a trip or sometimes even during a meeting, he can be expected upon waking to join in with a fresh idea without missing a beat.

Müller has always been quick to grasp the essential. It is no wonder that books on effective learning strategies piqued his particular interest. When he traveled to Ethiopia, the journey alone provided him with sufficient time to learn the basics of tropical medicine from a manual he had bought from a second-hand bookseller in Marseille. And, naturally, he had read Danis's presentation of osteosynthesis.[5] And yet it is amazing that his short stay of barely a day in Brussels was enough to convince Müller utterly of the Belgian surgeon's principles. As rumor will have it, Maurice Müller also mastered multiple sports disciplines after a brief but intense perusal of the right instructions. But those who know him well are keenly aware that quiet and unrelenting practice were indispensable to his success too, whether in wielding new instruments or performing magic tricks.

Merely understanding the essence of things has never satisfied Maurice Müller. He follows them through, considering all of their ramifications—and often with more patience than people looking for quick answers were willing to accept. Indeed, intellectual caution is to him part and parcel of the physician's duty. Thus he always took his time in testing methods and products before making them available to a wider public. For ten years he delved into and fleshed out the principles of osteosynthesis, first alone and later with a very limited number of friends, before he allowed them to be disseminated widely. Similarly, he and Sir John Charnley agreed to limit strictly the testing of their techniques and hip implants to the very smallest of circles for the first six years.

Despite his great skill at the operating table, Professor Müller has remained in awe of nature, always exercising the utmost respect. Not because of any mystical inclination, but rather on the insight that the sheer number of variables steering natural processes in the most diverse situations would always be able to take people, and physicians in particular, by surprise. His natural caution applies to everything that has more than one facet. Thus follows his lifelong imperative to document continually and evaluate treatments objectively until they are proved to be reliable. This is something he has consistently demanded, promoted and practiced. "Evidence-based medicine" may sound modern and critical, but it is nothing other than Maurice Müller's early call for operations and implants to be documented for as long a period as possible. Readers of Danis or even of Lambotte, another Belgian orthopedist, who coined the term *osteosynthesis*, were impressed by these physicians' case studies, accompanied as they were by thorough X-ray documentation. And it was Maurice Müller who subsequently was to systematize, perfect, and propagate this approach. For him it was an essential part of a surgeon's work and development, and it thus served as the organizing principle for the group of friends that was to become the Association for the

Study of Internal Fixation (AO/ASIF)—an organization that revolutionized the treatment of fractures worldwide.[6]

Back then, the importance placed by Maurice Müller on obligatory, systematic, and long-term documentation did not gain wide acceptance. If it had, he reckons today, patients would have been spared many unnecessary complications. Not without bitterness he blames the industry and certain colleagues for their myopia in overlooking, or even knowingly tolerating, long-term side-effects for the sake of quickly conquering new markets. He himself kept long-term records whenever possible. As long as he called the shots in his company, Protek, careful documentation was part of its creed. And what is more, he used the millions of francs that came to him in the form of licenses to finance his foundations, which had as a top priority the promotion of careful record-keeping in medical practice. To this day, these investments provide funding for university appointments, institutes, and projects all over the world and have contributed to making the assessment of therapies systematic, objective, and verifiable by third parties. In nearly all lectures he has held since becoming professor emeritus, he has focused on the necessity of such documentation. This could be his legacy.

Many pioneers of osteosynthesis, including Lambotte and Danis, were solitary individuals. But Maurice Müller is different: because it was his intention to establish reliable techniques that would benefit many, he sought within his growing group of friends the expertise that would help him along his way. He often visited the operating rooms of fellow surgeons, for example. What he saw there only increased his interest in improving and expanding upon his techniques. Müller realized that he could not achieve the reliability he was seeking simply by making small improvements here and there. Moreover, he knew that his goal would require the development of entire systems in which individual elements followed a set of guiding principles. These individual elements included instruments, implants, materials, a wide variety of products, help for planning, instruction, and assistance in special cases. Education became the core element of this approach.

With conviction and throughout his entire life, Maurice Müller has selflessly passed on his knowledge, going far beyond his academic duties. Thanks to him, hands-on, comprehensive training by practicing physicians and a broad range of methods became a hallmark of AO/ASIF and its successors. These very first courses have remained especially fresh in the memories of those students who had the privilege of attending them. They knew they were experiencing, at first hand, crucial innovations in the field of practical surgery. Today, AO/ASIF seminars in Davos and courses specializing in hip surgery in Bern have spawned a generation of imitators all over the world. AO/ASIF textbooks have been translated into every language and have become the standard.[7]

Education also has another, deeper meaning for Maurice Müller, however. During his time in Africa, he became convinced that a doctor only really knows his subject matter if he is capable of successfully teaching it to others in a clear and competent manner. Teaching is for him a way to ensure that he has understood what he wants to say.

At first, the devices that Müller and his friends improved, modified, and invented were crafted by hand. It was long before modern industrial manufacturing came into it, and so small was the business that two rooms in his sister's apartment were entirely sufficient for both storage and distribution. But when they started to disseminate their ideas, it soon became clear that ensuring efficient production and consistent quality would require industrial methods and partners. Personal financial success did not, however, play a role. After costs, the proceeds were funneled into research, education, and development. AO/ASIF wanted doctors, not businessmen, to make the important decisions. In the technical commission that steered product development, medical and technical issues were the prevailing criteria and not those of profit or the market. If a development made sense in the eyes of the surgeons, they did not worry about numbers.

Despite or perhaps because of these rules, after four decades these modest beginnings have been transformed into a range of businesses with worldwide presence. Today the net worth of all companies founded on these innovations—whether they be the original owners or simply imitators—is in the magnitude of dozens of millions of Swiss francs—unimaginable for those who still remember the first lathes in Grenchen, Waldenburg, and Winterthur.

Without Maurice Müller, these companies, jobs, and values would not exist today. All along, financial gain, in and of itself, has been of no interest to him. He has not profited personally from his inventions or developments, for he donated his patents and instruments to AO/ASIF. He has retained the rights to inventions related to hip treatments, but in this matter as well, the lion's share went to his foundations. As he once wrote to Renzo Piano, "Money only acquires value from what one does with it and from the results that remain even years later."[8] When he finally sold the Protek corporation to Sulzer, he set a large amount of the proceeds aside for a project he knew would be worthwhile—an act his wife and children also supported.

And this our cue to turn to the other founder: Martha Müller-Lüthi. Maurice Müller often said that he had his wife to thank for being able to pursue his dreams so consistently. She and Maurice met when he was fulfilling his military service in Linden, near Oberdiessbach. Her resolute way made an immediate impression on him. Yet she was a bit irresolute at that time: he looked dashing, but of course there were also

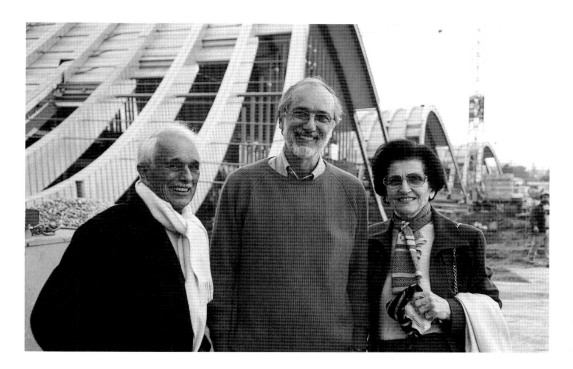

Professor Maurice E. Müller,
the architect Renzo Piano, and
Martha Müller-Lüthi in front
of the Zentrum Paul Klee, 2004

officers, and she had no way of knowing that the patrolman would become a major. When he called her out of the blue in 1946 to ask if she would follow him to Ethiopia, where a Swiss team of surgeons was to build new medical care facilities, she accepted and married him there. Maurice Müller remarked with a hint of irony, "Maybe she only said yes because of Africa."

From the first day in Ethiopia, Martha Müller-Lüthi realized that she would often have to wait patiently at the side of a physician who had devoted his life to his career. When she finally landed in Ethiopia after a long trip and months of separation, before even greeting her, Maurice Müller first had to discuss with a colleague detailed arrangements for the delivery of new mattresses to the hospital. Ever since that day, Martha Müller-Lüthi, like so many women of her generation, unconditionally accepted the responsibilities of a wife and mother standing by a ceaselessly busy man. While he was busy with operations, travel and research, she took care of house and hearth. She infused life into the home on Melchenbühlweg that she had had built. She looked after her husband, their three children, and the sizeable bundle of grandchildren to come—and last but not least, made welcome their friends and guests. Maurice Müller could, and indeed did, rely on her entirely. Once, when he sent his bank a payment authorization, they flat out denied his request because they were only familiar with his wife's signature.

Martha gradually began to create her own world with her own projects. She surrounded herself with architecture and architects, with art and artists, music and musicians.

In 1968 Martha Müller-Lüthi discovered the plot of land, bordering the Schöngrün area, on which the family house is now situated. In her customary way, she won over the owner, despite a long list of interested buyers who had gotten there sooner. "Well then, why don't you just reverse the order of the list?" she asked. Years later, one of the Müller family's foundations bought the adjacent property with the proceeds from Protek licenses. From that point on Schöngrün's development, its architecture and the accompanying plans and obstacles became a frequent topic of conversation between the married couple and other members of their family.

As Martha was making preparations for her husband's eightieth birthday in 1998, she managed to secure Maurizio Pollini, whose ability to play had been restored years before by Maurice Müller, as the headliner of the birthday concert. When it came to finding a venue, Martha had to content herself with the Hodler-Saal in the Kunstmuseum Bern, despite its acoustics. As luck would have it, the room had to be vacated immediately following the concert for a public discussion of the Klee collection's imperiled future in Bern—a discussion that was to spur public and political discourse on the matter. As Martha and Maurice Müller recount, it was not until this day that they realized the city might lose these wonderful paintings forever. Martha Müller-Lüthi had already shown an interest in Renzo Piano's museum designs for quite some time, and both she and her husband had already considered establishing a museum foundation, albeit without yet knowing what its particular mission would be. Be that as it may, immediately following the birthday concert in the museum, Martha and Maurice decided to what ends they would allocate the funds they had set aside, and what would eventually take shape in the center of Schöngrün: the Zentrum Paul Klee. At Martha's initiative, the Zentrum plans were later expanded to include a concert hall for performances by noteworthy artists.

It may be sheer serendipity that Paul Klee's final resting place lies just a few steps away from the new center which carries his name—a place where visitors will be able to marvel at his works and artistic worlds, and where Maurice Müller and his family have lived for many years. But perhaps one cannot write everything off to chance. In any event, the parallels between the lives of the artist Paul Klee and the physician Maurice Müller are striking. The achievements of both men hang on an extraordinary interplay of craftsmanship and intellect. Both Müller and Klee are similar in their inexhaustible and lifelong commitment to the paths they chose to follow in their early years. Each man knew that he wanted to, and would, achieve something completely different from that which had hitherto been expected in their respective areas of endeavor. From the beginning to the end of their careers, both men kept meticulous records of their work—not out of egotism, but rather because they wanted

to know how their thoughts, abilities, and knowledge changed over time, and what resulted from these changes. And finally, both men had not just a vision but also the ability to translate their dreams into works of art or medical practice. And in this way, both men changed their world.

Notes

1. See "Klee-Museum, meine Vision" (manuscript, September 22, 1998).
2. Manuscript by Chadwick F. Smith, August 24, 2002.
3. See Urs Heim, *Das Phänomen AO* (Bern, 2001), p. 26.
4. See Maurice E. Müller, "George Perkins Lecture" (manuscript, October 1, 1971).
5. Robert Danis, *Technique de l'ostéosynthèse* (Paris, 1932) and *Théorie et pratique de l'ostéosynthèse* (Paris, 1949).
6. On the history of AO/ASIF, see Heim, *Das Phänomen AO* (see note 3).
7. See especially Maurice. E. Müller et al., *Manual of Internal Fixation*, 3rd ed. (Berlin, 1991).
8. Maurice E. Müller to Renzo Piano, January 20, 2003.

LIVERPOOL JOHN MOORES UNIVERSITY
LEARNING SERVICES

Maurice E. Müller
Born 1918, childhood in Biel.

Specialist FMH (Foederatio Medicorum Helveticorum) in surgery and orthopedics; physician in Ethiopia, Holland, and Switzerland (Fribourg, Zürich); Head of the Department of Orthopedics and Traumatology at the Surgical Clinic of the Canton Hospital in Sankt Gallen.

1963–1980 University Professor and Director of the University Clinic for Orthopedic Surgery at the Inselspital in Bern.

He has also written numerous books and publications.

Maurice Müller bears twelve honorary doctorates and was awarded the Vesalius Ehrenring by the University of Basel. In addition, he is an honorary member of twenty-four societies worldwide, including his position as Honorary Fellow of the Royal College of Surgeons of England, as well as recipient of numerous international awards; in 2002 he was named Surgeon of the Twentieth Century by SICOT.

He is a founder or founding member of the following organizations:
Association for the Study of Internal Fixation (1958)
AO/ASIF Laboratory for Experimental Surgery in Davos (1959)
AO/ASIF Documentation Center in Bern (1964)
Protek AG Bern (1967)
Fondation Maurice E. Müller für Fortbildung, Forschung und Dokumentation in orthopädischer Chirurgie in Bern (Foundation Maurice E. Müller for Further Education, Research, and Documentation in Orthopedic Surgery in Bern, 1968)

Fundación Maurice E. Müller—España (1974)

International Hip Society (1975)

SICOT's journal *International Orthopaedics* (1976)

The Maurice E. Müller Foundation of North America (1983)

SICOT Fondation (1990)

Maurice E. Müller's appointments at universities and institutes:

Maurice E. Müller-Institut für Biomechanik der Medizinischen Fakultät der Universität Bern (Maurice E. Müller Institute of Biomechanics at the University of Bern's Medical Faculty, 1981)

Maurice E. Müller-Institut für Mikroskopie am Biozentrum der Universität Basel (Maurice E. Müller Institute for Microscopy at the University of Basel's Biozentrum, 1985)

Maurice Edmond Müller Professorship at the Harvard Medical School Boston (1988)

Maurice E. and Martha Müller Chair of Orthopaedic Surgery at the McGill University Montreal (1990)

Maurice E. Müller Program in Teaching, Documentation and Outcome Analysis in Orthopaedic Surgery in the Faculty of Medicine at the University of Toronto (1992)

Martha Müller-Lüthi

Born 1924, childhood in Linden, near Oberdiessbach.

Married Maurice Müller in 1946; together they have three children. She has lived with her husband in Ethiopia, Holland, and various locations in Switzerland.

Martha Müller-Lüthi completed training in architecture and was involved in the building of the house on Melchenbühlweg in Bern, the Fondation Maurice E. Müller as well as a watchmaking center for people with disabilities in Biel. She advances musical projects, in particular Camerata Lysy and those involving music students of the International Menuhin Music Academy (IMMA), and maintains a close relationship to architecture, painting, and sculpture, in which fields she has many friends.

In 2002 she opened parts of her art collection to the public.

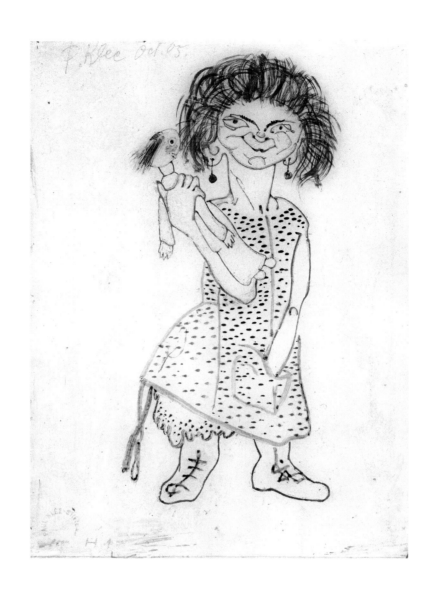

Paul Klee
Mädchen mit Puppe, 1905, 17
Girl with Doll

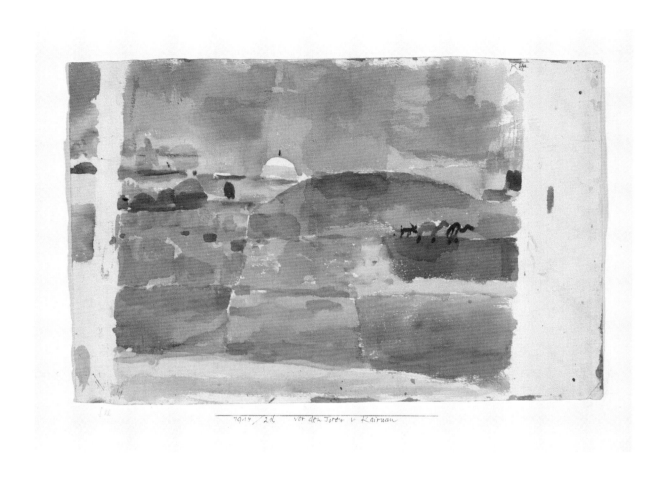

Paul Klee
vor den Toren v. Kairuan, 1914, 216
Before the Gates of Kairouan

63

LIVERPOOL JOHN MOORES UNIVERSITY
LEARNING SERVICES

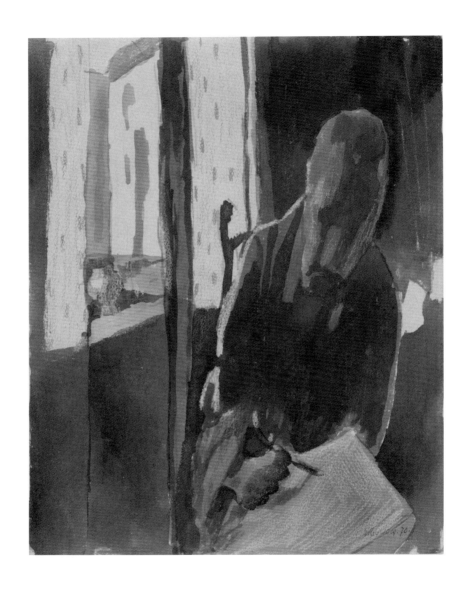

Paul Klee
Der Zeichner am Fenster, 1909, 70
The Draughtsman at the Window

64

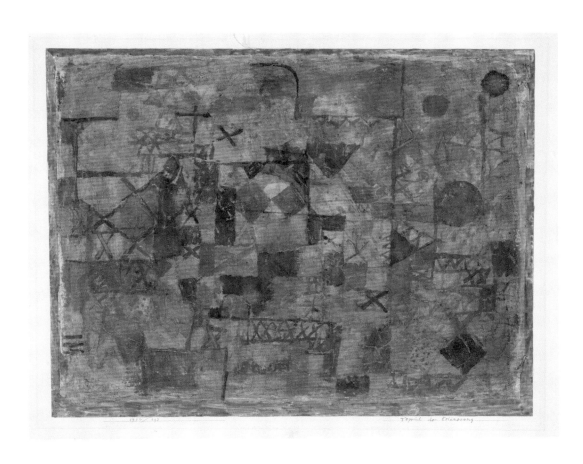

Paul Klee
Teppich der Erinnerung, 1914, 193
Carpet of Memory

Paul Klee
Steinbruch, 1915, 213
Quarry

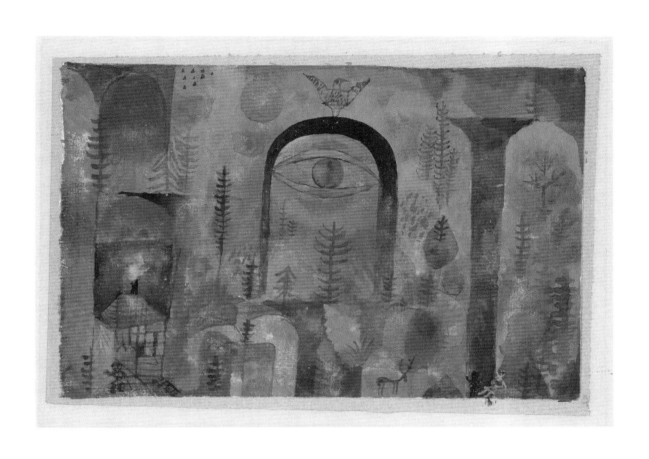

Paul Klee
mit dem Adler, 1918, 85
With the Eagle

LIVE... MOORES UNIVERSITY
LEARNING SERVICES

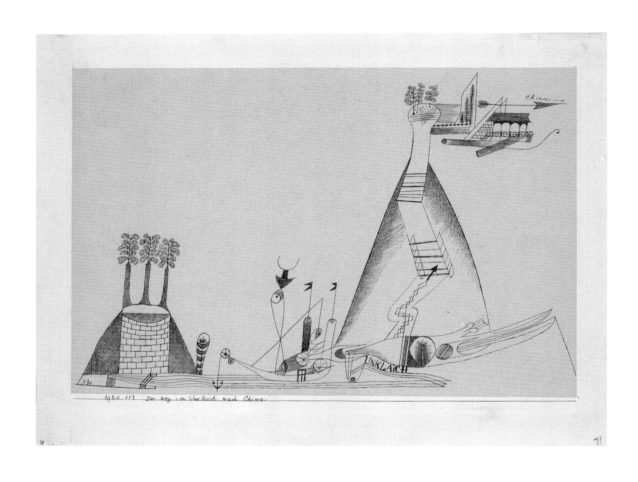

Paul Klee
Der Weg von Unklaich nach China, 1920, 153
The Way from Unklaich to China

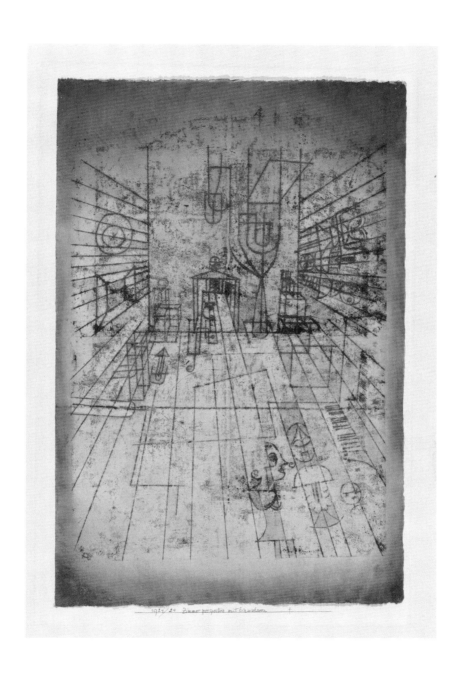

Paul Klee
Zimmerperspective mit Einwohnern, 1921, 24
Room Perspective with Inhabitants

Paul Klee
Choral und Landschaft, 1921, 125
Chorale and Landscape

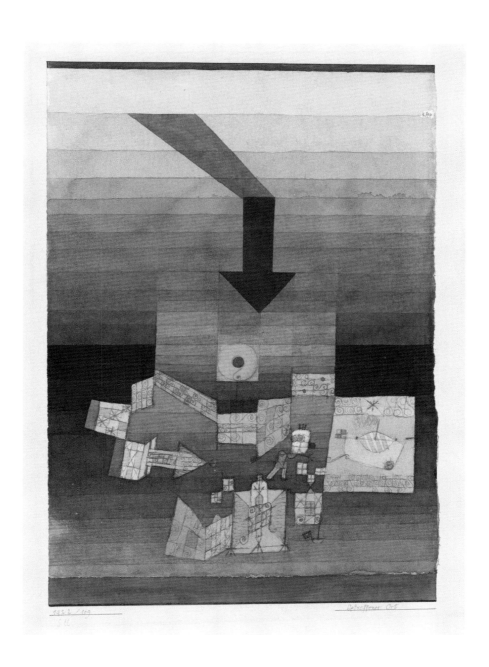

Paul Klee
betroffener Ort, 1922, 109
Affected Place

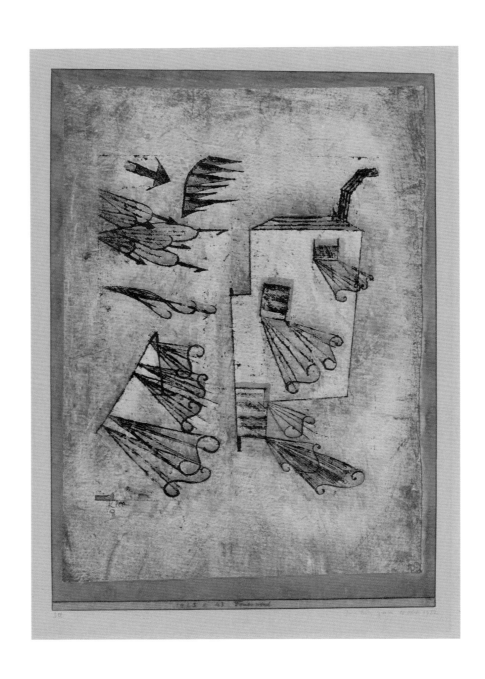

Paul Klee
Feuerwind, 1923, 43
Fire Wind

Paul Klee
ein Garten für Orpheus, 1926, 3
A Garden for Orpheus

73

LIVERPOOL JOHN MOORES UNIVERSITY
LEARNING SERVICES

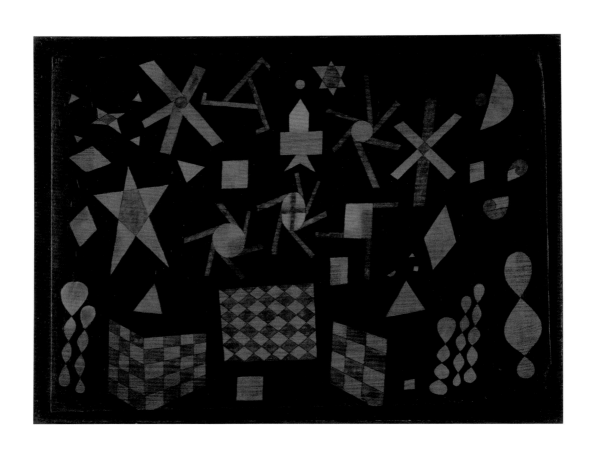

Paul Klee
Assyrisches Spiel, 1923, 79
Assyrian Game

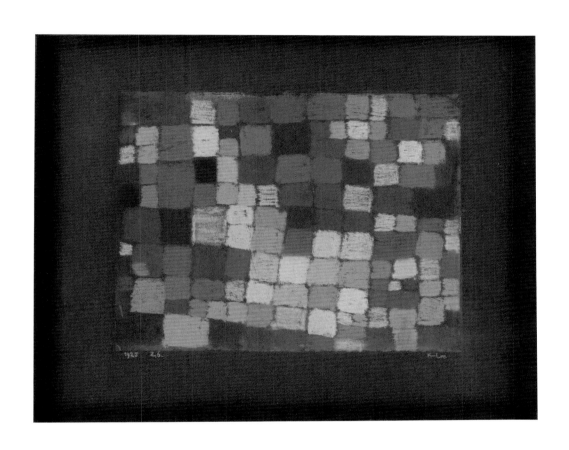

Paul Klee
buntharmonisch, 1925, 256
Colorful Harmonious

Paul Klee
Fisch=Leute, 1927, 11
Fish People

Paul Klee
italienische Stadt, 1928, 66
Italian Town

More Than a Museum
How the Zentrum Paul Klee Sees Itself

Ursina Barandun, Deputy Director and Director of Communication and Outreach, Zentrum Paul Klee, Bern

Paris, London, New York, Berlin, and Tokyo are among the major cities that in recent decades have made considerable use of famous collections and impressive museum buildings to promote new images of themselves at the municipal and national levels. In all these metropolises little effort or cost was spared to win over star architects to plan and construct new urban and cultural landmarks. Clearly, museums are still, or are once again, able to send a signal of political and economic confidence and contribute to local, regional, and national identity. One museum that has become particularly well known is the Guggenheim Museum in Bilbao, whose completion during the late 1990s triggered the cultural and economic upswing of an entire region, a phenomenon that was subsequently widely referred to as "the Bilbao effect." All this, of course, conflicts to some degree with the fact that, around the world, the description "museumgoer" can only be applied to a very small part of the population (ca. 8 percent). It has become evident that the needs of large sections of the population and the alleged social significance of these places of cultural interest diverge considerably.

In order to gain a better understanding of this situation and to demonstrate why the Zentrum Paul Klee will be more than just a museum, it makes sense to take a look at the history of the museum as an institution, the roots of which go back to the fifteenth and sixteenth centuries. It was at this time that Italian Renaissance princes started designing chambers, cabinets, and galleries in their castles and palaces to display curiosities of nature and rare objects of art. They did this for their own private edification. The cultivating and fostering of culture was the reserve of the courts, the church, and a few rich private individuals, for it was they who possessed both the authority and the necessary means required to commission works of art. By contrast, the museum in the sense of a publicly accessible private or public collection of items of art historical, natural historical, or cultural historical interest did not come into existence—apart from a few exceptions—until the second half of the eighteenth century.

The shift in function of the princely collections to civic museums arrived with the French Revolution; the storming of the Bastille in 1789 also toppled the old feudal order, the power structures of the state, and the traditional system of values. By placing the royal art collections under state control in 1791, the National Assembly succeeded, on the one hand, in saving the cultural heritage from the destructive rage of the angry populace, and on the other, in inscribing it with the new bourgeois ideals of freedom, equality, and brotherhood. Displayed to the public, the artistic treasures no longer represented the omnipotence of the French monarch; instead, they illustrated the splendid history and the outstanding achievements of a proud French citizenry.

The museum was optimally suited to encouraging the good taste of the "common people" and strengthening national awareness. To be sure, the museum's new educational agenda demanded a display format that suited this new purpose. Objects could no longer be hung or positioned following purely decorative criteria, as they were during the time of the princes. Rather, they now had to be selected with their intended purpose in mind, presented in a structured way, given explanatory labels, and, should the need arise, provided with additional commentary. Thus a model for the museum was born that has persisted to this day, which defined collecting, conserving, the conducting of research, and the imparting of knowledge as central tasks of the museum. That the museum as institution did not essentially develop further against the background of the scientific, technological, and sociocultural transformations of the twentieth century was not without its consequences, as clearly indicated by the low attendance numbers recorded by museums around the world in recent decades. This development is to the detriment of all of us, for museums can (still today) be of great benefit to the individual. Why?

People can only express their thoughts and feelings and communicate these to others if they are capable of giving form to their inner lives in a way that can be understood from the outside, by their fellow human beings. Ethical and aesthetic expression must come along in the form of socially recognized signs and symbols, such as images, language, sounds, or movements, if it is to be understood. This is the terrain of artists. They give shape to their thoughts in signs and symbols, thus availing themselves of a handwriting that is often quite unusual and individual. What is conveyed is never mere reality. The inventive spirit and creative power of artists enable them to reveal images that are overlooked at first glance, to bring out the words between the lines, and to guide the viewers' gaze behind the image surface—in short, to go beyond reality. The artist depicts visions of the world as it could and should be. Viewers who know how to decipher these symbols get to know the values that induced the artist to

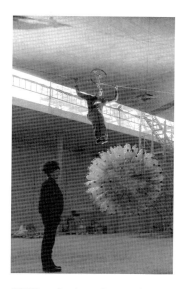

öff öff productions show works by Klee in the shell of the building at the topping-out ceremony on December 1, 2003.

LIVE... ...ERSITY LEARNING SERVICES

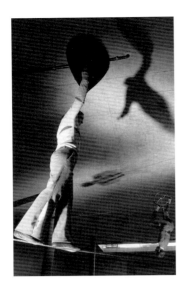

öff öff productions stage Paul Klee, Luft-Station (Air Station), 1926, 26

create his work. And viewers can in turn compare these to their own values, recognize correspondences and discrepancies, and thereby expand themselves and their world-views. They broaden their minds. Understanding the language of art does not primarily call for a knowledge of the fine arts but rather for life experience and intu-ition—"translation aids" that each and every person possesses, albeit to varying degrees, depending on one's age.

To illustrate why art is not art if it does not make the detour through the world of symbols, it is enough to imagine viewing nature through a frame. A detail with trees, flowers, and light would appear arbitrary and dull—an effect never encountered with an arranged still life. It is not the natural but the artificial that makes it possible for art to reproduce more than the real, and herein lies the great (socially) trans-formative potential of art. At least since Paul Klee, and that is more than sixty years ago, we know that "art does not reproduce the visible; rather, it makes visible." Anyone capable of working with symbols is able to perceive the world at a more com-plex level and consequently also able to create more complex forms. Therefore the inference that the inability to understand and make use of symbols is an expression of an extremely impaired ability to function in reality is equally valid. To put it another way: it is not reality TV that helps us understand the world, but art, music, theater, and literature.

Art—and this applies in equal measure to the fine arts, music, literature, and the per-forming arts—contributes fundamentally to the shaping of personality. For this reason, it is no accident that European middle-class society supported museums and enlisted them as educational institutions while it was constituting itself and establish-ing democratic structures after 1848. Ultimately, the flourishing of democracy was dependent on an educated citizenry. So it is no surprise that most museums—including those in the city of Bern—were founded in the period between the mid–nineteenth and mid–twentieth centuries.

Museums are monumental sites of collective cultural memory. It was always the elite and those in power who were responsible for their expansion and continued existence. In the years following 1968, an entire generation called into question the authority of the educated elite and pleaded for a more democratic education and culture. The founding of the first children's museums following the American example can also be traced back to these movements. "Hands off" was passé; and "hands on" became the new motto. Almost unnoticed, museums shirked their social mandate and yielded to the leisure market with its new and attractive multimedia offerings. Subsequently many museums concentrated on the collection and preservation of their inventory, and research followed the personal preferences of scholars. Research forms a fundamen-

tal basis for communication and thus, all visitor-oriented communication is based on research work that embraces the public interest. The educational task of museums has lost nothing of its significance and relevance even if many of those responsible are not implementing it with the necessary commitment.

The fast-paced developments in the fields of science and technology, the economic, political, and social transformations, as well as the increased virtualization of the world call into question beliefs we long thought certain. Explaining the present in terms of the past is becoming more and more complex and the development of strategies for dealing with the future increasingly demanding. We find ourselves being constantly pulled in conflicting directions between globalization and the search for identity, between preserving the familiar and the necessary openness for the new and unfamiliar, between the allure of money and the freedom to think, between shared responsibility for the community and personal independence. Against this backdrop is a growing general demand for orientation aids and educational sites. The art museum is one of the last places where today's hurried pace can be arrested and where we can find the necessary time and leisure to immerse ourselves in a world that not only imparts facts but timeless cultural values. Of course contemporary art tackles topical issues in a more direct way and is thus of great significance for civilization. However, because art in general deals with ethics and aesthetics—that is, with basic values—artistic movements and works of art from all periods are well suited to helping us distinguish between the essential and the nonessential. And that is the first step toward taking the essential seriously.

Many people avoid museums because they lack the knowledge they think a visit requires. Or they undertake their visits accompanied by enormous performance pressure and with the constant fear that they will fail to understand what is being communicated. That this false reverence and these prejudices were not eliminated long ago is something museums must accept responsibility for. It is their duty to do everything within their power to provide real experiences of art to broad sections of the public. Openness, life experience (in keeping with one's age), intuition, and curiosity are required on the part of the viewer; guidance aimed at the needs of the visitor is a service that the museum must provide so that a museum visit can turn into an individual experience. A museum is not a place to dig in your heels but a place to be astonished, and astonishment is the first step toward understanding.

The Zentrum Paul Klee differs from traditional art museums in its insistence on a targeted appeal to those segments of the population who have never, or who have only rarely, set foot in a museum. The standards of the program of offerings and outreach projects are correspondingly high. The Zentrum Paul Klee endeavors to meet

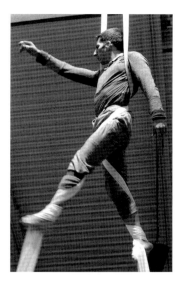

öff öff productions stage Paul Klee,
Uebermut (High Spirits), 1939, 1251;
see fig. p. 120

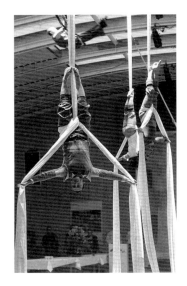

öff öff productions stage Paul Klee,
Uebermut (High Spirits), 1939, 1251

visitors wherever they are in regard to age, education level, and sociocultural group, thereby leading some to art for the first time while providing others with a deepened awareness. Because the visitor is the focus of the Zentrum Paul Klee's efforts, our research projects will be directed toward areas of interest for our outreach activities. The Zentrum Paul Klee should be, and needs to be, a place of pleasurable interaction and debate between people and art, because this is the only way for encounters with art to become lasting experiences and because this is the only way we can justify the investment of public resources.

The Zentrum Paul Klee wishes to make a name for itself not only through this clear orientation on its public, but also through the breadth of its core cultural offerings. Art, music, and theater not only exist *next* to each other at the Zentrum Paul Klee, but also *with* each other, generating ever more innovative interdisciplinary forms of artistic expression. International cultural institutions that offer interdisciplinary art and cultural events meet with a very positive response, in particular from a younger audience. The Zentrum Paul Klee is thus treading a path with a future. Accompanying us on this journey are the numerous outreach programs of the children's museum and the multimedia offerings of the Museum Street. The Zentrum Paul Klee, as indicated by its name, is not just a museum, but a program—and logically so, as Paul Klee was an artist and musician, as well as a writer and performer.

Constituting the communications backbone of the Zentrum Paul Klee is the Museum Street, along which all paths lead to the center's interior. As an extended access zone, the Museum Street links the three hills of the center, widening in three places to create three plazas, one opposite each hill. Thanks to its location behind the 150-meter-long glass façade, the Museum Street is suited to its role as a light, airy place where one can simply linger or take a pleasant stroll before, after, or as an alternative to, a visit to the exhibition space. The Museum Street is unlike the conventional museum foyer in that it is the site of a sophisticated multimedia offering, a unique and important service provided by the Zentrum Paul Klee. The Museum Street and its offerings are, as a matter of principle, free of charge and also accessible outside the opening hours of the exhibition areas. This gives individual visitors and groups the opportunity to immerse themselves onsite in previsit preparations for, and postvisit evaluations of, an exhibition; Bern's local inhabitants come here to read an art magazine or meet friends in the café. The plazas are sites of information and communication, relaxation and gastronomy, each one designed differently with regard to its particular offering and feel.

What each plaza has to offer refers, and directly correlates, to the respective function of the hill behind it. Depending on the location, computer terminals inform visitors

about the cultural offerings of the center and of the city of Bern, and provide access to the center's database, which includes information about all ten thousand works comprising the complete œuvre of Paul Klee. As a non-electronic option, a reference library on the plaza of the South Hill invites visitors to enjoy a quiet read. The café can be found in the foyer zone of the North Hill, and the shop on the plaza of the Middle Hill. The Zentrum Paul Klee sees its shop as a communications platform supporting the center's efforts to reach out to the entire world.

The standards of the center's quality of service are particularly high along the Museum Street. A friendly, knowledgeable, and helpful staff, along with an inviting atmosphere, ample place to sit, and an easy-to-follow visitor's guide make a distinctive impression as one enters and leaves the center. This is where visitors will be inspired to further visits to the center, and that is why the Museum Street is also where guests are asked to communicate their suggestions and requests regarding the center and how it can optimize its services.

Communication with our visitors, however, is not limited to the offerings of the Museum Street. A short guide to the museum (which can be obtained in the shop and in book stores) as well as a guide leaflet are available to assist visitors during their visit to the Zentrum. The leaflet can be consulted the way one would a traditional brochure or, by means of bar codes, it can be "plugged in" at any computer terminal and used to access detailed information. Computer terminals are located in the North and South Hills and in the collection exhibition spaces in the Middle Hill. The wall texts and object labels are another integral part of the visitor information system. Beginning in 2006, an audio guide will offer content-rich programs and exciting new opportunities, making second and third visits well worthwhile. It is essential to present visitors with a variety of alternatives, as they know their own needs better than anyone. As a result, all media offerings are optional and anyone wishing to forgo the supplementary information can certainly do so without a guilty conscience—for the collection, the most important medium, is presented in a way to make this possible. And for those guests who would rather be accompanied on their visit by one of our expert guides, opportunities are available in several different languages and a variety of subject areas.

Because the aim and object of the Zentrum Paul Klee is to bring art to a wide public, we plan to display our mission statement in the center for the public to see. Our guests should know what they can expect from us, and, in return, we hope to learn which of their expectations were met and which were not. This will allow us to continue to make our work here as productive as possible. The mission statement of the Zentrum Paul Klee, dated June 30, 2003, is reproduced verbatim below.

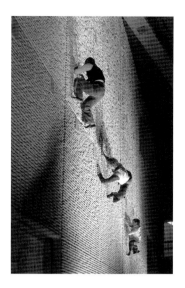

öff öff productions walking the line between circus, dance, and theater

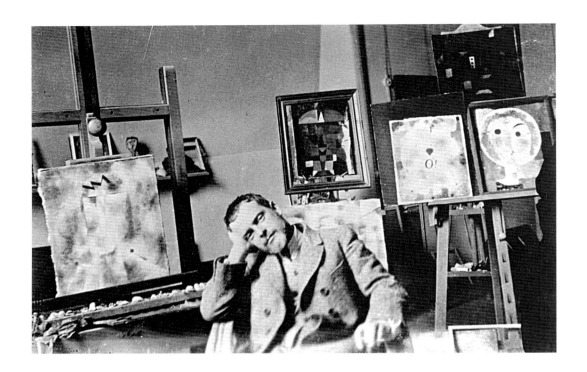

Paul Klee in his Bauhaus studio,
Weimar, 1922

Mission Statement

With around four thousand works, the Zentrum Paul Klee boasts the world's most important collection of paintings, watercolors, and drawings, as well as archival and biographical materials from all of Paul Klee's creative periods.

The central task of the Zentrum Paul Klee is to explore, using scholarly means, the artistic, pedagogical, and theoretical work of Paul Klee, to consider its significance within the cultural and social context of his time, and to make this work available to our visitors in a clear and vivid manner.

By keeping the questions we ask up-to-date, by introducing new scholarly interpretations and methodologically innovative presentations, the Zentrum Paul Klee wishes to bring Paul Klee's creative potential to bear as an impulse in the art and culture of today's world.

New avenues should be opened to our visitors and new experiences made possible that will stimulate a more intense examination of Klee and encourage repeat visits to the Zentrum Paul Klee.

Through its activities the Zentrum Paul Klee will establish itself around the world as the authoritative center for the investigation of the life, work, and influence of Paul Klee, and for the transmission of this knowledge.

In order to attain these goals, the Zentrum Paul Klee is developing a sophisticated offering of exhibition and outreach programs, geared toward the needs of our visitors with regard to their varying age levels, personal backgrounds, and cultural interests.

To that end,

| aesthetically pleasing, highly functional exhibition spaces are available for changing presentations from the collection and for special exhibitions;

| the communication zone provides a wealth of information materials in electronic and print format;

| a large activity area encourages children, teenagers, and adults to give free rein to their own creativity;

| interested visitors are able to gain insight into parts of our extensive inventory of drawings in areas specially designed for this purpose;

| a chamber music hall provides the ideal conditions for musical experiences;

| state-of-the-art event rooms and seminar spaces enable the exploration of themes and subjects from a variety of cultural and knowledge areas;

| the Sculpture Park and the area surrounding the center were designed by architect Renzo Piano to offer a unique symbiosis of nature and culture.

The Zentrum Paul Klee provides the basic structure for the implementation of its exhibition and outreach program by

| developing and employing attractive outreach and presentation methods;

| undertaking research projects that will broaden our knowledge of Klee's artistic milieu and the influence his work has had, and making the results of this research accessible to a wide public;

| expanding the collection's holdings with an eye to its central themes, also taking into account Paul Klee's circle of artist friends;

| updating the scholarship around the collection and undertaking conservation and restoration measures;

| cultivating exchanges with art museums around the world;

| cooperating with museums and other cultural and educational institutions at the municipal, cantonal, and national levels.

The Zentrum Paul Klee has been made possible by the Klee and Müller founding families; the public authorities and local population of the city, canton and the Civic Community of Bern (Burgergemeinde Bern); and our partners from industry and business. The architectural and spatial quality of the building is of crucial importance to the implementation of our mission statement with regard to our ability to bring our ideas to life and keep them alive. The architecture determines the functional and aesthetic framework and thus has a significant influence on the running of the museum. As set forth in detail elsewhere in this book, architect Renzo Piano carefully considered

85

LIVERPOOL JOHN MOORES UNIVERSITY
LEARNING SERVICES

what sort of architecture and topography would best correspond to the spirit and work of Paul Klee. He also had to comply with a space allocation program provided by the Maurice E. and Martha Müller Foundation. Though this program was expanded over the course of time, its rudiments were laid out at the beginning and had to be adhered to. The brilliance of Renzo Piano's architectural concept can be seen today—not just in the form he gave to the Zentrum Paul Klee but also in the way he created optimal conditions for the future operation of the museum. He allocated the operational space as follows: research and administration to the South Hill, fine arts to the Middle Hill, and music, the theater, conferences, the children's museum, and interdisciplinary activities to the North Hill. He then designed—an added bonus, as it were—the above-mentioned multimedia communications zone, the Museum Street, which links the individual areas and harmonizes them functionally, thematically, and aesthetically.

An artist—Paul Klee. An idea—the center. A building—a three-part undulating architectural gesture. A vision—a mission statement.

Under such preconditions it would be unthinkable to build anything but an enterprise that rests on cross-disciplinary common principles and basic structures. With this spirit as our starting point, the Zentrum Paul Klee has developed its marketing concept, presentation concept (which comprises the design of all our core offerings, from the presentation of our collection to the special exhibitions, cultural events, the children's museum, the shop, and gastronomic possibilities), communications concept, sponsoring concept, as well as its concept with regard to pricing, distribution, and merchandising. It would be too much to go into more detail here. Suffice it to say that these concepts are designed to respond to the needs of the visitors to the Zentrum Paul Klee, to reflect the interests of the different target groups, and to make use of the means available as efficiently and effectively as possible.

Music at the Zentrum Paul Klee

Kaspar Zehnder, Artistic Director for Music, Zentrum Paul Klee, Bern

Paul Klee as a Musician

Paul Klee wanted to be a musician. His musical calling has its roots in his childhood home. His father, Hans Klee, worked as a music teacher at the Staatliches Lehrerseminar (State Teachers' College) in Hofwil/Bern, and his mother, Ida Marie Klee-Frick, was a singer. While still at high school, Paul Klee played the violin in the Bern Music Society, and he continued to move in musical circles even after deciding to train as a visual artist in Munich, where he studied under Heinrich Knirr and later Franz von Stuck. That was how in 1899 he met the pianist Lily Stumpf, who later became his wife. Back in Bern, between 1902 and 1906, Klee again experimented with music, with literature, or both at the same time.

Klee's watershed experience as a musician was the Bern production of Offenbach's *Les Contes d'Hoffmann* at the newly constructed Stadttheater. He attended several performances and wrote enthusiastic letters to Lily in Munich. While Klee worked with Offenbach's music all his life, none of the composer's other works reveals his inner kinship with Klee more clearly than this one does, with its blend of seriousness and humor, fairy-tale and satire, earthiness and ethereality. In his diary entries Klee sometimes writes critically about local productions, lambasting the Bern idiom and program ("all of it without verve, every movement self-conscious and inhibited"),[1] and his reviews in the *Bernisches Fremdenblatt* are full of skeptical overtones. Yet Klee loved the world of opera, and especially the experience of an operatic performance, with its tension between composition and interpretation. He went to the opera wherever he happened to be. He saw opera as a heightened form of music. As a synthesis of music and theater it was equally stimulating to his ear and his eye. Opera mirrors the dual character of Klee's own creative gift.

Klee was a great connoisseur of the entire classical and Romantic operatic repertoire, from the operas of Mozart through *Carmen*, *The Bartered Bride*, and *Boris Godunov* to Debussy's *Pelléas et Mélisande* and the theatrical works of Leos Janáček and Richard Strauss. He was less ambivalent about Wagner and Verdi than is usually claimed on

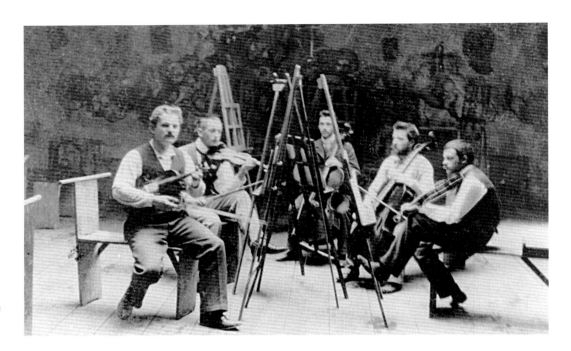

A quintett in the studios of Heinrich Knirr's school of drawing and painting, Munich, 1900

the basis of some of his notes. He knew the work of both composers and especially loved their final operas, *Parsifal* and *Falstaff*. Klee attentively followed developments in music as it became a modern art. He knew Stravinsky, Bartók, Hindemith, and Schönberg personally, though he never played their works. As an extremely self-critical violinist, he may not have felt equal to the novel technical difficulties of their music. However, possessed as he was of an utterly aesthetic sensibility, he may also have been disturbed by the amount of intellectual and pedagogical effort that had preceded what at that time was truly *New* Music. Perhaps he struggled with the difficulty of understanding something new, although within his own art he himself was very new. Perhaps he simply believed that musical abstraction had already achieved its full potential in the music of Bach and Mozart and that no further progress in that direction was necessary.

For Paul Klee, Mozart was the greatest of all musicians. His chamber music partner, Karl Grebe, says: "It would be pointless to talk about Paul Klee as a musician without mentioning Mozart, for Mozart was clearly the cornerstone of Paul Klee's musical worldview. Klee could perform Mozart's arabesques and little motifs with total precision and at the same time total warmth. His command of the pleasurable and exhilarating tension of Mozart's music, of its formal perfection in search of blissful fulfillment, reflected the inimitable assurance of a divine gift. His Mozart playing went right to the heart of the matter. If Mozart's essence may be described as a blend of demonic power, vivacious wit, and sensuality, then it may also be said that there is a genuine kinship between Mozart the musician and Klee the painter."[2]

There are numerous iconographic allusions to music in Klee's works (*Musiker* [*Musician*], 1937, 197; *alter Geiger* [*Old Violinist*], 1939, 310; *Sängerin der komischen Oper* [*Singer from the Comic Opera*], 1925, 225). Klee found it fascinating to combine musical associations with dimensions of visual art (*Fuge in rot* [*Fugue in Red*], 1921, 69, fig. p.166; *Landschaft in A dur* [*Landscape in A Major*], 1939, 91, fig. p.90; *Polyphon gefasstes Weiss* [*White Framed Polyphonically*], 1930, 140, figs. pp.90 and 167). Moreover, musicality is one of the decisive formal criteria of his œuvre, his artistic thought, and his pedagogical and theoretical writings. The compositional, rhythmic, and melodic aspects of many of his paintings and drawings are musically oriented. Some of the theoretical underpinnings of his work and his doctrine very specifically refer to sonic and musical elements. Some of his works can be played like musical scores. Bridges from the visual arts to music were not only central to Klee's life and work. Building bridges was also a major concern of the founding families Müller and Klee, and thus plays an important role in the basic conception of the Zentrum Paul Klee. With its musical program, the Zentrum Paul Klee seeks to appeal to both traditionally oriented audiences and new generations of music lovers, and it seeks to build bridges that meaningfully refer to Paul Klee. Despite his firm belief that music had already passed its high point, Paul Klee influenced the music of his contemporaries and their successors with his artistic, literary, and essayistic work to a degree that is unique among his contemporaries. The Zentrum Paul Klee possesses an extensive scholarly archive containing more than 250 scores and some 170 recordings of compositions that either make reference to Klee's work or are inspired by it.

Paul Klee
alter Geiger, 1939, 310
Old Violinist

Paul Klee
Fuge in Rot, 1921, 69
Fugue in Red

The Musical Museum

The Zentrum Paul Klee would like to be a place to which people return again and again to enjoy art and culture. It therefore includes changing presentations of items from the permanent collection, temporary exhibits, interactive multimedia offerings, and a children's museum among its core offerings. The musical events, for their part, are intended to help the Zentrum Paul Klee establish itself from the very start as a place that people interested in culture like to visit and visit regularly. The center's musical activities may be described as unfolding in four concentric circles, with the Zentrum Paul Klee at their nucleus. The ideal platform for the innermost circle is the concert and event hall, the Auditorium, with three hundred seats. Its stage is ideally suited for chamber music and small orchestra concerts, though its technical equipment also makes it possible to expand the program to include (musical) theater, experimental music, and multimedia works. The second circle includes all of the

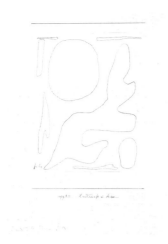

Paul Klee
Landschaft in A dur, 1939, 91
Landscape in A Major

Paul Klee
polyphon gefasstes Weiss, 1930, 140
White Framed Polyphonically

exterior and interior spaces of the Zentrum Paul Klee, that is, the exhibition spaces, the children's museum, the Museum Street, the lobby, the restaurants, and the scenic and in part agrarian landscape surrounding it. The third circle includes all of the possible performance sites in the city of Bern and environs. The Zentrum Paul Klee here leaves its home territory and figures as an organizer or co-organizer (together with allied cultural institutions) in existing performance spaces. Finally, the fourth and outermost circle consists of the national and international arenas, where the Ensemble Paul Klee performs as a visiting ensemble. This house ensemble is intended to lend a musical dimension to the brand "Zentrum Paul Klee" and to represent the Zentrum Paul Klee outside of Bern.

The artist's biographical links to music were not the only factor in determining the musical activities of the Zentrum Paul Klee. The keywords and commentaries below give a brief insight into other areas that played an equally significant role in the design of the musical program:

Contemporaneity. The Zentrum Paul Klee does not confine its repertoire to particular musical periods, for example those which Paul Klee especially admired or the first half of the twentieth century. On the contrary, its programs are distinguished by their variety and the fact that they are open to current musical trends and—entirely in the spirit of Paul Klee—react flexibly to changes in culture and society.

Synesthesia. With music as the starting point, the program forges links not only to literature and the visual arts, but also to theatrical, cinematic, and interactive art forms in order to stimulate different senses simultaneously and broaden the experiential possibilities. Paul Klee's artistic thinking is highly synesthetic; that is, it is marked by interaction between the senses.

Heterogeneity. On the one hand, the focus here is on combining classical instruments with instruments like the oud, the taragot, the balalaika, the cymbalom, and the xala. On the other, it is on programs that play with different musical traditions and develop an attractive combination of contrasts thanks to surprising confrontations of styles. This relates to Klee's practice of combining disparate materials and techniques.

Improvisation. The interpretation of a musical work in a theatrical or improvisational manner subjects it to a constant process of redefinition. In this context, not only the stage but the auditorium plays a crucial role. Performers and listeners connect, commune, and respond to each other in a continual interaction very similar to that which develops in the contemplation of visual art.

Miniature. In this smallest form of concert or composition, the musical statement is reduced to its essence. Since most of his works are small, Paul Klee was also called "the Little Master of Modernity."

The Ensemble Paul Klee

To realize its musical goals, the Zentrum Paul Klee has formed a house ensemble, the Ensemble Paul Klee, a loose grouping of eight to fifteen musicians distinguished by a clear approach to programming and an unmistakable musical profile on the international stage. The reference point for the formulation of its programs is Paul Klee, although the link may also be indirect, as suggested above.

The Ensemble Paul Klee will gain public standing and a recognizable musical personality through a series of in-house productions. These productions are not only or even primarily concerts, but also take the form of musical offerings presented to visitors of the Zentrum Paul Klee in spontaneous encounters and in connection with thematic, spatial, and temporal events. These include productions presented free along the Museum Street of the Zentrum Paul Klee under the heading "Street Music: Miniatures, Improvisations." They are inspired by Bern's tradition of street music and cabaret; allude to the nearby presence of the highway, which strongly influenced Renzo Piano's architectural design; or emphasize the significance of the Museum Street as a promenade and pedestrian zone. Radiating out from the Museum Street, musical works may also be heard in other locales throughout the Zentrum, for example in the children's museum, Kindermuseum Creaviva, and—especially when the compositions, improvisations, or musical works in question relate to specific images—in the exhibition spaces themselves.

Sound site, 2002

Another format is the "Twenty-Minute Concert," which seeks to enrich the experience of visitors to the permanent collection and temporary exhibits of the Zentrum Paul Klee by adding a synesthetic dimension to their stay. As brief, moderated concerts, they provide a window onto the ensemble's current musical work and enable visitors to experience the inner connection between music and the visual arts sensuously and concretely. These short concerts take place during the galleries' open hours and feature music that Klee heard, played, and loved; music by his contemporaries; and music that refers to his work or is inspired by it. It is one of the Ensemble Paul Klee's important tasks to reexamine and illuminate these connections from ever new angles.

As the pedagogical platform of the Zentrum Paul Klee, Kindermuseum Creaviva works with all aspects of the Zentrum, including music. The Ensemble Paul Klee collaborates closely with the children's museum and develops concerts and musical activities on selected topics in workshops and courses with children and young people. The goal is to promote young people's artistic and compositional sensibilities in an enjoyable way. Thanks to expert guidance, children's visits to concerts and exhibits should result in a lasting relationship with music and art.

The Ensemble Paul Klee seeks to meet the standards of a highly professional ensemble

unique both in Bern and in the Swiss and ultimately the international arenas. It therefore also performs away from home and itself plays host to national and international ensembles whose philosophy and level of artistic excellence are comparable to its own. Thus, for example, the Ensemble Intercontemporain, the Ensemble Modern, the Ensemble Phoenix, the Klangforum Wien, and the Ensemble Contrechamps will all play for Bern audiences at the Zentrum Paul Klee. Oriented as it is around the concept of the Zentrum Paul Klee, its program clearly distinguishes the Ensemble Paul Klee from these formations, enabling it to make attractive contributions to their concert series within the framework of a program exchange.

Especially notable is the Camerata Bern, a fourteen-member string orchestra that for more than forty years has been performing throughout the world as the musical ambassador of the Swiss capital. At the Zentrum Paul Klee, the Camerata Bern will put on an annual and independent subscription concert series. While the series will be independent of the Zentrum, it will involve points of contact with Paul Klee and the Zentrum. These reside in the nature of the Camerata's programs, which span multiple musical periods; the interdisciplinary formats of their concerts; and a pedagogical program for the children's museum.

The auditorium's outstanding acoustics, the possibilities for live sound and video recordings, and the presence of a field for electroacoustic experimentation create ideal conditions for a chamber music series with young and celebrated soloists, duos, trios, and quartets all the way to ten-member ensembles. Here, too, the Zentrum is guided in its definition of the program by the focus on Klee, his personal predilections, his artistic milieu, and his impact on subsequent generations of composers and musicians.

In addition to the everyday cohabitation of music and the visual arts at the Zentrum Paul Klee, there are also moments when music takes center stage. Well-known orchestras, conductors, and soloists will perform at the Zentrum Paul Klee within the clearly defined temporal and thematic boundaries of festivals. A Klee music festival will consist of concerts and other musical offerings, supplemented by symposia planned and executed in collaboration with Bern University's musicological institute and the Sommerakademie im Zentrum Paul Klee (Summer Academy at the Zentrum Paul Klee).

The architecture and infrastructure of the Zentrum Paul Klee offer ideal conditions for conferences, conventions, and corporate events. The Ensemble Paul Klee has a widely varied, multi-period repertoire, and it is ready at any time to design a musical backdrop that corresponds to the wishes and ideas of its partners. If a musical program helps to lighten the mood at private viewings, conventions, corporate gatherings,

or public events, that in no way conflicts with the high qualitative standards of the Zentrum Paul Klee. The musical program, like the Zentrum as a whole, seeks to appeal to a broad audience, and it is always true to the motto—and here again it takes its bearings from Paul Klee—"conviviality, humor, poetry, and lightheartedness."

Notes

1. Paul Klee, *Tagebücher* (Bern, 1988), p. 171.
2. Karl Grebe, "Paul Klee als Musiker," in *Paul Klee und die Musik*, exh. cat. Schirn Kunsthalle (Frankfurt a. M., 1986), pp. 205 ff.

Further Reading

Düchting, Hajo. *Paul Klee—Painting and Music*. Translated by Penelope Crowe. Munich et al., 1997.
Klee, Paul. *The Diaries: 1898–1918*. Edited by Felix Klee. Translated by Pierre B. Schneider, R. Y. Zachary, Max Knight. Berkeley and Los Angeles, 1964.
——. *Briefe an die Familie*. Edited by Felix Klee. Cologne, 1979.
Moe, Ole Henrik, ed. *Paul Klee und die Musik*. Exh. cat. Schirn Kunsthalle, Frankfurt a. M., 1986.
Paul Klee—Die Kunst des Sichtbarmachens. Edited by the Kunstmuseum Bern/Paul-Klee-Stiftung and Seedamm Kulturzentrum Pfäffikon. Exh. cat. Seedamm Kulturzentrum, Pfäffikon and Bern, 2000.

The Children's Museum in the Zentrum Paul Klee
"Art does not reproduce the visible; rather, it makes visible."

Adrian Weber, Director, Kindermuseum Creaviva, Zentrum Paul Klee, Bern

When Professor Maurice E. Müller, MD, presented his vision for the Zentrum Paul Klee for the first time in 1988, the teacher and researcher made clear that a central part of the facility should consist of a children's museum, a place for all people "between the ages of four and ninety-nine" who wanted to get involved in art in a practical way. To help realize this vision, he established the Fondation du Musée des Enfants auprès du Centre Paul Klee together with his daughter Janine Aebi-Müller, donating funds to cover the construction costs of this unique children's museum, as well as its operating expenses until the end of 2011. The current board of the foundation, in addition to the president, Professor Maurice E. Müller, and the vice-president, Janine Aebi-Müller, includes Corinne Mariéthoz-Aebi, Professor Franz Kellerhals, LLD, Laurence de Cecco, and Ted Scapa. The Schweizerische Mobiliar insurance group, one of the founding partners of the Zentrum Paul Klee, also generously supported the construction of the facilities. The cornerstone for the Zentrum was laid on June 20, 2002, symbolically located at the site of the future children's museum.

An orthopedic surgeon who over decades had passed on the art of orthopedic surgery to countless students and physicians, Professor Müller wanted practical art education to play a key role at the Zentrum Paul Klee. He discovered Paul Klee's work in all its depth and complexity only after his retirement. Motivated by this discovery, he took part in workshops for children and families in art museums and quickly realized the great educational potential of Klee's life and œuvre. We are fortunate that the founder of the Zentrum Paul Klee is eager to provide everyone with the opportunity to awaken their slumbering thirst for knowledge.

As Müller himself emphasizes, the Kindermuseum Creaviva would not exist in its current form were it not for his daughter Janine Aebi-Müller. In 2002, she expressed her desire that "the focus in the children's museum be on the entire creative process. Art should be experienced as playful experimentation using all five senses. The motivating force is curiosity, which seeks and discovers the beauty of the world—and

in this we discover ourselves." As a private physiotherapist, Janine Aebi-Müller works in a field related to that of her father. Art and music are her callings. When she lived in the United States with her husband and three children, she taught arts and crafts at various private schools for over seven years, from preschool to middle school. She saw that art education plays a different role in the United States than it does in Switzerland, allowing children to develop more freely and experience art at first hand.

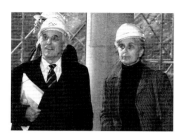

Professor Maurice E. Müller with daughter Janine Aebi-Müller at the children's museum section of the building site, 2004

Back in Switzerland, her children were always told what and how to draw and paint. Free creativity at school thus came to an abrupt end, so she encouraged it at home instead. Janine Aebi-Müller actively promotes aesthetic education in our society because she is convinced that individuals should be able to know and understand both the world and themselves better, and only when people are creative can their inner being be revealed. The Kindermuseum Creaviva is therefore designed to be "an adventure for the mind and the heart," as Carola Giedion-Welcker once said about Paul Klee's art. Janine Aebi-Müller sees parallels between Paul Klee's way of working and her father's: Both men were pioneers in their fields—researchers, creative workers, teachers. Both men carefully documented their methods and yet remained playful at heart.

A children's museum is a place, tailored to the needs of young people, for finding out about the world. Its goal is to awaken children's curiosity and creativity by taking a "learning by doing" approach. The first children's museum in the world was founded in Brooklyn, New York, in 1899. In the United States alone, hundreds of museums, especially science museums, followed this example in subsequent years. Museums in Europe also began to focus on their youngest visitors, starting around 1970 in the wake of pedagogical reform. Numerous museums and museum departments designed for children were established to spread the workshop idea. One of the largest children's museums in Europe is ZOOM in Vienna.

The first children's museum in Switzerland was opened in Baden in 1985 and is based on a collection of toys. In 1987 there followed the Technorama in Winterthur, which is modeled after American science centers and became famous for its effective teaching of technology and science using a learning laboratory. In fall 2004, Kindercity in Volketswil opened its doors, a pedagogical amusement park for eight- to twelve-year-olds. After 1980, art museums began to establish education departments. The Kunstmuseum Bern, with its extensive Klee collection, played a leading role in art education in schools, and Paul Klee became known to every schoolchild in the canton of Bern. Especially in the early phases of its development, the Kindermuseum Creaviva profited from excellent cooperation with the museum education service

95

LIVERPOOL JOHN MOORES UNIVERSITY
LEARNING SERVICES

Children's workshop

of the Kunstmuseum Bern, as well as with teachers', children's, and youth organizations and European and Swiss museum associations. At the same time, the development of the Kindermuseum Creaviva helped strengthen the networks involved in art education.

The Kindermuseum Creaviva, being part of a "monographic museum," is the first children's museum based on the work of a single artist. Its name, Creaviva, is constructed from *creare* and *vivere*, the Latin words for "create" and "live" or "experience." This name can be understood by speakers of many languages and is meant to provide inspiration to individuals of all ages. Klee's work is interdisciplinary, and the Kindermuseum Creaviva will address the whole range of his creative work, "Klee's universe," functioning as a place where all people above the age of four can experience their surroundings using all of their senses. Exhibitions, installations, and workshops provide the framework for an active involvement with art. People come here to analyze their own perceptions, interpretations, and understanding, posing questions and finding or shaping their own answers.

In order to establish itself as an authority in the realm of art education in the medium term, Kindermuseum Creaviva seeks to collaborate closely with other museums on an international level, organizing symposia and seminars in further education. The goal is to allow Klee's legacy to be experienced, taught, and lived. Situated at the interface of knowledge and practice, the children's museum provides offerings for groups of all ages and interests: workshops, modular learning programs (with practical tips for using them in the museum's studio, in the classroom, or at home), themed exhibitions, and events.

The children's museum itself is designed to resemble a workshop. During the Zentrum Paul Klee's opening hours, a workroom is available for any visitor, even those who drop by unannounced. In this open studio, a variety of practical, supervised activities make Paul Klee come alive to four- to ninety-nine-year-olds as they meet one another and encounter art. All participants get to take home something they have created with their own hands. Thanks to a donation by the St. Gallen educational specialist Hans Hochreutener, Kindermuseum Creaviva also possesses an excellent collection of children's drawings. The museum plans to analyze and document this collection in its entirety, making it available to teachers and, in part, to the general public.

As of June 2005, Kindermuseum Creaviva has only just embarked on its exciting journey. For its future development, organizers plan to put time and space to optimum use. Kindermuseum Creaviva has at its disposal a full 7,500 square feet in the basement of the North Hill. Two stairways and an elevator connect it to the Museum Street. Along the inside of the building's glass façade there extends a loft—a large open room

for displaying the highlights of the collection. It also contains a reference library, computer terminals, coat checks, and restrooms. The heart of the museum is comprised of three studios and the workrooms, as well as a photo lab and a ceramic oven.

A separate reception area serves as a welcome area for the museum's guests. In good weather visitors can take their work outdoors to the lawn in front of the loft.

When Paul Klee was four years old, his grandmother gave him colored chalks and his first drawing lessons. In his great uncle's restaurant he discovered fantastic shapes in the marble of the tabletops and copied them out. His mother preserved many of his drawings from childhood and his school years. When Klee was an established artist he included eighteen of these childhood drawings in his works catalogue and thus gave them the status of works of art (figs.). This shows how important Klee felt his own childhood to be in his artistic development.

Artists in the group Der Blaue Reiter (The Blue Rider), to which Klee was close, also held that childhood was the ideal for artistic production. Children were regarded as the incarnation of creativity, their creative power springing from their closeness to the origins of being. In 1912, Klee wrote as much in the periodical *Die Alpen*: "Primal sources of art still exist, such as one finds in ethnographic collections or at home in the nursery. Reader, do not laugh! Children also have the capacity, and there is wisdom in this fact! The more helpless children are, the more instructive are the examples they give us, and they must be sheltered from corruption at an early age. Parallels are found in the works of the mentally ill, and neither childish habits nor insanity are insults capable of affecting what we mean here. All of this must be taken very seriously—more seriously than all the art museums in the world, if reform is to be achieved today."[1]

Starting in 1907, Paul Klee added the role of househusband to his role as father. His journals reflect his almost scientific interest in his son Felix. Starting in 1916, he made hand puppets for the young boy. With these figures Paul and Felix later made fun of scenes from everyday life or happenings in the Bauhaus. Klee's pictorial language is often trivialized as being "childish," but Klee himself always resisted this simplification. Rather, his motifs arose from his attempts to examine the world and distill its essence. The majority of his motifs depict the universally applicable rather than the specific, the concrete. Because Klee's pictures depend on the power of suggestion, on directing our gaze in a certain direction without restricting it to any single perspective, they can be understood by children and art specialists alike.

Klee was a highly intelligent youth, but a mediocre pupil. At the Bauhaus he presented his students with a curriculum of free development, warning them not to succumb to the academic belief in rules. Instead, he encouraged them to appropriate the tools of

Paul Klee
Azor nimmt die Befehle der Mad. Grenouillet entgegen, 1883, 13
Azor Receiving Mrs. Grenouillet's Orders

Paul Klee
Droschkengespann, 1883, 14
Horse and Carriage

Paul Klee
Dame mit Sonnenschirm, 1883, 15
Lady with Parasol

LIVERPOOL JOHN MOORES UNIVERSITY
LEARNING SERVICES

art for themselves. He knew that inspiration, or what he called "intuition," was just as important for artistic development as learning the rules of perspective. He once advised a fellow teacher, "Lead your students out into nature, let them experience how a bud is formed, how a butterfly opens its wings, so that they become as rich and mobile as nature itself."[2]

Notes

The quotation in the heading is from Paul Klee, "Schöpferische Konfession," in *Schöpferische Konfession*, anthology published by *Tribüne der Kunst und Zeit XIII*, ed. Kasimir Edschmid (Berlin, 1920), p. 28.

1. Paul Klee, "München," *Die Alpen* 6, no. 5 (January 1912), p. 302.
2. Hans-Friedrich Geist, "Paul Klee und die Welt des Kindes," *Das Werk* 37 (June 6, 1950), p. 191.

Further Reading

Osterwold, Tilman. *Paul Klee—Ein Kind träumt sich*. Exh. cat. Württembergischer Kunstverein, Stuttgart, 1979.

The Summer Academy at the Zentrum Paul Klee

Prof. Norberto Gramaccini, Director, Sommerakademie im Zentrum Paul Klee, Bern

The idea of a summer academy arose early in the discussions about establishing a Paul Klee museum. In the mid-1990s many still hoped that an expanded Klee collection and other art institutions in Bern might share a home under the classical pediment of the Progymnasium, the former middle school, in Hodlerstrasse. In particular, these included the University of Bern's Institute for Art History (Institut für Kunstgeschichte, IKG) and the planned contemporary art department of the Kunstmuseum Bern. The Academy of Fine Arts (Hochschule der Künste Bern, HKB), which at the time was still divided into various institutes (HGKK), was also to move its offices (if not all of its facilities) into this building. The goal was to improve communications between the various institutions and make joint projects easier to plan and carry out. Based on Klee's pedagogical ideas and the goals of the Bauhaus, the summer academy was to act as an integrating force at the center of a heterogeneous structure. It was hoped that the summer academy would open up new perspectives for emerging artists as well as for students of art history by combining theory and practice—perspectives that would become visible in research, artistic production, and exhibitions. From the very start, the idea was to provide a common platform for teachers and students from Switzerland and abroad.

The ten years that elapsed between these first ideas and the current reality gave new and challenging impulses to the project. Things that might have been stuck together somehow or other in the old classrooms can be situated much more clearly in the Zentrum Paul Klee built by Renzo Piano—not just in terms of space, but also in terms of content. The Sommerakademie im Zentrum Paul Klee has moved beyond its original function of connecting various institutions in Bern. It has become more autonomous and can now meet international expectations. It no longer defines itself, looking backwards, as a continuation of the Bauhaus idea; instead, it seeks to meet contemporary needs in art education by offering a high-quality postgraduate program to a select group of artists. Its new purpose follows on the reform of higher education as set forth in the Bologna Declaration in 1999 by the European ministers of education;

the Bern Institute of Art History and the Academy of Fine Arts each brought forth initiatives for bridging the gap between theory and practice that had become visible ten years ago. The establishment of a chair for contemporary art and the creation of a transdisciplinary focus through Faculty Y at the Academy of Fine Arts symbolize a new way of thinking. No longer do these institutions stick to traditional tasks; instead, they strive to discover synergies between the academic and technical aspects of student education. What was still lacking in Bern was the inclusion of foreign artists, curators, and other key figures in the art world who come to the city for short periods of time to work together with emerging artists. As it exists today, the Sommerakademie provides the framework for these encounters. Its director and the program manager, who are supported by the Zentrum Paul Klee and an outstanding foundation board, are responsible for the annual program.

The Sommerakademie takes place each year in the first half of August and lasts for ten days. Artists who have completed a program of study at an art academy, or who can show equivalent qualification, are eligible. Those who are interested apply directly, and roughly ninety individuals and institutions that play an important role in the domestic and international art world (art academies, galleries, art societies, museums, critics, curators, and collectors) have a special right to nominate applicants. An international jury selects ten to fifteen participants from among the applicants and chooses one artist for the annual scholarship.

The success of the Sommerakademie's work will depend on how well it is able to take up contemporary themes and handle them convincingly and appropriately. Thus the choice of an annual theme is extremely important and requires careful preparation. The theme provides the focus for the public lectures and events, as well as for the theoretical program and subsequent publication. As great importance is placed on giving professional curatorial expression to the annual theme, a curator is appointed each year to oversee collaborative work on the overall program and ensure its successful realization. The exhibition serves as a basis for all course work—and as a springboard for explaining to the public the selection criteria, content, and goals of each year's Sommerakademie. The opening exhibition is also an ideal prelude to each summer's program.

Every year the Sommerakademie invites prominent instructors to Bern to supplement the courses with lectures, guided tours, and round table discussions in a series of evening events. The broader activities of the Zentrum Paul Klee and other cultural institutions that work with the Sommerakademie are also part of its offerings. For ten days each summer, Bern will be the center of Swiss artistic and cultural life. This includes careful, year-long preparations, arranging for new contacts, and staying

abreast of everything happening in the world of art. An initial, virtual test site is provided by a practical seminar at the University of Bern, which is given in the semester before each summer academy. Here students in the curatorial studies program have the opportunity to prepare for the event. An annual publication on the year's theme represents a lasting contribution by each Sommerakademie team.

The fact that we have a successful summer academy today can be traced back to a number of fortunate events: first among these is the building of the Zentrum Paul Klee. In addition, a great deal of commitment was necessary to ensure that the Sommerakademie would be financially independent and able to carry out its educational mission over many years. The Berner Kantonalbank (BEKB | BCBE) has made this commitment. Special thanks are due here to Peter Kappeler (chairman of the board), Jean-Claude Nobili (CEO), and Maximilian Haselbach (chief education officer). Their dedication to this project was proof of their daring and vision, for one of the capital city's chief goals in the cultural sphere consists precisely in turning Bern into an educational hub. The Sommerakademie also thanks Peter Schmid, former director of education for the canton of Bern and current president of the Maurice E. and Martha Müller Foundation, who was the first to support the project. Andreas Marti, director of the Zentrum Paul Klee, and Ursina Barandun, deputy director and director of communication and outreach of the Zentrum Paul Klee, are to be thanked for reacting promptly to the Berner Kantonalbank's offer in the educational sector and for proposing the Sommerakademie. Their knowledge, patience, and friendly support were a major factor in the project's success in its early phases of development. Barbara Mauck, who came on board as program manager in 2004, was instrumental in fashioning the concept behind the academy as it presents itself to us today.

LIVERPOOL JOHN MOORES UNIVERSITY
LEARNING SERVICES

"The way Klee works is truly wonderful. He needs just a minimum of line to reveal his whole truth. That's how a Buddha draws. Calm, cohesive, not moved by any passion, the most unmonumental line; searching and childlike, it reveals greatness. It is everything, sincere, delicate, many superlatives, and above all, it is new. As Blake says, 'grandeur of idea is founded on precision of ideas.' The works of all important people have their roots in a simple but all-embracing realization. To have found it means to have found oneself, and with it the world and all things."

Oskar Schlemmer, painter, 1916

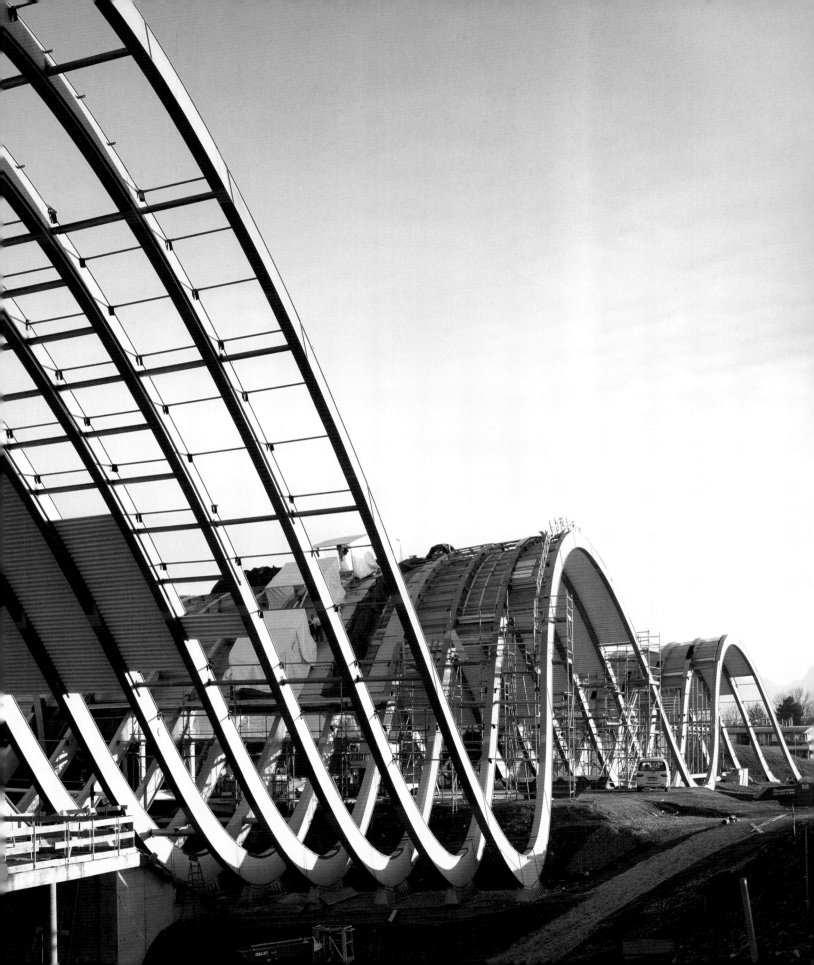

LIVERPOOL JOHN MOORES UNIVERSITY
LEARNING SERVICES

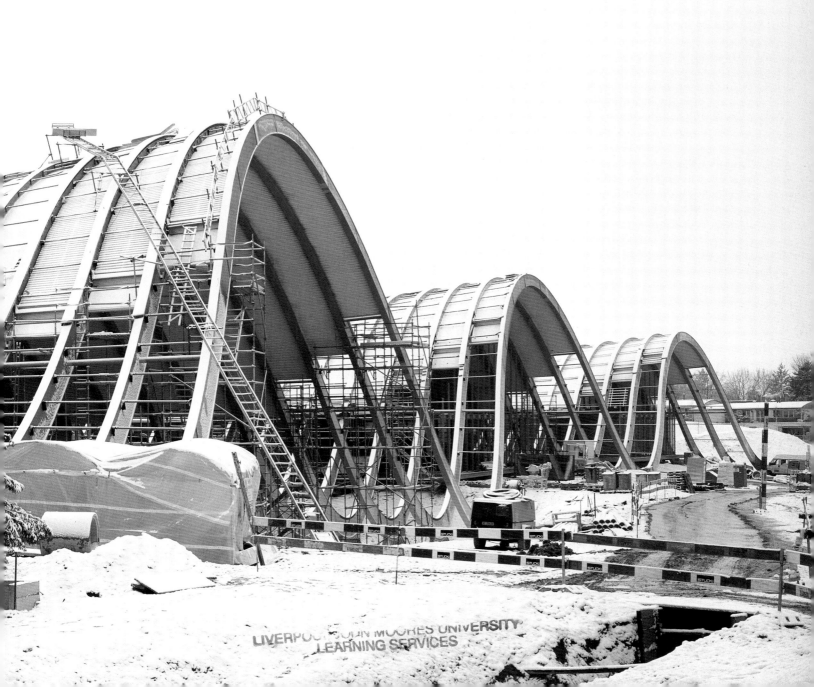

LIVERPOOL JOHN MOORES UNIVERSITY
LEARNING SERVICES

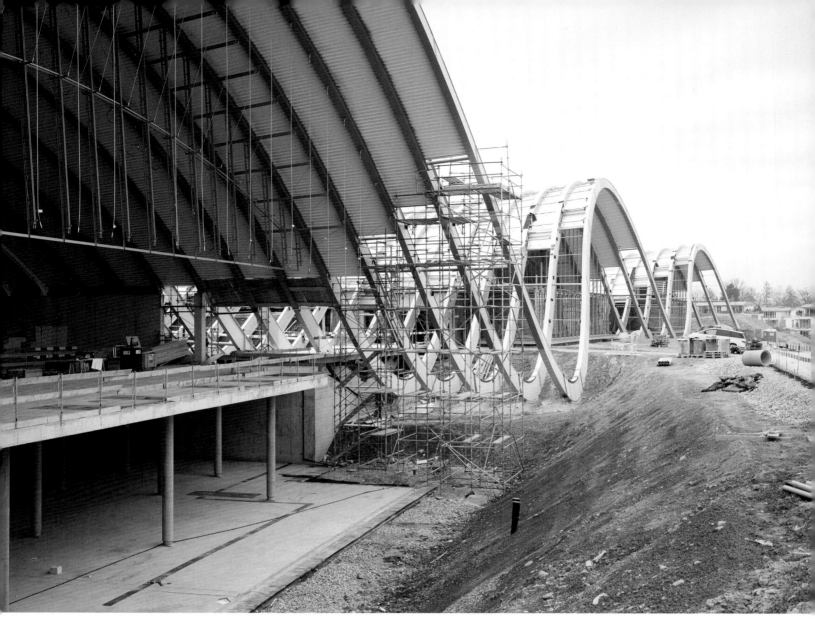

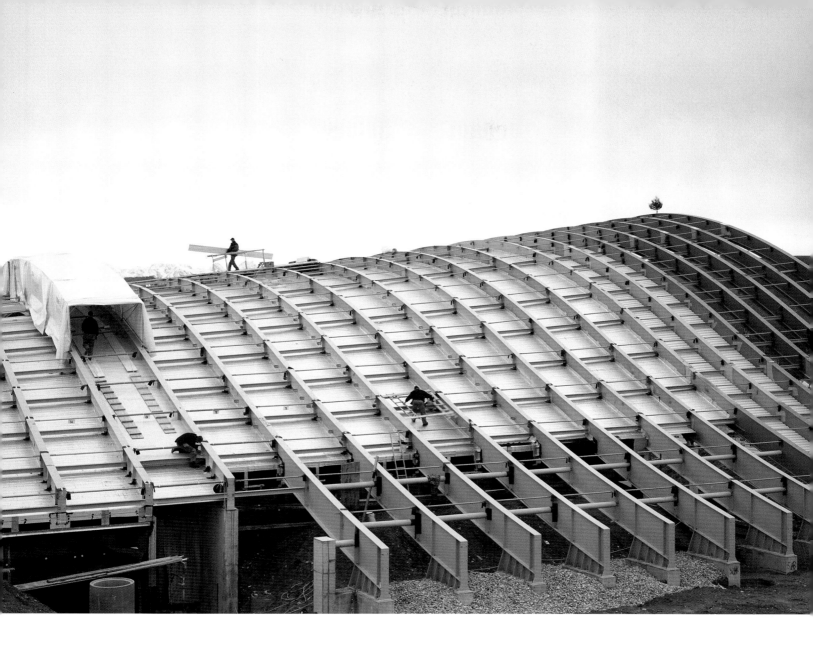

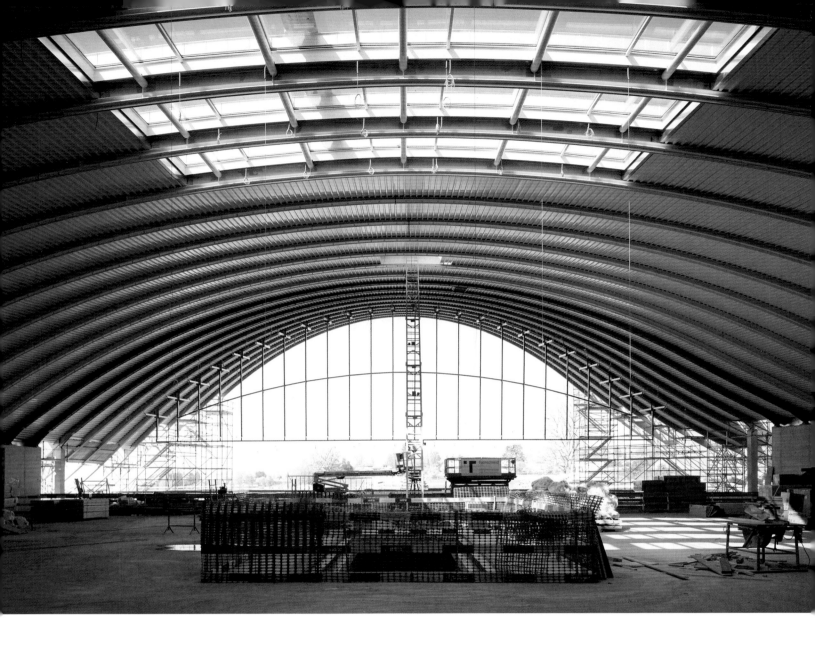

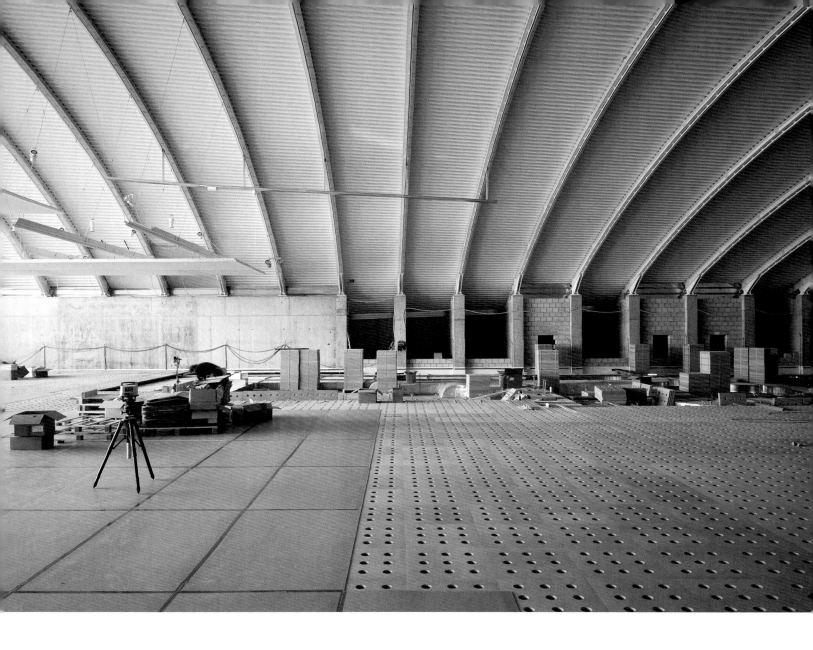

LIVERPOOL JOHN MOORES UNIVERSITY
LEARNING SERVICES

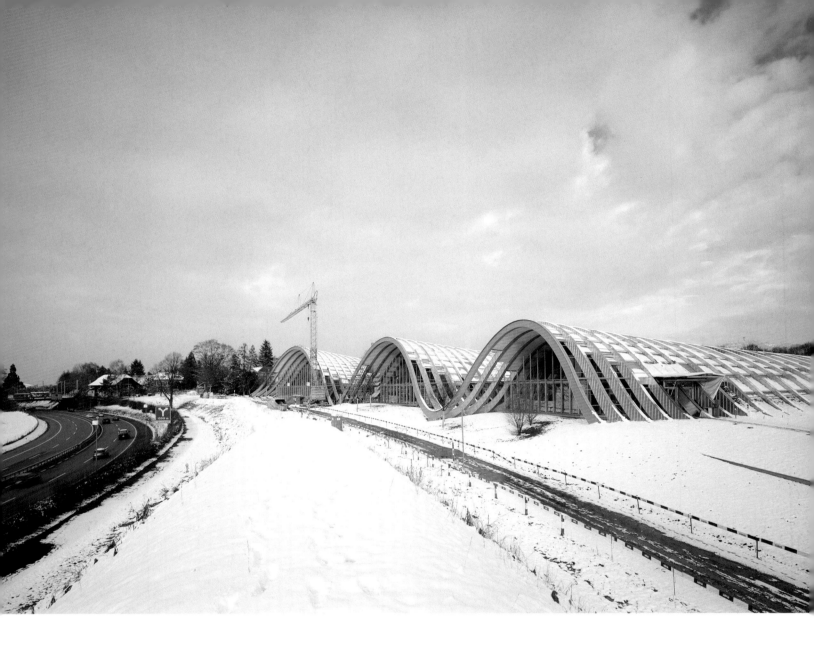

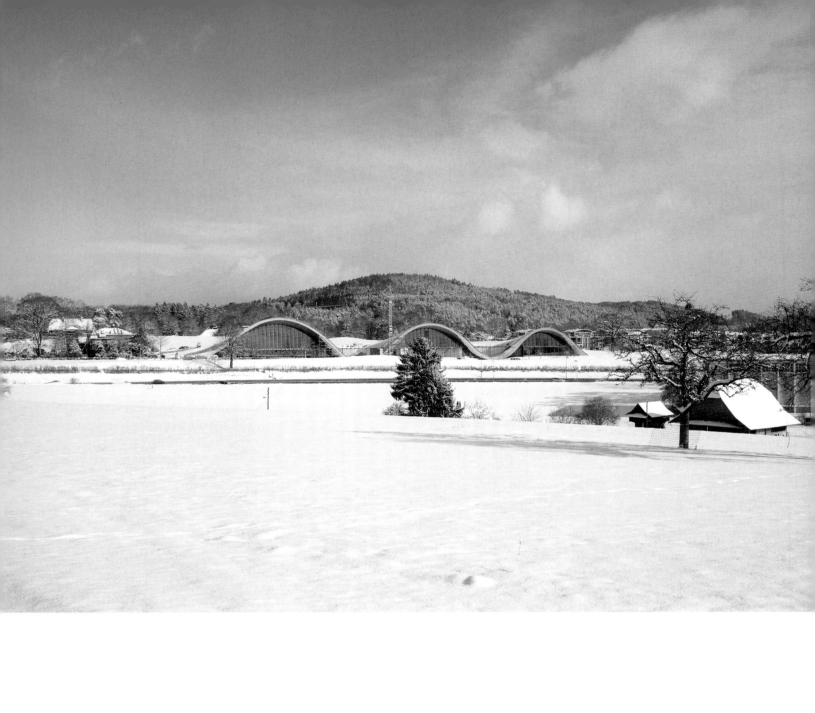

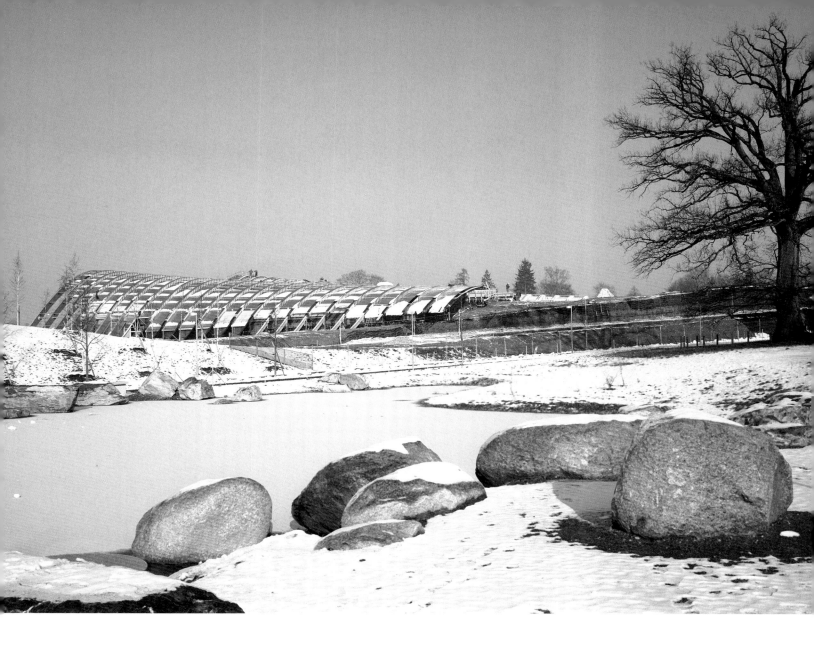

LIVERPOOL JOHN MOORES UNIVERSITY
LEARNING SERVICES

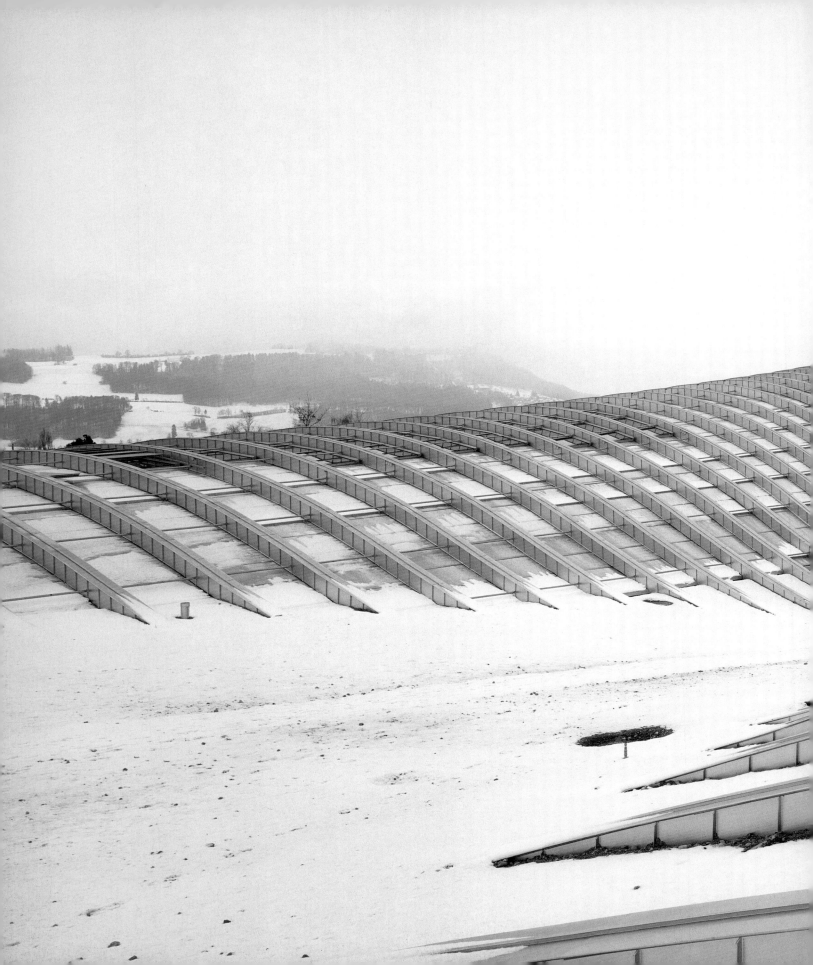

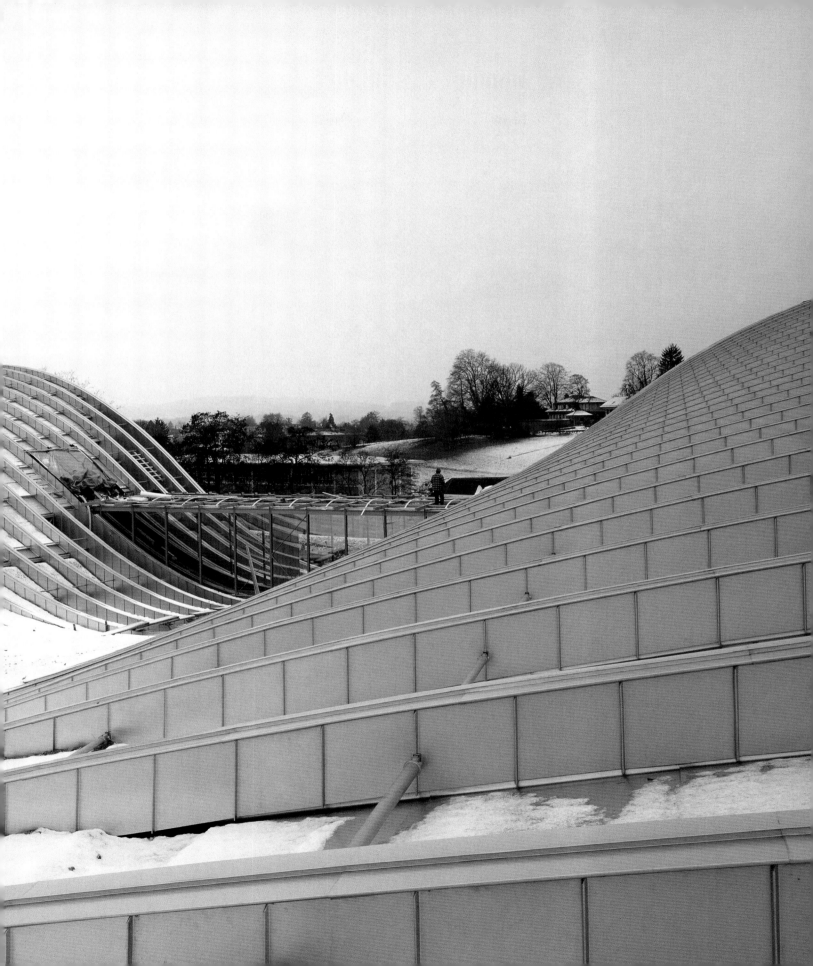

Paul Klee's World

LIVERPOOL JOHN MOORES UNIVERSITY
LEARNING SERVICES

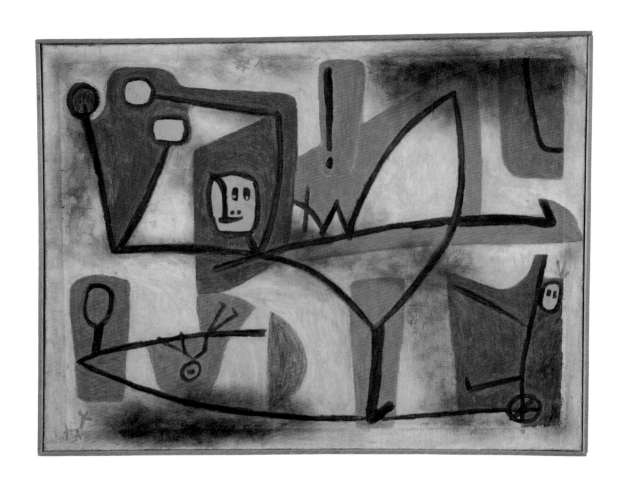

Paul Klee
Uebermut, 1939, 1251
High Spirits

Views of Klee

The Collection and Its Presentation in the Zentrum Paul Klee

Prof. Dr. Tilman Osterwold, Art Director, Zentrum Paul Klee, Bern

The Physiognomy of Images

New exhibition spaces open up new perspectives onto the work of an artist who began to question his artistic self-image in paintings, drawings, and writings about one hundred years ago. In the landscape of three hills designed by Renzo Piano for the Zentrum Paul Klee, the Middle Hill is dedicated to the artistic personality of Paul Klee. With our awareness for artistic content in mind, the architecture has been inspirational for the way art is here related to the viewer. It gives the work of Paul Klee a home in a retrospective which, looking to the future, brings into the present this multi-talented, thoughtful, and playful artist and his all-embracing, illuminating, and penetrating conscious. It confronts his work with the artistic phenomena of his generation as well as the present-day context. This way of seeing makes it all the more exciting to re-evaluate particular aspects of Paul Klee's work and—together with the architecture's innovative possibilities—to present them under a contemporary aspect. The maxim guiding the presentation of Klee's work is, to open the view into the artistic substance; into the physiognomy of the images; into the human sphere projected by the work onto the viewer; into the modernity of their composition, which tears apart the accepted spectrum of perception and breaks with the familiar patterns of taste; into the interdisciplinary complexity of the work's intellectual orientation, which was unique in Klee's generation and is of utmost relevance from today's point of view.

The process of opening the view begins with an architectural introduction associating wide vistas and free paths. What will we see first?

Our eyes fall upon a colorful, vital, restless and, for Klee, relatively large late work from 1939 titled *Uebermut* (*High Spirits*, 1939, 1251, fig.). This compactly composed painting confronts the viewer with its brash directness. Black linear shapes form a figurative scenario which is ferocious in its use of vivid colors, rich contrasts, and a harmonious-disharmonious palette. All of the forces appear centered, bound together, and explosive—only just under control. The painting is both loud and cool, childish and clever, dance-like and demonic. The exclamation mark floating in blue at the

top of the axis urges the viewer to engage in dialogue, corresponding to the arms which, embedded in aggressively stimulating strokes of raucous red, suggest the commanding beat of a drum. You can hear this painting—it is an acoustic as well as visual composition. The main actor faces in all directions, also risking a cautious, questioning look forward. The figures appear to act in a variety show or in the circus. The actor (male or female?) attempts a balancing act. Balance and equilibrium—a central theme in the form and content of Klee's entire work—are precarious. The painting contains little in terms of stability. Nothing is fixed—everything is unsure, risky, and vague. The painting evokes the intentions of an artist's existence: crossing boundaries, expanding horizons, blasting normality, and changing laws. The world of images flirts in a serious yet jovial, diabolical, and subtle way with the euphoria of an artistic flight that tears away day-to-day feelings. At the same time there is the melancholy awareness that it could end with a nosedive into existential tragedy—a serious personal and social theme for Klee at that time.

The entrance into the world of Paul Klee follows a programmatic layout. The images are not presented in a chronological order but in a dialogue that brings out the complex levels of expression in Klee's work. So let us have a look at some of the characteristics that had a particular metaphorical meaning for Klee and that, recurring in ever-new contexts, are at the heart of his compositional confrontation with the creative process:

l For him, the human and natural essences motivate the artistic principle. Nature, growth, and movement form an allegory of creation, the genesis of the image. The universe—both microcosmic and macrocosmic—contains the entirety of the human individual and the natural context.

l The stage becomes a visual metaphor for the artistic. Klee invents scenarios that explore the forms and meanings of balance, equilibrium, and their disruption. The theatrical presentation of the image brings out and dramatizes Klee's ambivalent position concerning the comic and the tragic.

l Architecture and topography are metaphors for the image's structure and composition, themselves suggesting ways of approaching the works. (Klee's principles of composition, based on this criterion, inspired the interior design and presentation of the collection, thereby helping visitors to find their way.)

l Music and musicality are basic elements in Klee's creative thought; a principle of composition that involves rhythm and movement as well as the orchestration of different elements as the central components in the composition of the image (*Garten=rhythmus* [*Garden Rhythm*], 1932, 185, fig. p. 142).

| Childhood is a basic existential element of Klee's sense of a balanced relationship between the primitive and professionalism, ingenuousness and ingenuity, the creative urge and the intellect.

| The facial expression, the external view of the internal, is interpreted by Klee as the physiognomy of the image. He analyzes the temporal functions implicit in the act of perception and applies these experiences to his compositions (*Blick aus Rot* [*Glance Out of Red*], 1937, 211, fig. p. 143).

These and other criteria, which characterize Klee's artistic thought and levels of image composition, are influenced by his basic insight that works of art are not self-satisfying, self-contained, intrinsic pieces of art. They show all thought about life, the world, and art as a unified whole while dialogically reflecting the process through which we approach these constructs.

In 1919 Klee produced landscape compositions—the first peak of his career as a painter—which were at the same time guided tours through the complex landscape of artistic expression (*"Felsenlandschaft" (m/Palmen und Tannen)* [*"Rocky landscape" (With Palms and Fir Trees)*], 1919, 155, fig. p. 171; *Komposition mit Fenstern* [*Composition with Windows*], 1919, 156, fig. p. 205). These are constructive, deserted landscapes, whose architectural topography seems labyrinthine, chaotic, and complicated. Heterogeneous levels of form recur. The spatial dimensions of depth topple onto the surface—the foreground supports the entire work. The mixture of architecture, landscape, plants, letters, or abstract surfaces indicates a stepwise approach in the composition of the image, where the different elements are added, arranged, and combined through an irregular system. The harmony, mood, and atmosphere of the pictures are not without a certain artificiality. The stage-like character can be compared with the narrative paintings of late medieval Italy and southern Germany, in which different scenes from a continuous story are scattered in an extensive landscape. Apparent naivety and consciously implied simplicity are combined with a sophisticated perfectionism of technique and composition. Klee maintains a primitivist reflex reminiscent of the manner in which children construct conglomerates of landscape and architecture. Topographic relationships and landscape accessories are simplified, especially with regard to spatial perspective. The color tones are homogenous, differentiated, and in parts broken up by extremes. Form, color, and the context of space filter memories, melancholy, desire, and vision. The factual, the material, and the visible are made strange in unexpected combinations transcending the realms of fiction. "Art does not reproduce the visible; rather, it makes visible," says Klee.[1] Dualistic, multi-layered, heterogeneous, and sometimes contradictory levels of experience are

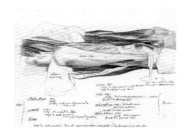

Paul Klee
Ohne Titel (Anatomische Zeichnung der Oberschenkelmuskulatur), 1902
Untitled (Anatomic Drawing of the Femoral Muscles)

made visible—sometimes to the point of ambiguity and the obscuring of perception. It is precisely imperfection, irritation, and imprecision that act as decisive impulses for what keeps perception in constant motion. Depicting nature and the visible means stagnation. Klee began to perfect his realist techniques and methods of naturalist form at the age of thirteen, applauded, as he notes in his memoirs, by his immediate friends and family (Sketchbooks 1892–98). He finalized the development of techniques with figure and anatomic studies in Munich (*Ohne Titel (Anatomische Zeichnung der Oberschenkelmuskulatur)* [*Untitled (Anatomic Drawing of the Femoral Muscles)*], 1902, fig.).

In the 1920s Klee produced a series of abstract works whose right-angled, constructive, mosaic-like surfaces of applied color are disoriented, unstable, imprecise, floating, and balanced—in full contrast to the constructivism of the time. The surfaces seem to vibrate reciprocally into neighboring spaces, showing signs of latent movement. (This sequence of exciting, non-representational compositions is at the center of the exhibition.) Though there is a clear proximity to Bauhaus and to Klee's pedagogically oriented theoretical work, these compositions go much farther. This group of works illustrates how all constructive principles are modified to achieve a state of irritation. In addition, the titles of the paintings allude to meanings that challenged Klee to take creative liberties (*Bildarchitectur rot gelb blau* [*Pictorial Architecture Red, Yellow, Blue*], 1923, 80, fig. p. 144; *Harmonie aus Vierecken mit rot gelb blau weiss und schwarz* [*Harmony of Rectangles with Red, Yellow, Blue, White and Black*], 1923, 238, fig. p. 145). Klee distills the elementary pictorial functions from natural, landscape, architectural, and other phenomena. (The intensity of color echoes the inspiration he found during his travels in Tunisia in 1914 as well as the tendency—first emerging during the time there—to divide the subject matter up and explore it through two-dimensional surfaces. Perhaps Klee was inspired by the checked patterns of Berber carpets.) Klee's tendency to use grid and the serial patterns of "dividual" structures is reminiscent of a specifically ornamental style, allowing the seemingly equal image segments to take on different functions in his visual universe. (Comments on the subject of "individual-dividual" can be found in Klee's 1925 Bauhaus publication *Pädagogisches Skizzenbuch* [*Pedagogical Sketchbook*].) In the pointillist compositions of 1932—produced in Düsseldorf, where Klee was a professor of painting at the Staatliche Kunstakademie—the process of dividing the complete image is conceptualized as a weave of countless polymorphic and individual elements subtly modified in form and color. However, Klee's method of separating compositional elements is consciously unsystematic. In *Ranke* (*Tendril*), a composition from 1932, 29 (fig. p. 271), the network of colored dots is riddled with ornamental, linearly curv-

ing melodies. The idea of the painting is subtly ironic if we consider that the oval frame was taken from an antique—a baroque mirror. Images composed in the pointillist style cannot be linked to any material background—they seek their identity in an abstract subtlety (*durch ein Fenster* [*Through a Window*], 1932, 184, fig. p. 272). Paul Klee's unorthodox way of creating spaces and organizing the rhythm of imagery and movement arises from his thoughts on topography and the observation of communicative relationships in different spatial contexts. Gardens, parks, and landscapes are favorite subjects in Klee's work. At the same time, they are metaphors for his ideas on composition.

Paul Klee
der wandernde Kopf I, 1939, 742
The Wandering Head I

Wandering through Klee's world of images—through the exhibition spaces—the visitor finds orientation in Klee's topographical philosophy. ("Wandering" is a metaphor Klee enjoyed using: *der wandernde Kopf* [*The Wandering Head*]—the title of a series of drawings from 1939, fig.; "The roads that the exploring eye travels ... are not bound by time and space"—is an example of the theory and psychology of perception with which Klee operates in his theoretical texts.) The concept of the exhibition in the Zentrum Paul Klee uses the images to appeal to the visitors' unorthodox, erratic rhythms of movement and their readiness for self-reflection. Thus for example the constructive watercolor *Monument im Fruchtland* (*Monument in the Fertile Country*) from 1929, 41 (fig. p. 146), on which the postal address of the Zentrum Paul Klee is based, could inspire the interpretation of his work—a finely structured, simplified landscape which lives from multiple levels simultaneously placed behind and adjacent to each other. The levels expand, limit, open, and close—ever seeking a new, expanded horizon. The net-like composition encompasses a central zone full of color, small bright spaces, side-areas, and pathways into the various expanses of color and differentiated spatial arrangements, which are suggestive of moods. There is a palpable, reserved decisiveness in the creation of space, the topographical montage. There are quiet zones, vital zones, harmonies, and tensions—always depending on the color, form, and location of the surfaces. The beginning lies nowhere in particular and has its corresponding provisional end somewhere between top and bottom. Nor are there any boundaries at the sides. This is reminiscent of Klee's *Landschaft am Anfang* (*Landscape in the Beginning*) from 1935, 82 (fig. p. 147), in which the open spatial structure—in a subdued green—is broken up by the "wandering" black topographical line whose movement appears uncertain and aimless. There is no beginning and no end. Its several layers of paint give this painting a relief-like structure—in the process of creation the image has solidified into landscape.

What does Klee's understanding of topographical intention mean for the exhibition? The interior design and the placement of the works inspire the visitors to follow their

Paul Klee
labiler Wegweiser, 1937, 45
Unstable Signpost

own rhythm of movement. There is no guideline on how to move through the exhibition. This is achieved by an open, stage-like layout of neutral, white-painted walls. Based on square modules of various heights, this system includes longer and shorter components implying the dimensions of walls and streets. Everything is suspended freely, with no marked paths to follow. Associations with titles of Klee's works arise, such as *labiler Wegweiser* (*Unstable Signpost*), 1937, 45 (fig.), *Zerstörtes Labyrinth* (*Destroyed Labyrinth*), 1939, 346 (fig. p. 149), *harmonisierte Störungen* (*Harmonized Disturbances*), 1937, 130; with terms he invented such as *schwerleicht* (heavy-light); with his thoughts on the subject of "deviation" and "derangement" or on precise and, at the same time, imprecise simultaneity; with Klee's penchant for the approximate and unstable, the act of balance, gray zones—his interest in intermediate worlds; furthermore the creatively effective ambivalence of order and chaos, construction and intuition as well as his fundamental view of interdependent contradictions; and thus, with compositions, work titles, intentions, coined terms, and correspondences that document Klee's openness and unorthodox way of thinking with regard to composition and sense of direction, rhythm of movement and spatial orientation.

In 1933 the Nazis dismissed Klee from his position as professor at the academy in Düsseldorf. At that time, Klee found himself at a peak of his career as an artist and teacher—including both social and financial recognition. Moving to Bern—emigration—effected a change. Klee moved to a region he knew well, an area which had made a decisive impression on his development and which suited his Swiss temperament. Here he sought to start afresh as an artist. He began "with a small orchestra," as he put it in a letter to his friend Will Grohmann, the art historian, working only infrequently. In his work from 1934 to 1936 he appears to have been eager to experiment. Klee developed further variations of his distinctively informal style of painting bound with contextual reminiscences. A few of the pieces in the Zentrum Paul Klee document this phase of creativity and its heterogeneous compositional spectrum.

In 1936 Klee produced the small panel painting *das Tor zur Tiefe* (*The Gate to the Depth*) 1936, 25 (fig. p. 148). It combines a constructive order of composition with a style of painting showing informality and refined workmanship in the details, and both of these stylistic components are in dialogue. The mosaic-like surfaces are geometrically skewed—Klee uses the term "derangement" in his theoretical writings. The inner life of the color-balanced, sometimes colorful surfaces is set in fluid motion by the informal style of brushwork and other artistic techniques. The surfaces act as individual images within the entire painting. Through a confused perspective creating spatial bewilderment, they open toward a black-painted area—*The Gate to the Depth*: an abstract allegory of reality as interpreted in visual philosophy.

With the onset of his serious and life-threatening illness, Klee's work went through far-reaching changes accompanied by an increased output. This was combined with stylistic consensus—punctuated, as always with Klee, by phases of experimentation. His late style is shaped by a specific language of signs and symbols which he continually developed and modified from 1937 through 1940 (*Insula Dulcamara*, 1938, 481, fig. p. 197). It is an ongoing process of simplification and abstraction combining essences of script, calligraphy, and code with areas of color. Klee transcends reality, he creates paintings and drawings that transport the material world into dream-like, surreal spheres, abstract dimensions full of mystery. His sign language seems sometimes to function like a pictorial cryptography (*Geheim Schrift bild* [*Secret Type-face*], 1934, 105); his hieroglyphs are reminiscent of secret codes which sometimes seem almost impossible to decipher (*der Graue und die Küste* [*The Gray Man and the Coast*], 1938, 125, fig. p. 275). It is as if Klee wished to avoid—on the basis of his own rules—any possibility of deciphering the encoded language into categories of fact, knowledge, or understanding. "The calligram belongs to writing down in a medium, introspective drawing," Klee says in his pedagogical writings.

"Should everything be known? I don't think so!" Klee wrote this in delicate pencil underlined with white paint on an unfinished 1940 composition done on packing paper with colored paste and grease crayon. Countless anonymous objects seem to stray about and merge with each other, as if all things were ordered by impulse (*Ohne Titel (Komposition mit den Früchten)* [*Untitled (Composition with Fruits)*], ca. 1940, fig. p. 175).

The painting *Destroyed Labyrinth* from 1939, 346 is difficult to interpret. In its almost monochrome fashion, it internalizes a certain degree of suggestive disorientation. Paintings from this phase of Klee's life combine flat expanses of color with a linear framework which is usually dark. Ciphers and symbolic elements characterize Klee's later work. Every detail seems to be moved and moving, fluctuating and continuous. This imagery reflects the "diary" of drawings and paintings on paper in which Klee—excessively and obsessively—sounds out the boundary regions of labyrinthine and seemingly chaotic form (*KOP* [*Head*], 1939, 1225, fig. p. 150). The panel paintings distill the essence from this pictorial diary, they channel the quantitative richness of his reflection into unique single compositions (*La belle jardinière*, 1939, 1237, fig. p. 157). In the panel paintings Klee carefully, thoughtfully, and conceptually constructs and orders what in his graphic and colored works on paper is spontaneous.

A look at this phase of his work (which a number of outstanding examples document in the collection of the Zentrum Paul Klee) reveals a symbiosis of contrary images and motifs in his artistic expression that runs parallel to a dialectic of allegorical rela-

LIVERPOOL JOHN MOORES UNIVERSITY
LEARNING SERVICES

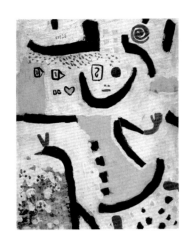

Paul Klee
ein Kinderspiel, 1939, 385
A Children's Game

Paul Klee
Ohne Titel (Schnecke), 1883
Untitled (Snail)

tionships between abstraction and reality. Klee projects his artistic line, his autonomous language, and his sense of imagery with an intense consistency. The individual nuances within the image structure are oriented toward the encompassing perspective and the openness with which he artistically confronts the complex dimensions of reality. In this way Klee shows art as an expression of free creativity, of that which keeps the world in motion. In his late work, Klee intensifies the existential memories of childhood and the first experiences of confronting reality with art. As the creative instinct of his final years broadens his artistic nature, he becomes ever more aware of how carefree and whole the intuitive world of childhood is, an awareness that results in playful creativity, improvisation, experimentation, and creative adventure (*ein Kinderspiel* [*A Children's Game*], 1939, 385, fig.; *Ohne Titel (Schnecke)* [*Untitled (Snail)*], 1883, fig.).

In this late phase, Klee inimitably develops the secret contextual levels of meaning found in form and color, line and (internal) spaces. In the panel painting *blaue Blume* (*Blue Flower*) from 1939, 555 (fig. p. 154), linear, colored, and object-related elements grow together to form a manifestation of blue. (This is reminiscent of Romanticism and Novalis's "blue flower.") Klee differentiates the shapes, layers, and colors of the monochrome so that blue emerges as an expression of a transcendental world (*Früchte auf Blau* [*Fruits on Blue*], 1938, 130, fig. p. 155). The metaphorical world of blue has a long history beginning with an early portrait of Klee's sister, Mathilde (*Ohne Titel (Porträt der Schwester Mathilde)* [*Untitled (The Artist's Sister)*], 1903, fig. p. 156), and continuing with the watercolors from Kairouan (Tunisia) and the compositions of the 1920s. Proximate to the *Blue Flower*, Klee composed the painting *tief im Wald* (*Deep in the Wood*), 1939, 554 (fig.), whose subject is green. Colors, along with their complementary and contrasting energies, grow to be a programmatic, elementary form of expression in his work. A chronological approach to Klee's work reveals the full complexity of his color tones—tone colors—and their manifold levels of meaning.

Paul Klee's Interdisciplinary Topography

"Form must blend with world view," Klee noted in his diary in 1917 while stationed in Gersthofen, near Munich, during the war.[2] The historical perspective of the statement is directed at a more profound, philosophical interpretation of art, aimed at challenging creation and approaching reality in a complex way. Klee characterizes art as an "allegory of creation": "Art and creation follow the same basic principles" (1919–20 Diary, Appendix, p. 518). Growth and genesis are concepts that in Klee's artistic thought combine with movement as the decisive criterion for creative potential: art emerges as an expression of people's creative rhythm, as a process of approxima-

tion and perception. The conception, the compositional procedure, and the contextual motivations of his work are influenced by this way of looking at things. *Vorhaben* (*Intention*) from 1938, 126 (fig. p. 159), painted on newsprint, depicts a combination of individual characters in a latent state of abeyance. Figural shapes set things in motion, providing ignition in a listless, directionless state governed by endless coincidence. The worlds of children and adults seem to be separate from one another—for the moment. The two lightly-graded monochrome halves of the painting, in which black characters run free, correlate to each other contrapuntally. The black, gray, brown, and pink animated hieroglyph-like characters, together with a blue "Egyptian" eye making eye-contact, characterize a sense of calm—of soothing movement. The figural means of presentation are oriented on script and calligraphy, articulating conceptual activity and program.

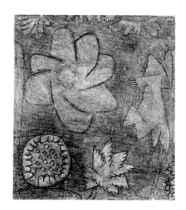

Paul Klee
tief im Wald, 1939, 554
Deep in the Wood

Klee's thoughts concerning art and creation are reflected in various text passages as well as in incisive aphorisms in diaries, letters, writings, and pedagogical sketches, all of which supply the intellectual and theoretical background for the searching philosophy of his visual work. Klee describes art—makes art visible—as people's means of getting closer to reality. The texts illustrate the context in which he places his art: it is the extensive framework of human coexistence with all its opportunities for movement and encounter, individuation and common ground, the "highways and byways"—to play on the title of one of Klee's compositions—which meet only so as to diverge again; there are bridges and intersections, harmonies and disturbances, balances and counter-balances.

Paul Klee uses art to approximate the complexity of his experience of reality, in the respective disciplines as well as from a holistic perspective. Klee's œuvre grapples with the various aspects of language, theater, and music; it concerns itself with architecture, technology, history, social aspects, as well as mythology and stories of creation. It reflects on aspects of science, astronomy, physicality, philosophy, psychology, and even medicine (see the associations with the cardiovascular system in the pedagogical texts). Body language and the psychosomatic habitus of the individual as well as interpersonal dialogue are brought together with social phenomena. Klee delves into and meditates on the subjects of childhood, the erotic, old age, death, and spirituality. Klee's paintings and drawings reflect anthropological aspects as well as an artistic interest in cultures outside of Europe and art by the mentally ill (see the collection and book of Dr. Hans Prinzhorn, published in 1922). His pedagogical works and sketches examine complex issues of composition and style on the basis of behavioral, ideological, scientific, musical, and other relationships. Klee's theoretical research, insights, and teachings congeal in concrete visual experiences.

Paul Klee
dieser Kopf versteht die Gleichung
nicht, 1939, 67
This Head Does Not Understand
the Equation

The means of artistic expression, the philosophy and scientific experience that constitute Klee's artistic identity are universally applicable. In this respect, the interdisciplinary philosophy of the Zentrum Paul Klee corresponds to the interdisciplinary content of Klee's artistic thought. The presentation of his work within the exhibition is founded upon the reciprocity of these correlations, their dialogue and magnetism, their formal and contextual attraction, and their orchestration within the visual isolation of thematic aspects. The result is a mosaic that infers creative rhythm, artistic line, compositional conceptuality, and formal stringency—along with the imponderables of balance and the dissonant breaking of harmonious equilibrium. Klee invents his own language of images and signs, and with it he rediscovers art—an authentic reality that adheres to its own rules—and further develops it for himself.

The close correspondence between personality and work gives the artistic representation a communicative, dialogue-oriented power in the respective mediums. The world of the stage and theater, the dramaturgical and directorial, the cut and thrust of production and reception are the soul of Klee's artistic role-playing. Many pictures and drawings deal with the iconography of the theater. Here Klee shows art and life as stage culture, dream theater, a figment of the imagination, where artistic principles cut loose from the ordinary. Figures and scenery speak a secret sign language, moving rhythmically through the picture. Actors, musicians, and singers perform; puppets, masks, witches, and demons stimulate (*Puppen theater* [*Puppet Theater*], 1923, 21, fig. p. 152; *Zaubertheater* [*Magic Theater*], 1923, 25, fig. p. 202; *Schauspieler* [*Actor*], 1923, 27, fig. p. 225). Acrobats and tightrope walkers balance (*Der Seiltänzer* [*The Tightrope Walker*], 1923, 121, fig. p. 165). They disturb the homogenous equilibrium that people assume they themselves possess in material and transcendental reality. Klee's early grotesques and caricatures already show his theatrical leanings, his love of the mask-like, of irony and the alienation technique. Klee developed many variants of pictures with the stage as their subject during his period of teaching at the Bauhaus, where he was in close contact with fellow artists such as Oskar Schlemmer and followed the Bauhaus principle of working across media and disciplines. He made a puppet theater for his son Felix, its droll figures taking the popular Punch and Judy show and turning it into an unreal and eerie phantasmagoria, serious yet playful (*Ohne Titel (Selbstporträt)* [*Untitled (Self Portrait)*], 1922, fig. p. 278). In particular in his late work these phantoms reappear in colored works and drawings on paper (*Kohl-Teufel* [*Cabbage Devil*], 1939, 714, fig. p. 151). Klee connects his joy of inventing stories—his talent for contemplation, for entering through his pictures into traumatic levels of consciousness, memories, fears, and visions—with childhood. Art focuses the sphere of one's life. Klee presents childhood as a fundamental experience for learn-

ing to approximate reality; the game becomes ever more serious and the urge to go beyond ever more reckless. Klee has always had a unique way of invoking childhood and manifesting simplicity, the naive, primitive, and carefree, by activating an artistic language.

The level of equilibrium, the constructive significance of the perpendicular, the dialectic of stability and instability are compositional criteria that are of great importance for Klee's message. Describing his feelings, Klee once spoke of "the balancing act of being." Slightly modified versions of this aphorism appear in his diary and in letters as Klee gradually approximates his own perception. The 1939 drawing *dieser Kopf versteht die Gleichung nicht* (*This Head Does Not Understand the Equation*), 67 (fig.), internalizes the unstable process of cognition. The title variations "On the Way to Equation" and "Toward Equation," noted on the cardboard base, document how Klee gradually came into his own work (compare the *Näherungen* [*Approaches*] series, 1939, fig.). Pictures such as the famous *Tightrope Walker*, 1923, 121 deal with the complex of instability and balance, and Klee looked into the theory of this in detail in his lectures at the Bauhaus. The balancing, creative tightrope walker and adventurer is also a metaphor for the artist himself, who used the statements of his individual pictures to open himself to an unpredictable public and risk confrontation between his exotic role as an artist and the prevailing tastes of the time. The titles of pictures refer directly to the Klee's dealing with the imponderables of balance (for example *Schwankendes Gleichgewicht* [*Unstable Equilibrium*], 1922, 159, fig. p. 163; *Gewagt wägend* [*Daringly Balanced*], 1930, 144, fig. p. 162). Klee saw formal combinations as being full of tension, an inwardly turbulent, rhythmic principle—to the point of having an aggressive structure (*Schema eines Kampfes* [*Diagram of a Fight*], 1939, 1012, fig. p. 161). This compositional complex is of central significance for the symbiosis of existential and artistic components. The colored sheet *Kämpft mit sich selber* (*Struggles with Himself*) from 1939, 1189 (fig. p. 160), uniquely presents the internalization of a sense of direction which is both individual and universal, the imagining of a personally relativized, timeless state. The questions Klee asked in several drawings of that time, *woher? wo? wohin?* (*Whence? Where? Wither?*), 1940, 60 (fig. p. 132), manifest themselves as the linear framework of a comprehensive orientation centering around the vertical line of the body's posture. The step forward—accompanied by a powerful color tone—is also simultaneously turned into a step backward. We see the abstract physiognomy of a face. From the front it looks troubled. In all its abstractness it is distorted and enigmatic; emphatic red underlines its efforts to seek indirect eye contact with whoever is opposite. Form and content are identical; the content is expressed directly through the use of form. The uncertainties of movement keep the

Paul Klee
Näherung händlich, 1939, 453
Approach to Handy

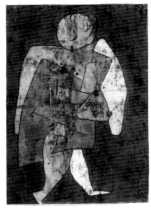

Paul Klee
woher? wo? wohin?, 1940, 60
Whence? Where? Whither?

picture in unresolved tension, where the element of enduring (inner) peace is concealed. The intermeshed pencil lines are unpretentious, the background is neutral in color. Colored light and the condensed structures of the Zulu pen energize the going and seeing.

The interior design for the presentation of Klee's works at the Zentrum is based on his own ambivalent thoughts on topographic motifs. "Let us develop, let us make a small journey to the land of better understanding and be guided by a topographical map …," Paul Klee begins the second chapter of his essay "Schöpferische Konfession" (Creative Confession), published in 1920—shortly before his so significant and fertile period as lecturer at the Bauhaus in Weimar—in an anthology put out by the writer Kasimir Edschmid.[3] Here Klee speaks directly to the reader and aims to engender an interpersonal dialogue, with each party presenting their individual view of themselves as artist; every communicative and psychological aspect integrated into this passage is closely tied up with topographic ideas—metaphors: "Let the first act of motion be one that goes beyond the neutral position (line). Shortly thereafter, we stop to catch our breath (a broken line or articulated line if several breaks are made). Look back over the distance covered (countermovement). Mental evaluation of the distance covered and that remaining (cluster of lines). A river bars our way, so we use a boat (undulating motion). Upstream there would have been a bridge (series of arches). On the other bank we meet a fellow traveler with the same goal, to go where great understanding lies in store. At first there is joyous agreement (convergence), then gradually differences emerge (two very separate lines). A certain agitation in both of them (expression, dynamics, and psyche of the line)."[4] The application of behavioral psychology to composition is a fascinating feature to be found throughout Paul Klee's work, and Klee's language shows how important his talent as a writer and poet was for the propagation and reception of his work.

For Klee, topography is a complex structure that we can perceive in its reality, interpret with metaphors, and express in philosophical terms. It provides many of his themes: landscapes, gardens, parks, architecture, and urbanity. Topography also determines the location of ideological concepts. It helps plan the artist's work and concretize a picture's composition, the structure of which can be seen as pictorial architecture, a pictorial landscape.

Architecture is Klee's example of the ambivalence of stasis and motion, the result of a creative artistic process that is also functional and efficient, where stability and systematic procedure are married to artistic flexibility in design. These criteria are reflected in the many possible ways there are of perceiving architectures, which go beyond practical experience and use. The eye, mental reflection, and emotional sensitivity endow

the construction with a higher motion. It is precisely the inversion of architectural principles into the complexity of mental perception that fascinates Klee in depicting these themes (*Pictorial Architecture Red, Yellow, Blue*, 1923, 80, fig. p. 144; *Kleine Felsenstadt* [*Small Town among the Rocks*], 1932, 276, fig. p. 158). Architecture and urbanity, cityscapes and landscapes depend on the rivalry between artificial and natural principles, on the synchronicity of ordered and organic essences. This tension is what particularly interested Klee in dealing with this genre, because his artistic genius thrived in the complex interplay of artificial and natural factors. Artistic composition takes concrete form within the web of ambivalent relationships between objective factuality and the capricious ways of aesthetics and emotions. His artistic thought tells of the conflicting forces in art: fantasy and education, intuition and rationalism, improvisation and construction, spontaneity and calculation, instinct and consciousness.

The rhythmic motion in Paul Klee's art, which combines powers of improvisation and construction, is deeply inspired by music and musicality, by acoustic phenomena. Texts, theoretical excursions—in particular his Bauhaus lectures and didactic sketches—observe and analyze the affinity, the inner relationship of composed structures in music and the graphic arts. Harmony and polyphony, melody and rhythm, time and pitch as well as musical genres and categories (fugue, counterpoint) are core criteria in this context. In each case the harmony of these elements implies musicality, it makes the picture both audible and visible in its "temporally motivated construction." Whereas music passes, a picture can be perceived and experienced by the "probing eye" for an endlessly long time. Klee also conducted theoretical experiments with the correspondence between sounds and colors. (The combination of sound and color also interested the painter Wassily Kandinsky and the composer Aleksandr Scriabin.) The relationship of melodic, rhythmic, harmonic, processual, and spatial factors—the combination of polyphony with temporal dimensions—makes up the complexity of musical forms, which can be transferred to both spatial characteristics and perspective, and to phenomena concerning the composition of the picture. Their regularity and tonal-acoustic levels of association underpin a significant part of Klee's pictures. Klee's œuvre contains a number of variations on iconographic themes (*Musiker* [*Musician*], 1937, 197; *alter Geiger* [*Old Violinist*], 1939, 310; *die Sängerin der komischen Oper* [*The Singer at the Comic Opera*], 1925, 225) and concrete musical associations (*Fuge in Rot* [*Fugue in Red*], 1921, 69, fig. p. 166; *Landschaft in A dur* [*Landscape in A Major*], 1939, 91, and *Landschaft in C dur* [*Landscape in C Major*], 1939, 92, figs. p. 134; *polyphon gefasstes Weiss* [*White Framed Polyphonically*], 1930, 140, fig. p. 167; *landschaftlich-polyphon* [*Scenic-polyphonic*], 1934, 88, fig. p. 134). Several of his works can even be freely interpreted as scores.

LIVERPOOL JOHN MOORES UNIVERSITY
LEARNING SERVICES

Paul Klee
Landschaft in A dur, 1939, 91
Landscape in A Major

Paul Klee
Landschaft in C dur, 1939, 92
Landscape in C Major

Paul Klee
landschaftlich-polyphon, 1934, 88
Scenic-polyphonic

The relationship between image and language belongs in this context—it has a certain affinity to the relationship between music and language. Here temporality and expression, articulation and meaning come together. Language, writing, typography, and poetry are all powerful creative instruments in Klee's work. Sound and text, phonetics and the meaning of concepts are so vivid in his pictures as to become tangible. Klee's language of signs and symbols is a further development of his writing into the abstract (*abstracte Schrift* [*Abstract Writing*], 1931, 284, fig.). The integration of typographical elements creates complex new associations (*Alpha bet I* on newsprint, 1938, 187, fig. p. 168; *Alphabet II*, 1938, 188, fig.). The link to poetry and prose can be found in Klee's metaphorical imagery. Text pictures from 1939 and 1940 demonstrate the degree of background meaning in his art when he uses typographical, linguistic, and literary elements. Klee's encoding of the 1938 drawing *Anfang eines Gedichts* (*Beginning of a Poem*), 189 (fig. p. 169), points to the inspirational and mysterious beginnings of artistic creation ("So may it secretly begin"—the first line of a song that Johann Sebastian Bach dedicated to his wife Anna Magdalena). Here disorderliness and confusion stand in relationship to vagueness; coincidence and uncertainty to concreteness; fragmentary imperfection to conceptualization. Klee's 1918 picture *Einst dem Grau der Nacht enttaucht …* (*Once Emerged from the Gray of Night …*), 17 (fig. p. 164), is a poetic amalgam of abstraction and reality, a colored composition like a tableau which is both unorthodox and constructional. The originals of Paul Klee's texts are to be found in letters, diaries, various publications, a volume of poetry, lectures, and didactic writings. Klee's literary talent is also manifest in the originality of many of the titles he gave to his works: the pictures and drawings included in the works catalogue abound with associations and witty wordplay (*Don Juan, 461. Abenteuer* [*Don Juan, 461st Adventure*], 1939, 195; *Simplex besucht Complex* [*Simplex Visits Complex*], 1940, 314; *Museale Industrie* [*Antiquated Industry*], 1940, 295; *falscher Kopf am falschen Ort* [*Wrong Head in the Wrong Place*], 1939, 587, fig.).

Paul Klee's interdisciplinary program is rooted in the interplay of different media with their own complex experiences and interests. The empirical and the artistic converge in the conceptual structures of communication. Other seemingly contrary spheres also meet: the scientific and the intuitive, the everyday and the theatrical, the real and the abstract, architecture and art, the mythological and the real-existing. The banal encounters the transcendental, primitive naivety meets conceptual professionalism, and instinct faces calculation. This complex network of individual and universal factors with their mutually determinative interrelationships reflects Paul Klee's artistic personality in his pictures and use of language—it is here that his self-perception is concentrated.

The nineteenth century was the historical foundation for Paul Klee's development both as an individual and as an artist. An awareness of social traditions and a range of historicizing, romanticizing, idealizing ideas formed the basic pattern of his tastes—a set of aesthetics that was shielded by ethical and moral rules. These stabilizing aspects also shaped the Klee family and their social environment. The family's cultural interests fostered the development of Klee's artistic talents. When looking back at his childhood, Paul Klee devoted some thought to this and pointedly characterized particular educational behavior patterns and cultural preferences of his environment with a mix of understanding, thoughtfulness, and irony. The academic conventions of the art schools were a major problem for Klee, as they were for other young artists of his generation. Klee pursued his studies in Munich; he learned graphic modeling in the studio of Heinrich Knirr. During his time as a student in Franz von Stuck's class at the academy in Munich (1899–1901), which was interrupted by summer stays in Bern, Klee did his first landscape paintings (*Ohne Titel (Aarelandschaft)* [*Untitled (Aare Landscape)*], ca. 1900, figs. pp. 230–31). "It sounded great to say you were a student of Stuck's, but in reality it wasn't half so hot," Klee wrote in his diary in December 1900 (122). The treatment of artistic traditions, composition techniques, and the academic use of color did not match the "tone of [his] feelings," as he called it at the time. Klee was fascinated by the freedom of form and composition of Auguste Rodin's nude drawings and watercolors. His trip to Italy in 1901–2 with his Bern friend, the painter and sculptor Hermann Haller, allowed him to orient himself in art history and develop his own standpoints (*Schwebende Grazie (im pompeianischen Stil)* [*Hovering Grace (in the Pompeian Style)*], 1901, 2, fig. p. 170). Klee immersed himself in art history, examining it critically and with an awareness of the present; he projected what he saw into his own artistic conception of himself. Klee's many letters to his future wife Lily Stumpf and to the family, the gist of which he integrated into his diary, show how intensively he dealt with complex questions of art, philosophy, psychology, literature, and music. The years until 1902–3, when Klee's artistic identity really emerged, were largely ones of self-reflection and orientation. The turn of the century was the key to breaking away from conventions and discovering new terrain. Paul Klee's early work of those years fits into the vein of art nouveau (*Aare Landscape*). His search for a new beginning, for creative substance based in simplicity, was unique for the art of the epoch—and momentous. For Klee it was what really provided the initial thrust. He first spoke about this in 1901. Later he considered the *Komiker* (*Comedians*), a series of etchings, to be his "completed Opus I" (fig. p. 136). Immediately after this, Klee pursued his linear fantasies to the level of imprecise scrawls

Paul Klee
abstracte Schrift, 1931, 284
Abstract Writing

Paul Klee
Alphabet II, 1938, 188

Paul Klee
falscher Kopf am falschen Ort,
1939, 587
Wrong Head in the Wrong Place

Paul Klee
Komiker, 1904, 10
Comedian

Paul Klee
Komiker. (Inv. 4.), 1904, 14
Comedian

Paul Klee
Akt, 1905, 34
Nude

(*Akt* [*Nude*], 1905, fig.). After meeting Kandinsky, Kubin, and artist friends of the group Der Blaue Reiter (The Blue Rider) around 1911–12, Klee created the *Candide* illustrations (fig.) after Voltaire's novel, bringing his tendency to "tread new ground in psychological improvisation" (1908 Diary, 842) to its first climax. But it was not until experiencing Tunisia that he grasped the key to color. "I am in the grip of color … color and I are one …," he noted in 1914 in Kairouan.

Paul Klee—son of a Swiss mother and a Bavarian father who worked as a music teacher near Bern—grew up in the city of Bern. He remained a German citizen all his life. He applied for Swiss citizenship in 1939, but approval from the authorities in Bern only came through after his death in 1940. During World War I Paul Klee was called up into the German reserve forces. He was stationed in the vicinity of Munich and did not move from there. In this period he only produced a few drawings and colored works; in them he further developed the impressions of his journey to Tunisia and the *Candide* cycle, moving toward a kind of abstract instability of perspective (*Vogel-Flugzeuge* [*Bird-airplanes*], 1918, 210, fig.). Klee wrote letters to his family and kept a diary, noting his reflections and ruminating about his skeptical, critical interpretations of current events. He reflected on power politics, violence, and war—and their detrimental effects on art—with real depth of personal feeling: "I have long had this war inside me" (1915 Munich Diary, 952). In pictures and texts he commented with cynical consternation on power structures, leading politicians, and warmongers (*Der grosse Kaiser, zum Kampf gerüstet* [*The Great Emperor, Armed for Battle*], 1921, 131, fig. p. 252). Paul Klee ended his diary in 1918. In Munich he sought to develop his talents in an open cultural environment free from the dominance of autocratic arrogance—embodied in the pompousness of Kaiser Wilhelm II—and its devastating effects on recent history, on people, and art. Scandals, factional disputes between Old and New had molded the art scene shortly after 1900 and particularly in Berlin and Munich. With the end of World War I, in which Paul Klee's friends August Macke and Franz Marc had been killed, a new period of social and artistic development began, in which the abstract, the individual, the emotional, the break with academic formalism—also intended as an affront against antiquated notions of art—unfolded and came to bear. Klee's 1919 landscape compositions (figs. pp. 171 and 205) reflect this visionary energy, which finds its way back from tragic experiences to his own carefree fantasies.

During his Bauhaus period in Weimar and Dessau, Klee and his artist colleagues presented an interdisciplinary plan for an artistic practice merging into society. The events of recent history—violence and war—repeated themselves in a most terrible way. The Nazi dictatorship eliminated society's creative potential, confiscated artworks, banned artists from painting, closed down the Bauhaus, and dismissed museum direc-

tors. In 1933 the Nazis suspended Paul Klee from his post as professor at the Kunst-akademie in Düsseldorf. Klee valued his teaching position and had felt that his time in Düsseldorf was a chance to reorient himself. He emigrated to Switzerland, where he was to live until his death in 1940. As the Nazis' grip on power tightened—and concomitant to his dismissal—Klee's work witnessed his intense reflection on the themes of violence, war, conflict, struggle, hierarchy, dictated opinion, and oppression. Klee developed a psychogram-like style of drawing where, in clusters of powerful lines and graphically fragmented abbreviations, he sketched scenarios, which, proceeding from everyday, interpersonal behaviors and personal experiences, interpreted the menacing aggression that destroyed all social consensus (*tote Puppen* [*Dead Dolls*], 1932, 150, fig. p. 138). (Beginnings of this form of reflection go back to 1913, the year before the outbreak of World War I.) This is the first time that drawing in Klee's œuvre became a prolonged, quantitatively escalating, diary-like process—an obsession for articulating artistic experiences and visions on cheap drafting paper that Klee reactivated in 1938 in the face of the parallel he saw between his own terminal illness and murderous war (*Kinder spielen Angriff* [*Children Playing Attack*], 1940, 13, fig. p. 153). Klee's work shows a deeply felt translation of contemporary phenomena into the private realm. His juxtaposition of violence and personal environment harks back to his own rich and varied experience and observations that went back to his childhood; to the patterns of socialization in families and educational institutions; to the games and toys that are also used for war games and provide the corresponding backdrop for them; to children who dress up as soldiers; to the adults who define morality, education, and the law; to the conflicts between grown-ups and children; to corresponding group behavior; to the problems of authoritarian role models. Klee's artistically unorthodox drawings from 1932–33 document an obsession with interpreting his own feelings in that historically menacing situation. In this context he created impressive small pictures—unique, lonely panel paintings—which are a study of his ego and *raison d'être* as an artist trampled underfoot by politics (*von der Liste gestrichen* [*Struck from the List*], 1933, 424, fig. p. 258). These pictures were Klee's attempt to work his way out of his distress, and they are harsh and cruel in their intensity. Fear, anxiety, and danger appear masked, as ghostly spheres (*Kopf eines Märtyrers* [*Head of a Martyr*], 1933, 280, fig. p. 172). They are visions of terror reminiscent of a child's levels of experience—of nightmares, where dream and reality coalesce into an inexplicable world of their own.

In the final years of his life, Klee's artistic projections recall and condense his childhood ever more intensely. The hectic phase of 1933 is past, purged through the pencil drawings of 1938–40 to achieve a tense calm marked by earnest reflection and con-

Paul Klee
Candide, 9 Cap, Il le perce d'outre
en outre, 1911, 62
Candide, Chapter 9, Il le perce
d'outre en outre

Paul Klee
Vogel-Flugzeuge, 1918, 210
Bird-airplanes

Paul Klee
tote Puppen, 1932, 150
Dead Dolls

templative simplicity. Combined with irony and the grotesque, it relies on the simplicity of a small number of clearly drawn, slightly vibrating, unstable lines. These are composed like a grid or curved, coiled around themselves, partly interlocking, and look like minimalist signs of self-perception. Klee's black-brush drawings are very fluid (*ein Kind träumt sich* [*A Child Dreams*], 1939, 495, fig.), while intensely applied colors—usually colored paste—are a sign of piercing expressivity (*hungriges Mädchen* [*Hungry Girl*], 1939, 671, fig. p. 262). The simplicity and reductive pro-gram of these graphic works—mainly painted on drafting paper and letter paper—follow the principle formulated by Klee at an early stage: "Primitiveness [is] the ultimate professional awareness" (1909 Diary, 857). The intensity and internalized depth of the panel paintings of that time make an unparalleled impression. In artistic terms, Klee felt himself to be entirely on his own. In this period, in which his precarious social position was closely tied up with his critical state of health, he occupied himself—parallel to his expanding œuvre—with the *Oresteia*, Aeschylus's classical trilogy, in which people's search for themselves leads to impassioned conflicts; these are connected with power, war, and death—and end in tragedy. (Klee read and compared three German translations; "The best"—he wrote to Will Grohmann—"would have been somewhere in the middle.") Klee realized that the history of humanity is lived out in the history of the individual existence. This insight was the basis of a significant theme in his art. People's approximation to the real world creates the intermediate world of art, a realm in which everything is permitted, which can withstand everything, which opens and deepens, which follows its own strategies and plans.

"*Nulla dies sine linea*": Paul Klee noted this aphorism—one translation of which would be "No day without a line"—in 1938 in his works catalogue under number 365, a drawing entitled *Süchtig* (*Addicted*; pencil on letter paper). "*Nulla dies sine linea*" is a variation—with a slight change in language and meaning—on an aphorism in Pliny's Natural History, chapter 35. Klee's later work, in particular from 1938 to 1940, is characterized by a marked quantitative escalation. His output of drawings increased considerably. On January 2, 1940, he wrote to Will Grohmann: "That was a prolific year. I've never drawn so much, and never more intensely." "My production of pictures is increasing in scale and above all in speed, and I can't quite keep track of all these 'children'—they just spring up … The twelve hundred pictures in '39 must be considered a record," he had written to his son Felix on December 29, 1939. In May 1940 Paul Klee ended his works catalogue with the 366 numbers of a whole year—a biographical criterion that represents a conceptual detail by treating the cycle of the year as a symbol of the cyclic dimension of creative processes (*Stilleben am Schalttag* [*Still Life on Leap Day*], 1940, 233, fig. p. 173).

Around 1940 Klee produced a large-format panel painting that is part of his estate but which he did not integrate into his works catalogue (*Ohne Titel (Letztes Stillleben)* [*Untitled (The Last Still Life)*]), 1940, fig. p. 277). The picture is a completed work combining objects of different origin, like a still life. The composition seems arbitrary and amateurish. Imperfect, fragmentary objects act and pose against a black background; they lack real stability—but are insistent. Instability leaves everything material in a kind of limbo. The black background seems transparent; filigreed, black, hieroglyph-like ciphers form up on it. The black surface is also populated, almost invisibly, by hairs of Klee's cat Bimbo—we see a vision of depth that beams forth from the two-dimensionality of the elements of the picture; this is set off by the overpowering orange curve of a crooked, floating table, off balance, bearing flower and plant ciphers that seem to be glowingly engraved into it. The surface of the table appears to be sinking into the picture's depth but at the same time drives visual contact forward, toward the viewer—an ingenious optical illusion. The spatial ambivalence of two-dimensional positions characterizes the picture. The composition is interspersed with highly symbolic figurines: an exotic sculpture and a handleless coffeepot rise up off the table. In the top left of the picture, sculptured vase-like shapes—adorned with plants that look like insects—are tied together tightly with unrelated three-dimensional bodies. The sun and moon are painted in a simplified way, like a child sees and paints them. Bright colors compete with black. The blue at the top left is confronted with the red of the precariously dangling axe. Its bloody red symbolizes danger, and the other thriving bright colors penetrate the senses. The transient, the material, is confronted with universality and infinity. No tendency to romanticize and idealize present—past—future! The laws of space and perspective seem to have been abolished, straightness deranged, equilibrium upset, the recognizable estranged, clarity muddied. In the foreground, Klee's own drawing *Engel, noch hässlich* (*Angel, Still Ugly*), 1940, 26 (fig. p. 140), reappears, tipped at a disconcerting angle. Klee incorporates the linear grid of his 1940 pencil drawing into the painting by using gentle gradations of color and adds structure to give the original lines three-dimensional shading, making them come alive. The painted version of this picture in the picture gives a transcendental aura to the drawing of the angel and the reminiscence—fused with it—of things past and imaginable. The way in which Klee translates the object-like and the imaginary into painting and blends them into a whole, his allegorical balancing act between abstraction and reality, simplicity and alienation, is reminiscent of one of his diary entries, where he succinctly summarizes the essence of his work: "Abstraction from this world more than a game, less than a collapse of this world" (1913 Diary, 922).

Paul Klee
ein Kind träumt sich, 1939, 495
A Child Dreams

139

LIVER _MOORES UNIVERSITY
LEARNING SERVICES

Paul Klee
Engel, noch hässlich, 1940, 26
Angel, Still Ugly

Our tour through Paul Klee's work ends with text pictures by the Swiss artist Rémy Zaugg (on the rear wall of the Zentrum's Middle Hill). They deal with Klee's famous aphorism: "Art does not represent the visible; rather, it makes visible." This conceptual work forges a link to the imagining of perception. Paul Klee's art has a real presence, it sees itself in our time, it is confronted with the Now and Today. Klee begins his 1920 essay "Schöpferische Konfession" with the maxim: "Art does not represent the visible; rather, it makes visible." This is probably the most commonly cited (and somewhat inflated) statement of an early modern artist. The formulation begins with negation—"does not represent the visible"—unusual for Klee, who in his texts always thinks progressively—"makes visible." But his experience will have shown him that the necessity of breaking away from conventions, which he addressed as early as 1900, is a never-ending issue. The popular notion of art as mimesis is timeless. Klee and some of his contemporaries recognized that art invents reality, that art in itself represents a reality that renews itself without end. This world of art, fed by complex experiences, initiates a dialogue from person to person. Bringing out the vitality of this inspiring process is the goal of the Zentrum's presentation. It conspires with the architecture to open the view on Klee, offering a tour through a pictorial world whose discursive energy engages the viewers' perception and sensitivity, making them the real theme of the exhibition.

Notes

1. Paul Klee, "Schöpferische Konfession," in *Schöpferische Konfession*, anthology published by *Tribüne der Kunst und Zeit XIII*, ed. Kasimir Edschmid (Berlin, 1920), p. 28.
2. Paul Klee, *Tagebücher* (Bern, 1988), diary for 1917, entry 1081; further references to the diaries are given in the text; all translations are our own.
3. Klee 1920 (see note 1).
4. Ibid, p. 29

Further Reading

Klee, Paul. Pedagogical Sketch Book. Translated by Sibyl Peech. New York, 1944.
————. *The Diaries: 1898–1918*. Edited by Felix Klee. Translated by Pierre B. Schneider, R. Y. Zachary, Max Knight. Berkeley and Los Angeles, 1964.

Paul Klee
Garten=rhythmus, 1932, 185
Garden Rhythm

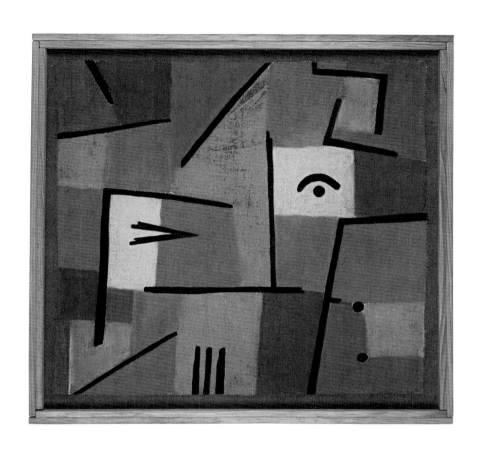

Paul Klee
Blick aus Rot, 1937, 211
Glance out of Red

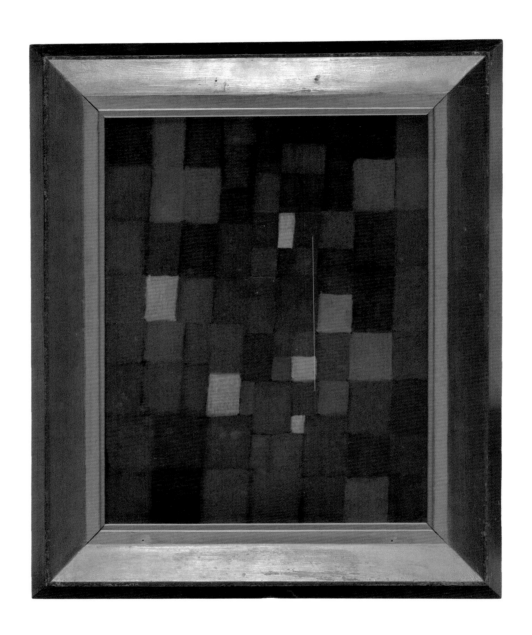

Paul Klee
Bildarchitectur rot gelb blau, 1923, 80
Pictorial Architecture Red, Yellow, Blue

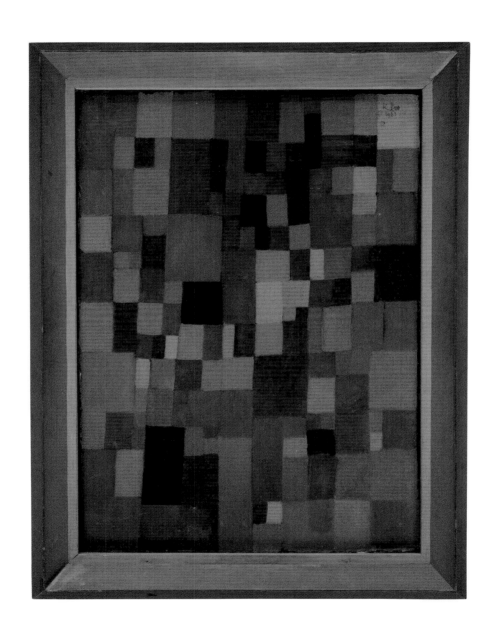

Paul Klee
Harmonie aus Vierecken mit rot gelb blau
weiss und schwarz, 1923, 238
Harmony of Rectangles with Red, Yellow, Blue,
White and Black

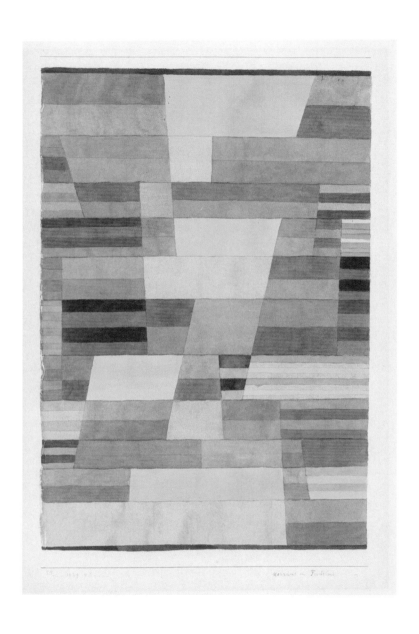

Paul Klee
Monument im Fruchtland, 1929, 41
Monument in the Fertile Country

Paul Klee
Landschaft am Anfang, 1935, 82
Landscape in the Beginning

LIVERPOOL JOHN MOORES UNIVERSITY
LEARNING SERVICES

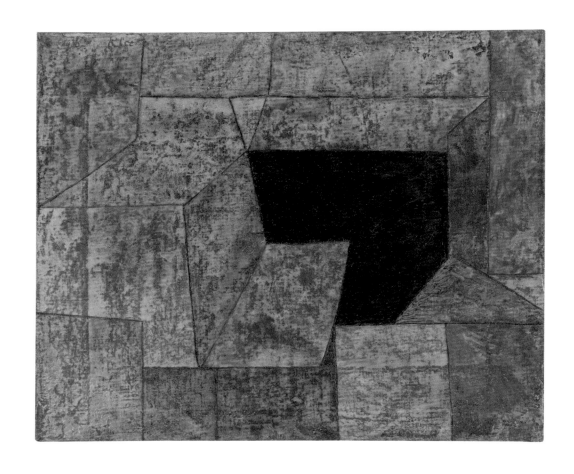

Paul Klee
das Tor zur Tiefe, 1936, 25
The Gate to the Depth

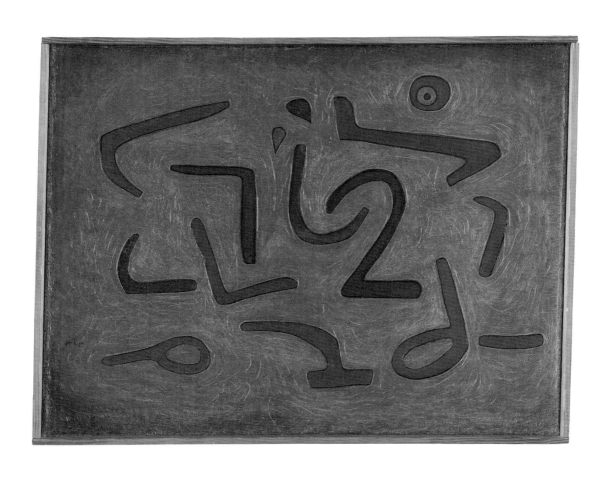

Paul Klee
Zerstörtes Labyrinth, 1939, 346
Destroyed Labyrinth

Paul Klee
KOP, 1939, 1225
Head

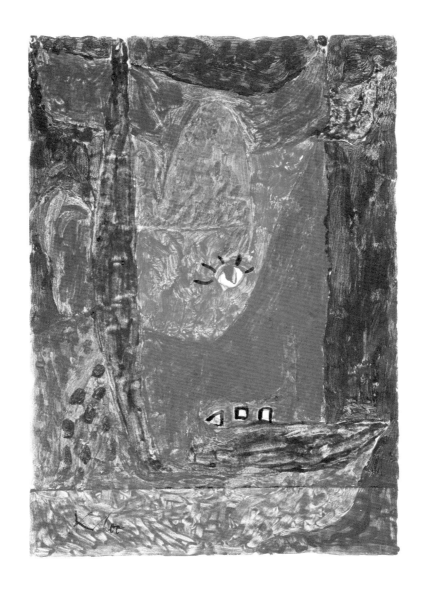

Paul Klee
Kohl-Teufel, 1939, 714
Cabbage Devil

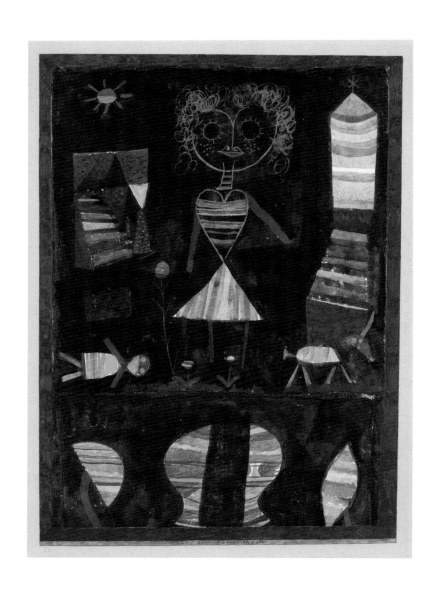

Paul Klee
Puppen theater, 1923, 21
Puppet Theater

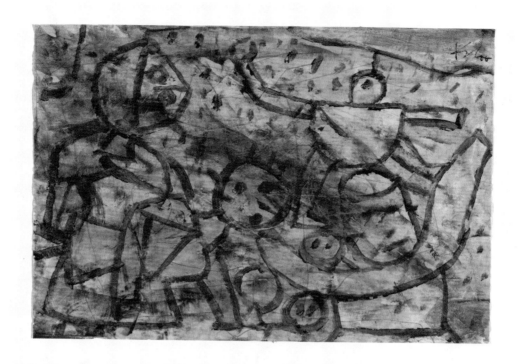

Paul Klee
Kinder spielen Angriff, 1940, 13
Children Playing Attack

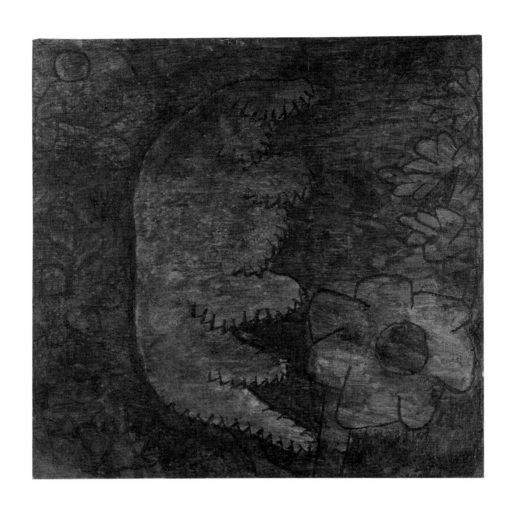

Paul Klee
blaue Blume, 1939, 555
Blue Flower

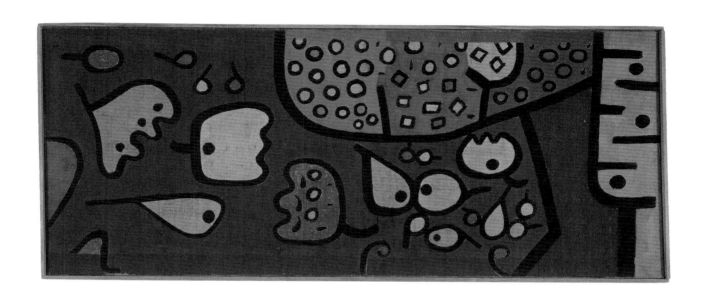

Paul Klee
Früchte auf Blau, 1938, 130
Fruits on Blue

LIVERPOOL JOHN MOORES UNIVERSITY
LEARNING SERVICES

Paul Klee
Ohne Titel (Porträt der Schwester Mathilde), 1903
Untitled (The Artist's Sister)

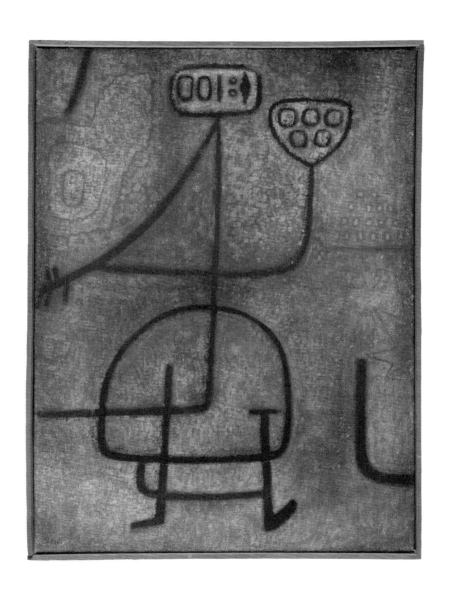

Paul Klee
la belle jardinière, 1939, 1237

157

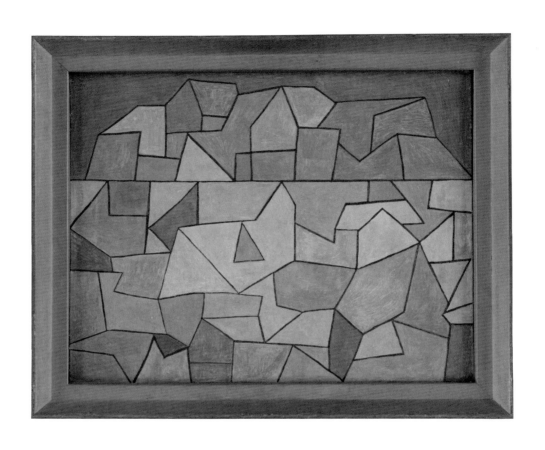

Paul Klee
Kleine Felsenstadt, 1932, 276
Small Town among the Rocks

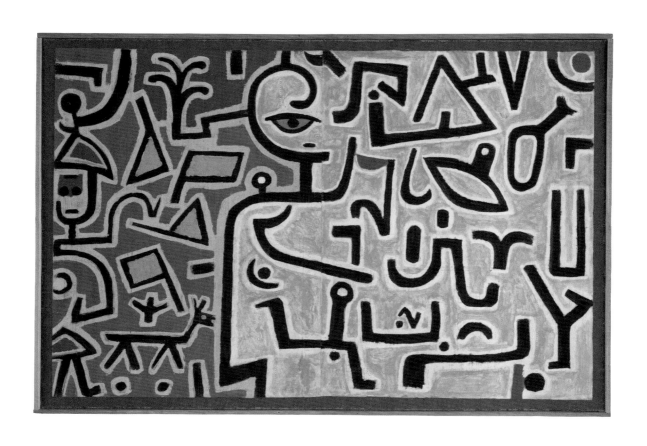

Paul Klee
Vorhaben, 1938, 126
Intention

LIVERPOOL JOHN MOORES UNIVERSITY
LEARNING SERVICES

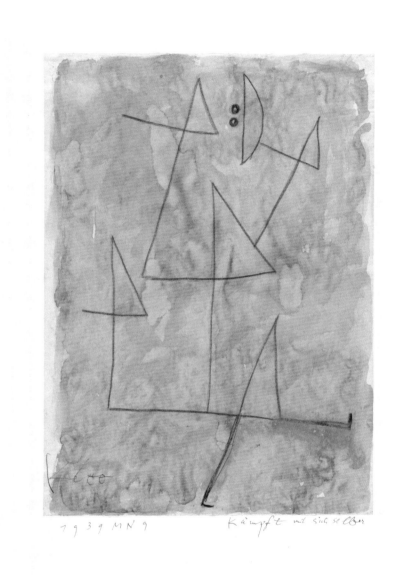

Paul Klee
Kämpft mit sich selber, 1939, 1189
Struggles with Himself

Paul Klee
Schema eines Kampfes, 1939, 1012
Diagram of a Fight

Paul Klee
gewagt wägend, 1930, 144
Daringly Balanced

Paul Klee
Schwankendes Gleichgewicht, 1922, 159
Unstable Equilibrium

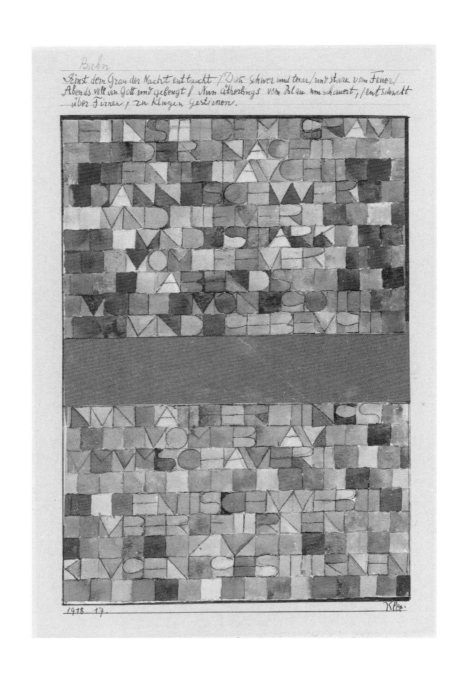

Paul Klee
Einst dem Grau der Nacht enttaucht ..., 1918, 17
Once Emerged from the Gray of Night ...

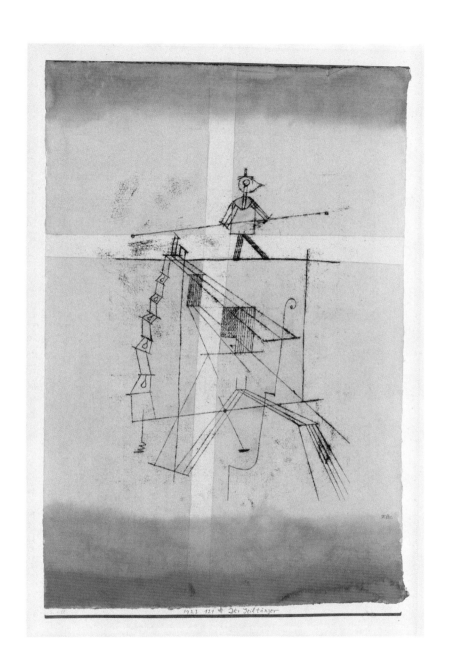

Paul Klee
Der Seiltänzer, 1923, 121
The Tightrope Walker

165

LIVERPOOL JOHN MOORES UNIVERSITY
LEARNING SERVICES

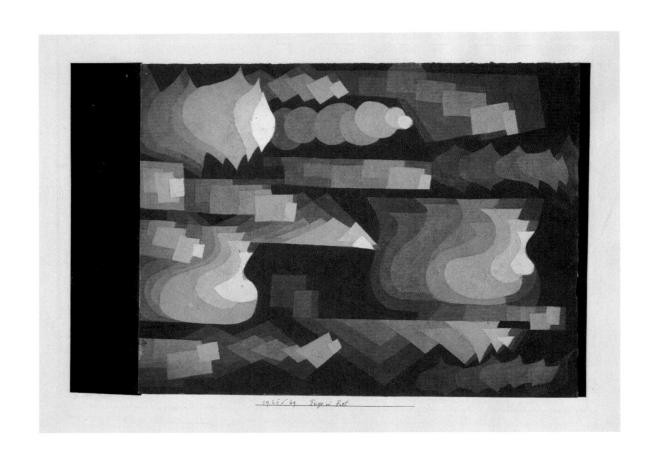

Paul Klee
Fuge in Rot, 1921, 69
Fugue in Red

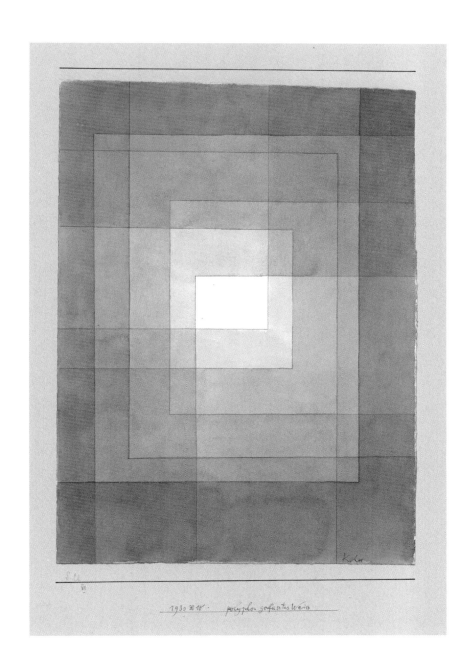

Paul Klee
polyphon gefasstes Weiss, 1930, 140
White Framed Polyphonically

Paul Klee
Alpha bet I, 1938, 187
Alphabet I

Paul Klee
Anfang eines Gedichtes, 1938, 189
Beginning of a Poem

Paul Klee
Schwebende Grazie (im pompeianischen Stil), 1901, 2
Hovering Grace (in the Pompeian Style)

Paul Klee
"Felsenlandschaft" (m/Palmen und Tannen), 1919, 155
"Rocky landscape" (With Palms and Fir Trees)

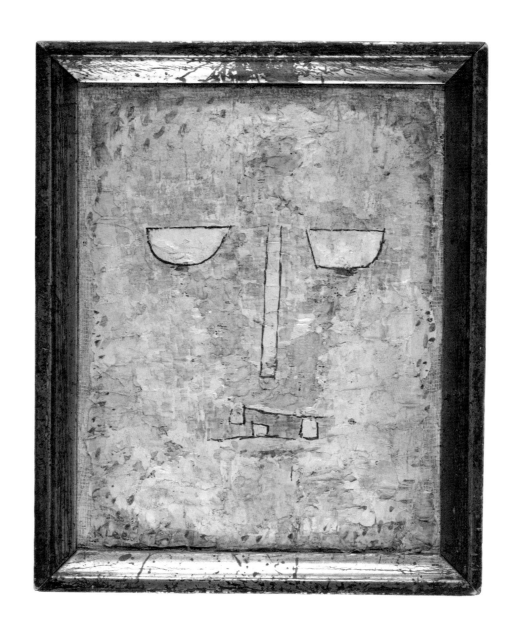

Paul Klee
Kopf eines Märtyrers, 1933, 280
Head of a Martyr

172

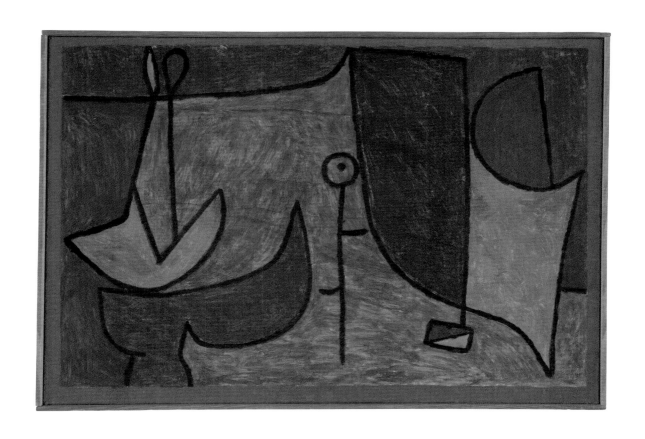

Paul Klee
Stilleben am Schalttag, 1940, 233
Still Life on Leap Day

173

LIVERPOOL JOHN MOORES UNIVERSITY
LEARNING SERVICES

"In the beginning was … the what? Things moved freely, so to speak, in directions neither crooked nor straight. They should be conceived of as having been in ur-movement, going where they went, going in order to go, aimless, without will, obeying nothing, their movement, as a matter of course, an immovable 'condition.' This is, at first, only a principle: the thing moving itself, that is, not a law of motion, not a particular will, nothing special, nothing ordained. Chaos and anarchy, a cloudy churning. Something intangible, nothing heavy, nothing light (heavy-light), nothing white, nothing black, nothing red, nothing yellow, nothing blue, only a sort of gray. Nor any precise gray, nothing precise at all, only the undefined, the vague. No here, no there, only an everywhere. No long-short, only an everywhere. No far-near, no today, yesterday, tomorrow, only a tomorrow-yesterday. No doing, just a being. No pronounced quiet, no pronounced movement, only a 'turning into shadow.' Only a something: mobility as the precondition to changing this original condition."

Paul Klee, Unendliche Naturgeschichte (Infinite Natural History), introduction to the chapter "stil, ur-stil" (style, ur-style), Pädagogischer Nachlass (Pedagogical Estate), PN17a M20/10, Zentrum Paul Klee, Bern

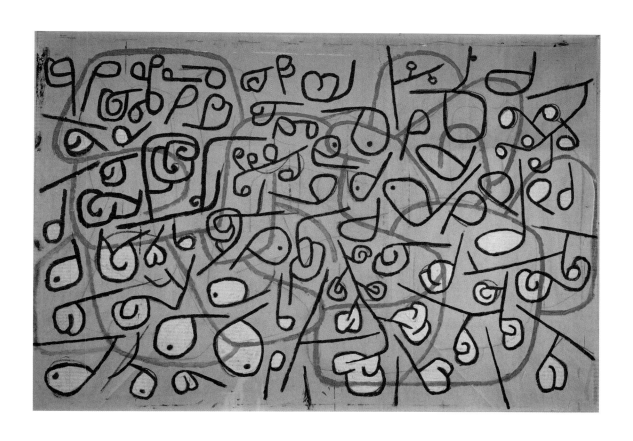

Paul Klee
Ohne Titel (Komposition mit den Früchten), um 1940
Untitled (Composition with Fruits)
The picture contains the handwritten words,
"Should everything be known? I don't think so!"

Paul Klee: Biography

Dr. Michael Baumgartner, Deputy Art Director and Curator of Collection, Exhibits, and Research, Zentrum Paul Klee, Bern

1879

Paul Klee is born in Münchenbuchsee near Bern on December 18, the second child of Hans Klee (1849–1940) and Ida Klee (1855–1921), née Frick. His sister Mathilde (died 1953) was born three years earlier. His father is a music teacher at the Staatliches Lehrerseminar (State Teachers' College) in Hofwil, near Bern, his mother a trained singer.

1880

The family moves to Bern. The boy receives his first lessons in drawing and coloring from his grandmother, Anna Catharina Rosina Frick, née Riedtmann.

1886–97

Paul Klee (right) with his sister Mathilde and their uncle Ernst Frick, Bern 1886

Klee attends primary school in Bern. He obtains his secondary education in the humanities program at the schoolhouse of what was later the Progymnasium on Waisenhausplatz. He fills his schoolbooks and notebooks with caricatures, copies images from magazines and calendars, and draws objects from nature. For Klee, the final years of school are a trial: "I would have liked to run away before my eleventh-grade exams, but my parents stopped me." The newspaper *Die Wanze* (The Bug), which he and two friends produced for the last year of middle school, causes a scandal at the school. The resolve to become an artist is growing in Klee even during his school years. He spends a long time wondering whether to become a musician or a painter.

1898

Klee starts keeping a diary; the first entry is dated April 24. He completes his secondary education at the Städtische Literarschule in September. Just one month later, on October 13, he moves into an apartment in Munich, where he attends the private drawing school run by Heinrich Knirr. From the autumn of 1900, he also studies under Franz von Stuck at the Academy.

1899

Klee meets the pianist Lily Stumpf (1876–1946) at a musical soirée.

1901

He leaves von Stuck's painting class. On October 22, Klee and the Bern sculptor Hermann Haller leave for a six-month period of study in Italy. Klee travels to Rome via Genoa and Livorno, and rents a room in the capital.
The overwhelming richness of Rome's classical art plunges Klee into an artistic crisis.

1902

Klee becomes engaged to Lily Stumpf. He lives with his parents in Bern for the next four years, unable to secure an independent living from his art. His primary sources of income at this time are engagements as a violinist at the Bernische Musikgesellschaft (Bern Music Society). Klee regards this period at his parents' home as an opportunity to find himself and to mature.

Paul Klee, Bern, 1896

Hermann Haller and Paul Klee on a bridge over the Tiber in Rome, February 1902

1905

Klee travels to Paris for two weeks with Hans Bloesch and Louis Moilliet, friends he has known since the days of his youth in Bern.

The Klee family in their garden at Obstbergweg 6, Bern, September 1906: Klee's sister Mathilde, wife Lily Klee-Stumpf, Paul Klee (top row, left to right), Klee's father, Hans Klee, and his mother, Ida Klee (bottom row)

1906

Klee spends two weeks in Berlin during April. On September 15, he marries Lily Stumpf in Bern. Two weeks later, the couple move to Munich.

1907

Felix Paul Klee is born on November 30, the son and only child of Paul and Lily Klee.

1909

Felix becomes grievously ill in the spring; Paul Klee takes on the task of caring for the child. The family spends the summer holidays this year, as in the following years until 1915, in Bern and the surrounding area, particularly on Lake Thun. In November, Klee has the idea of illustrating Voltaire's *Candide*. The drawings are not executed, however, until 1911.

1910

Klee has his first solo exhibition in July. Comprising fifty-six works, the exhibition starts at the Kunstmuseum Bern and moves on to the Kunsthaus in Zürich, the Kunsthandlung zum Hohen Haus in Winterthur, and the Kunsthalle in Basel.

1911

In February, Klee begins to compile a handwritten catalogue of his works. From this point until just before his death, he keeps a painstaking record of his artistic production.
In autumn, Louis Moilliet arranges for Klee to meet his fellow artist Wassily Kandinsky. Klee becomes familiar with the aims of Der Blaue Reiter (The Blue Rider).
In the Swiss monthly *Die Alpen*, edited by his old friend Hans Bloesch, Klee publishes reviews of exhibitions and cultural events in Munich.

1912

Franz Marc and Wassily Kandinsky invite Klee to take part in the second Blaue Reiter exhibition at Hans Goltz's bookshop in Munich. Seventeen of his works go on show.
In April, he travels to Paris for a second time and visits the artists Robert Delaunay, Henri Le Fauconnier, and Karl Hofer in their studios.

1914

Klee travels to Tunisia at Easter with his artist friends August Macke and Louis Moilliet. The trip takes him via Marseille to Tunis, St. Germain, Hammamet, and

Kairouan. After his return, Klee holds a joint exhibition with Marc Chagall in Herwarth
Walden's Galerie Der Sturm in Berlin; in October he presents his latest watercolors,
painted in Tunisia, within the framework of the Neue Münchner Sezession artists'
movement, of which he is a founding member. The assassination of the heir to the
throne of the Austro-Hungarian empire in Sarajevo on June 28 leads to the outbreak
of World War I. On September 26, 1914, Macke is killed in action near Perthe-les-
Hurlus in Champagne.

1915

Klee has a chance meeting with the poet Rainer Maria Rilke in Munich. He spends
the summer in Bern; on his return journey to Munich, he goes to Goldach on Lake
Constance to visit Kandinsky, who, as a Russian national, has had to leave Germany
following the outbreak of war.

1916

On March 4, Klee's friend Marc is killed at the front near Verdun. Klee is deeply
grieved. On March 11, he is himself drafted into the German army as a soldier. He is
first sent to the recruiting depot in Landshut. On July 20, he is attached to the second
reserve infantry in Munich, then transferred in August to the maintenance company
of the air corps in Schleissheim. From there he accompanies planes that are transported
on the ground to Cologne, Brussels, and Nordholz in northern Germany.

Paul Klee with his fellow soldiers during World War I, Landshut 1916

1917

In January Klee is transferred to the Royal Bavarian Flying School V in Gersthofen where he is a clerk in the finance department. His joint exhibition with Georg Muche at the gallery Der Sturm in February is a commercial success.

1918

Klee is sent on leave until his demobilization in February 1919. He stops keeping a diary and never goes back to it. But in the years to follow, Klee does rework and edit his diaries, turning them into his autobiography.

1919

After being released from military service, Klee rents a studio in the Suresnes Schlösschen in Werneckstrasse in Munich. During the postwar Bavarian Soviet Republic he becomes a member of the Munich Council of Fine Artists and of the Activist Committee of Revolutionary Artists. Oskar Schlemmer and Willi Baumeister try unsuccessfully to have Klee admitted to the Stuttgart Academy. On October 1, Klee signs a sole agency contract with Hans Goltz, owner of the Galerie Neue Kunst–Hans Goltz in Munich.

1920

From May to June, Hans Goltz puts on the biggest Klee exhibition to date in his gallery, a retrospective with 362 works. On October 29, Walter Gropius calls Klee to the Staatliches Bauhaus in Weimar. Klee's first fundamental essay on the theory of art appears in Kasimir Edschmid's anthology *Schöpferische Konfession*. Leopold Zahn and Hans von Wedderkop publish the first monographs on Klee.

1921

In March, Wilhelm Hausenstein's monograph *Kairuan oder eine Geschichte vom Maler Klee und von der Kunst dieses Zeitalters* is published—the most important book up to that point on Klee as an artist. On May 13, Klee commences his academic teaching career at the Bauhaus with a course in "practical composition." As master of form, he is head of the workshop for book binding.

1922

Klee takes over the artistic direction of the gold-silver-copper smithy from Johannes Itten, then in the autumn exchanges it with Oskar Schlemmer for the latter's workshop for glass painting.

1923

Klee's essay "Wege des Naturstudiums" (Ways of Nature Study) appears in the publication on the events in the Bauhaus week.

1924

The first Klee exhibition in the United States takes place from January 7 to February 7, organized by Katherine S. Dreier of the Société Anonyme, New York. The artists' group Die Blaue Vier (The Blue Four) is founded on March 31 on the initiative of Emmy "Galka" Scheyer. The Blaue Vier's works are exhibited primarily in the United States. Along with Klee, the group is made up of Lyonel Feininger, Wassily Kandinsky, and Alexei Jawlensky. In September and October, Klee and his wife spend time in Italy, particularly in Sicily. On December 26, the leading members of the Bauhaus submit to enormous political pressure and declare the school in Weimar closed from April 1925.

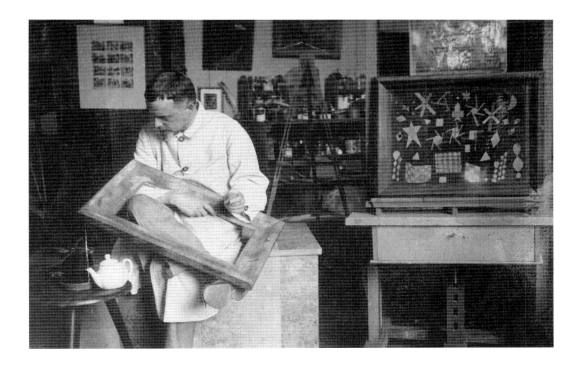

Paul Klee in his studio at the Bauhaus Weimar, 1924

1925

In March the municipal council of Dessau decides to invite the Bauhaus to move to the town. Klee's *Pädagogisches Skizzenbuch* (*Pedagogical Sketch Book*) appears in October as the second volume of a series of Bauhaus books published by Walter Gropius and László Moholy-Nagy. Klee cancels his agency contract with Hans Goltz and consequently increases his business contacts with Alfred Flechtheim, the owner of two galleries of the same name in Berlin and Düsseldorf. Klee's first exhibition in France runs from October 21 to November 11 in the Paris Vavin-Raspail gallery.

In November, some of his pictures are shown at the first Surrealist exhibition at the Galerie Pierre in Paris.

1926

Klee and his family move to Dessau on July 10. There they live with Wassily and Nina Kandinsky in one of the three duplexes built by Gropius for Bauhaus masters.

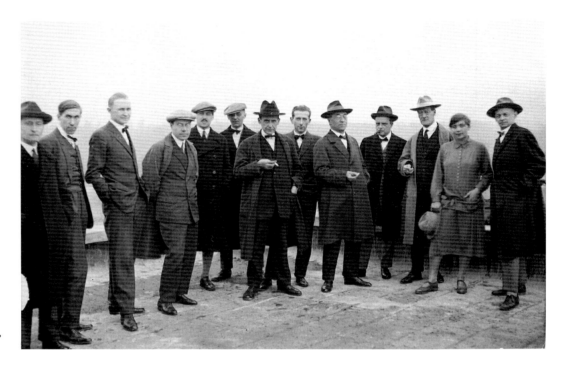

Bauhaus masters on the roof of the Prellerhaus, Bauhaus Dessau, 1926: Josef Albers, Hinnerk Scheper, Georg Muche, László Moholy-Nagy, Herbert Bayer, Joost Schmidt, Walter Gropius, Marcel Breuer, Wassily Kandinsky, Paul Klee, Lyonel Feininger, Gunta Stölzl, Oskar Schlemmer (left to right)

1927

Starting in April, Klee teaches the Bauhaus's Free Workshop Painting, also known as the Free Painting Class. From October, he teaches design for weavers. In the late summer, he travels to Porquerolles and Corsica.

1928

Klee publishes the essay "exakte versuche im bereich der kunst" (Precise Experiments in the Field of Art) in the *Bauhaus* journal in February. Hannes Meyer becomes the new Bauhaus director. On December 17, Klee begins a four-week trip to Egypt, paid for by the Klee-Gesellschaft (Klee Society), a group of collectors founded by Braunschweig collector Otto Ralfs in 1925 with the aim of supporting Paul Klee.

1929

Klee and his wife spend their summer holidays in France and Spain. Klee begins negotiating with the Staatliche Kunstakademie Düsseldorf on the prospect of obtaining a professorship. He is at the pinnacle of his success and is regarded as one of Germany's most internationally respected artists. The Museum of Modern Art in New York, the Nationalgalerie, and the Galerie Alfred Flechtheim in Berlin organize major exhibitions for Klee's fiftieth birthday.

1931

Klee takes up his professorship at the Düsseldorf Academy on July 1. He rents a room in Düsseldorf, but keeps his apartment in Dessau until April 1933. He and Lily go to Sicily in the summer.

1932

Following an application by the National Socialists, the Dessau council votes to close down the Bauhaus.

1933

The National Socialists take power across Germany in January. In mid-March, Klee's apartment in Dessau is searched. On April 21, Klee is suspended from his position as a professor at the Düsseldorf Academy; under the law for the restoration of the professional civil service, Klee is officially dismissed as of January 1, 1934. On October 24, he signs a sole agency contract with Daniel-Henry Kahnweiler, the owner of the Paris Galerie Simon. On December 24, Klee emigrates to Switzerland—as his wife did two days before—initially living in his parental home in Bern.

1934

In January, Paul and Lily Klee move into a small apartment at Kollerweg 6, moving again on June 1 to a three-room apartment at Kistlerweg 6. The monograph *Paul Klee: Handzeichnungen 1921–1930* by Will Grohmann appears in November. Its publisher is in Potsdam; the company is seized by the National Socialists in April the following year.

1935

In August Klee contracts bronchitis, which develops into pneumonia. In November he falls ill again; the illness is diagnosed as measles. Klee is largely confined to his bed.

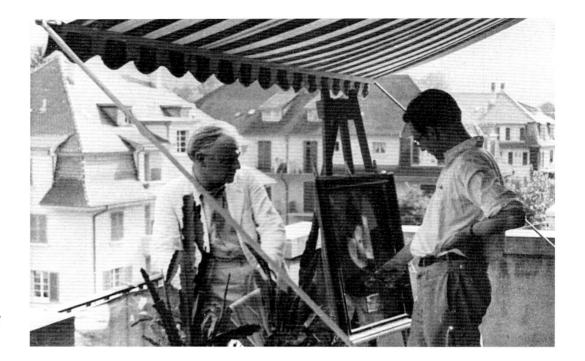

Paul and Felix Klee on the balcony of the apartment at Kistlerweg 6 in Bern, 1934

1936

Continuing poor health means that Klee is forced to stop work for about half a year, and even after that he is unable to get much done. His output for the year is just twenty-five works—an all-time low.

1937

Klee's health stabilizes, and he is once more able to work more intensely. On July 19, the exhibition *Entartete Kunst* (Degenerate Art) opens in Munich. In slightly reduced form, it runs until 1941 as a traveling exhibition and is shown in twelve other German and "Austrian" cities. It contains seventeen of Klee's works. The National Socialists seize 102 of Klee's works from public collections and sell most of them abroad. Pablo Picasso visits Klee on November 27. In 1937, Klee produces 264 works—nearly as many as in the years before his illness.

1938

From this year on, gallery owner J. B. Neumann and two art dealers who have emigrated from Germany, Karl Nierendorf and Curt Valentin, organize regular Klee exhibitions in New York and other cities in the United States.

Paul Klee in his studio at
Kistlerweg 6 in Bern, July 1939

1939

In April Georges Braque twice visits Klee in Bern. On April 24, Klee applies for Swiss citizenship. With 1,253 registered works—most of them drawings—1939 is Klee's most productive year ever.

1940

Klee's father Hans dies on January 12. In May, Klee goes to the southern Swiss canton of Tessin for a period of convalescence. His state of health deteriorates suddenly in June. He dies on June 29 in the Clinica Sant'Agnese in Locarno-Muralto, just days before he would have received Swiss citizenship.

LIVERPOOL JOHN MOORES UNIVERSITY
LEARNING SERVICES

Paul and Lily Klee (1933–40) and the Administration of the Paul Klee Estate (1940–46)

Stefan Frey, Klee Estate Administration, Bern

The "Entartete Kunst" exhibition, Munich, July 19 to November 11, 1937; Room 3 on the second floor with the "Dada Wall": Paul Klee's painting Sumpflegende, 1919, 163, hangs below two works by Kurt Schwitters.

Paul and Lily Klee's Emigration from Düsseldorf to Bern

Immediately after Hitler seized power on January 30, 1933, Nazi functionaries stepped up their attacks on Paul Klee. In virulent articles they abused him as a "typical Galician Jew."[1] "Exhibitions of shame" were held—precursors of the touring exhibition *Entartete Kunst* (Degenerate Art) from 1937 to 1941 (fig.)—and Klee's pictures denounced as "Bolshevik trash."[2] Led by a police officer, storm troopers searched Paul and Lily Klee's house in Dessau in their absence on March 17, 1933, and confiscated three laundry baskets full of files, including evidence of a secret bank account in Switzerland. Since Paul Klee feared arrest on charges of currency offenses, he fled the country and stayed in Switzerland from March 19 to April 2. Thanks to the intervention of his friend, the Bern businessman Rolf Bürgi (fig.), son of Hanni Bürgi-Bigler (fig.), the first and leading Klee collector in Switzerland, Klee received the files back without further investigation. He was one of the first artists to be barred from teaching in Germany, suspended from his chair at the Staatliche Kunstakademie in Düsseldorf "with immediate effect" on April 21, 1933 (fig.). In late October 1933 he received official notice that his position would terminate on January 1, 1934. Alfred

Telegram from the acting director of the Kunstakademie Düsseldorf to Paul Klee, Düsseldorf, April 21, 1933

Flechtheim, Klee's main art dealer since 1927, was forced by Nazi culture functionaries to cease business activities at his Düsseldorf branch gallery by the end of March 1933 and in his main gallery in Berlin by October 30, 1933. Klee was thus deprived of all means of earning his living in Nazi Germany and forced "to completely reorient himself economically."[3]

By early October Paul Klee and his wife had decided to leave Düsseldorf and emigrate to Bern. This step required careful preparations. In the spring of the same year Rolf Bürgi had bought a large house with several apartments in Bern on Klee's account. On October 24, Paul Klee concluded a sole agency contract with Daniel-Henry Kahnweiler, the owner of the Galerie Simon in Paris. In early November Bürgi applied to the Aliens Department in Bern for a residence permit for Paul and Lily Klee. On December 18—Paul Klee's birthday—Bürgi sent word to the Klees in Düsseldorf that a residence permit had been assured. Lily Klee arrived in Bern just two days later, Paul Klee on December 24. Their only son Felix (fig. p. 189) and his wife Ephrosina stayed on in Germany, where they had become established professionally, he as a theater director and she as a singer. Paul and Lily Klee chose Bern as their new home because they had a number of friends there. At first they lived with Paul Klee's father, Hans Klee, and his sister Mathilde at Obstbergweg 6 (fig. p. 188), before moving to a furnished two-room apartment at Kollerweg 6. When their household goods and works of art arrived from Düsseldorf on June 1, 1934, they finally moved into a three-family house at Kistlerweg 6 in the Bern suburb of Elfenau, taking a three-room apartment (fig. p. 188) with a modest studio for Klee. They were to live in this apartment for the rest of their lives.

Paul Klee was a German citizen and wished to apply for Swiss citizenship as soon as possible. Receiving a better category of residence permit after five years of uninterrupted residence in Bern, Klee had the Bern lawyer and art collector Fritz Trüssel submit a naturalization application on his behalf on April 24, 1939. Explaining his reasons for moving to Switzerland to the security police and criminal investigation department in Bern on July 11, 1939, Klee said: "After the termination of my employment in Düsseldorf I decided to return to Switzerland, and since I had many good friends in Bern, it was only natural for me to remain here. Since I feel I am a Swiss and never broke off my ties here, I now quite naturally wish to formalize this relationship."[4] Although one of the police officers dealing with the application qualified Klee's art as a threat to Swiss culture and denied that the applicant, who had spent almost half his life in Bern, had any genuine ties with Switzerland, Bern's municipal government and the naturalization commission recommended to the city council to approve Paul Klee's application in their meeting on July 5, 1939. No doubt Klee would have

Rolf Bürgi, Bern, January 1927

Hanni Bürgi-Bigler, Bern, around 1930

187

LIVERPOOL JOHN MOORES UNIVERSITY
LEARNING SERVICES

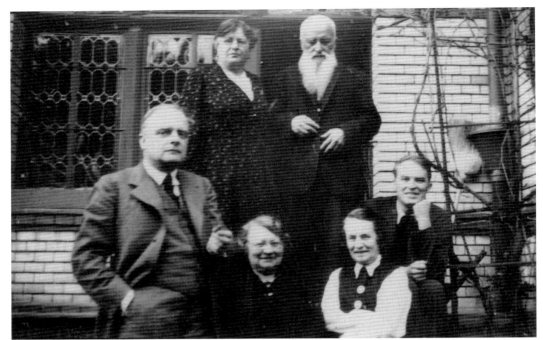

Mathilde and Hans Klee, Paul and Lily Klee, Gertrud and Will Grohmann (left to right, top to bottom), Obstbergweg 6, Bern, February/March 1935

Paul and Lily Klee's apartment in Kistlerweg 6, third floor, Bern, July/August 1937

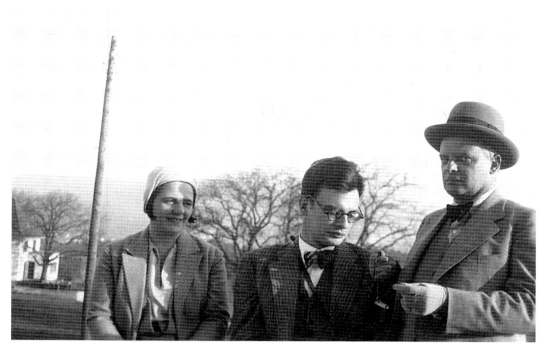

Ephrosina Grezhova, Felix and
Paul Klee, Basel, fall 1931

Paul Klee Memorial Exhibition,
Kunsthalle, Basel, February 15 to
March 23, 1941; on the wall:
Schwebendes, 1930, 220;
Polyphonie, 1932, 273;
Auftrieb und Weg, 1932, 190;
durch ein Fenster, 1932, 184;
Angst, 1934, 202;
Engel im Werden, 1934, 204
(from left to right)

Lily Klee, probably in Lucerne, summer 1946

Felix Klee, opera director, Ulm, 1935

Paul and Felix Klee with Hermann and Margrit Rupf-Wirz (left to right) in front of St. Ursus' Cathedral in Solothurn, 1937

been granted Swiss citizenship, had he not died at the Clinica Sant' Agnese health resort in Locarno-Muralto on June 29, 1940, just a few days before the decisive meeting. Born in Switzerland to a German father and a Swiss mother, Paul Klee died a German, and his wife Lily also remained a German citizen, though she applied for naturalization in the 1940s. This situation was to have widespread repercussions for Klee's artistic estate.

Lily Klee, Rolf Bürgi, and the Paul Klee Estate (1940–46)

After her husband's death, Lily Klee (fig.) managed the artistic estate in exclusive usufruct. Her only son, Felix (born in 1907 in Munich), remained in Germany in 1933. In 1926 he had begun his training as a theater director; in 1932, he married the Bulgarian singer Ephrosina Grezhova (fig. p. 189). A year later he received a five-year contract as a director and actor at the Stadttheater Ulm, from where he moved on to the theater in Wilhelmshaven. In 1940 Felix and Ephrosina's only child, Alexander—nicknamed Aljoscha—was born in Sofia. In a contract of inheritance (see CD-ROM) Felix Klee renounced "his claims to his father's estate … in favor of his mother." In return for the right to sell pictures from the estate, Lily Klee undertook to assist her son and his family with monthly payments if required—roughly of the same amount that she and Paul Klee had sent them for years—and released Felix from the obligation "to support her in the future in any way."

Lily Klee considered it her life's task to preserve her husband's artistic and literary estate for posterity and to ensure that his work be given the place it deserved in the history of art and culture. She worked toward this goal by aiding publications and organizing a number of large Klee exhibitions (see CD-ROM; fig. p. 189). "A small circle of friends, artistically-minded young people, stood by me, so I didn't have to face this responsibility all by myself,"[5] she emphasized in the summer of 1945. In addition to Rolf Bürgi and his wife Käthi (fig.), this circle of friends in Bern included several other couples—Hermann and Margrit Rupf-Wirz (fig.), Hans and Erika Meyer-Benteli (figs.), and Werner and Maya Allenbach-Meier (figs. p. 193). Hermann Rupf, a businessman and co-owner of a dry-goods store, was the most significant collector of Klee's works in the Swiss capital alongside Hanni Bürgi-Bigler—he made his first purchase in 1914. The publisher Hans Meyer-Benteli had met Paul and Lily Klee in January 1935 in Bern and since then regularly bought pictures of Klee's. The architect Werner Allenbach came into contact with Lily Klee after her husband's death and also became a Klee collector.

Lily Klee supported herself by the considered sale of works from the estate, through which she generated an annual income of between eight and eleven thousand Swiss

Käthi Bürgi-Lüthi with son Christoph
and husband Rolf, St. Moritz, 1953

francs. She sold pictures to museums in Bern (fig. p. 196), Basel (fig. p. 192, top), and Zürich (fig. p. 192, middle) and to private individuals, above all the four Bern collectors mentioned above—Allenbach, Bürgi, Meyer-Benteli, and Rupf. On inquiry she made works available for exhibition and sale in galleries in Switzerland. Over the years she also loaned significant works to the Kunstmuseum Basel and the Kunstmuseum Bern (figs. pp. 197, 199, 228–29, 232–33).

In 1940 the estate is estimated to have comprised six thousand works. Some of these were unsold works—particularly the art of Klee's youth and student years (fig. p. 198) and from 1933 to 1940 (figs. pp. 199–200)—others belonged to a collection of works that Paul Klee kept for himself. It must have been in 1919 or 1920 that Klee decided to withhold certain works from sale and assemble an "estate collection" of his own, including selected panel paintings, polychrome sheets (watercolors, gouaches, mixed media works, etc.), and his monochrome sheets (drawings). On the reverse of the oil painting *Komposition mit Fenstern* (*Composition with Windows*), 1919, 156, he noted "Not to be sold; for the estate collection" (figs. pp. 192, 205). In a retrospective letter from January 1934 he wrote to the Paris art dealer Daniel-Henry Kahnweiler: "Since 1920 I have not sold any drawings, I own them all myself, and only ever part with one when I give it as a special present and mark of favor."[6] As of 1925, if not earlier, he identified the polychrome sheets of his personal collection with the word "Sonderklasse" (special class) on the cardboard base, also abbreviated to "S. Kl." and "S. Cl." (figs. pp. 201–3).

Rolf Bürgi was a friend and adviser to Lily Klee, assisting and supporting her in many of her business matters; in the fall of 1941 Lily gave him an official mandate to this effect. This was complying with a wish of Paul Klee, who had confided his worries regarding his wife and his artistic estate to Bürgi in 1938. Bürgi writes: "He [Paul Klee] was particularly concerned with how to retain at least his most important unsold

Hans Meyer-Benteli, 1940s

Erika Meyer-Benteli, 1940s

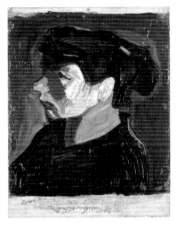

Paul Klee
blaue Nacht, 1937, 208
Blue Night

Paul Klee
Ueberschach, 1937, 141
Super-chess

Reverse of the work Komposition
mit Fenstern, 1919, 156, with
a note in Klee's own hand: "Not for
sale; for the estate collection"

works as an integral collection. He wanted me to help his wife in all financial matters, look after the artistic estate, and more specifically, handle relations with the art dealers."[7] At the end of 1940 he was already negotiating "as the sole representative of Mrs. Paul Klee"[8] with another museum, the Kunsthalle Bern, about holding the *Gedächtnisausstellung Paul Klee* (Paul Klee Memorial Exhibition). In October 1941 Rolf Bürgi and Lily Klee formalized their business relationship in a new agreement with unlimited duration.[9] It entitled Rolf Bürgi, in agreement with Lily Klee, to conduct negotiations on the sale, endowment, donation, and loaning of works from Paul Klee's estate and administer the reproduction rights to the works. Bürgi had the right of disposal of the entire literary estate, albeit again in agreement with Lily Klee. As an expense allowance he received a 5 percent share "of all returns from the work."

In April 1941 Rolf Bürgi negotiated an agreement between Lily Klee and Messrs. Werner Allenbach and Hans Meyer-Benteli concerning the preparation of a book about the diaries, letters, and other writings in Paul Klee's estate; the 1924 Jena lecture *Über die Moderne Kunst* (*On Modern Art*) was the only piece to be published by Benteli in Bern in 1945. In 1946 Lily Klee awarded the rights to publish Paul Klee's didactic writings in two volumes, edited by Jürg Spiller, to Benno Schwabe & Co., Basel.

When the end of the war at last made foreign travel possible again, Rolf Bürgi negotiated directly with Daniel-Henry Kahnweiler in Paris and Karl Nierendorf in New York in March and April 1946 (fig.). The aim was to reorganize the sale of works from the Paul Klee Estate with these major pre-war art dealers; Nierendorf had taken over as Klee's sole agent in North America in 1938. Acting as "general agent of the heirs of Professor Paul Klee,"[10] Bürgi concluded a new contract with Karl Nierendorf for this purpose. It guaranteed the Nierendorf Gallery full rights as sole representative for both North and South America, and Nierendorf undertook to buy works from the Paul Klee Estate to the net value of at least 24,000 Swiss francs annually.

Lily Klee's Will

In October 1945 Lily Klee still had no word of her son, and concern for the future of her late husband's works moved her to draft her will (see CD-ROM). In the will she provided for Paul Klee's artistic estate to be looked after by a commission comprising her son Felix, Werner Allenbach, Rolf Bürgi, Hans Meyer-Benteli, Hermann Rupf, and the Zürich art historian Carola Giedion-Welcker. She stipulated in particular that after her death "all functions concerning my husband's artistic estate, such as sales and the fixing of sale prices, exhibitions, loans, negotiations regarding publications, etc., [should pass] to this commission." Lily Klee made a point of ascertaining that the

chosen Swiss members agreed to be on the commission on a voluntary basis, but she never elaborated her "special wishes and provisions regarding the artistic estate" of her husband or an "arrangement concerning rights and obligations" of the commission, as she had intended.

Although there are many gaps in Lily Klee's testamentary dispositions, it can be assumed that she set down her will very much with the implementation of her husband's wishes in mind. In the last years of his life Paul Klee repeatedly mentioned in conversations with friends that he "wanted to bequeath an estate, that was not for sale, to a Swiss museum. He was unable to decide between Basel and Bern, and waited for the decision from Bern regarding his citizenship application,"[11] as Hermann Rupf emphasized in his address at the opening of the first exhibition of the Paul-Klee-Stiftung (Paul Klee Foundation) in the Kunstmuseum Bern (see CD-ROM). Since Paul Klee did not leave a will, when he died it was not clear whether he wanted to bequeath part of his artistic estate to a Swiss museum as a gift, donation, or deposit.

It was doubtful, however, whether Lily Klee's last will could ever be translated into action, because all German assets in Switzerland were frozen in the spring of 1945 in accordance with a decision of the Swiss Federal Council. In August 1945 Lily Klee complied with the request to declare all her assets in Switzerland to the Swiss clearing office in Zürich. Since Switzerland acceded to the Allies' Washington Agreement (see CD-ROM) on June 27, 1946, there was now the very real danger that, when Lily Klee died, her husband's artistic estate would be confiscated, sold, and dispersed throughout the world because Lily's heirs lived in Germany. The Washington Agreement ordered the liquidation of assets in Switzerland that belonged to Germans resident in Germany. The revenue was intended as a form of reparation to the Allies.

After all German theaters were closed on September 1, 1944, in preparation for "total war," Felix Klee had been conscripted into a heavy artillery unit despite his impaired vision and sent to the Eastern Front in Poland in early 1945. At the end of the war he was taken prisoner by the Soviets in Czechoslovakia and for a long time was listed as missing. In 1946 he was discharged from a Soviet prisoner-of-war camp and just before mid-September arrived in Sommerhausen am Main, where his wife and their six-year-old son had been evacuated from Würzburg (fig. p. 194).

Rolf Bürgi informed Lily Klee of the possible consequences of the Washington Agreement. The fate of Ernst Ludwig Kirchner's estate in Switzerland was a warning: after the death of Erna Kirchner, the Swiss clearing office took over the management of the Kirchner estate; only the intervention of the curator of the Kunstmuseum Basel, Georg Schmidt, prevented an overhasty sale of the whole estate. Hearing this, Lily Klee begged Bürgi to "do all he possibly could to realize her wishes regarding Paul Klee's

Maya Allenbach-Meier, around 1955

Werner Allenbach, around 1960

Karl Nierendorf, presumably New York, 1930s or 1940s

193

LIVERPOOL JOHN MOORES UNIVERSITY
LEARNING SERVICES

Ephrosina Grezhova Klee with son
Alexander, Sommerhausen,
July 28, 1946

estate."[12] On September 11, 1946, she concluded a new five-year contract specifying her business relationship with Rolf Bürgi, which replaced the agreement of October 28, 1941. Lily Klee made Bürgi the "sole agent of the work of Professor Paul Klee for the entire world, with the exception of Switzerland"[13] and thus also granted him the right to conclude contracts with art dealers and publishers. To this end Bürgi was to establish a permanent office in Bern. As an expense allowance he claimed 15 percent of the net returns, which was less than half the usual art dealer's margin. Lily Klee had been in poor health for months before concluding the contract. The "never-ending agitation, worry, and grief due to my son being unaccounted for," she said, afflicted her to such an extent that in May and June 1946 she "had to get medical treatment."[14] On September 16 she suffered a stroke and passed away, without regaining consciousness, on September 22, 1946.

Notes

This chapter is a compilation of revised extracts from two extensively annotated articles by Stefan Frey, "Chronologische Biographie (1933–41)," in *Paul Klee: Das Schaffen im Todesjahr*, exh. cat. Kunstmuseum Bern (Stuttgart, 1990), pp. 111–32, and "Rolf Bürgis Engagement für Paul und Lily Klee sowie die Gründung der Paul-Klee-Stiftung," in *Paul Klee: Die Sammlung Bürgi*, exh. cat. Kunstmuseum Bern and Hamburger Kunsthalle (Wabern-Bern, 2000), pp. 199–217.

1. Hendrik, "Abgetakeltes Mäzenatentum: Wie Flechtheim und Kaesbach deutsche Kunst machten," *Volksparole*, January 4, 1933, quoted in Otto Karl Werckmeister, "Von der Revolution zum Exil," in *Paul Klee: Leben und Werk*, exh. cat. Kunstmuseum Bern (Stuttgart and Teufen, 1987), p. 40.
2. Christoph Zuschlag, *"Entartete Kunst": Ausstellungsstrategien im Nazi-Deutschland*, Heidelberger kunstgeschichtliche Abhandlungen, n.s., 21, ed. Kunsthistorisches Institut der Universität Heidelberg (Worms, 1995), p. 59.
3. Paul Klee to Rudolf Probst, November 6, 1933, published in extracts in Stefan Frey and Wolfgang Kersten, "Paul Klees geschäftliche Verbindung zur Galerie Alfred Flechtheim," in *Alfred Flechtheim: Sammler, Kunsthändler, Verleger*, exh. cat. Kunstmuseum Düsseldorf and Westfälisches Landesmuseum für Kunst und Kulturgeschichte (Münster and Düsseldorf, 1987), p. 86.
4. Quoted in Jakob O. Kehrli, "Weshalb Paul Klees Wunsch, als Schweizer Bürger zu sterben, nicht erfüllt werden konnte," *Der Bund*, January 5, 1962.
5. Lily Klee, "Lebenslauf" (typescript, Bern and Vitznau, August 4, 1945), p. 3, Archiv Bürgi, Bern.
6. Quoted in Jürgen Glaesemer, *Paul Klee: Handzeichnungen II, 1921–1936*, Sammlungskataloge des Berner Kunstmuseums: Paul Klee, vol. 3 (Bern, 1984), p. 160, note 15.
7. Rolf Bürgi, "Nachlass Klee: Meine Ausführungen zur Vernehmlassung der Schweizerischen Verrechnungsstelle vom 19. Oktober 1951" (typescript, Bern, November 28, 1951), p. 9, Archiv Bürgi, Bern.
8. Rolf Bürgi to Max Huggler, November 18, 1940 (carbon copy), Archiv Bürgi, Bern.
9. Published in full in *Paul Klee: Die Sammlung Bürgi*, exh. cat. Kunstmuseum Bern and Hamburger Kunsthalle (Wabern-Bern, 2000), p. 254.
10. Contract between Karl Nierendorf and Rolf Bürgi, dated July 17, 1946, Archiv Bürgi, Bern.
11. "Ansprache des Herrn Hermann Rupf anlässlich der Eröffnung der Ausstellung *Paul Klee* im Kunstmuseum Bern, 11.8.1956"(typescript), Kunstmuseum Bern.
12. Bürgi 1951 (see note 7), p. 24.
13. Published in full in Bern and Hamburg 2000 (see note 9), p. 256.
14. Lily Klee to Othmar Huber, July 21, 1946 (fragment), Archiv Bürgi, Bern.

LIVERPOOL JOHN MOORES UNIVERSITY
LEARNING SERVICES

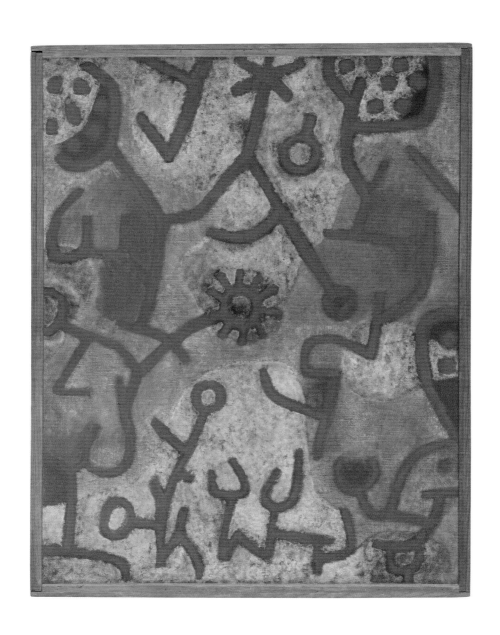

Paul Klee
Flora am Felsen, 1940, 343
Flora on the Rocks

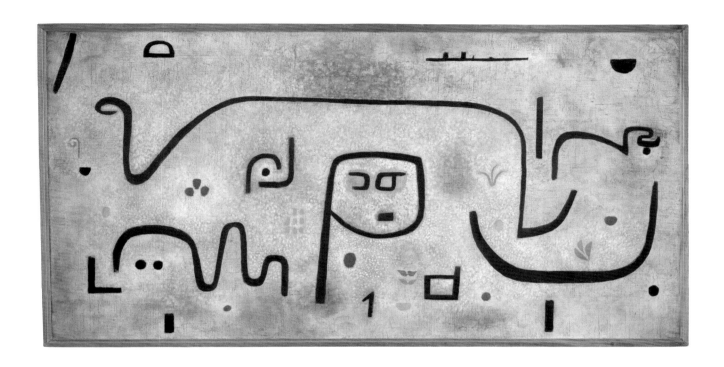

Paul Klee
Insula dulcamara, 1938, 481

Paul Klee
Selbst, 1899, 1
Myself

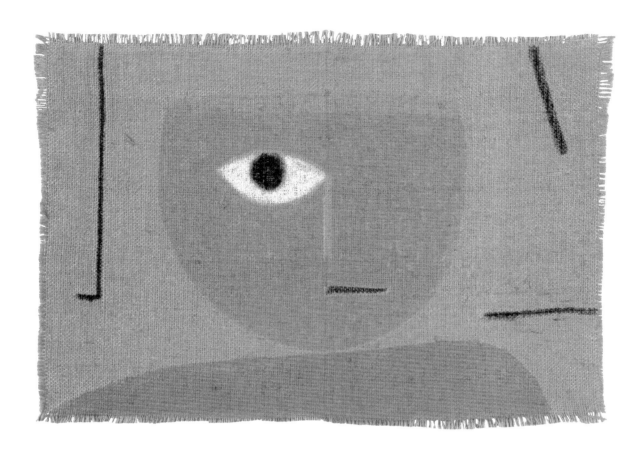

Paul Klee
das Auge, 1938, 315
The Eye

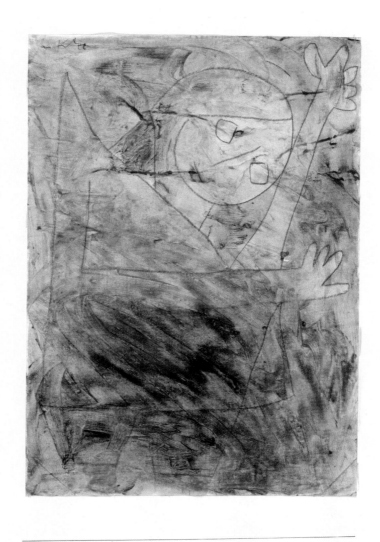

Paul Klee
Engel, noch tastend, 1939, 1193
Angel, Still Groping

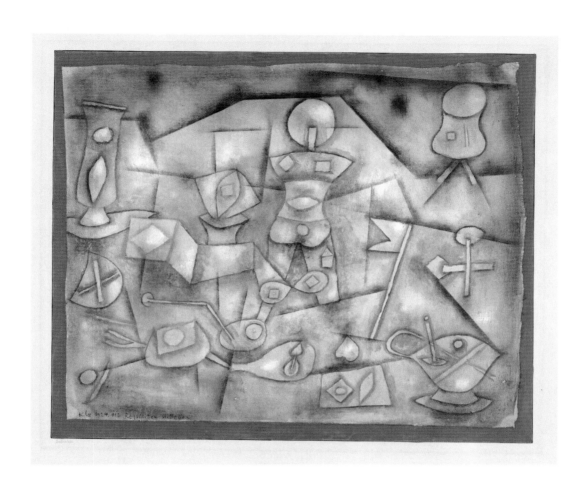

Paul Klee
Requisiten Stilleben, 1924, 112
Still Life with Props

201

LIVERPOOL JOHN MOORES UNIVERSITY
LEARNING SERVICES

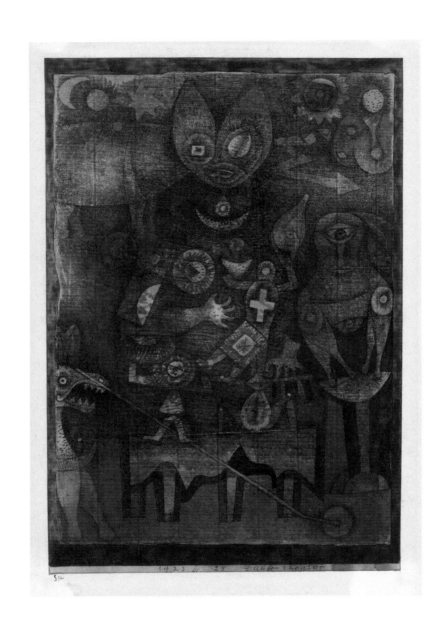

Paul Klee
Zaubertheater, 1923, 25
Magic Theater

Paul Klee
Lumpen gespenst, 1933, 465
Ragged Ghost

Paul Klee
Tiergarten, 1918, 42
Zoological Garden

Paul Klee
Komposition mit Fenstern, 1919, 156
Composition with Windows

LIVERPOOL JOHN MOORES UNIVERSITY
LEARNING SERVICES

The Establishment and Activities of the Klee-Gesellschaft and the Paul-Klee-Stiftung (1946/47)

Stefan Frey, Klee Estate Administration, Bern

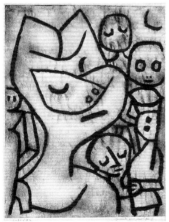

Paul Klee
Schlosser, 1940, 274
Locksmith

Paul Klee
Gebärde eines Antlitzes I, 1939, 1176
Expression of a Face I

"To set up a monument to the great Bern artist and his work"

In view of the very real danger that the Paul Klee Estate with around six thousand works could be dispersed under the Washington Agreement when his widow Lily Klee died, Rolf Bürgi offered it for sale to Karl Nierendorf. In the contract drawn up on September 16, the very day Lily Klee suffered a stroke, the two men agreed to the sale for $90,000 (around 360,000 Swiss francs) to the Paul Klee Society managed by Nierendorf in New York. Since Bürgi hoped to find a Swiss buyer instead of the New York art dealer, however, he delayed signing the contract. At a meeting in Zürich-Oerlikon on September 18, he offered the pictures from the Paul Klee Estate to a personal acquaintance, the industrialist and art collector Emil Georg Bührle, for the price of 350,000 Swiss francs. The following day he went down to 250,000 Swiss francs. Bührle declined without making Bürgi a counteroffer.

Following Bührle's refusal, Rolf Bürgi sold Paul Klee's entire artistic estate, including the publication rights and his library, to Hermann Rupf and Hans Meyer-Benteli for 120,000 Swiss francs on September 20, 1946, two days before Lily Klee's death. The buyers contractually agreed to "bequeath an appropriate collection from the acquired estate to both the Kunstmuseum Bern and the Kunstmuseum Basel as a gift" and to "select a well-rounded collection that is not for sale" to suitably represent Klee's work (contract of sale see CD-ROM). The purchase price, which the curator of the Kunstmuseum Bern, Max Huggler, said in the following year was fair, was transferred to a blocked account in favor of Felix Klee.

Hans Meyer-Benteli and Hermann Rupf founded the Klee-Gesellschaft (Klee Society) together with Rolf Bürgi and Werner Allenbach on September 24, 1946 (partnership agreement see CD-ROM), and transferred the Paul Klee Estate into its possession. In addition to the abovementioned obligations stipulated in the contract of sale of September 20, the partnership agreement also laid down an obligation to support Felix Klee and his aunt Mathilde Klee.

The Klee-Gesellschaft deposited the estate in the Kunstmuseum Bern and divided it

into three categories: works that were not for sale (at least 3,200 works), pictures intended as gifts (at least 30 works), and works for sale (around 2,500 works). The society fulfilled the central promises laid down in its contract of sale when it established the Paul-Klee-Stiftung (Paul Klee Foundation) in 1947—it was to find a new home in the Kunstmuseum Bern in 1952 (see pp. 209–10)—and gave 11 works each as gifts to two other museums, the Öffentliche Kunstsammlung Basel (fig. p. 206, top) and the Kunsthaus Zürich (fig. p. 206, bottom) early in 1948.

Max Huggler, presumably 1940s

Carola Giedion-Welcker

The Founding of the Paul-Klee-Stiftung

On September 30, 1947, the Klee-Gesellschaft followed the advice of the director of education in Bern canton, Markus Feldmann, and established the Paul-Klee-Stiftung (incorporated in Bern). It endowed this new foundation with part of the artistic estate of Paul Klee—works that had been selected as not for sale. This selection consisted of 40 panel paintings, 150 polychrome and 1,500 monochrome sheets (e.g. watercolors, gouaches, mixed media works, and drawings), one copy each of the prints still available, a number of reverse-glass paintings, sculptures, several documents, and Paul Klee's library (foundation deed see CD-ROM). Three years later it added a further 1,500 works to the foundation's collection, mainly designs and sketches classified as being not for sale. Apart from monochrome sheets, the partners of the Klee-Gesellschaft brought into the foundation above all the impressive colored works that Paul Klee had personally chosen for his own estate. In 1950 Mathilde Klee also gave several of her brother's pictures to the society, care of the Paul-Klee-Stiftung, "since she feared that after her death these works could be treated as German property and sold."[1]

The seven-member board of the foundation included all four partners of the previous society. Hermann Rupf was president and Rolf Bürgi secretary, Markus Feldmann sat on the board as representative of the Bern cantonal government, Max Huggler as representative of the Kunstmuseum Bern (fig.), and the Zürich art historian Carola Giedion-Welcker was also a board member (fig.).

The goal of the Klee-Gesellschaft in setting up the Paul-Klee-Stiftung was to create an inalienable artistic collection that was suitable to demonstrate the significance of Paul Klee in exhibitions in Switzerland and abroad. It also aimed to create an archive on the life and work of Paul Klee that would be open to serious scholarly research (see CD-ROM).

Siegfried and Angela Rosengart,
Lenzerheide, 1947

Curt Valentin

Further Activities of the Klee-Gesellschaft

Between 1947 and 1952 the Klee-Gesellschaft sold a good three fifths of the approximately 2,500 works from the Paul Klee Estate selected for sale. The sales mainly took place via the Galerie Rosengart in Lucerne (fig.), the Nierendorf Gallery in New York, and the Buchholz Gallery run by Curt Valentin in New York (fig.). Through these sales the society aimed above all to recover the purchase price (120,000 Swiss francs) and cover its costs resulting from the administration of the estate and the establishment of the Paul-Klee-Stiftung. Pictures from the Paul Klee Estate were also bought into the personal art collections of the partners of the Klee-Gesellschaft.

The Klee-Gesellschaft organized a range of exhibitions of Paul Klee's works in its own name, above all in Germany (see CD-ROM), and initiated numerous exhibitions and sales of works by providing the art dealers mentioned above with pictures of Klee's.

At the same time, the society organized a traveling exhibition stopping in six European and fifteen American cities to present the works of the Paul-Klee-Stiftung that were not for sale. Together these exhibitions marked the beginning of a well-directed worldwide promotion and reception of Klee's works in the postwar period.

Notes

This chapter is a revised extract from the extensively annotated article by Stephan Frey, "Rolf Bürgis Engagement für Paul und Lily Klee sowie die Gründung der Paul-Klee-Stiftung," in *Paul Klee: Die Sammlung Bürgi*, exh. cat. Kunstmuseum Bern and Hamburger Kunsthalle, (Wabern-Bern, 2000), pp. 199–217. The quotation in the title is from a letter by Hermann Rupf and Max Huggler to Rolf Bürgi, December 16, 1952, Archiv Bürgi, Bern.

1. Felix Klee to Rudolf Moser, November 14, 1950 (carbon copy), Archiv Bürgi, Bern.

The Paul-Klee-Stiftung (1947/52–2004)

Dr. Christine Hopfengart, Curator for Research and Documentation,
Library of the Zentrum Paul Klee, Bern

For over fifty years the Paul-Klee-Stiftung (Paul Klee Foundation) has been the scientific competence center on Klee. Together with the Klee family and in cooperation with the Kunstmuseum Bern, it has made a crucial contribution to Paul Klee—an artistic special case—becoming one of the most famous artists of the twentieth century. The Paul-Klee-Stiftung has more than 2,500 paintings, drawings, and colored works on paper at its disposal—the largest collection of Klee's works anywhere in the world—and at the same time has established itself as a unique documentation and research center on Klee as a famous twentieth-century artist.

The Beginnings

The origins of the Paul-Klee-Stiftung are complex. Its history reflects both the history of our time—the aftermath of Nazism and war—and the story of a private inheritance. It took five years from the establishment of the foundation by the Klee-Gesellschaft (Klee Society) on September 30, 1947, until Felix Klee, Paul Klee's son, finally recognized it and its assets were confirmed in 1952.[1] The foundation's collection consisted of 40 panel paintings, 161 polychrome sheets (watercolors, gouaches, etc.), 2,251 drawings, 10 sketchbooks, 11 sculptures, 27 reverse-glass paintings, and 87 prints. In addition there were such important documents as Klee's complete handwritten works catalogue, the around three thousand sheets of teaching materials in the Pädagogischer Nachlass (Pedagogical Estate), the manuscripts of his writings on art theory, and his library of books on art. The purpose of the foundation was defined as being, on the one hand, to create an "inalienable artistic collection," and on the other hand, to "set up an institution in Switzerland open to serious art-historical research."[2]

When the Paul-Klee-Stiftung was founded it was not yet known at which museum it would one day be located. The Kunstmuseum Bern, which had made depot space available for Klee's entire estate since 1946, hoped that the Klee-Gesellschaft would decide in its favor, but the Kunstmuseum Basel and the Kunsthaus Zürich were also

interested in hosting the Paul-Klee-Stiftung. When Max Huggler became the director of the Kunstmuseum Bern in 1944 he announced in an outline of his plans that he wanted to integrate a large collection of Klee's work into the museum, obviously thinking of the estate and the possibility of receiving loans and gifts. In 1946 he reaffirmed his interest by purchasing the picture *Flora am Felsen* (*Flora on the Rocks*), 1940, 343 (fig. p. 196), from Lily Klee, who in turn gave the panel painting *Insula Dulcamara*, 1938, 481 (fig. p. 197), to the museum as a loan.

The Klee-Gesellschaft and the museum reached the decision to deposit the Paul-Klee-Stiftung in the Kunstmuseum Bern in January 1948, just a few weeks after the museum had presented the collections of the foundation to the public for the first time.[3] The Klee-Gesellschaft gave the museums in Basel and Zürich a gift of eleven works each, some of them significant paintings.

Bern, Basel, or Zürich seems not to have been the only issue discussed in these few weeks, but again Huggler succeeded in prompting a decision benefiting the Kunstmuseum Bern. We know from him personally that the board of the Paul-Klee-Stiftung was at the time also considering a location in Bern other than the Kunstmuseum: "The founding of a separate Klee museum was a serious consideration, and Hermann Rupf offered to make his house in Brückfeld available. There was also talk of a plot of land on Egelmösli. My objection here made the decision go in favor of Hodlerstrasse. Which once more goes to support the old saying: ARS UNA EST—art is one."[4]

By putting the Paul-Klee-Stiftung in the care of the Kunstmuseum Bern, Huggler made a first decisive step toward extending the collection of the Kunstmuseum to include international modern art—until then it had largely been limited to Swiss art.

The lower basement of the 1936 building, previously reserved for the Graphics Collection, was now earmarked for the presentation of the foundation's collection. This building was replaced in the 1980s by the large extension of the Kunstmuseum, and today only the outer wall with Cuno Amiet's sgraffito remains. The exhibition space consisted of a long corridor with display cases and storage cupboards beneath them, and bays branching off to the sides (fig.). At the end of the corridor was the "Klee-Kabinett," a small study room where interested visitors could view all the works that were not on exhibition.

The Paul-Klee-Stiftung in the 1950s and 1960s

Work at the Paul-Klee-Stiftung in the 1950s was dominated by curatorial tasks—all of Klee's works at the foundation had to be inventoried, and the works on paper had to be mounted. Max Huggler, who was both museum director and extraordinary professor of art history at the University of Bern, now began to introduce students to

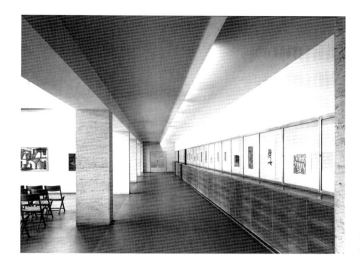

The Paul-Klee-Stiftung's space in
the Kunstmuseum Bern in the 1950s

Klee and encourage them to address his work. One photo shows him teaching in the Klee-Kabinett, surrounded by open portfolios (fig. p. 212). One of his students was Harald Szeemann, who in 1955 wrote one of the first research papers on Klee—a study of his early drawings.

In 1956 Huggler realized the foundation's plan to show Klee's work in a large-scale retrospective and to catalogue all of Klee's panel paintings and polychrome sheets owned by the foundation. With its 756 works, this retrospective was the largest Klee exhibition ever held to date.

Huggler planned the exhibition in such a way as to highlight the foundation's scholarly obligation and expertise. For each of Klee's creative years he chose a number of works in exact proportion to Klee's actual production in that year, so that the exhibition reflected Klee's œuvre in a downsized but quantitatively accurate way.

The response to the retrospective was most enthusiastic, particularly abroad, but in Switzerland too the message came through: "Bern is Klee's 'Bayreuth'," the *Neue Zürcher Zeitung* put it.

Due to its extensive holdings, the Paul-Klee-Stiftung received an increasing number of requests for loans during the 1950s. Huggler was initially reticent for conservation reasons, and he was supported in this in particular by board member Johannes Itten, who always warned how fragile Klee's works were.

But as of the second half of the 1950s there were major exhibitions abroad. A Scandinavian tour was carried out in 1958, and in 1961 a first large loan of works traveled to Japan.

LIVERPOOL JOHN MOORES UNIVERSITY
LEARNING SERVICES

Max Huggler with students in the "Klee Kabinett," ca. 1953/54: Elka Spoerri (2nd from left), Katalin von Walterskirchen (3rd from left), Harald Szeemann (4th from left)

The Paul-Klee-Stiftung as a Documentation Center

The conversion of the Paul-Klee-Stiftung into a documentation center in the early 1970s ushered in a new phase in the foundation's history. It no longer saw itself exclusively as custodian of the collection, but began building up an archive on Paul Klee and within just a few years developed into a competence and information center on the artist. This reorientation coincided with the employment of Jürgen Glaesemer (fig.), who was to decisively shape the work of the Paul-Klee-Stiftung for almost twenty years (1971–88). Glaesemer looked after both the Paul-Klee-Stiftung and the Graphics Collection of the Kunstmuseum, and in this joint capacity he continued the close link between the Paul-Klee-Stiftung and the Kunstmuseum that had been established in the eras of Max Huggler (until 1965) and Huggler's successor, Hugo Wagner (1965–80) (fig.). The Paul-Klee-Stiftung also gained weight in its own right through creating the international documentation center.

The decision to establish a detailed documentation on Klee's work was made in early 1972 and manifested in an ambitious work schedule. Parallel to this, the foundation's entire Klee collection was to be published. The long-term aim was the publication of a catalogue of Klee's œuvre.[5]

In the summer of 1973 Glaesemer presented the first of four planned catalogues on the collections, the volume on Klee's early drawings (childhood–1920), which was accompanied by an extensive exhibition in the Kunstmuseum Bern. In 1976 the survey of the colored works was completed, to be followed in 1979 by Klee's later drawings and sketches (1937–40). On both occasions Glaesemer organized an exhibition, albeit complemented by some colored works. The last stage was concluded in 1984 with the catalogization and exhibition of Klee's drawings from 1921 to 1936. This exhibition was held in the new rooms in the extension of the Kunstmuseum that had

opened in 1983. The four volumes on the collection went far beyond the usual form of inventorization. Their extensive texts represented the first up-to-date overview of Klee's work since the 1950s. Further publishing activities of the Paul-Klee-Stiftung in these years included the annotated facsimile edition of Klee's first Bauhaus lectures in Weimar (1921/22), the *Beiträge zur Bildnerischen Formlehre* (Contributions to a Theory of Pictorial Form), and the critical new edition of Klee's diaries edited by Wolfgang Kersten.

Glaesemer's second great project was the documentation of Klee's work. For every single work of Klee's a file was started with an illustration and data on the work. In this way, working in collaboration with the then assistant at the Paul-Klee-Stiftung, Stefan Frey (1981–86), the foundations were laid for the later *Catalogue raisonné Paul Klee*. In these years Jürgen Glaesemer had a profound influence on the Paul-Klee-Stiftung. Despite his enormous scholarly achievement in surveying the entire collection, for him the Paul-Klee-Stiftung was much more than just a place of research. His philosophy centered around *experiencing* the original works. He criticized the established interpretative tendencies and distanced himself from them, saying that all works merited attention, not just the recognized masterpieces (which he called "esthetically consumable prestige objects"). Rather, he placed special emphasis on Klee's drawings and conducted a meticulous study of the Pädagogischer Nachlass. In a manner typical of the 1970s and 1980s, Glaesemer made a bold connection from Klee to Concept Art and Minimal Art and identified principles of contemporary art particularly in Klee's cycles of drawings from the late 1930s. For Glaesemer, Klee was by no means the harmless storyteller that many liked to see in him in the 1950s and 1960s, but a highly complex mind that sought to deal with the questions he faced through art, aided by his superior intelligence and a pronounced sense of irony. Glaesemer thus laid the foundation for a broader understanding of Klee as an artist, taking account of his achievements in the field of art theory and his complex relationships to the art and reality of his time.

Collaboration between the Paul-Klee-Stiftung and Felix Klee was closer in the 1970s and 1980s than it had been in the preceding two decades. Felix Klee had become a member of the foundation's board in 1953 and its president in 1963. In these roles he supported the work of the foundation as best he could. In particular, he allowed copies of Klee's correspondence with artists, art dealers, and collectors to be made available for research purposes. This was a fundamental precondition for the conversion of the Paul-Klee-Stiftung into a research center. Felix Klee's only reservations concerned the works catalogue—he feared that publication of Paul Klee's handwritten entries would encourage counterfeits of Klee's works.

Jürgen Glaesemer setting up the exhibition "Die Gleichzeitigkeit des Anderen," 1987

Hugo Wagner, Director of the Kunstmuseum Bern, 1978

Josef Helfenstein, Paul-Klee-Stiftung curator from 1988 to 2000

The Catalogue raisonné Paul Klee

After Jürgen Glaesemer's untimely death in 1988, Josef Helfenstein (fig.) took over the running of the Paul-Klee-Stiftung under museum director Hans Christoph von Tavel (1980–95) (fig. p. 307). The project *Catalogue raisonné Paul Klee* played a dominant role in his term of office (1988–2000). Work on the project began in earnest in 1988, using as a basis the documentation put together over the preceding fifteen years or more. For Helfenstein and the project manager, Stefan Frey, the memorial exhibition on the fiftieth anniversary of Klee's death, *Paul Klee—Das Schaffen im Todesjahr* (Paul Klee—The Works from His Last Year), was an opportunity to cover all of Klee's works from the year 1940 and publish them in the initial volume *Paul Klee—Verzeichnis der Werke des Jahres 1940* (Paul Klee—A List of His Works from 1940). In the process, essential features of the plan for the *Catalogue raisonné* took shape.

As with every works catalogue, here too it was necessary to develop a systematic approach tailored to the artist's work. The central goals were to survey Klee's œuvre with precision and to complete the magnum opus in a reasonably short period.

Klee's handwritten works catalogue, which he kept for almost thirty years from 1911 to 1940, served as the basis. Here he had entered all his works and numbered them consecutively. These records were therefore the most important reference for the inclusion of a work in the *Catalogue raisonné*, which also adopted Klee's chronological organizing principle. Entries were therefore not arranged according to art historical categories (painting, drawing, prints), but were left in Klee's own, mixed order. The resulting overview of the œuvre thus also gives us insights into its evolution and Klee's personal bookkeeping method.

The various tasks involved in compiling the *Catalogue raisonné* were organized on an exact schedule. Between 1991 and 1998 a separate research team of varying composition conducted the further investigations necessary to catalogue the œuvre of almost ten thousand works as completely as possible. Under the project management of Christian Rümelin (1996–2002), a Klee database under development since 1988 served as a tool here. It proved so innovative and helpful that it was taken as the basis for a museum database used in many large European museums today.

Publication of the *Catalogue raisonné* began in 1998. Meanwhile the Benteli-Verlag in Bern was won as a partner for the project. To accompany publication of the first volume, the Paul-Klee-Stiftung organized a symposium in cooperation with the Institute for Art History at the University of Bern that brought together international Klee researchers. The results of the symposium were put out in the book *Paul Klee: Kunst und Karriere* (Paul Klee: His Art and Career), the first volume in the series

Schriften und Forschungen zu Paul Klee (Writings and Research on Paul Klee) published by the Paul-Klee-Stiftung.

The *Catalogue raisonné Paul Klee* is one of the most extensive works on a representative of classical modern art. On the basis of preparatory work done in the 1970s and 1980s, the material was surveyed and made accessible to the public in the relatively short span of fifteen years. When the project has been completed, the Zentrum Paul Klee will continually update the database, and certain areas of it will be made accessible to the public.

While work on the *Catalogue raisonné Paul Klee* was under way, the Paul-Klee-Stiftung continued to provide its services undiminished. These included supervising researchers who came to work at the Paul-Klee-Stiftung, advising museum staff from other institutions preparing Klee exhibitions, and providing loans from the collection of the Paul-Klee-Stiftung. Another field of work was the examination of works of art and the issuing of certificates of authenticity, for which the Paul-Klee-Stiftung is the only recognized institution in the world. Its regular clients included art dealers, auction houses, and private collectors who wished to verify the authenticity of works presented to them as original Klees. However, the publication of each new volume of the *Catalogue raisonné* saw a drop in the number of inquiries, since the works catalogue now dealt conclusively with many cases.

Finally, in terms of exhibitions, the Paul-Klee-Stiftung had presented the complete collections in the 1970s and 1980s and now turned to more specialized topics. In the exhibitions of Die Blaue Vier (The Blue Four) and the Bürgi Collection (organized in collaboration with Stefan Frey), the focus shifted to personalities who collected and promoted Klee's work.

Catalogue raisonné Paul Klee, vol. 1 (1883–1912), published by the Paul-Klee-Stiftung, Bern 1998

The Zentrum Paul Klee

The death of Felix Klee in 1990 brought about a change in the development of the Paul-Klee-Stiftung. Two years later his son, Alexander Klee, proposed the establishment of a Klee museum to the then director of the Kunstmuseum, Hans Christoph von Tavel.[6] In 1997 Livia Klee-Meyer, Felix Klee's widow, gifted practically all the works awarded to her from the Felix Klee Estate to the City and Canton of Bern, giving the decisive impetus for the rapid planning and realization of the Zentrum Paul Klee. In 1998 Alexander Klee also contractually agreed to loan the future museum the works from his share of the inheritance, some of them permanently.[7]

In this situation the board of the Paul-Klee-Stiftung, the foundation's executive body, decided to provide the basis for a new institution by establishing a new foundation together with the City and Canton of Bern—the Stiftung Paul Klee-Zentrum

Christine Hopfengart, Paul-Klee-Stiftung curator from 2001 to 2004

(Paul Klee-Zentrum Foundation). The Paul-Klee-Stiftung would make all of its Klee works, its archive and library part of the new collection, and all its staff would also become part of the new body. The contract on the incorporation of the Paul-Klee-Stiftung into the Stiftung Paul Klee-Zentrum (see CD-ROM) was signed on September 1, 2000.

From 2001 to 2004 Christine Hopfengart (fig.) was curator and manager of the Paul-Klee-Stiftung. In these years the work of the Paul-Klee-Stiftung focussed on preparing the expanded future activities of the Zentrum Paul Klee. For example, the foundation tailored its loan policy to expand the existing network of partner institutions and arranged future possibilities for cooperation in the exhibition field. At the same time these loans were used as a diverse forum to inform the artistic public in Italy, Germany, and France about the Zentrum Paul Klee. The domiciling of the works donated by Livia Klee or loaned by Alexander Klee and from other private collections in the Kunstmuseum Bern freed up the Paul-Klee-Stiftung and gave it great flexibility in its activities, which was also of benefit to the permanent presentation of Klee's work in the Kunstmuseum. The Paul-Klee-Stiftung took on new tasks where research and publicity work overlap, for example in providing consultancy for many film and television projects and publishing the book *Paul Klee 1927* for a founding partner of the Zentrum Paul Klee.

The Paul-Klee-Stiftung developed a fundamental tool of relevance to the Zentrum Paul Klee—the "picture database." In cooperation with the Institute of Media Technology at the University of Basel, high-resolution digital photographs were made of pictures in the Klee collections to be brought together in the Zentrum Paul Klee. These images of facsimile quality were then integrated into the existing Klee database that the Zentrum Paul Klee will use for communication with visitors, research, restoration work, and the loan or sale of pictures in digital form.

New projects were also started in the archive and collection area in addition to the ongoing expansion of documentation on Klee's life and work. For instance, Klee's former students were systematically listed, their descendants were contacted, and a number of gifts received. This student archive, which is to be further developed in the future, complements the Pädagogischer Nachlass owned by the foundation. The research project *Klee und Bern* is of a similar bent, seeking to find tangible traces of Paul Klee and his family in Bern. Although most of Klee's contemporaries have since died, the foundation has been able to make a series of interesting discoveries and rediscoveries. Apart from the collection of traditional documents, oral history methods are applied here to record people's memories and stories.

For over half a century the Paul-Klee-Stiftung was the central venue for cultivating,

researching, and publicizing the work of Paul Klee. On January 1, 2005, its tasks were taken over by the Zentrum Paul Klee, which continues to fulfil them while extending their scope—with the old and new objective of researching the complex work of Paul Klee and conveying it to broad sections of the culturally interested public in an attractive and enduring way.

Notes

1. On the history of the establishment of the Paul-Klee-Stiftung, see the article by Stefan Frey, pp. 206–8.
2. Deed of foundation of the Paul-Klee-Stiftung, dated September 30, 1947, Archiv Paul-Klee-Stiftung, Bern; also see CD-ROM.
3. See the letter from the management of the Kunstmuseum Bern, January 16, 1948, which was sent to the Paul-Klee-Stiftung on Rolf Bürgi's instigation, Archiv Paul-Klee-Stiftung, Bern.
4. Max Huggler, "Paul Klee aus persönlicher Sicht" (typescript of lecture held on March 17, 1994, in the Kunstmuseum Bern), Archiv Paul-Klee-Stiftung, Bern.
5. Minutes of the meeting of the management of the Kunstmuseum Bern, January 24, 1972, Archiv Kunstmuseum Bern; minutes of the meeting of the board of the Paul-Klee-Stiftung, November 23, 1972, Archiv Paul-Klee-Stiftung, Bern.
6. See chapter "Alexander Klee—His Collection and His Commitment to the Zentrum Paul Klee," pp. 226–28 of this publication.
7. See chapter "The Livia Klee Donation," pp. 235–45 of this publication.

Felix Klee and the Estate Collection

Stefan Frey, Klee Estate Administration, Bern

How Felix Klee Reclaimed His Inheritance

On November 13, 1948, Felix Klee moved from Sommerhausen am Main to Bern with his wife and their child on invitation of the Klee-Gesellschaft (Klee Society), which until then had supported him with food parcels. Initially the Klee-Gesellschaft bore the costs of the family's stay in the Swiss capital. But it stopped its support in 1949 when Felix Klee—the sole heir of Paul and Lily Klee—asserted his claim to the entire Paul Klee Estate and the author's rights, and called in a lawyer. Felix Klee cast doubt on the validity of Rolf Bürgi's contract of sale with Hermann Rupf and Hans Meyer-Benteli and challenged the statutory basis of the Paul-Klee-Stiftung (Paul Klee Foundation). A four-year lawsuit ensued between Felix Klee and the Klee-Gesellschaft, which ended in late December 1952 with an out-of-court settlement brokered by the Swiss clearing office (extracts see CD-ROM). Under this agreement the contract of sale of September 20, 1946, was annulled; Felix Klee recognized the legitimacy of the Paul-Klee-Stiftung and, being his parents' sole heir, was awarded the Paul Klee Estate complete with the rights and duties this involved; the partners of the Klee-Gesellschaft each issued him ten works which they had received from the estate in around 1950 (Rolf Bürgi: figs. pp. 257, 275; Werner Allenbach: figs. pp. 221, 277; Hans Meyer-Benteli: figs. pp. 222, 259; Hermann Rupf: figs. pp. 223–24); the Klee-Gesellschaft was dissolved on December 31, 1952.

On December 4, 1952, through the agency of the Swiss clearing office, Felix Klee entered into a separate agreement with the Paul-Klee-Stiftung (reproduced in full on CD-ROM). He expressed his agreement with the continued existence of the Paul-Klee-Stiftung and recognized its holdings as they existed in 1947; of the 1,500 works added to the foundation in 1950 he received all the panel paintings and polychrome sheets, also a third of the monochrome sheets, reverse-glass paintings, prints, and sculptures—these all became his property. The Paul-Klee-Stiftung now owned a total of 40 panel paintings, 161 polychrome sheets, 2,251 monochrome sheets, 10 sketchbooks, 11 sculptures, 27 reverse-glass paintings, and 87 prints. The foundation was

conferred the copyright of all of Klee's works in its possession and was also awarded Paul Klee's most significant writings, the works catalogue, the didactic writings, the diaries, a book of poems, and the Jena lectures; and also the art-historical part of the library on Paul Klee. In a statement in 1954 to the Swiss supervisory commission for carrying out the Washington Agreement (see CD-ROM), Felix Klee moreover undertook not to sell the works received from the Paul-Klee-Stiftung or to take them abroad, either individually or collectively, for the duration of ten years; he also agreed to make them available to the Paul-Klee-Stiftung for exhibitions whenever it requested. Werner Allenbach, Rolf Bürgi, and Hans Meyer-Benteli left the board of the foundation at the end of 1952; Felix Klee joined this body and, after the death of the president, Hermann Rupf, presided himself from 1963 to 1990.

Felix Klee and Helmut Dimmig talking on Radio Studio Bern, summer 1966

The Felix Klee Estate Collection

The share Felix Klee took over from his parents' former estate early in 1953 comprised 97 panel paintings, 414 polychrome sheets, 614 monochrome sheets, 4 small sculptures, 2 reliefs, 13 reverse-glass paintings, 41 prints, and 69 pictures by artists who were friends of Paul and Lily Klee. Furthermore he received personal documents from and concerning Paul and Lily Klee—in particular his parents' private and business correspondence and their library, the contents of Paul Klee's studio, and personal effects such as Paul Klee's violin and Lily Klee's grand piano. Felix Klee added all these items to his own collection, which his wife had rescued from their apartment in Würzburg after it was badly damaged in a bombing raid in spring 1945: thirty glove puppets made for him by his father between 1916 and 1925 (figs. pp. 278–81), a few pictures by Paul Klee (fig. p. 225), and letters from his father to him and Ephrosina.

Felix Klee Promotes Paul Klee

Since Felix Klee worked as a director of radio plays and presenter at Swiss Radio, he managed the estate collection, the most comprehensive privately owned Klee collection, purely on the side until his retirement in 1972 (fig.). Only then was he able to give unlimited attention to his father's inheritance and its interpretation. From 1955 until his death in 1990 he arranged over fifty extensive exhibitions with the estate collection in Europe, America, and Asia. As a generous lender he also made pictures from his own private collection available for more than sixty Klee exhibitions and countless other shows involving the works of multiple artists. He gave long-term loans to half a dozen museums in Germany and Switzerland. Parallel to these exhibition and loaning activities he became a committed art and culture writer. He gave opening speeches and slide lectures, wrote catalogue entries and articles in anthologies. Three

LIVERPOOL JOHN MOORES UNIVERSITY
LEARNING SERVICES

books edited by him were to have a particularly strong influence on the "Klee community": in 1957, he published Paul Klee's diaries, arguably the most important written source on the artist; three years later he put out his father's poems, followed in 1979 by Paul Klee's letters to the family (see CD-ROM).

Long before the Paul-Klee-Stiftung began compiling a systematic archive on Paul Klee's life and work, Felix Klee started putting together a photographic documentation of his father's œuvre based on his own collection. This documentation formed the basis of his journalistic work and the consultations from which museum staff and others benefited when planning retrospective and thematic Klee exhibitions; it was also his guide when establishing the authenticity of pictures and checking the proofs of reproductions.

On the occasion of his eightieth birthday in 1986, both Switzerland and Germany paid tribute to Felix Klee, who had become a Swiss citizen in 1960, for his loyalty to his father and great commitment to his art. The University of Bern conferred an honorary doctorate on Felix Klee, and the president of the Federal Republic of Germany granted him the German Order of Merit, First Class. In 1989 at the opening of the Klee exhibition in Visp, made possible through his efforts, Felix Klee for the first time publicly expressed his intention to establish a family foundation based on the estate collection. Before any detailed arrangements could be made, however, he died unexpectedly on August 13, 1990.

Note

This chapter is a compilation of revised extracts from two extensively annotated articles by Stefan Frey, "Paul Klee in Bern," in *Paul Klee—Die Zeit der Reife: Werke aus der Sammlung der Familie Klee*, exh. cat. Kunsthalle Mannheim (Munich and New York, 1996), pp. 175–84, and "Rolf Bürgis Engagement für Paul und Lily Klee sowie die Gründung der Paul-Klee-Stiftung," in *Paul Klee: Die Sammlung Bürgi*, exh. cat. Kunstmuseum Bern and Hamburger Kunsthalle (Wabern-Bern, 2000), pp. 199–217.

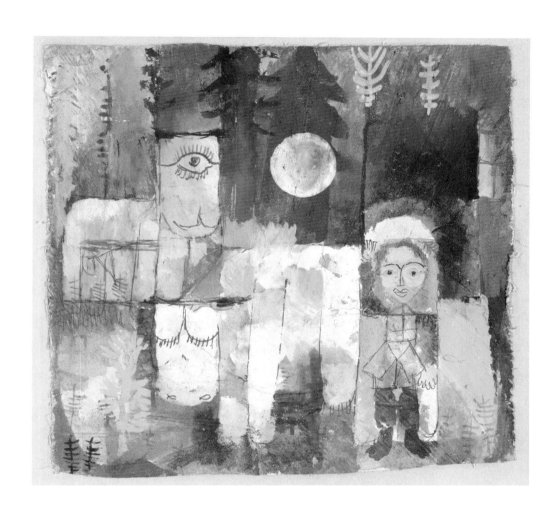

Paul Klee
Sexuelle Erkenntnis eines Knaben, 1918, 111
Sexual Discoveries of a Boy

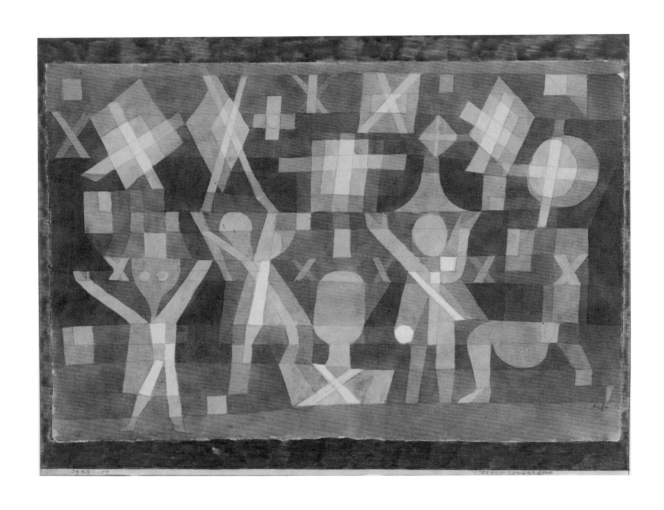

Paul Klee
Sternverbundene, 1923, 159
Connected to the Stars

Paul Klee
Die Erfindung, 1934, 200
The Invention

Paul Klee
Wachstum auf Stein, 1929, 258
Growth on Stone

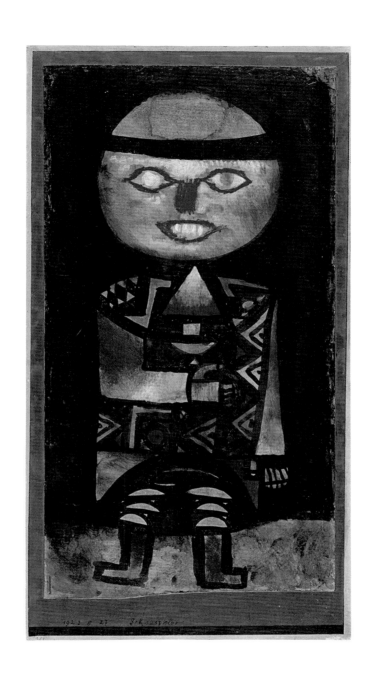

Paul Klee
Schauspieler, 1923, 27
Actor

Alexander Klee—His Collection and His Commitment to the Zentrum Paul Klee

Stefan Frey, Klee Estate Administration, Bern

Paul Klee
Gemeiner Wiedehopf,
Zoologieheft II (Vögel), 1895
The Common Hoopoe, Zoology II
(Birds)

In its almost fifty years of existence, the Felix Klee Estate Collection has received a relatively small number of new additions, but in other respects has expanded considerably. In late 1953, at the age of thirteen, Alexander Klee inherited from his aunt Mathilde a total of sixty-three of his grandfather's works—seven panel paintings, twenty-seven polychrome and seventeen monochrome sheets, two prints, four school exercise books with illustrations (fig.), a textbook with marginal drawings (fig.), and a five-part painted folding screen (fig. p. 230–31). These were almost exclusively works from Paul Klee's youth that Mathilde had either been given as presents by her brother or inherited from her parents, Hans and Ida Klee-Frick. When his father died in 1940, Paul Klee renounced his share of the inheritance in favor of his sister, who for years had selflessly cared first for their mother, then for their father. Even friends of the Klee family did not know that Alexander Klee had come to be in possession of a Klee collection, since Felix Klee subsequently integrated it into his estate collection and proceeded to present it under his own name.

Although Alexander Klee assisted his father from the mid-1970s in managing the estate collection—for example by organizing several significant Klee exhibitions in Japan— he scarcely appeared in public as the grandson of the famous artist Paul Klee until after his father's death. In keeping with family tradition, however, he followed creative lines of work: from 1958 he attended the photography class at the École des Arts et Métiers in Vevey and from 1963 he lived and worked as a press photographer in Zürich for several years. From 1970 to 1975 he was a bookseller in Bern. In 1967 he took up graphic arts and painting on the side, but in 1976 became a fully-fledged freelance artist. He is also known under the pseudonym Aljoscha Ségard.

After his father's death, Alexander Klee took over the tasks that fell to him as a representative of the Klee family. Since 1990 he has been president of the board of the Paul-Klee-Stiftung (Paul Klee Foundation), which he joined in 1972. Until 1995, the Felix Klee Estate Collection and Archives with their substantial written and photographic documents on Paul Klee and his family were administered by the community

of heirs Alexander Klee formed with his stepmother Livia Klee-Meyer—they were Felix Klee's sole heirs. On December 18, 1991—Paul Klee would have turned 112 that day—Alexander Klee met with the director of the Kunstmuseum Bern, Hans Christoph von Tavel (fig.), and discussed the possibility of works of art and documents from the Felix Klee Estate being stored and exhibited in the Kunstmuseum Bern. Six months later virtually all the works and a large part of the documents were transferred to the Kunstmuseum Bern, where for more than a decade they augmented the works of the Paul-Klee-Stiftung and formed the main focus of the Klee exhibits. In the fall of 1992 Alexander Klee proposed to Hans Christoph von Tavel the founding of a museum devoted exclusively to Paul Klee. The museum management and the relevant agencies of the City and Canton of Bern took on the concrete planning of the museum in March 1993 after the heirs of Felix Klee had indicated that they would leave the Kunstmuseum Bern a significant part of the estate collection as a permanent loan. In 1995 Livia and Alexander Klee tackled the task of dividing up the Felix Klee Estate Collection. Alexander accepted the proposal developed by Eberhard W. Kornfeld and Christine Stauffer from Galerie Kornfeld in Bern on behalf of the heirs, on the following premises: Since Livia wanted her share of the Felix Klee Estate Collection to go to the public, she was assigned those works that complemented those of the Paul-Klee-Stiftung (see chapter on the Livia Klee Donation, pp. 234–45). The largest part of the sixty-nine pictures by artists who were friends of Paul and Lily Klee was awarded to Alexander (fig. p. 228). On May 14, 1997, Livia made over practically all the works assigned to her to the Residency Community and the Canton of Bern; a correspond-ing donation agreement was signed (see CD-ROM). One condition was attached—that the public bodies establish a museum devoted to Paul Klee by 2006. In a second contract regarding division of the estate, dated April 3, 1998, the two heirs

Paul Klee
Fitzliputzli, Wodan, Mohamed, Inri, Isis, in Handbuch der Geschichte für die oberen Klassen des Gymnasiums und Realschulen, 1897 (marginal drawings in Klee's high-school history textbook)

Dr. Hans Christoph von Tavel (right) talking with Felix and Alexander Klee at Felix Klee's eightieth birthday celebration at the Kunstmuseum Bern, November 28, 1987

Alexej von Jawlensky
Kreolin, 1913
Creole Woman

Franz Marc
Ohne Titel (zwei Pferde vor blauem
Berg), 1913
Untitled (Two Horses by a Blue
Mountain)

agreed that Alexander Klee would take over the Felix Klee Archives by himself, but in return promised to donate the part relevant to Klee research to the Zentrum Paul Klee no later than one year after its opening—the opening of the Felix Klee Archives will give significant stimulus to future research on Klee. In mid-1998 Alexander Klee contractually agreed to permanently lend the Zentrum Paul Klee selected works from the part of the Felix Klee Estate Collection he had been awarded, and also works he had inherited from Mathilde Klee (figs. pp. 229, 232–33). Furthermore, he signed an agreement regarding the depositing of the remaining works in his possession in the Zentrum Paul Klee. Thanks to the goodwill of Felix Klee's heirs, the significant parts of Paul and Lily Klee's estate—divided in 1947—are being reunited for good in the Zentrum Paul Klee over fifty years after the establishment of the Paul-Klee-Stiftung by the Klee-Gesellschaft.

From the mid-1990s Alexander Klee intensified his cooperation with the Paul-Klee-Stiftung, which from then on took care of the administration of the copyright of Paul Klee's works and the loaning of relevant photographic material. He supported the Paul-Klee-Stiftung in obtaining finances for the project *Catalogue raisonné Paul Klee* by making the loans for the profitable exhibitions in Japan, South America, and Italy available to it for free. In order to cope with the growing volume of work also generated by his involvement in realizing the Zentrum Paul Klee, he opened an office of his own in Bern in 1996—the Paul Klee Estate Administration. In 2002, together with Stefan Frey and Wolfgang Kersten, he founded the journal *Klee-Studien—Beiträge zur internationalen Paul-Klee-Forschung und Edition historischer Quellen* (Klee Studies—International Paul Klee Research and Edition of Historical Source Material). In his capacity as co-editor of the five issues of this series to have appeared to date, he continues his father's prolific publishing activities.

Paul Klee
Empfindsame Jungfrau mit d. Maßliebchen, 1906, 21
Sentimental Virgin with Daisy

229

LIVERPOOL JOHN MOORES UNIVERSITY
LEARNING SERVICES

Paul Klee
Ohne Titel (Aarelandschaft), um 1900
Untitled (Aare Landscape)

Paul Klee
geöffnet, 1933, 306
Opened

232

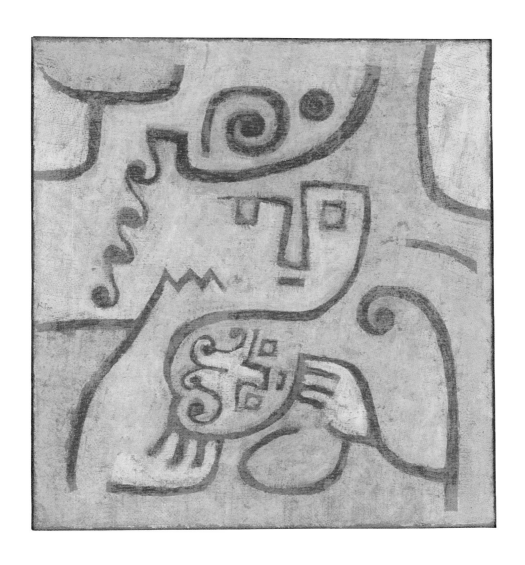

Paul Klee
Mutter und Kind, 1938, 140
Mother and Child

LIVERPOOL JOHN MOORES UNIVERSITY
LEARNING SERVICES

The Bürgi Archive

Stefan Frey, Klee Estate Administration, Bern

Along with the Klee family archive, the archive of the Bürgi family contains the most important collection of written and photographic reference material on the life and work of Paul Klee and his family. It documents both the great involvement of the art-minded building contractor's wife, Hanni Bürgi-Bigler (1880–1938)—the first and most significant collector of Klee's works in Switzerland—and the decades of friendship that bonded their son Rolf (1906–67) and daughter-in-law Käthi with Paul and Lily Klee.

Rolf Bürgi was an insurance salesman, and as of 1931 he advised Paul Klee as a trustee in financial and taxation matters and helped the Klees move from Düsseldorf to Bern in 1933.

After Klee's death in 1940 he complied with his wish and supported his widow, acting as a close personal adviser to her in business activities, such as organizing exhibitions, facilitating publications, and selling pictures. In 1946 Bürgi saved the Paul Klee Estate from being confiscated and liquidated under the Washington Agreement by selling it to the Klee-Gesellschaft (Klee Society), of which he himself was a member. He was the driving force behind the Klee-Gesellschaft's establishment, in 1947, of the Paul-Klee-Stiftung (Paul Klee Foundation), which since 1952 has been housed in the Kunstmuseum Bern, and used his influence to realize Klee's intention to bequeath part of his artistic estate to a Swiss museum.

The Bürgi Archive preserves most of Rolf Bürgi's extensive business and personal correspondence with Lily Klee, private collectors, art dealers, museums, publishers, and various government agencies, as well as the files on the history of the Hanni Bürgi-Bigler and Rolf Bürgi collections. Bürgi's descendants, represented by Christoph A. Bürgi, have now made these documents available to the Zentrum Paul Klee for research purposes. These documents, which are an ideal addition to the files in the Klee family archive, will provide fresh stimulus for research on Klee.

The Livia Klee Donation

Dr. Michael Baumgartner, Deputy Art Director and Curator of Collection, Exhibits, and Research, Zentrum Paul Klee, Bern

Long before ground was broken for the Zentrum Paul Klee, Livia Klee-Meyer laid its actual foundation in 1997 with her gift to the City and Canton of Bern.
Livia Klee has modestly said of her generous donation, "It is marvelous to give this collection to the public and to know that it will now have a home."[1]

Late Love

Felix Klee and Livia Meyer were married in 1980 when he was seventy-three and she was fifty-eight, and they went on to live together in Bern for ten years. The extraordinary tale of their relationship has its beginnings in the late 1920s. In 1927, Felix Klee, then twenty years old, met little Livia in Dessau for the first time at the newly constructed Bauhaus, where his father worked as a teacher. Livia had come to Dessau with her family as a five-year-old child when her father, the Basel architect Hannes Meyer, was appointed to chair the architecture department at the Bauhaus. The following year, Meyer succeeded Walter Gropius as the director of the Staatliches Bauhaus. Livia and her sister Claudia grew up in the Bauhaus milieu with a group of other children of the same age. Their playmates included Jan Scheper as well as Jaina and Karin Schlemmer, the children of the Bauhaus masters Hinnerk Scheper and Oskar Schlemmer (figs. pp. 236–37). Their domain and their playground was the little pine forest near the Dessau masters' houses in the Burgkühnauer Allee, a genuine paradise for the children, who loved to explore. Their neighbor and big friend was Felix Klee, who was volunteering as an assistant director at the Dessauer Theater at the time and enjoyed putting on the occasional show for the little ones with his hand puppets, which his father had made for him between 1916 and 1925 (figs. pp. 278–81). Livia Klee recalls: "I didn't know for sure if the puppets might not be real—they are still alive for me today."[2] When their fathers left the Bauhaus—Paul Klee became a professor at the Staatliche Kunstakademie Düsseldorf in 1931, while Hannes Meyer moved to the Soviet Union as a city planner and architect in 1930—the children's paths diverged as well. Felix Klee trained as a theater director in Germany. After finishing school in Zürich, Livia

Felix Klee, Dessau, 1926

235

LIVERPOOL JOHN MOORES UNIVERSITY
LEARNING SERVICES

Children of the Bauhaus masters on the balcony of one of their villas: Livia Meyer, Jan Scheper, Jaina Schlemmer, Claudia Meyer, Karin Schlemmer (from left to right), Dessau, 1927

Villas of the Bauhaus masters in Dessau, architect: Walter Gropius

Children of the Bauhaus masters on the balcony of one of their villas: Livia Meyer, Jan Scheper, Jaina Schlemmer, Claudia Meyer, Karin Schlemmer (from left to right), Dessau, 1927

Livia Klee-Meyer and Felix Klee in the park of the Louisiana Museum, Humlebæk, 1986

Livia Klee in front of her atelier in
Kirchgasse, Zürich, around 1960

Meyer completed an apprenticeship as a dressmaker and then went to the school of
arts and crafts. After World War II she worked as a dressmaker in Amsterdam and
Cape Town until the 1950s, when she opened the atelier Couture Livia in the Kirch-
gasse in Zürich (fig.).

After returning to Zürich, Livia contacted Felix Klee, who had moved to Bern from
Germany with his family in 1948. When his wife, Ephrosina Klee-Grezhova, became
seriously ill, Livia Meyer stood by his side with advice and practical assistance as
he cared for her. Ephrosina died in 1977. Felix Klee and Livia Meyer had grown closer
during that difficult time, and they discovered their mutual love. In 1980 they wed,
and from then on they lived in two apartments at Freiburgstrasse 54 in Bern. Together
they devoted themselves to Paul Klee's artistic estate and organized and visited exhibits
throughout the world (fig. p. 237).

When Felix Klee died suddenly and unexpectedly on August 13, 1990, Livia was left
on her own. In 1995 his collection was divided up between Livia Klee-Meyer and
Alexander Klee, the son of Felix Klee and Ephrosina Klee-Grezhova, in a way that
already reflected Livia's plan to give her portion to the public. Both heirs agreed to the
proposal developed for them by Eberhard W. Kornfeld and Christine Stauffer of
the Galerie Kornfeld in Bern. Livia received those works from the Felix Klee Estate
Collection which complement and consolidate the holdings of the Paul-Klee-Stiftung
(Paul Klee Foundation) as the basis of a future Klee museum.

The Works of the Livia Klee Donation

The donation encompasses 682 works: 46 panel paintings, 168 polychrome sheets
(watercolors etc.), 368 monochrome sheets (drawings), as well as 7 reverse-glass
paintings and 5 graphic sheets. The collection also includes 30 hand puppets, 9 sculp-
tures and reliefs, as well as 49 works by artists who were friends of Paul and Lily
Klee and gave them some of the works as gifts.

A full appreciation of the quality and extent of the Livia Klee Donation is the task of
a comprehensive monograph. The publication of such a work is among the first
priorities of the Zentrum Paul Klee. The present volume, which marks the opening of
the Zentrum Paul Klee, can do no more than convey a few impressions of the treas-
ures the collection contains.

The Monochrome Sheets

In its drawings, the Livia Klee Donation focuses on the artist's early and late work.
The years 1908–9 and 1912 as well as 1933, 1938, and 1939 are especially well
represented. The collection contains a relatively high proportion of so-called post-

humous works, which constitute more than 10 percent of the whole. These are works that Paul Klee did not include in his handwritten catalogue of his works, either because he did not regard them as valid or because he was unable to complete them before his death. In terms of their subjects, the donation's drawings focus on self-portraits and portraits of family members, grotesques, "political" drawings from 1933, and representations of human beings and animals from the late work.

In his self-portraits, the artist emerges from the shadow of the work and enters the picture himself. The self-portraits are simultaneously mirrors and projection screens, vehicles of self-reflection and self-representation. They enable the viewer to experience the artist as a subject, even if only from a distance. In his earliest self-portrait, which dates from his students days in Munich and has the terse title *Selbst* (*Myself*), 1899, 1 (fig. p. 198), Klee is posed as in a photograph, as an athletic young man. In the later self-portraits, by contrast, the aspect of interiority becomes more pronounced. The artist represents himself in the attitude of the melancholy thinker (*Junger männlicher Kopf in Spitzbart, handgestützt* [*Young Man with Goatee, Resting His Head in His Hand*], 1908, 42), as a researcher bent over a microscope (*Zchnng. zu e. Holzschnitt* [*Drawing for a Woodcut*], 1909, 39), or emphasizes the intellectual aspect of his work, as in *Abwägender Künstler* (*Pondering Artist*), 1919, 73 (fig. p. 246). The crowning high point of the group of self-portraits is the watercolor version of the lithograph based on the drawing *Versunkenheit* (*Meditation*), 1919, 75, in which Klee depicts himself as an artist who no longer turns his gaze outward but rather, inward, in meditation (fig. p. 247).

Still largely unknown is a group of thirty-seven grotesque representations, which Klee drew on transfer paper with a lithographic pen or lithographic chalk in 1912. They date from the same time as his illustrations for Voltaire's *Candide* but seem even more spontaneous and immediate (fig. p. 137). The irregularly cut, often intentionally soiled, small-format sheets—some of them no bigger than a scrap—are as it were artistic provocations, in which Klee undermines any pretension to aesthetic purity.

The grotesque is also present in the ironic and enigmatic "political" drawings in the Livia Klee Donation, in which Klee in 1933 gave expression to his critical view of Nazism and Hitler's seizure of power, and returns in a large group of drawings from 1938 and 1939, in which the artist created a veritable naturalist's cabinet of eccentric, often ambiguous, and sometimes comical creatures from the twilight world between the human and animal kingdoms (figs. pp. 172, 249–51, 258, 260).

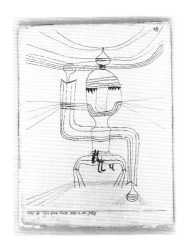

Paul Klee
Der grosse Kaiser reitet in den
Krieg, 1920, 68
The Great Emperor Rides to War

The Polychrome Sheets

In terms of their chronology, artistic techniques, and subjects, the 168 polychrome sheets in the Livia Klee Donation embrace the entire spectrum of Klee's artistic work. The earliest work, a little sketch of a landscape, probably dates from 1901, while the latest ones date from 1940, the year of the artist's death.

The polychrome sheets include works in the most disparate media, including watercolor and gouache, tempera, colored paste, pastel, and oils, as well as colored pencils and colored chalk. In addition to paper (and wrapping paper and newsprint), Klee also used fabrics as the substrate for his images, including cotton, linen, damask, muslin, and burlap. He often combined different media and experimented with plaster of Paris, casein, chalk, and wax primings.

Typical of this complex materiality is the sheet *Der grosse Kaiser, zum Kampf gerüstet* (*The Great Emperor, Armed for Battle*), 1921, 131 (fig. p. 252), an ironic look back at the fall of the German Empire at the end of World War I. First Klee used the oil transfer method to transfer the outlines of his drawing *Der grosse Kaiser reitet in den Krieg* (*The Great Emperor Rides to War*), 1920, 68 (fig.) to a plaster priming placed on a piece of linen. Then he watercolored the resulting fields and stripes and enclosed them in a border of Indian ink. Finally he mounted the image substrate on cardboard and framed it with black watercolor.

The early colored works on paper (1905–12) are primarily portraits, beginning with representations of Klee's wife, in *Lily*, 1905, 32, and his son Felix (fig. p. 253). From 1910 on there are small grotesque or imaginary portraits that point to the new direction of Klee's work as a member of Der Blaue Reiter (The Blue Rider; fig. p. 254).

The watercolors *Tunesische Scizze* (*Tunisian Sketch*), 1914, 212 (fig. p. 255) and *In den Häusern v. St. Germain* (*In the Houses of St. Germain*), 1914, 110 (fig. p. 256) represent a valuable addition to the Zentrum Paul Klee's collection, since Klee produced very few sheets on his journey to Tunisia in 1914. *Tunisian Sketch* is drawn with rough strokes, while in *In the Houses of St. Germain* the artist reduces the rectangle of the picture plane to glowing fields of color, a technique that is typical of this period in his career.

A major work from Klee's time at the Bauhaus in Weimar is the sheet *Scheidung Abends* (*Separation in the Evening*), 1922, 79, in which he gave artistic form to insights from his analytic activity as a teacher, with masterful command of glazing technique (fig. p. 257).

More than two thirds of all the colored works in the Livia Klee Donation date from 1933 to 1940, the last seven years of Paul Klee's creative activity. In two impressive works from the year of the Nazis' seizure of power, *von der Liste gestrichen* (*Struck*

from the List), 1933, 424 (fig. p. 258) and *Geheim Richter* (*Secret Judge*), 1933, 463 (fig. p. 260), Klee gives nightmarish expression to his forebodings about the true character of the new rulers.

The treasures of the years 1934 to 1940—ninety-seven works from Klee's years in exile in Bern—include such celebrated works as *dieser Stern lehrt beugen* (*This Star Teaches Bending*), 1940, 344 (fig. p. 259) and *Schwefel-Gegend* (*Sulfur Region*), 1937, 255 (fig. p. 261), but they also contain many works that do not bear out the conventional view of the artist's late work. These include the sheets *hungriges Mädchen* (*Hungry Girl*), 1939, 671 (fig. p. 262) and *Fall-Bäume* (*Descending Trees*), 1939, 280 (fig. p. 263) as well as a series of almost monochrome sheets that do not appear in the catalogue of Klee's works, in which the artist seems to anticipate *art informel* (fig. p. 264).

The Reverse-Glass Paintings

With seven works from the Livia Klee Donation and the holdings of the former Paul-Klee-Stiftung as well as additional works on loan from private collections, the Zentrum Paul Klee has in its possession three quarters of the fifty-seven reverse-glass paintings by Paul Klee that are known to exist today. They include a surprising contribution to the group of family portraits, a portrait of Klee's father, Hans, that bears the laconic title *m Vater* (*My Father*), 1906, 23 (fig. p. 265). Klee painted the glass pane with a coat of opaque black Indian ink and cut the features of his father's portrait into it with fine engraver's strokes. He then placed a white ground behind it, causing his father's imposing aspect to emerge even more powerfully.

Another work from the Livia Klee Donation, *Mädchen, sich bückend, von einem schlangenartigen Dackel gefolgt* (*Girl, Stooping, Followed by a Snake-Like Dachshund*), 1906, 22 (fig. p. 266), which dates from the same year, shows how multifaceted and diverse in its subjects Klee's early work was, even in the field of reverse-glass painting. It thematizes carnality and sexual desire with blunt and unequivocal allusions, while at the same time defamiliarizing them with reminiscences of the art of the Japanese woodcut.

The Panel Paintings

In addition to ten major paintings from the last three years of Klee's creative activity, the Livia Klee Donation's forty-six panel paintings also include important works from various phases of his career. The donation's earliest painting is the oil painting *Mädchen mit Krügen* (*Girl with Jugs*), 1910, 120 (fig. p. 267), which is one of the artist's first attempts to reduce his painting to color fields and organize the painting's pictorial space as a plane. The influence of Pablo Picasso and Henri Matisse is unmistakable.

241

LIVERPOOL JOHN MOORES UNIVERSITY
LEARNING SERVICES

Created nine years later, the painting *Junger Proletarier* (*Young Proletarian*), 1919, 11 (fig. p. 268) is one of the few works in which Klee grapples directly with his contemporary social and political milieu. Six months after the November Revolution of 1918, which led to the abdication of the last German emperor at the end of World War I, the Bavarian Soviet Republic was proclaimed in Munich. Klee took a stand and joined the Activist Committee of Revolutionary Artists. When the Soviet Republic was suppressed in July 1919, he temporarily retreated to Switzerland, because he was afraid he would be arrested.

In that same year, Klee painted two works that are closely related stylistically but have contrasting subjects, »*Felsenlandschaft*« (*m/Palmen und Tannen*) ("*Rocky Landscape*" [*with Palms and Fir Trees*]), 1919, 155 (fig. p. 171) and *mit der Marionette* (*With the Marionette*), 1919, 159. With their highly abbreviated, emblematic representations of plants, sun, moon, and stars and their architectural motifs, they are typical of Klee's growing tendency to incorporate symbols into his works toward the end of World War I, a practice that established his reputation as a mystical artist detached from the world. The paintings *Städtebild* (*rot/grün gestuft*) (*Picture of a Town* [*Red-Green Gradated*]), 1923, 90 (fig. p. 269) and *Harmonie der nördlichen Flora* (*Harmony of the Northern Flora*), 1927, 144 (fig. p. 270) illustrate the wide range of Klee's abstract creative output during his period as a teacher at the Staatliches Bauhaus in Weimar and Dessau. The earlier work was painted in Weimar and the later one in Dessau. Both are examples of the so-called square paintings, which are based on rows of different-colored square and rectangular surfaces and attest to Klee's systematic study of the theory of color. The painting from the Weimar Bauhaus period is one of the earliest examples of the group. With its tonal chromatic movements and its allusions to architectural elements such as domes and arches, it represents an intuitive and associative treatment of its subject. By contrast, the painting *Harmony of the Northern Flora*, with its precise geometric grid and its cool, reduced use of color, is marked by a fundamentally distanced and analytic approach.

The paintings *Ranke* (*Tendril*), 1932, 29 (fig. p. 271) and *durch ein Fenster* (*Through a Window*), 1932, 184 (fig. p. 272) are masterpieces of what is called the artist's pointillist phase of 1930 to 1932. During these years, Klee applied the paint in dots and distributed it in patterns across the surface of the work in imitation of the divisionist technique of the French neoimpressionists. In *Tendril*, he condensed light, air, and water—the organic elements of life and growth—into symbols. In *Through a Window*, he refined the principle of his square paintings by adding the technique of the pointillistic application of paint, turning it into a transparent artistry of light. With eighteen pieces, the artist's late work—he emigrated to Bern in December 1933—

figures prominently among the panel paintings in the Livia Klee Donation. It is only possible to discuss three of them as examples here, without forgetting that the donation also contains other works of extraordinary importance, including *Katastrophe der Sphinx* (*Catastrophe of the Sphinx*), 1937, 135 (fig. p. 273), *Blick aus Rot* (*Glance out of Red*), 1937, 211 (fig. p. 143), and *Wellenplastik* (*Wave Sculpture*), 1939, 1128 (fig. p. 274).

Typical of Klee's late style is the painting *Der Graue und die Küste* (*The Gray Man and the Coast*), 1938, 125 (fig. p. 275), with the reduction of its artistic means to succinct, almost hieroglyphic signs that depend on the context for their symbolic content.

In *The Gray Man and the Coast*, Klee used a piece of double burlap as his substrate, priming it and painting it with colored paste. The painting's palette is restricted to blue and shades of gray. A zigzag line traverses the painting's surface from top to bottom, dividing it into horizontal segments. Thanks to Klee's choice of title, we perceive the line as a coastline and feel as if we were looking down from high above at a fjord landscape. We read the blue region as ocean, the curved lines as boats, and the thick horizontal stroke with three dots above it in the middle of the painting as a ship.

This way of looking at the image shifts abruptly when we focus on the "inside" of the zigzag shapes or the "gray man" in the upper left-hand corner of the painting. Now we no longer seem to be looking at the objects from above, but from in front. The key to this change of perspective, which may be regarded as an ambiguous commentary on visual perception, lies in the role of the "gray man" as a paradigmatic observer. He is at once the subject of perception and a mirror of the objects perceived.

The painting *blaue Blume* (*Blue Flower*), 1939, 555 (fig. p. 154) is Klee's homage to the Romantic poetry of Novalis's fragmentary novel *Heinrich von Ofterdingen* as well as to the color blue as a symbol of the Romantic longing for the infinite. At the end of his life, Klee once more gave potent expression to his affinity with the spiritual world of Romanticism, which had influenced his artistic thought decisively during World War I.

Ohne Titel (*Letztes Stillleben*) (*Untitled [The Last Still Life]*, 1940, fig. p. 277)—the phrase is a posthumous designation coined by Felix Klee, and it has become established as the title of the work in the scholarly literature—is one of the paintings left in the studio at Kistlerweg 6 after Paul Klee's death (fig. p. 244). The master's spirit lives on in this painting, with its irony and poetic ambiguity, more than in any other of his works. One last time, the *Engel, noch hässlich* (*Angel, Still Ugly*), 1940, 26 (fig. p. 140) peers out from the image, and an archaic statuette seems to proffer an impish greeting. Two little figures riding bicycles upside down in the magic wood in the upper left seem to be Klee's last reminiscences of the fantasy world of childhood. In

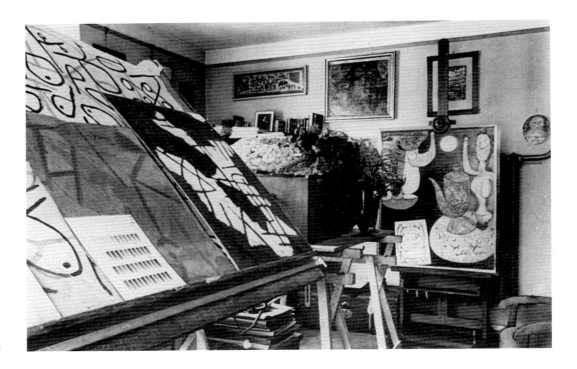

Paul Klee's studio in Kistlerweg 6, photographed after his death, 1940

The Last Still Life, the artist once again passes creatures from his drawings, like the "ugly angel," in review, and in doing so points to the paramount importance of his drawings for his entire creative output.

The Hand Puppets

The hand puppets in the Livia Klee Donation constitute a unique treasure trove for the Zentrum Paul Klee. The artist made them for his son Felix between 1916 and 1925 out of the most disparate materials. Klee followed the often "drastic"[3] performances that Felix gave in the puppet theater, which he had also made, with great enjoyment. He made the first figures—"Kasperl," "Gretl," "Sepperl," "The Devil," "The Policeman," and "Lord Death" (fig. p. 279)—for his son's ninth birthday. With a single exception (Lord Death), they were all destroyed in a bombing raid in Würzburg in 1945. For the design of the heads and costumes, Klee at first restricted himself to plaster of Paris and simple fabrics. With time he incorporated other, more unusual materials. For the heads he used a cow bone and nutshells, rabbit skin and genuine bristles, matchboxes, and even an electrical outlet. For the costumes—made by Sasha von Sinner, creator of the famous Sasha dolls, using scraps from Lily Klee's sewing box—cotton fabrics with various patterns as well as linen, silk, velvet, corduroy, and leather put in their appearance.

As Klee expanded the materials he used for his hand puppets, he also broadened his cast of characters. "Kasperl," "Sepperl," and "Gretl" were soon joined by a "Bandit,"

Puppet theater with the puppets Lord Death and Sepperl (destroyed in 1945), frame and decorations by Paul Klee, 1924

a "Russian Peasant," and a "White-Haired Eskimo," as well as many others, including such curious fellows as the "Genie of the Matchbox" (fig. p. 280) and the "Electrical Spook," the "Big-Eared Clown" (fig. p. 281), and the "Devil with Glove-Ringed Fingers."

In all, Klee created some fifty hand puppets between 1916 and 1925, of which thirty have been preserved. The theater, made out of old picture frames and scraps of fabric, also included stage sets, which have survived in Dessau. The first stage set was composed of illustrations that Klee had taken from *Der Blaue Reiter* almanac.⁴ Later stage sets bear the stamp of the abstract formal language of the Bauhaus (fig.).

Although the hand puppets are not works of art in the strict sense, they reflect essential qualities of Paul Klee's creative output: an almost instinctive assurance in the use of artistic elements and techniques, an unbridled zest for experimentation with new design materials, a boundless imagination that assimilates any and every material to its purposes, and a poetic spirit that causes images and words to come together.

Notes

1. Konrad Tobler, "Zum 80. Geburtstag von Livia Klee-Meyer: In ihr ist das Bauhaus lebendig," *Berner Zeitung*, June 5, 2002, p. 25.
2. Tobler 2002 (see note 1), p. 25.
3. Felix Klee, *Paul Klee: Puppen, Plastiken, Reliefs, Masken, Theater* (Neuenburg, 1979), p. 16. This book is available in English as *Paul Klee: Puppets, Sculptures, Reliefs, Masks, Theatre*, trans. James Emmons (Bern at al., 1979).
4. Comp. Wassily Kandinsky and Franz Marc, *The Blaue Reiter Almanac*, ed. Klaus Lankheit, trans. Henning Falkenstein (London, 1974).

LIVERPOOL JOHN MOORES UNIVERSITY
LEARNING SERVICES

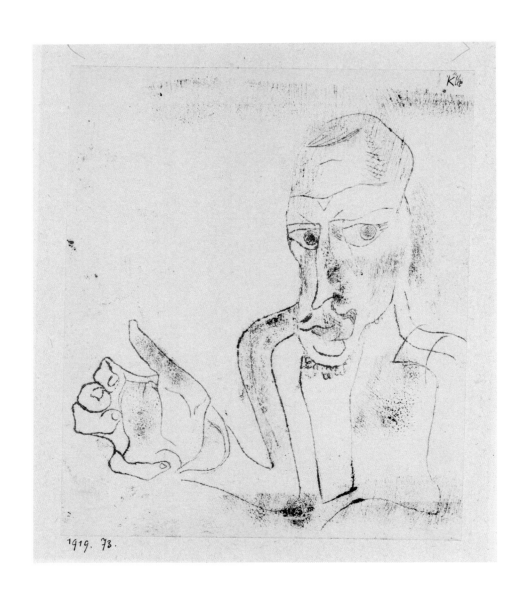

Paul Klee
Abwägender Künstler, 1919, 73
Pondering Artist

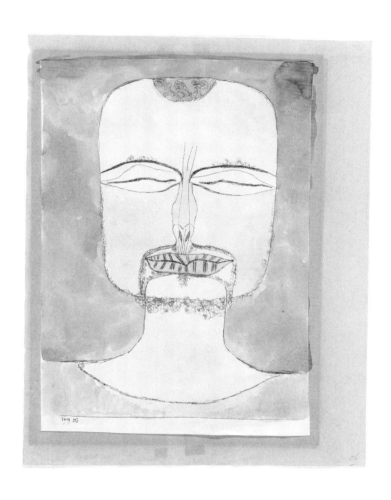

Paul Klee
nach der Zeichnung 19/75 (Versunkenheit), 1919, 113
Copy of the drawing 19/75 (Meditation)

Paul Klee
Angst, 1912, 155
Fear

Paul Klee
eilen nach Schutz, 1933, 389
Running for Shelter

Paul Klee
Scham los, 1939, 416
Shame Less

Paul Klee
Mister Kin Lade, 1939, 684
Mr. Jawbone

251

LIVERPOOL JOHN MOORES UNIVERSITY
LEARNING SERVICES

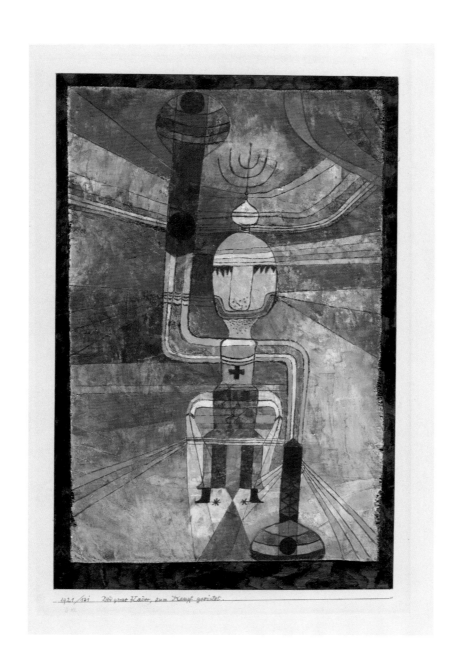

Paul Klee
Der grosse Kaiser, zum Kampf gerüstet, 1921, 131
The Great Emperor, Armed for Battle

Paul Klee
Kinderbildnis, 1908, 64
Portrait of a Child

Paul Klee
Maske, 1912, 57
Mask

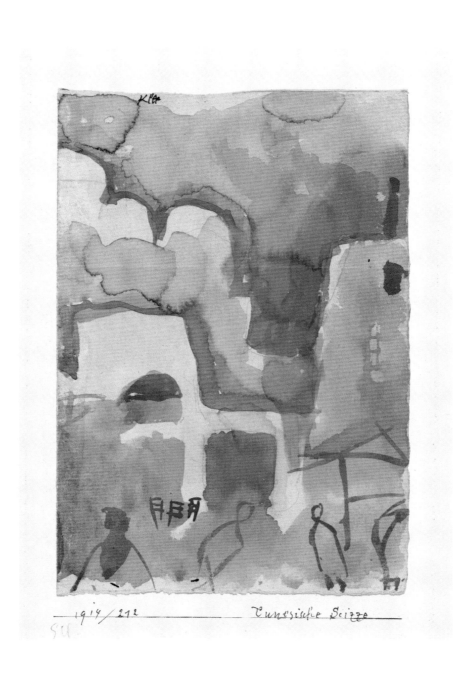

Paul Klee
Tunesische Scizze, 1914, 212
Tunisian Sketch

255

LIVERPOOL JOHN MOORES UNIVERSITY
LEARNING SERVICES

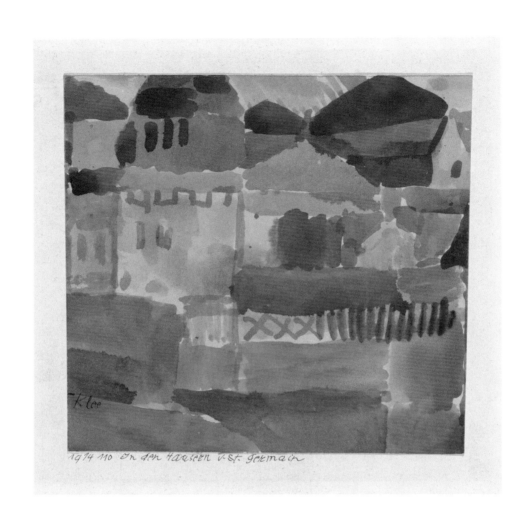

Paul Klee
In den Häusern v. St. Germain, 1914, 110
In the Houses of St. Germain

Paul Klee
Scheidung Abends, 1922, 79
Separation in the Evening

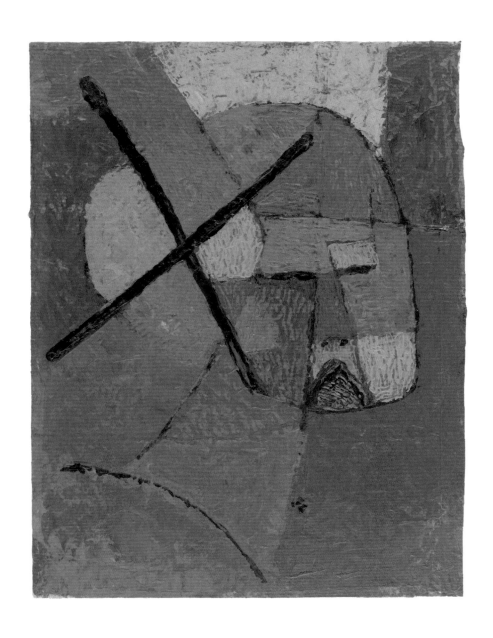

Paul Klee
von der Liste gestrichen, 1933, 424
Struck from the List

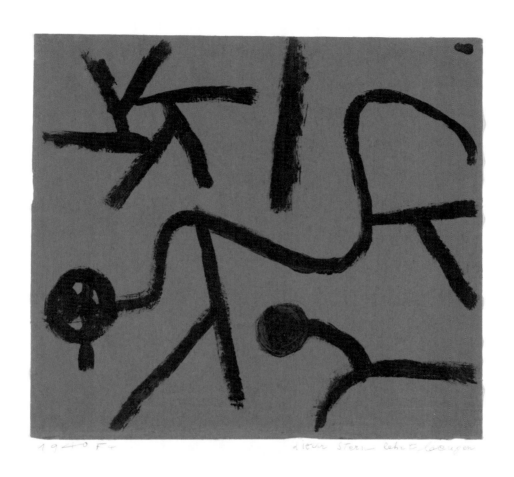

Paul Klee
dieser Stern lehrt beugen, 1940, 344
This Star Teaches Bending

259

Paul Klee
Geheim Richter, 1933, 463
Secret Judge

Paul Klee
Schwefel-Gegend, 1937, 255
Sulfur Region

LIVERPOOL JOHN MOORES UNIVERSITY
LEARNING SERVICES

Paul Klee
hungriges Mädchen, 1939, 671
Hungry Girl

262

Paul Klee
Fall-Bäume, 1939, 280
Descending Trees

Paul Klee
Ohne Titel (Ineinander Gefügtes), um 1939
Untitled (Joined Together)

Paul Klee
m Vater, 1906, 23
My Father

265

LIVERPOOL JOHN MOORES UNIVERSITY
LEARNING SERVICES

Paul Klee
Mädchen, sich bückend, von einem schlangenartigen
Dackel gefolgt, 1906, 22
Girl, Stooping, Followed by a Snake-like Dachshund

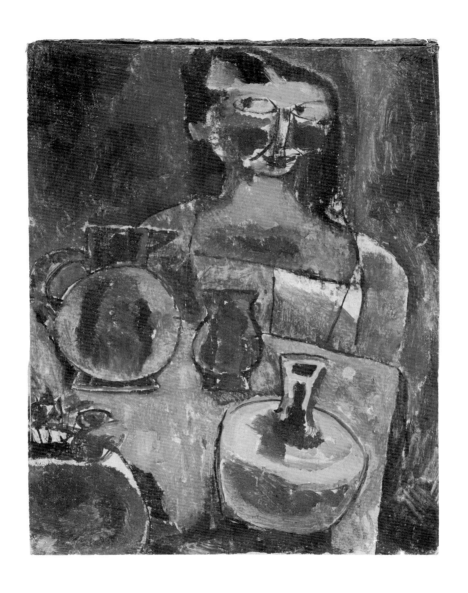

Paul Klee
Mädchen mit Krügen, 1910, 120
Girl with Jugs

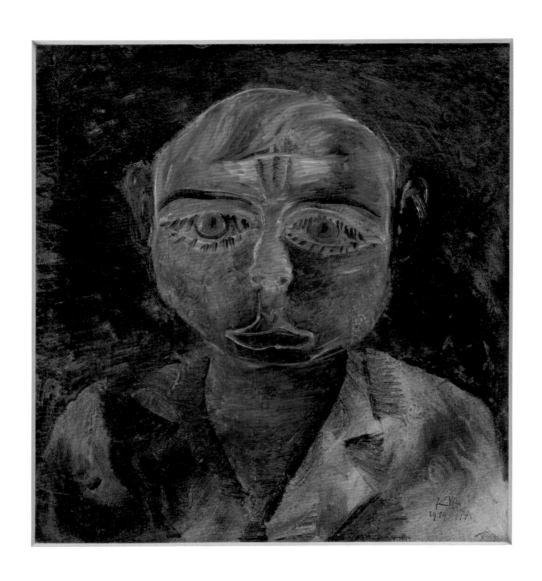

Paul Klee
Junger Proletarier, 1919, 111
Young Proletarian

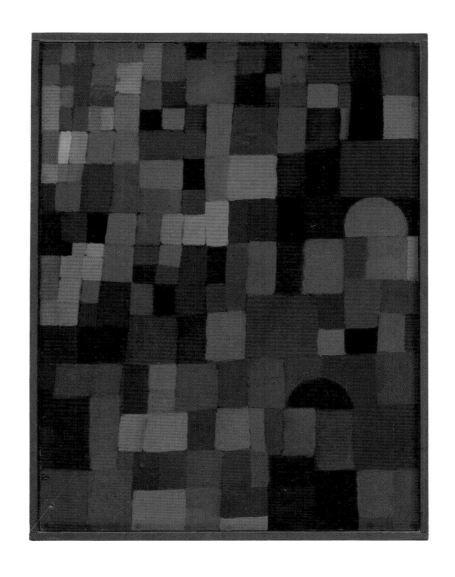

Paul Klee
Städtebild (rot/grün gestuft), 1923, 90
Picture of a Town (Red-green Gradated)

LIVERPOOL JOHN MOORES UNIVERSITY
LEARNING SERVICES

Paul Klee
Harmonie der nördlichen Flora, 1927, 144
Harmony of the Northern Flora

Paul Klee
Ranke, 1932, 29
Tendril

271

LIVERPOOL JOHN MOORES UNIVERSITY
LEARNING SERVICES

Paul Klee
durch ein Fenster, 1932, 184
272 Through a Window

Paul Klee
Katastrophe der Sphinx, 1937, 135
Catastrophe of the Sphinx

273

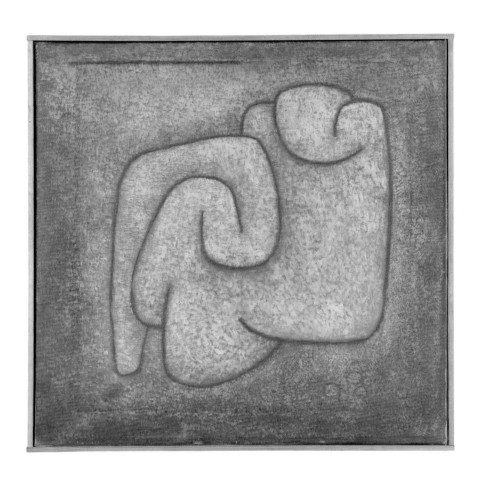

Paul Klee
Wellenplastik, 1939, 1128
Wave Sculpture

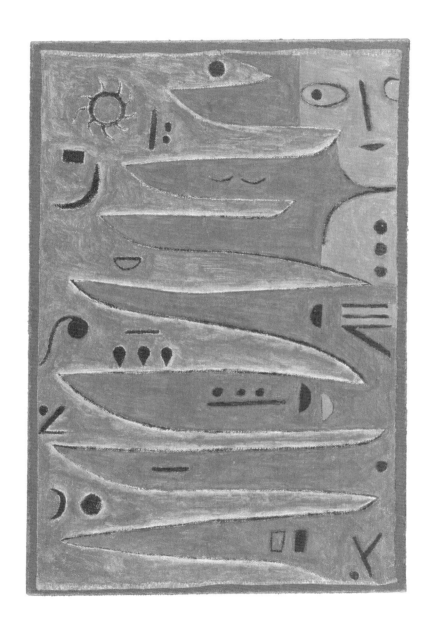

Paul Klee
der Graue und die Küste, 1938, 125
The Gray Man and the Coast

LIVERPOOL JOHN MOORES UNIVERSITY
LEARNING SERVICES

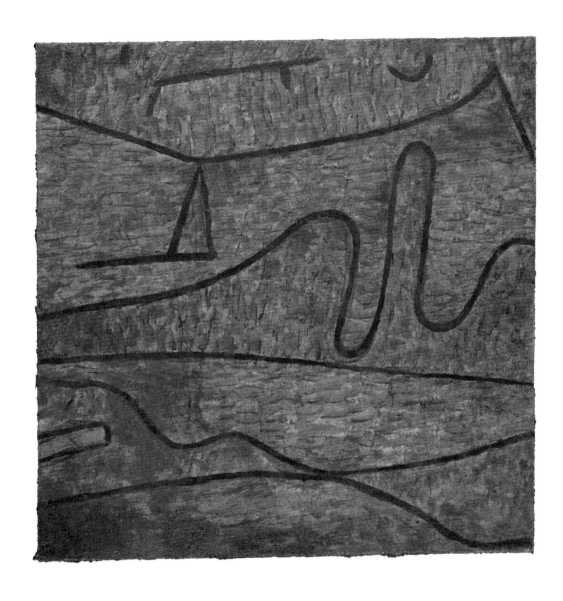

Paul Klee
Klippen im Fahrwasser, 1939, 668
Cliffs in the Channel

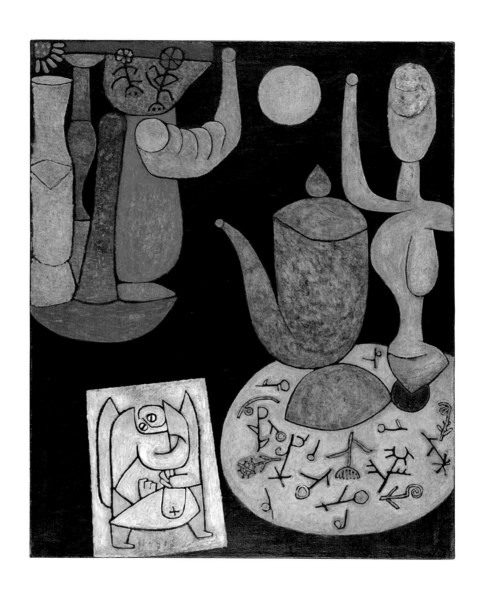

Paul Klee
Ohne Titel (Letztes Stillleben), 1940
Untitled (The Last Still Life)

Paul Klee
Ohne Titel (Selbstporträt), 1922
Untitled (Self Portrait)

Paul Klee
Ohne Titel (Herr Tod), 1916
Untitled (Lord Death)

279

LIVERPOOL JOHN MOORES UNIVERSITY
LEARNING SERVICES

Paul Klee
Ohne Titel (Zündholzschachtelgeist), 1925
Untitled (Genie of the Matchbox)

Paul Klee
Ohne Titel (Breitohrclown), 1925
Untitled (Wide-Eared Clown)

LIVERPOOL JOHN MOORES UNIVERSITY
LEARNING SERVICES

"As I've already said, I think the whole charm of this place lies in the gentle curve of the hill. If we look at the terrain through the eyes of a topographer, work it like a farmer works his field, and only then move on to the work of the architect, we will definitely be able to create a place that is sheltered, but not isolated."

Renzo Piano, architect

The building takes shape,
April 2004 to September 2004

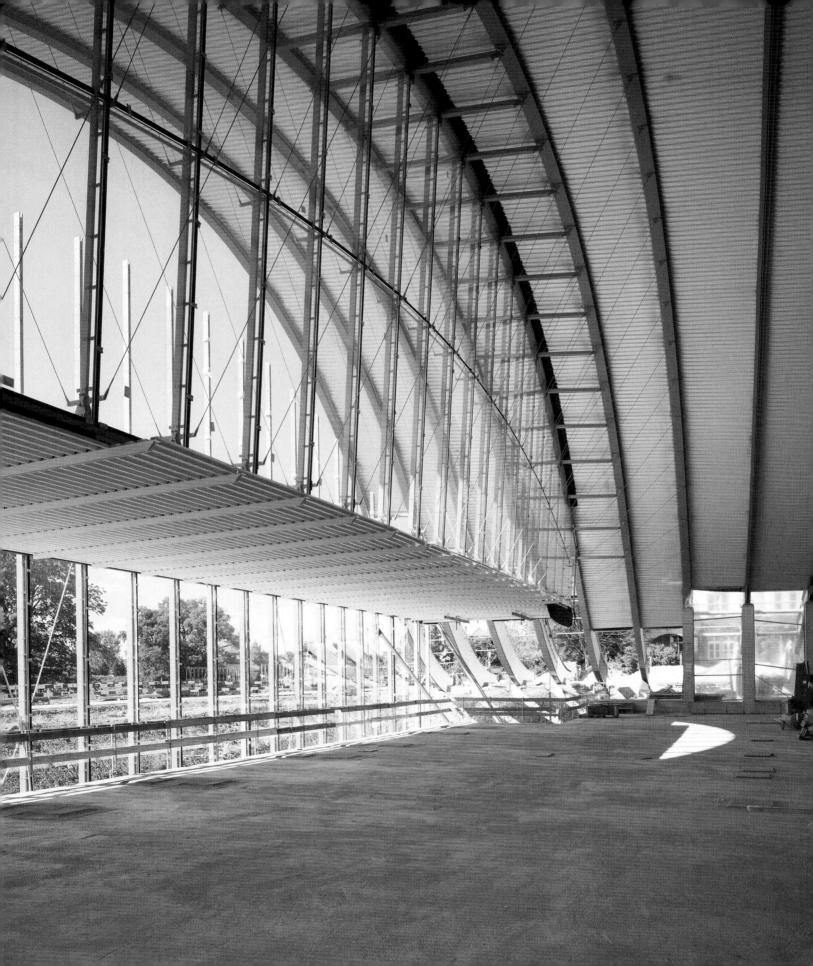

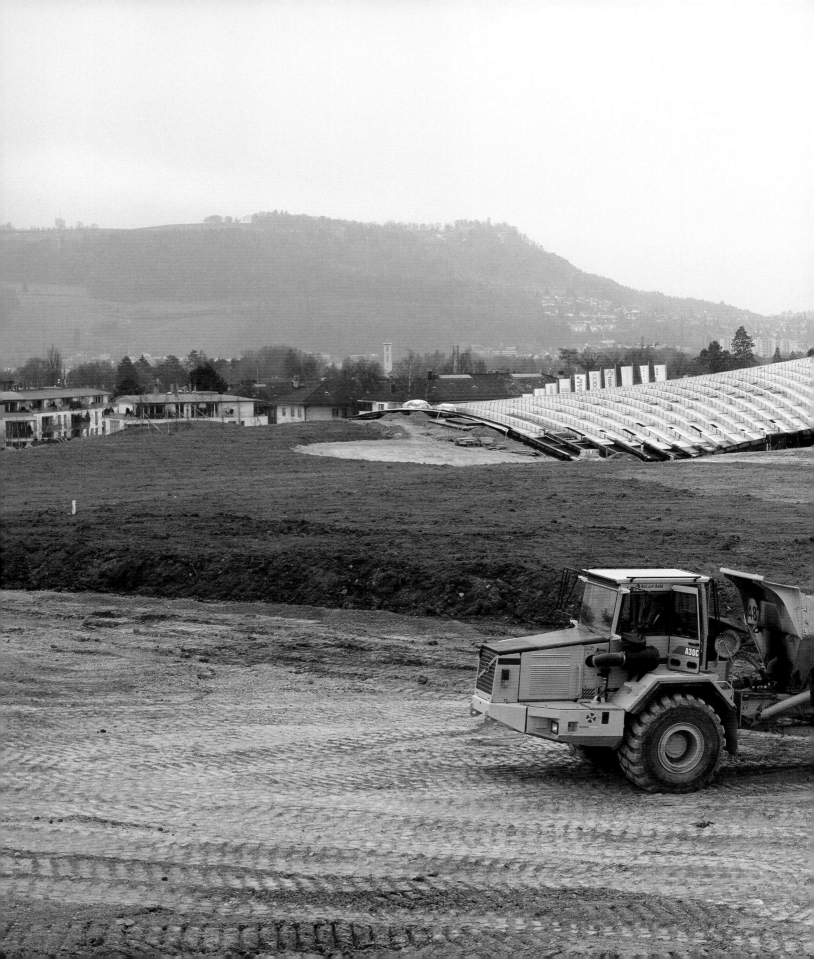

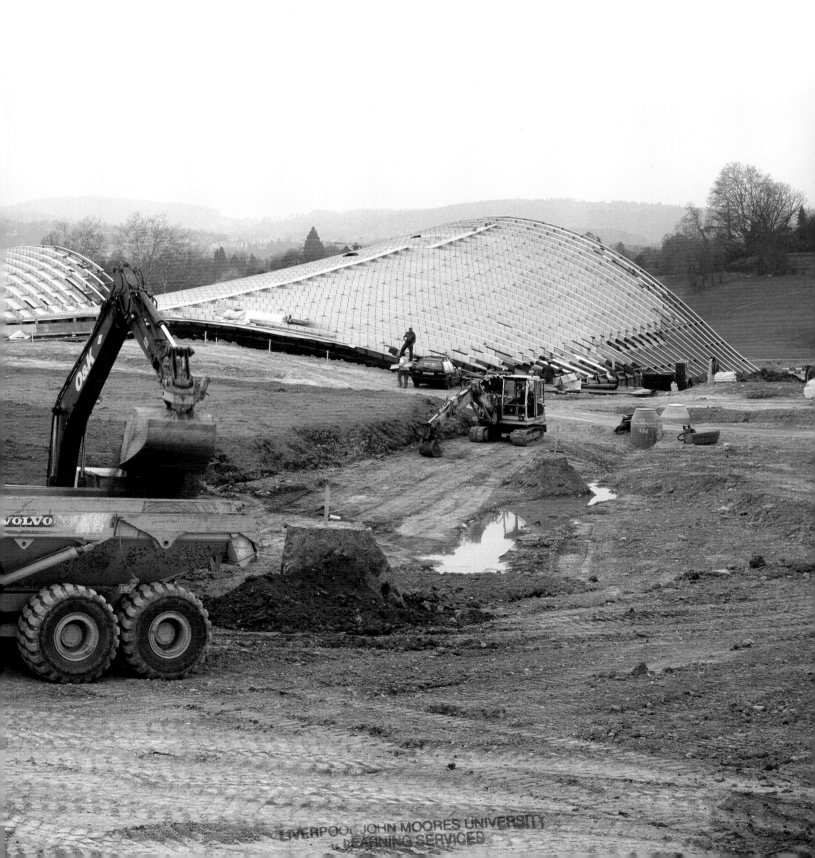

LIVERPOOL JOHN MOORES UNIVERSITY
LEARNING SERVICES

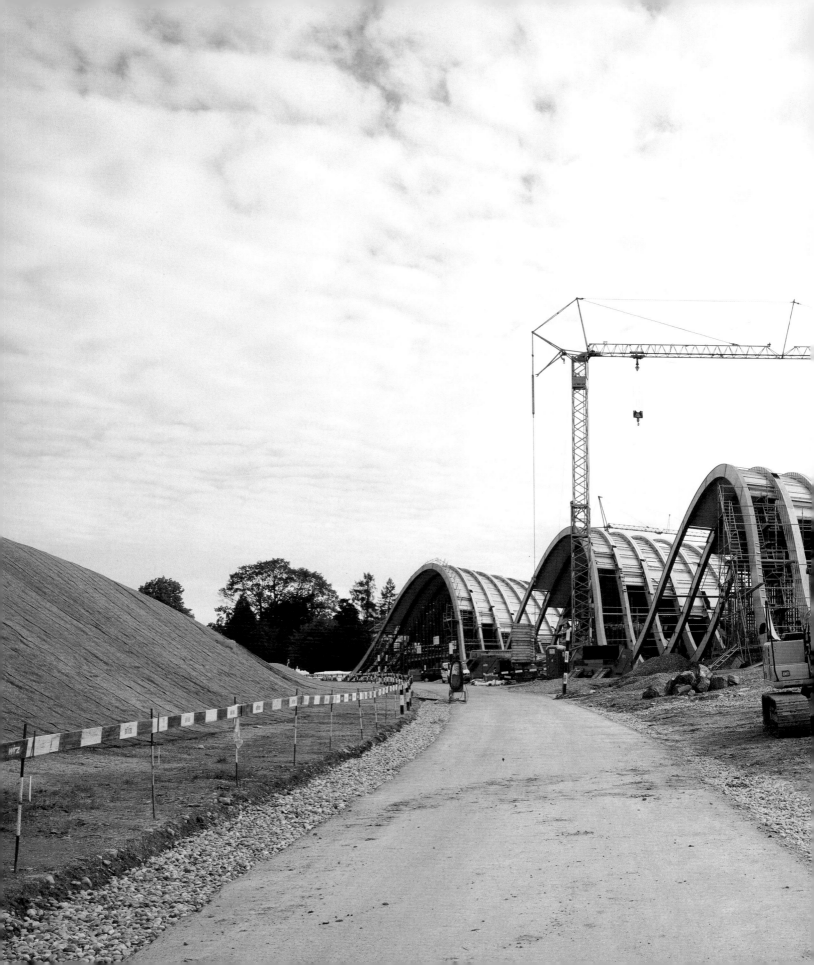

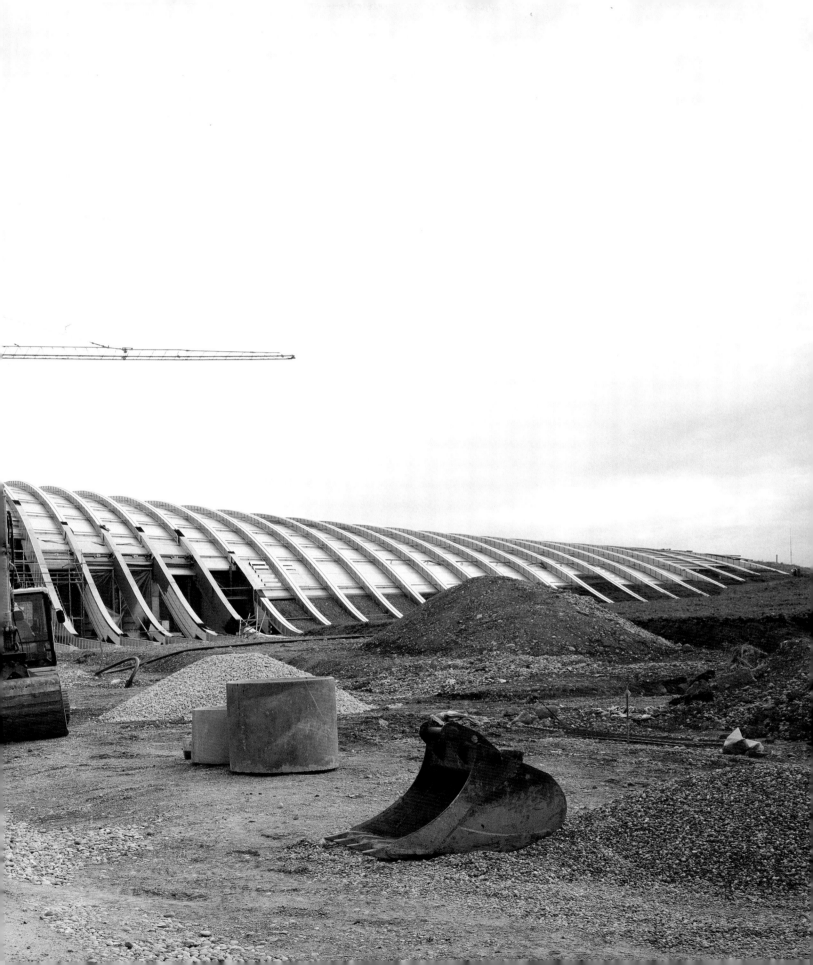

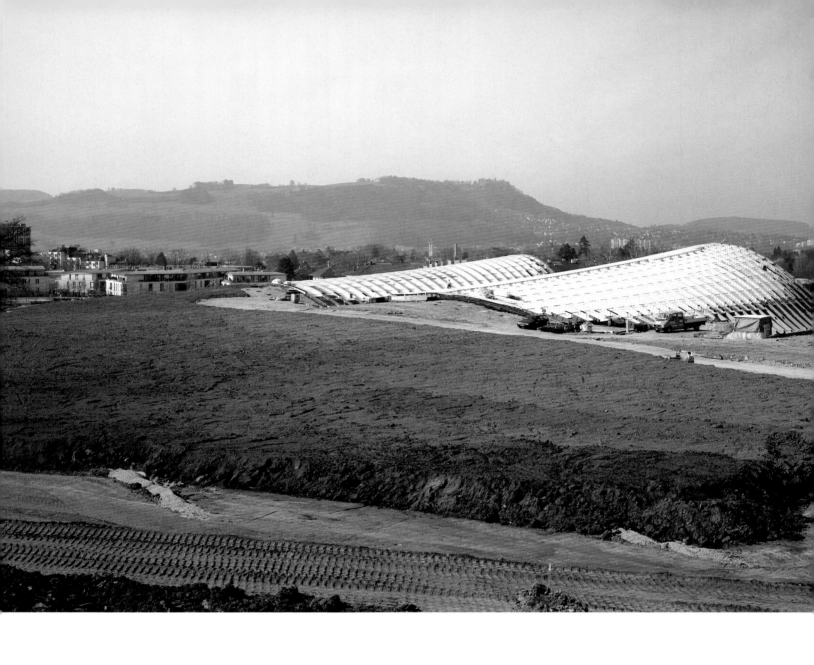

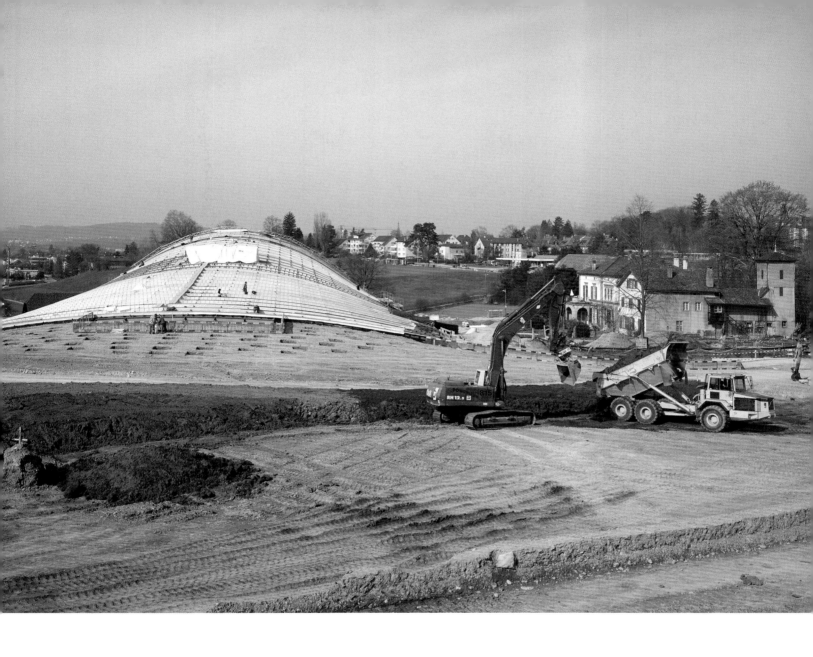

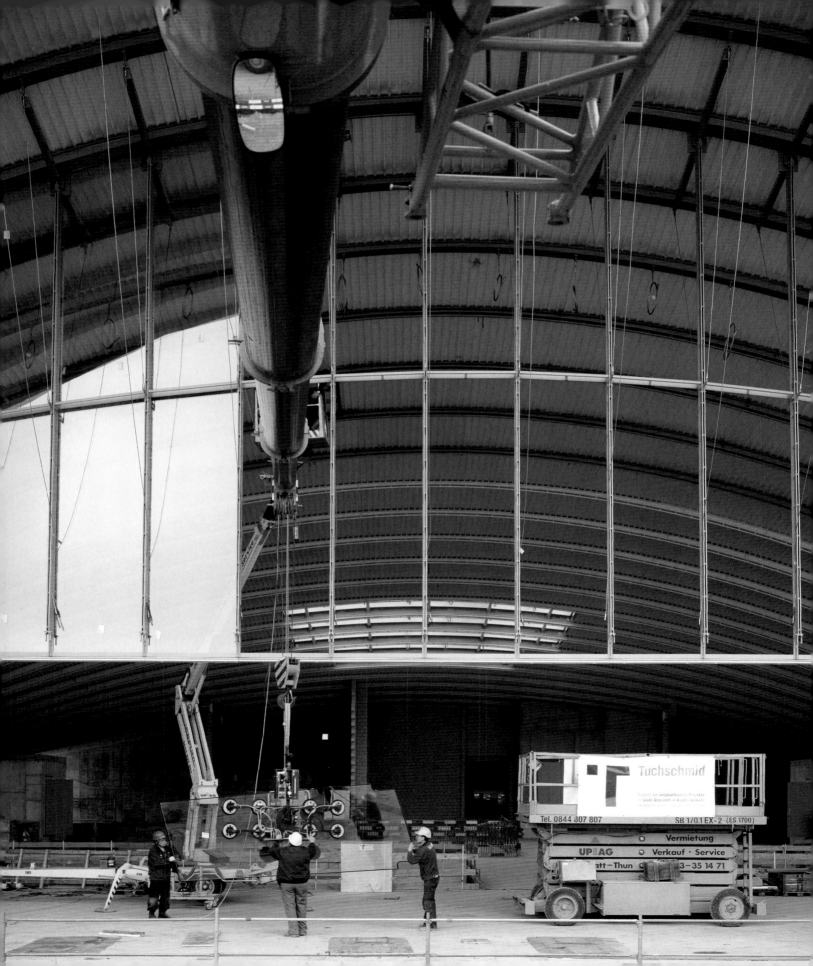

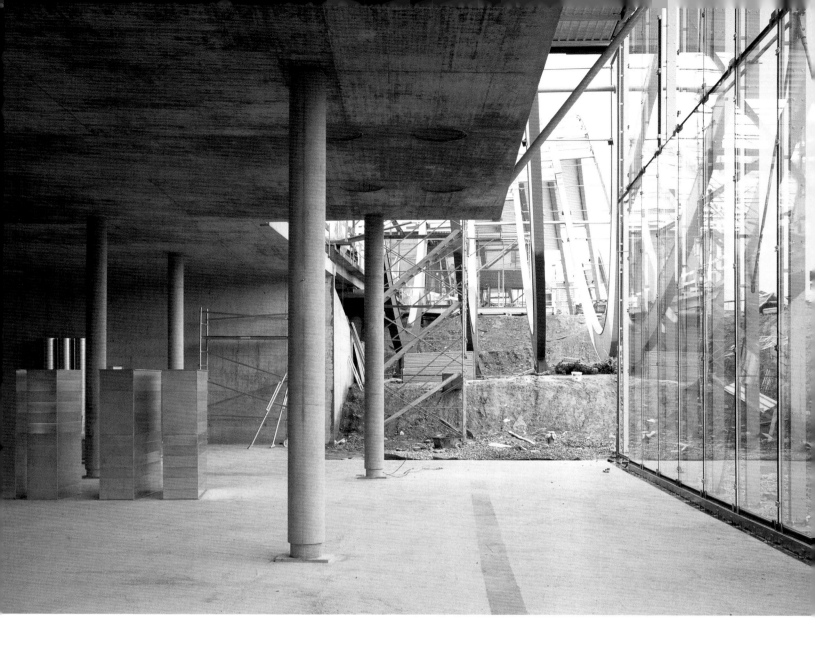

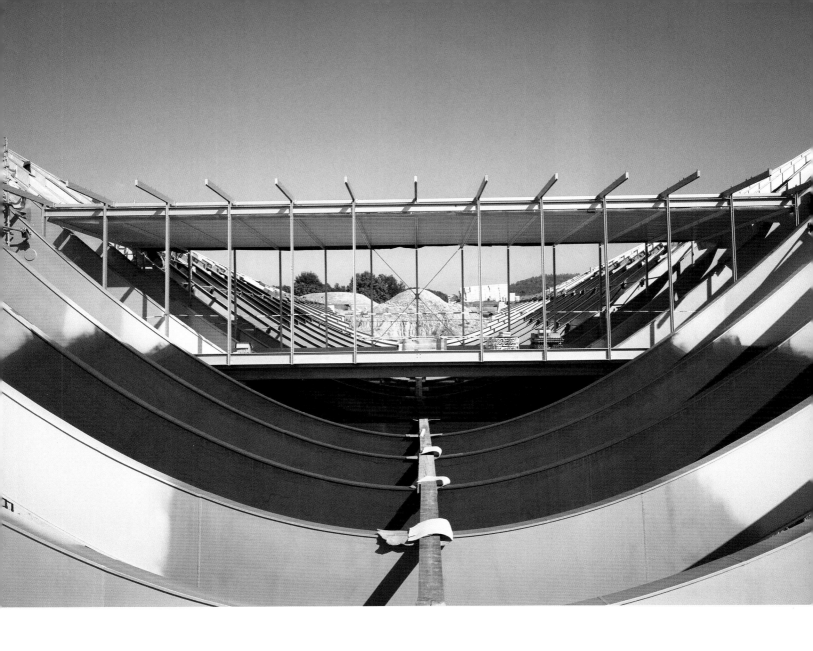

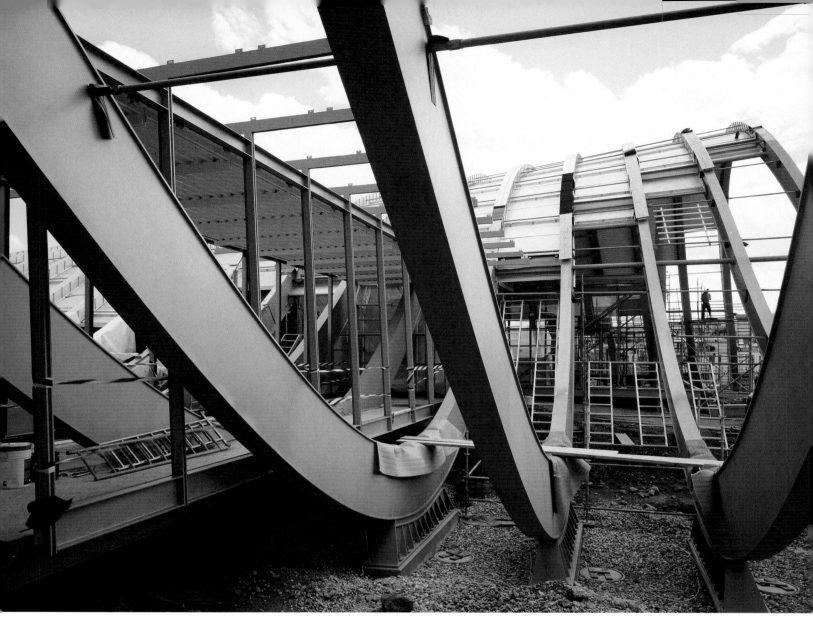

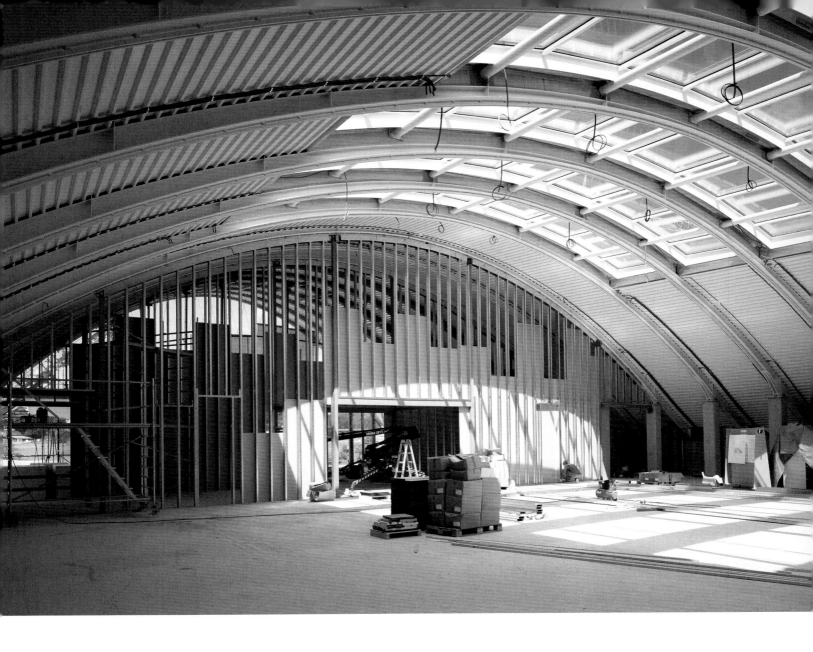

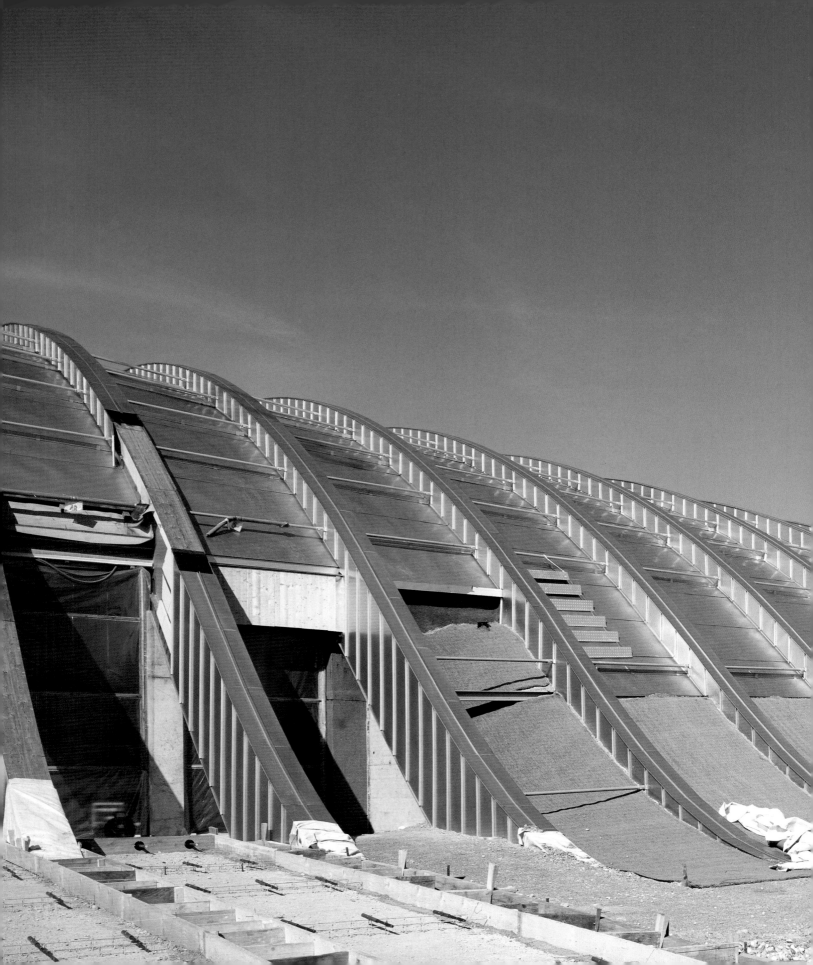

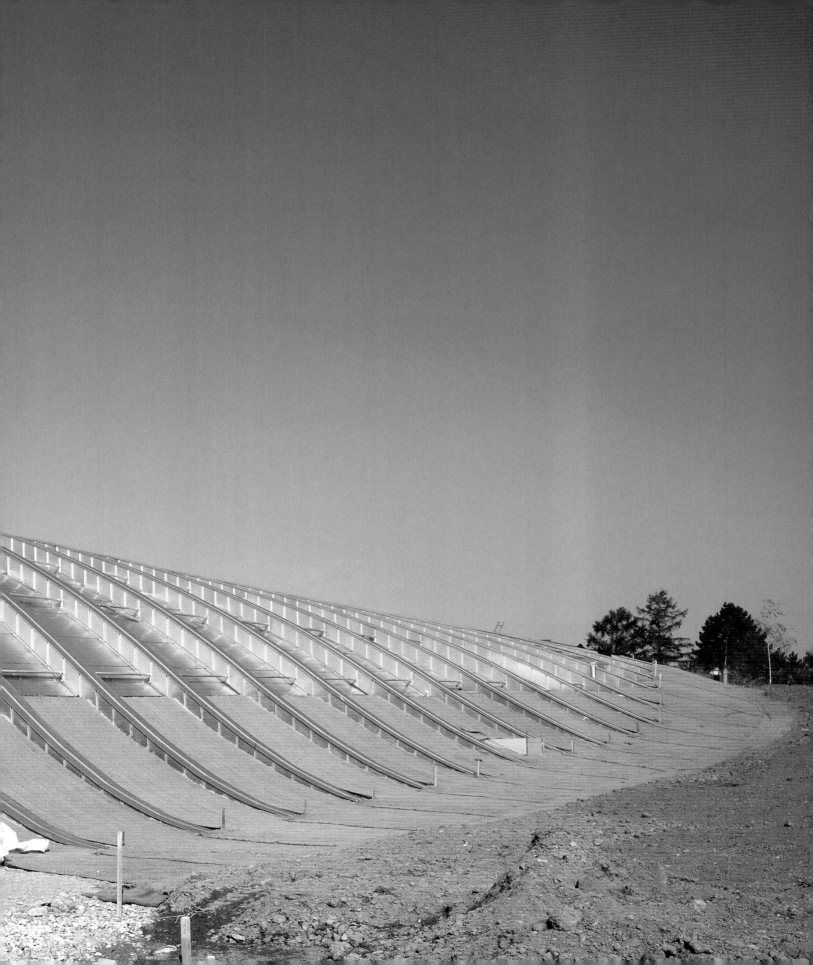

Realization: The Making of a Cultural Center

LIVERPOOL JOHN MOORES UNIVERSITY
LEARNING SERVICES

Bern and the Zentrum Paul Klee

Andreas Marti, Director, Zentrum Paul Klee, Bern

Peter Schmid, Member of the Cantonal Governement (1979–98), Director of Education (1990–98), and President of the Maurice E. and Martha Müller Foundation

Dr. Klaus Baumgartner, Mayor of Bern (1993–2004) and first Vice President of the Stiftung Paul Klee-Zentrum (2000–04)

Innovations do not have it easy. This is not only true in Bern, but it is especially true in Bern. The idea of building a museum devoted entirely to Paul Klee was greeted by the public with a wide variety of responses. From the beginning, art lovers in Bern, Switzerland, and Europe as a whole reacted with enthusiasm. The same was true in the political arena. The authorities of the City, Canton, and Civic Community (Burgergemeinde) of Bern responded very positively to the Klee and Müller families' initiatives. Despite the risks, they gave free rein to their enthusiasm (a rare thing in politics), promoted and supported the project, and worked for its success at every stage. Bern's culture scene reacted quite differently. In the music world, initial rejection and skepticism soon gave way to interest in a rich and diverse collaboration. Parts of the art scene in the city of Bern, however, continued to reject the project right up to its inauguration, sometimes openly but more often behind closed doors. That is unfortunate. The project leaders of the Zentrum Paul Klee sought out their partners in the art and museum world from the beginning, gave them information, and offered to collaborate closely with them. The fact that, not infrequently, their efforts were rewarded with blunt rejection and in part even biting ridicule and wounding contempt for their work is one of the very few negative experiences in what has otherwise been a marvelous project.

Whether their skepticism and reservations are justified will only transpire when the Zentrum Paul Klee has a certain amount of operational experience behind it. But one thing is certain: if the voters of the city and canton of Bern and the politicians had reacted to the founding families' offers and ideas as negatively as portions of the art world have done, the Zentrum Paul Klee would never have been built. Let us take consolation in the words of a singer of Bern dialect songs, who writes and sings in one of them, "Kunscht isch gäng es Risiko" (Art is taking risks).[1]

Great deeds are the work of great individuals. It is thanks to the initiative and gifts of Alexander Klee, Livia Klee-Meyer, as well as Professor Maurice E. Müller and Martha Müller-Lüthi that it was possible to take on this great work.

However, were it not for two politicians and their positive receptijon of those offers, their negotiating skill, and their enormous persistence, the work itself would never have been completed: Peter Schmid, former director of education of the canton, and Dr. Klaus Baumgartner, the former mayor of Bern. They gave the project political backing; managed it with supreme ability and confidence, even in crises and difficult phases; and always lent their unqualified support to the project managers.

Note

1. Mani Matter, "Der Eskimo," Bern-German song, 1966.

Klee Family Initiatives, 1992–97

Andreas Marti, Director, Zentrum Paul Klee, Bern

Alexander Klee, co-founder of the Zentrum Paul Klee and President of the Paul-Klee-Stiftung (1991–2004)

The Klee-Gesellschaft (Klee Society), through its members Werner Allenbach, Rolf Bürgi, Hans Meyer-Benteli, and Hermann Rupf, acquired the artistic estate of Paul Klee from his widow Lily Klee in 1946, shortly before her death, and in 1947 founded the Paul-Klee-Stiftung (Paul Klee Foundation) on the basis of the most important part of those acquisitions. The first considerations for constructing a Klee museum came after this, though the idea was soon rejected. At the time, in view of the existing infrastructure and the synergies between the collection of the Kunstmuseum Bern and the Paul-Klee-Stiftung's holdings, the integration of the Paul-Klee-Stiftung into the Kunstmuseum Bern was found to be preferable. Under an agreement with the Klee-Gesellschaft, Felix Klee, the only son of Paul and Lily Klee, received in late December 1952 well over a thousand works from the estate of Paul and Lily Klee. During his lifetime, Felix Klee guaranteed the cooperation between the two separate complexes of his parents' estate through his dual roles as president of the foundation board of the Paul-Klee-Stiftung and as owner of the Klee estate collection. After his death on August 13, 1990, his heirs and the Kunstmuseum Bern pursued a closer collaboration. It was through these efforts that the construction of a Klee museum in Bern once again became a topic of discussion. Bern was a top choice of location from the start, since the artist had felt at home in Bern, had spent a large part of his life in this city, and had enjoyed his first large-scale retrospective in Switzerland at the Kunsthalle Bern. Moreover, between the inventories of the Paul-Klee-Stiftung and of the Klee family, the two by far largest collections of Paul Klee's works were already situated in Bern. Felix Klee did not leave a will. In 1989, however, he publicly expressed the intention of incorporating his collection into a family foundation, thus both keeping the collection as whole as possible and at the same time making it accessible to the public.[1]

The idea of building a Paul Klee museum goes back to January 13, 1993, when Alexander Klee, Felix Klee's only son and the grandson of Paul and Lily Klee, suggested founding a Klee museum in Bern with the support of the family collection to Dr. Hans

Christoph von Tavel, at the time director of the Kunstmuseum Bern.[2] The director informed the museum commission, and the president of the museum commission, Peter Schmid, then member of the cantonal government, made known to the governments of the Canton and City of Bern that the Klee family was prepared, were a Klee museum to be founded in Bern, to preserve the family collection and make it accessible to the public.

As a result, intensive planning efforts began at the Paul-Klee-Stiftung, at the Kunstmuseum Bern, in the museum commission, in the cultural delegation of Bern's municipal council, and through a working group tasked by the president of the museum commission to outline the political proceedings. In a letter dated June 1, 1993, the Klee family—through its trustee, lawyer Max Beat Ludwig—however asked for patience and for strict confidentiality.

At the Kunstmuseum and in the municipal council's working group, which were considering possible locations, a favored choice swiftly emerged: the former Progymnasium (secondary school) on Waisenhausplatz. At the time, this site seemed especially suitable because of the great synergies that could be expected to arise through its proximity to the Kunstmuseum. The location also had an emotional value, since Paul Klee went to school and wrote and passed his graduation exams here.

On October 13, 1993, Stefan Frey, then a research fellow at the Paul-Klee-Stiftung, presented a number of possibilities for an agreement between the Klee family and the Paul-Klee-Stiftung to the director of the Kunstmuseum Bern.[3]

In spite of the Klee family's request for confidential treatment, an interview with Dr. Hans Christoph von Tavel published in the *Berner Zeitung* on March 11, 1994, shed a first light on the plans for the Klee museum. An April 29, 1994 conversation between Peter Schmid, Dr. Klaus Baumgartner, Max Beat Ludwig, and Dr. Hans Christoph von Tavel proved to be of great importance in furthering the planning efforts. Dr. Baumgartner, then mayor of Bern, argued that a decision was needed very soon. The municipal council, he said, had reserved the building on Waisenhausplatz for the Paul Klee museum, since it shared the view that the location near the Kunstmuseum was ideal. But the City and Canton of Bern needed to know under which conditions the family would be prepared to turn over their collection. Until this was known, he added, it was impossible to put the necessary human and financial resources into the work. Peter Schmid, then director of education in the Canton, likewise pointed out that there was great readiness on the part of the Canton to support the project and to move forward together with the City of Bern.

In discussions with the Klee family representative, Peter Schmid emphasized that the City and Canton were determined to realize the project. The City of Bern would

Dr. Hans Christoph von Tavel, Director of the Kunstmuseum Bern (1980–95)

Andreas Marti, project leader for the Paul Klee-Zentrum (1997–2001) and Founding Director of the Zentrum Paul Klee

Ursina Barandun, member of the project management team of the Paul Klee-Zentrum (1997–2001), Deputy Director and Director of Communication and Outreach at the Zentrum Paul Klee

Federal Court Judge Dr. Lorenz Meyer, member of the project management team of the Paul Klee-Zentrum (1997–2001) and President of the Paul Klee-Stiftung der Burgergemeinde Bern

make the building available, and the Canton would pay the expansion and renovation costs, thus securing the financing of the project.[4] The education director and the mayor visited Livia Klee-Meyer on a number of occasions to negotiate in talks at which her lawyer, Dr. Andreas Jost, was also present.

The April 29, 1994 discussion led further to the creation of an initially informal project management team within the administration, made up by a representative of the City of Bern (lawyer Christoph Reichenau, legal adviser to the City of Bern) and two representatives of the Canton (Andreas Marti, general secretary of the Education Directorate of the Canton of Bern, and Ursina Barandun, research fellow at the Education Directorate of the Canton of Bern). This project management team was predominantly occupied with three tasks. First, a draft was prepared for an agreement between the public bodies of the City and Canton of Bern and the Klee family. Second, talks were held with the Interessengemeinschaft Museum für Gegenwartskunst (Interest Group Museum of Contemporary Art, IGG), aiming at the realization of a combined Paul Klee museum and museum of contemporary art at the Waisenhausplatz schoolhouse site. Third, the formal organization of the project was prepared. Under the leadership of the Kunstmuseum Bern and the Paul-Klee-Stiftung, it was to include the Civic Community of Bern (Burgergemeinde), which in numerous discussions had already stated its readiness to make substantial and in particular financial contributions to the project.[5]

The expanded project management team—now formally appointed—began its work on March 26, 1997. The team was comprised of the following members: the Civic Community of Bern was represented by its vice-president, Dr. Kurt Hauri (until May 27, 1997) and from May 28, 1997, by Dr. Lorenz Meyer, member of the Kleiner Burgerrat (Lesser Civic Council); the City of Bern delegated its legal adviser Christoph Reichenau (until June 30, 1998) and from July 1, 1998, Peter Tschanz, general secretary of the Präsidialdirektion (Presidential Department of the City of Bern); from the Canton of Bern, there was Ursina Barandun. The project leader was Andreas Marti. Before its dissolution on July 31, 2001, the project management team conducted eighty-six sessions, including numerous workshops with museum and construction specialists as well as moderated discussions and a hearing with international museum experts. Over time, the following individuals gave their advice: Dr. Thomas Aebersold, lawyer for the Müller family, Dr. Josef Helfenstein, curator of the Paul-Klee-Stiftung, Ueli Laedrach, Bern's municipal architect, and Toni Stoos, director of the Kunstmuseum Bern. Elisabeth Ryter, MA, managed the project, the Maurice E. and Martha Müller Foundation, and the Stiftung Paul Klee-Zentrum from April 1, 1998 until the end of July 2001.

A July 3, 1997 agreement between the Canton, the Residency Community, and the Civic Community of Bern regarding the creation of a Paul Klee museum and a museum of contemporary art in the city of Bern fixed the fundamentals of the project. In this agreement, Bern's three public bodies reaffirmed their intent to create a Paul Klee museum together—provided that Livia Klee-Meyer and Alexander Klee made available the anticipated gifts and loans.[6]

On July 21, 1997, the project planning reached a decisive juncture when Livia Klee-Meyer donated to the Canton and Residency Community of Bern the works that had come to her from the estate of Felix Klee. She only kept eleven works that remained in her apartment. Her donation came with the condition that all of the works would return to the donor, debt-free and free of charge, if the necessary building and operating loans for the envisaged Paul Klee museum were not approved in legally valid form by December 31, 2001, the construction permit and other necessary administrative approvals not issued by December 31, 2003, or the Paul Klee museum not opened by December 31, 2006. The result of these three conditions was to greatly accelerate the planning efforts, since neither the public bodies involved nor the project leadership wanted the infamy of having voided such a generous gift simply by missing deadlines. Another important milestone came on November 3, 1998: Alexander Klee concluded a long-term loan agreement and a loan agreement with the project management team for works by Paul Klee and for works by artist friends of Paul and Lily Klee. This meant that—with the gift of Livia Klee-Meyer, the loans from Alexander Klee, and the holdings of the Paul-Klee-Stiftung—the future Paul Klee museum would be able to show the world's largest collection of Klee's work. In numbers, more than 40 percent of the nearly ten thousand works encompassed by Klee's œuvre would find a home in the new museum. It cannot be repeated too often that the breakthrough was the result of Livia Klee-Meyer's generous and selfless gift. Had she not made the gift, it would not have been possible to continue with the planning process.

The first planning phase resulted in a strategy paper issued by the Gesamtprojektausschuss (Overall Project Committee) on May 18, 1998. The committee's first president was Peter Schmid (until May 31, 1998), followed from June 8, 1998, by Dr. Hans Lauri, finance director of Bern canton; it included the then mayor of Bern, Dr. Klaus Baumgartner, and the president of the Civic Community of Bern, Dr. Kurt Hauri.[7] In the strategy paper, discussing goals, general conditions, project organization, and how best to proceed, Bern's three public bodies reiterated their will to create and operate a Paul Klee museum in Bern in cooperation with the Paul-Klee-Stiftung. At the same time, they asserted that the City and Canton of Bern—though not the Civic Community—wished in addition to create and operate a museum of contemporary

Elisabeth Ryter, manager of the project management team of the Paul Klee-Zentrum (1998–2001)

Dr. Hans Lauri, Member of the Cantonal Government, Finance Director of Bern Canton (1994–2001); President of the Stiftung Paul Klee-Zentrum (2000–2001)

LIVERPOOL JOHN MOORES UNIVERSITY
LEARNING SERVICES

Livia Klee-Meyer, Bern, 1985

art, sharing space and operations with the Paul Klee museum. Following a suggestion by Professor Norberto Gramacchini, professor of art history at the University of Bern, they also reaffirmed their intent to expand the Paul Klee museum into a Paul Klee center, incorporating at least the shared library of the Kunstmuseum Bern and the Institute for Art History of the University of Bern, and preferably the entire Institute for Art History and the Paul Klee-Akademie as well.

The idea of not only creating a museum for Paul Klee, but of founding an entire cultural center, returned to the project's beginnings. In the original planning, to be sure, the thought of founding a center solely concerned Paul Klee's work in the visual arts. Music, literature, and teaching had not yet been incorporated into the conception. The aforementioned strategy paper set forth that the Paul Klee museum and the museum of contemporary art, as well as the relocation of the library and of the Institute for Art History, should be addressed in one conceptual, operational, situational, and architectural plan. The distribution of the expected costs was also laid out. The strategy paper called for the Canton of Bern to contribute thirty million Swiss francs, the City of Bern to contribute twenty million Swiss francs, and the Stiftung Kunsthalle ten million Swiss francs in investment costs. For operating costs, there were hopes to profit, on the one hand, from modest operating contributions from the Canton and the City. On the other hand, plans were made for the Civic Community of Bern to use the proceeds from their planned one-time contribution of twenty million Swiss francs to make an annual contribution of one million Swiss francs to operating costs. Prelimi-

nary decisions on the location were also made at the time. The original plans proposed to house the Paul Klee museum—expanded into a Paul Klee center—and the museum of contemporary art in the school buildings on Waisenhausplatz and on Speichergasse, or in additional buildings on the school grounds and by incorporating part of the existing Kunstmuseum. But things turned out very differently.

Even before the decisive offer by the Müller family gave the project a fundamentally new direction, the project management team had commissioned an architecture firm to evaluate locations in the center of Bern. Though nearly everyone involved in the project had assumed that the museum would inhabit the former Progymnasium on Waisenhausplatz, the location evaluation arrived at an altogether new result: "For a Paul Klee museum, the site on Kleeplatz (the slope on the south bridgehead of the Lorrainebrücke) is the most suitable of all sites."[8]

Notes

1. On the history of the Paul-Klee-Stiftung and the Paul Klee Estate, see the texts in this volume by Stefan Frey and Dr. Christine Hopfengart, pp. 186–95 and pp. 209–20, respectively.
2. Hans Christoph von Tavel and Josef Helfenstein, "Zur Zusammenführung der Sammlungen der Familie Klee und der Paul-Klee-Stiftung im Hinblick auf ein geplantes Klee-Museum" (working paper, October 1994).
3. Stefan Frey, "Vereinbarung zwischen Familie Klee und der Paul-Klee-Stiftung/Kunstmuseum Bern betreffend der Familiensammlung" (working paper, October 13, 1993).
4. Memorandum by Dr. Hans Christoph von Tavel on a conversation between Peter Schmid, Dr. Klaus Baumgartner, Max Beat Ludwig, and Dr. Hans Christoph von Tavel, dated April 29, 1994.
5. On the role of the Civic Community of Bern, see also the text by Dr. Lorenz Meyer, pp. 364–66.
6. Agreement between the Canton, Residency Community, and Civic Community of Bern regarding the creation of a Paul Klee Museum and a museum of contemporary art in Bern, dated July 3, 1997.
7. Strategy paper issued by the Gesamtprojektausschuss, dated May 18, 1998.
8. Urban expertise compiled by Metron Architekturbüro AG, Brugg, dated August 1998.

LIVERPOOL JOHN MOORES UNIVERSITY
LEARNING SERVICES

The Müller Family Donation and the Creation of the Maurice E. and Martha Müller Foundation (1998–2000)

Andreas Marti, Director, Zentrum Paul Klee, Bern

In spring 1998, the Gesamtprojektausschuss (Overall Project Management) and Gesamtprojektleitung (Overall Project Committee) were in the process of making initial plans for the city center location, and work on studies for the expansion of the Kunstmuseum Bern was already well underway with the management of the Kunstmuseum and the Paul-Klee-Stiftung (Paul Klee Foundation). It was at this point that Dr. Thomas Aebersold, the lawyer for Professor Maurice E. Müller und Martha Müller-Lüthi, contacted Peter Schmid, then director of education of Bern canton. On behalf of his clients he offered two lots in Schöngrün, in the eastern part of the city of Bern, as a construction site for the project, as well as a financial contribution of at least thirty million Swiss francs. With this offer, plans for the project took an unexpected turn and at the same time acquired a new dimension.

With the arrival of Professor Maurice E. Müller and his wife Martha Müller-Lüthi, two individuals were now involved in the planning and realization of the Paul Klee center who did not simply regard themselves as patrons of the arts. No, the Müllers wished to participate fully in the thinking, designing, and decision making that went on at the project's front lines. Thus, from the very first days of negotiations, a partnership was formed between private initiative and the public sector. In numerous conversations with the project leaders, Professor Maurice E. Müller elaborated his vision. That vision may be summarized in eight points:

1. To build a home for Paul Klee's estate as well as a forum for presenting it that does justice to the artist, as a gift to the city and canton of Bern;

2. To create a cultural center (not simply an art museum), in which there is room for music, literature, theater, and dance in addition to the visual arts;

3. To provide a wide variety of offerings and events, which make use of the center's entire infrastructure and employ the latest technologies;

4. To use the tools of education to make the world of Paul Klee accessible to the widest possible sectors of the population (and to help achieve this, to create a children's museum for visitors aged four to ninety-nine);

5. To organize temporary exhibits in addition to the permanent collection, so that as many of Klee's works as possible from museums and private collections can be exhibited in Bern, at least temporarily;

6. To organize scholarly conferences and other events and thus attract large numbers of people to art in general and Paul Klee's works in particular;

7. To create a place where people from all sectors of society can spend time, reflect, and communicate;

8. To commission the architect Renzo Piano to plan and build the center, giving Paul Klee's work an adequate architectural setting.

For her part, Martha Müller-Lüthi focused her attention on music. It was her idea to build a concert hall at the Zentrum Paul Klee that meets the very highest standards. As if that were not enough, Martha Müller-Lüthi possesses a large and exceptional sculpture collection, and as plans evolved for the project she agreed to place a number of exquisite items at the public's disposal in a sculpture garden that she herself had a hand in designing.[1]

No description of the Müller family's donation can be complete without making mention of the special role of one of their children, Janine Aebi-Müller. She always participated in her parents' negotiations and talks and, with her own ideas, exerted a lasting influence on the evolution of the center as a whole and the definition of the content of the children's museum. Her commitment far exceeds what one is entitled to expect of a volunteer collaboration.

How did the project leaders and the public authorities react to the Müllers' offers and ideas?

At first it was a classic "yes but" situation: yes, gratitude and joy at the Müllers' generous offer, but at the same time and above all, doubts about whether it was right simply to abandon existing plans. Planning for the city center location was far advanced. The basic idea of expanding the Kunstmuseum had, it seemed, been widely accepted, even if the question of location was not uncontroversial and had by no means been permanently resolved. Suddenly the whole idea of merging a Paul Klee museum with a museum of contemporary art was up in the air. Finally, it had to be accepted that the Müller family insisted on the Schöngrün location and also wished to forgo an architectural competition. Precisely the architectural competition, however, had thus far been a very important concern of the project leaders, since competition can enhance the quality of the result.

However, it was soon decided that the Müller family's offer was too good to be rejected. The project leaders' initial reservations gave way to great enthusiasm. On

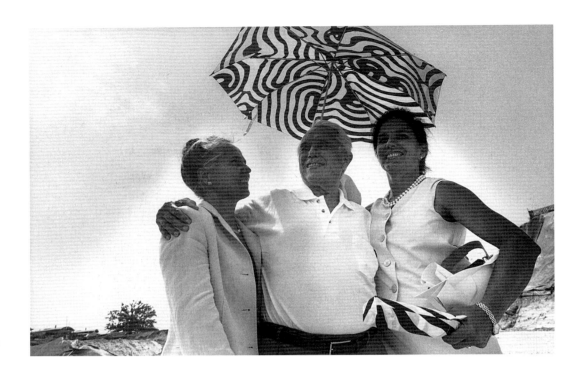

Professor Maurice E. Müller with daughters Janine Aebi-Müller (left) and Denise Spörri-Müller at the laying of the foundation stone, June 20, 2002

November 4, 1998, negotiations among the Müller family representative, the family itself, and the agents of the project, which took place in a gratifying atmosphere of openness and dialogue, led to the conclusion of a framework agreement between the Canton, the Residency Community, and the Civic Community (Burgergemeinde) of Bern, on the one hand, and Professor Maurice E. and Martha Müller-Lüthi on the other, regarding the realization and operation of a Paul Klee museum. On the same day, Professor Maurice E. and Martha Müller created the Maurice E. and Martha Müller Foundation (MMMF). The foundation's purpose is to conserve and cultivate Paul Klee's cultural legacy as well as to create a Paul Klee museum, including a research center, in Schöngrün, Bern, and to support its operations financially.[2]

With the new location and the involvement of Renzo Piano, the project had acquired an entirely new direction. Moreover, its framework conditions were now clearly defined. Paul Klee's estate—to the extent that it lay in public hands—was to have its new home in Schöngrün. The private Maurice E. and Martha Müller Foundation, in close consultation with the public sector, assumed responsibility for the center's planning and construction. It was also established that there would be no architectural competition. Finally, the project planners abandoned the idea of creating a Paul Klee center by combining a Paul Klee museum with a museum of contemporary art, the Institute for Art History at the University of Bern, and the Paul Klee-Akademie. The notion of a *Zentrum*, or center, however, was retained in keeping with Professor Müller's vision. By contrast with its character in earlier plans, it was expanded to in-

Dr. Thomas Aebersold, Secretary of the Maurice E. and Martha Müller Foundation, Martha Müller-Lüthi, and Janine Aebi-Müller at the laying of the foundation stone

Jean-Pierre Müller, MD, son of the founders Maurice E. Müller and Martha Müller-Lüthi

clude music, literature, theater, dance, and education. Finally, since November 4, 1998, responsibilities have been clearly defined. While the MMMF assumed responsibility for the construction of the center, which upon completion is placed at the public sector's disposal free of charge, the City and Canton of Bern are responsible for the center's operation.

On November 17, 1998, the board of the Maurice E. and Martha Müller Foundation, with the former member of the cantonal government, Peter Schmid, as president, and Professor Maurice E. Müller as honorary president, took up its work. The Müller family generously permitted the public sector—the Civic Community, Canton, and City of Bern—to have the majority on the board. In addition to the president and honorary president, the first board consisted of the following individuals: Dr. Thomas Aebersold, secretary and treasurer; Janine Aebi-Müller; Ursina Barandun; Dr. Josef Helfenstein; Alexander Klee; Andreas Marti; Dr. Lorenz Meyer; and Peter Tschanz. Elisabeth Ryter took over administrative duties, and Ueli Laedrach, Bern's municipal architect, took part in the sessions as a permanent member in an advisory capacity. As early as its second session, on December 18, 1998, the board decided to award a direct contract to the Genoese architect Renzo Piano for the planning and realization of the center.

The project then evolved with a speed that is highly unusual by Bern standards. Renzo Piano and his partner, Bernard Plattner, were commissioned to prepare a master plan and preliminary project on the basis of an outline of the museum submitted by

315

LIVERPOOL JOHN MOORES UNIVERSITY
LEARNING SERVICES

Peter Tschanz, General Secretary of the Presidential Department of the City of Bern, member of the project management team of the Paul Klee-Zentrum (1998–2001) and the Maurice E. and Martha Müller Foundation

Architect Ueli Laedrach, head of the Building Commission and the Building Committee

the project managers and a space allocation plan derived from it. As soon as planning began, Renzo Piano determined that the lots belonging to the Maurice E. and Martha Müller Foundation, which covered somewhat more than twenty-one thousand square meters, would almost certainly be insufficient or unsuitable for the construction of the center. In early 1999, therefore, the MMMF approached the City of Bern, which owned the land that bordered the two lots on the north. Here again the public sector showed its generosity. The City of Bern agreed to make its land—sixty-eight thousand square meters intended as a reserve for future cemetery expansion—available for the planning of the Paul Klee center. As early as April 1999, the Renzo Piano Building Workshop submitted a first preliminary draft, which they were able to develop into a preliminary project during the summer of that same year. The project managers, the Gesamtprojektausschuss, and the Maurice E. and Martha Müller Foundation were able to present the plans to the public on December 9, 1999, at an exhibition at which Renzo Piano delivered an inaugural address. In 2000 and 2001, the project was presented on two further occasions in the Kornhaus in Bern, each time with a different focus.

Notes

1. For more on the Sculpture Park, see Werner Blaser's article in this book, pp. 395–96.
2. Framework agreement regarding the realization and operation of a Paul Klee museum, dated November 4, 1998; foundation deed of the Maurice E. and Martha Müller Foundation, dated November 4, 1998; also see CD-ROM.

The Establishment of the Stiftung Paul Klee-Zentrum (2000 and 2001)

Andreas Marti, Director, Zentrum Paul Klee, Bern

Livia Klee's donation came with a condition attached: that the City and Canton of Bern would, as quickly as possible, make the donated works over to an as yet unfounded entity that would bear responsibility for a future Paul Klee center.

Before this operating entity could be founded, however, the relationship between the Paul-Klee-Stiftung (Paul Klee Foundation), which had existed since 1947, and the City and Canton of Bern had to be clarified. The creation of a Paul Klee center would establish the conditions necessary to realizing the goals of the Paul-Klee-Stiftung. But it is only now that the Livia Klee Donation, Alexander Klee's loans, and the collection of the Paul-Klee-Stiftung have been brought together that it can be said that the estate of Paul and Lily Klee has been reunited and can be shown to the public as a whole. On September 15, 2000, after extensive talks, the Paul-Klee-Stiftung, the Canton of Bern, and the Residency Community of Bern concluded a contract concerning the assimilation of the Paul-Klee-Stiftung to the yet to be founded Stiftung Paul Klee-Zentrum (Paul Klee-Zentrum Foundation).[1] That same day, the Canton of Bern, the Residency Community of Bern, and the Paul-Klee-Stiftung founded the Stiftung Paul Klee-Zentrum. The article establishing its purpose states that the foundation has the brief to work closely with the Canton and City of Bern as well as with the Kunstmuseum Bern to look after the foundation assets of the Paul-Klee-Stiftung, the Livia Klee Donation, and all of the works of art and other objects made available by donation, purchase, or loan (in particular from Alexander Klee). Furthermore, the foundation would cultivate the cultural legacy of Paul Klee by operating a Paul Klee center in Schöngrün, Bern.[2]

The first foundation board comprised the following members, some of whom were or had been part of the municipal and cantonal governments: Dr. Hans Lauri (president), Dr. Klaus Baumgartner (first vice president), Bernhard Hahnloser (second vice president), Mario Annoni, Professor Oskar Bätschmann, Therese Frösch, Alexander Klee, Dr. Lorenz Meyer, and Professor Maurice E. Müller. The deed of foundation and its later additions give the Canton of Bern and the Residency Community of Bern

Signing of the foundation deed of the Stiftung Paul Klee-Zentrum, September 15, 2000: Alexander Klee, President of the Paul-Klee-Stiftung; Bernhard Hahnloser, Vice President of the Paul-Klee-Stiftung; Dr. Hans Lauri, representative of Bern Canton; Dr. Klaus Baumgartner, former mayor and representative of the City of Bern (from right to left)

the right to name two members of the board. The Paul-Klee-Stiftung also delegates two members. The Civic Community of Bern (Burgergemeinde), the Regional Cultural Conference of Bern, the Maurice E. and Martha Müller Foundation, and the Fondation du Musée des Enfants auprès du Centre Paul Klee have one seat each. Werner Luginbühl has presided over the foundation board since September 1, 2001. That the presidency is held by an incumbent member of the cantonal government and another member sits on the foundation board, that the vice presidency is held by the former mayor of Bern and another member of Bern's municipal government sits on the board is testimony to the cultural and economic significance that the Canton and City of Bern attribute to the center.

On November 29, 2000, the foundation board held its first meeting and addressed the essentials of its proposal for future operations and the associated question what its cooperation with the Kunstmuseum Bern should look like. On January 11, 2001, the board proposed to the cantonal government, the governing council of the City of Bern, the museum commission of the Kunstmuseum Bern, the Verein Kunsthalle Bern, and the Stiftung Kunsthalle Bern that a working group be established with the task of working out proposals for a single entity to cover all art institutes in Bern.[3] The basis or point of departure for these discussions was supposed to be a study by Cyrill Häring, LLD, Basel, dated September 14, 1999.[4] In that study, produced for the project management of the Paul Klee center, Cyrill Häring had reflected on the model for the body to be responsible for the center once it had been founded. He had come

to the conclusion that a holding company should be founded for the future structure of Bern's art institutes—one umbrella for three legally, organizationally, and substantively autonomous institutions, i.e. the Kunstmuseum, the Museum für Kunst der Gegenwart (Museum of Contemporary Art), and the future Paul Klee center. He recommended a foundation under private law as the preferred form for this organization. The umbrella foundation would be founded by the public authorities together with the institutions to be covered by it. The three institutions would work together under the leadership of the umbrella foundation, which would define the cultural strategy and determine the distribution of means. The operational leadership would remain in the hands of the three institutions. This concept would also have had the advantage of being amenable to expansion at any time by adding other institutions. Innovative ideas are always difficult to justify and easy to reject. The proposal from the Stiftung Paul Klee-Zentrum was only moderately successful. No working group was established. In two meetings, one in June 2001 and the other in January 2002, the representatives of the Kunsthalle and the Kunstmuseum Bern rejected the initiative with more than sufficient clarity. At the time it appeared that collaboration among the art institutions in the city of Bern had been postponed to the distant future. The supporters of the Paul Klee center geared up to go it alone.

Werner Luginbühl, Member of the Cantonal Government and Director of Justice and Community and Church Affairs; second President of the Stiftung Zentrum Paul Klee (since 2001)

Notes

1. Contract on the assimilation of the Paul-Klee-Stiftung into the Paul Klee-Zentrum Foundation, dated September 15, 2000; see CD-ROM.
2. Foundation deed of the Paul Klee-Zentrum Foundation, dated September 15, 2000; see CD-ROM.
3. "Ein Dach für die bernischen Kunstinstitutionen," letter from the Stiftung Paul Klee-Zentrum, January 11, 2001.
4. Cyrill Häring, "Trägerschaftsmodell Paul Klee-Zentrum" (study, September 14, 1999).

LIVERPOOL JOHN MOORES UNIVERSITY
LEARNING SERVICES

Decisions of the Cantonal Parliament, the City Council, and the Sovereign of the City of Bern, and the Election of the Founding Director (2000 and 2001)

Peter Tschanz, General Secretary of the Presidential Department
of the City of Bern

Bern City Council debating the "Klee motion" on November 30, 2000; it was passed with 66 votes to 0.

Between the end of 2000 and early 2001 the ball was in the politicians' court: the City and Canton of Bern had to show that they were ready to fulfill their engagements based on the framework agreement of November 4, 1999. This may seem simple, but the following decisions were necessary to make it a legal reality:

Yes to a change in zoning in Schöngrün;

Yes to a loan for developing the Zentrum Paul Klee;

Yes to a land deal in which the grounds became the property of the City and Canton of Bern, half ownership going to each of the bodies;

Yes to a building loan;

Yes to a contribution to the building funds from the lottery proceeds.

With these decisions, the public commitment to the project came to roughly thirty-four million Swiss francs. On the cantonal level, the responsibility for the decision lay with the parliament (subject to a facultative referendum), while in the city of Bern the project had to go before all the voters.

The debates in the parliaments of the city and canton were quite similar in their content and emotional character. Before coming to a decision, the parliamentarians praised the detailed information that the project leaders had provided—information which allowed the two councils to make a well-founded decision. In addition to the obvious cultural advantages of the project, many members also mentioned the economic benefits to be expected for the city and canton, doubtless one reason for the broad acceptance the project found in all areas of the canton. Of course, critical voices were also to be heard. Given the tight public budgets, individual members raised the possibility that dedicating this much money to the Zentrum Paul Klee might lead to budget cuts for other cultural institutions or sponsorships. Luckily these fears have so far proved to be unfounded. And many of the speakers could not hide their pride in taking part in a political decision so historic in nature.

On November 27, 2000, the cantonal parliament accepted the project with 132 votes to 7 and 10 abstentions. Three days later it was the Bern city council's turn to

Director Andreas Marti interviewed by Swiss television

make their decision. Here, too, the result was clear: the verdict was 66 to 0 votes, with 2 abstentions. There was one more important hurdle in the city of Bern, however: On March 4, 2001, the public referendum took place in which the people of Bern were asked to make their sovereign decision on municipal credits in the order of ten million Swiss francs and on the re-zoning of the future site of the center. Given the preceding votes, we were not very worried that the citizens would reject the project. We were very pleased nonetheless at the strong majority of 78 percent votes in favor of the Zentrum. It was also encouraging that the project won in all parts of the city, even those far from the planned art center. For all those involved in the project, these results on the municipal and cantonal levels provided additional motivation—as well as the additional responsibility to live up to the high expectations that had been raised. As explained above, the project management consisted of members of participating institutions who took on a leadership role in addition to their usual activities. Meetings of the management team therefore often took place in the early morning or late evening. As the project became reality, the task of planning the Zentrum became increasingly time-consuming and difficult. This situation could not be allowed to last. It was decided to professionalize the project management and appoint a founding director as soon as possible after the referendum in the city of Bern gave a definitive green light to the building of the Zentrum Paul Klee. For the board of the Stiftung Paul Klee-Zentrum (Paul Klee-Zentrum Foundation), which had the choice of the first director, the question then arose what core competencies this director would need.

The Cantonal Governement debating the "Klee motion" on November 27, 2000; it was passed with 132 votes to 7 with 10 abstentions.

The referendum in the City of Bern on March 4, 2001, resulted in a clear 78 percent majority in favor of the Zentrum Paul Klee (debate in the City Council).

Were artistic leadership and curatorial competence already necessary at this early stage? Or would it be more effective to hire a generalist with experience in project management? Given the complexity of the project, the huge responsibility it entailed, and the time pressure involved, the board decided to offer the post to Andreas Marti, who had been heading the project management team and who was the general secretary of education for the canton of Bern. By choosing Marti, the person who knew the project best, the board's vote was also a vote to continue along the successful route taken thus far.

This choice of director placed responsibility for the project's operations in "new, old" hands. It was possible in this way to dissolve the previous project management team, a process which, at least for most of the members, did not entail any sense of emotional loss, since, with the exception of Elisabeth Ryter, every member remains active in another function in building the Zentrum Paul Klee.

Construction and the Preparations for the Opening (2001–5)

Andreas Marti, Director, Zentrum Paul Klee, Bern

On August 1, 2001, the head office of the Paul Klee-Zentrum was able to begin work with a very modest staff consisting of two full-time positions (secretary and director) at Weltistrasse 40, in the immediate vicinity of the future building site. The Canton of Bern had educated its home economics teachers at Weltistrasse 40 for decades. As part of Bern's reformation of teacher education, this curriculum was eliminated, so that the building was gradually being emptied, and the Canton of Bern generously made it available at no cost to the Stiftung Paul Klee-Zentrum (Paul Klee-Zentrum Foundation) as a temporary location from which to supervise construction and prepare for the opening of operations.

Throughout the course of the project, the City and Canton of Bern were not only fully involved in the planning work, but also provided numerous services at no charge. If that had not been the case, our costs would have been considerably higher during the planning phases.

The head office at Weltistrasse 40 had two tasks: On the one hand, it was to prepare for the opening of operations on behalf of the Stiftung Paul Klee-Zentrum—that is, to develop concepts for its core content. On the other hand, it supervised the construction planning and implementation on behalf of the Maurice E. and Martha Müller Foundation.

The process of applying for building permits proceeded very quickly and smoothly. On May 1, 2001, the project was announced. Three objections were submitted during the period allotted, but all three were withdrawn following a mediation hearing. The construction permit was issued on October 18, 2001. No challenges were filed, and in autumn 2001 excavation work began on the site, measuring just under ninety thousand square meters, that had been donated by the Maurice E. and Martha Müller Foundation and the City and Canton of Bern.

The Maurice E. and Martha Müller Foundation set up the bodies necessary for construction: a building commission headed by architect Ueli Laedrach oversaw the construction work on the strategic levels, and a building committee—consisting of

Laying of the foundation stone for the Zentrum Paul Klee on June 20, 2002: the President of the Maurice E. and Martha Müller Foundation, Peter Schmid; the architect, Renzo Piano; and the co-founder of the Zentrum Paul Klee, Professor Maurice E. Müller (from left to right)

Ueli Laedrach (chair); Dr. Thomas Aebersold, secretary of the Maurice E. and Martha Müller Foundation; and Andreas Marti, director of the Zentrum Paul Klee—managed operations. By June 20, 2002, Professor Maurice E. Müller, Peter Schmid, and Renzo Piano were able to lay the cornerstone on the center's North Hill, on the site of the children's museum, in the presence of about 250 invited guests. The founding documents of the Maurice E. and Martha Müller Foundation, of the Fondation du Musée des Enfants auprès du Centre Paul Klee, and of the Stiftung Zentrum Paul Klee (Zentrum Paul Klee Foundation) as well as newspapers for June 20, 2002, were placed in a steel box, which was then welded closed and placed in the foundation walls of the children's museum. Let us hope that the Zentrum Paul Klee enjoys a long existence, and our descendants will not discover this steel box from June 20, 2002, for hundreds of years.

Once the Maurice E. and Martha Müller Foundation had been granted the building permit, there were three primary tasks for the two foundation's boards and the center's management: the financing of the construction, the planning of operations, and the financing of operating costs.

The generosity of Professor Maurice E. Müller and his wife, Martha Müller-Lüthi, was almost unlimited. Acting through another foundation established and supported by Professor Maurice E. Müller, the Fondation Maurice E. Müller, they donated land totaling more than twenty-one thousand square meters to the Maurice E. and Martha Müller Foundation. They coupled this gift with the condition that the center be built either on this lot or incorporating this lot into the museum site in Schöngrün. Over several stages Mr. and Mrs. Müller gave sixty million Swiss francs to the foundation they had established. Later the Fondation Maurice E. Müller added a guarantee of ten million francs.

This gift is probably unique in Bern's history in every respect. But Professor Müller and his wife did not simply donate land and money, they also made a planning account available that, miraculously, was renewed year after year. This planning account enabled the project management and the board of the Maurice E. and Martha Müller Foundation to realize additional projects that benefited the quality of the final product. For example, Professor Müller commissioned the documentary film maker Peter von Gunten to film the entire process of planning and realization. The project management and the board of the Maurice E. and Martha Müller Foundation were also able to visit modern European museum buildings on several trips. Our study of the planning mistakes we identified in other projects clearly had a very positive effect on the results of our work. One of the characteristics of this founding couple is that they were unconditionally and uncompromisingly committed to their

project, and they set conditions and provisos that were always strictly in the interest of the matter at hand and within their own purview. Other patrons could surely learn something from this attitude.

Raising the financial resources for operations proved to be considerably more difficult than financing construction. The City of Bern, which shared the costs with the Canton during the projection phase, repeatedly confirmed that it intended to support the new cultural center within the framework of the Regional Cultural Conference of Bern.

The difficulty for the management of the Zentrum Paul Klee was that it had to calculate, without any historical data, its operating costs and proceeds to enable the Regional Cultural Conference to conclude a subsidy agreement for 2004 to 2007. As a kind of guideline, the Gesamtprojektausschuss (Overall Project Committee) had stipulated in 1999 that the subsidy sought by the Zentrum Paul Klee should not exceed the current subsidy of the Kunstmuseum Bern, which amounted to five million Swiss francs. The calculations of the project management—based on comparatively scanty documentation—however indicated that successful operations would require six million francs in public funds. Unfortunately, the board of the Regional Cultural Conference of Bern was even obliged to cut the five million francs that the board of the Stiftung Paul Klee-Zentrum was hoping receive to 4.3 million. Only if this cut was made, it seemed, could the new center be supported as one of five major cultural institution in the city under the subsidy agreements of the Regional Cultural Conference. The management of the Zentrum Paul Klee was painfully aware that this subsidy would not be sufficient for a satisfactory operation.

On the basis of a proposal for a museum submitted by Dr. Josef Helfenstein, curator of the Paul-Klee-Stiftung until 2001, and a proposal for the center developed by the project management, Renzo Piano and his team prepared the preliminary design and the construction project. At the beginning of the planning and collaboration with the Renzo Piano Building Workshop (RPBW) the project management was unaware of what it had gotten itself into. We had reckoned with an architectural office headed by an important architect, but with an architectural office of a traditional sort. At first we did not attribute any particular significance to the word "workshop" in the company's name, because we assumed that "workshop" was simply a fashionable word in the late twentieth century and could serve just as well in a company name. We were quickly taught otherwise. Even in the very first planning phase, as the construction project for the building application process was being drawn up, we could see how strong an emphasis Renzo Piano and his team, under the highly competent and unflappable direction of Bern-based architect Bernard Plattner, put on a workshop

Laying of the foundation stone on June 20, 2002: Kaspar Zehnder, the Artistic Director of Music at the Zentrum Paul Klee, conductor and flautist, is playing.

The public followed the laying of the foundation stone with great interest.

Mayor Dr. Klaus Baumgartner talking with former permanent secretary Dr. Klaus Jacobi

Architects and engineers posing on site

325

LIVERPOOL JOHN MOORES UNIVERSITY
LEARNING SERVICES

Architect Bernard Plattner, partner of the Renzo Piano Building Workshop and project manager at the Zentrum Paul Klee

Architect Kurt Aellen, partner of the arb firm of architects and project manager at the Zentrum Paul Klee

approach that closely involved the client. The representatives of the public authorities on the client side also had to adjust their ways. This was not planning in the traditional manner, but a comprehensive, step-by-step, iterative process to refine the whole and every detail. The approach to cost management was also extremely interesting and innovative. Because many of the details were worked out in the course of the planning process, as building permits were granted, we were working not with a cost estimate but with a budget. Early on, the RPBW had decided to collaborate with the office of arb in Bern and the architect Kurt Aellen as project leader. It was the skilled hand of Kurt Aellen that made it possible to successively restructure the budget as a cost estimate without significantly exceeding the projected numbers. It was an exciting process that played out over several years under the proficient direction of the president of the building committee, Ueli Laedrach, with meetings every fourteen days. Not infrequently the gloves came off, sparks flew, faces turned red, but everyone involved knew to take the others seriously. And in the background we could always sense the desire of our founders and of Renzo Piano to give Bern a gift of supreme architectural and substantive quality.

The management was always able to submit its proposals to the architect in a timely manner, and the architectural team's contributions and questions were always helpful and welcome. It would not do justice to the facts to deny that the reflections and answers from Renzo Piano and his team were eminently valuable to the evolution of the proposals and strongly influenced the center's substantive direction.

Just a year and a half after the cornerstone ceremony, the topping-off ceremony took place on the South Hill on December 1, 2003. The director had his first opportunity to present to the public the idea behind the center and its realization.[1]

For the management, 2004 and the first half of 2005 were taken up with hiring personnel, planning the interiors, and preparing for the launch of operations. Since summer 2003 there had also been intensive discussions with the Kunstmuseum Bern about how the two organizations could cooperate. The possibilities discussed ranged from a merger, as the maximal solution, to the foundation of a company that would handle all the services of both houses, as the minimal solution. The conclusion was sobering: for the time being there will be no close cooperation. The two organizations will be completely independent on both strategic and operative levels; they will combine certain services into a company that will be created in the future. If we consider that the Stiftung Paul Klee-Zentrum's initiatives to discuss this cooperation began on January 11, 2001, we can only say, *parturient montes ...*

From its earliest days, the history of the project has naturally been enriched by numerous memorable events. We should certainly mention the media conferences and

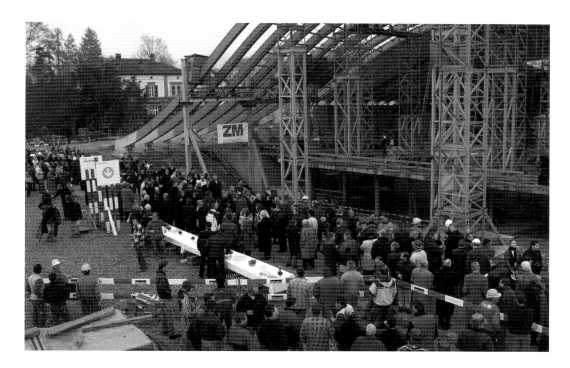

Start of the topping-out ceremony on December 1, 2003, in front of the North Hill

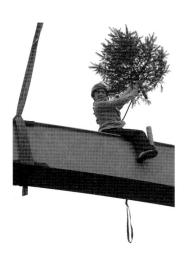

At the topping-out ceremony the pine tree is symbolically set at the highest point of the roof.

their varying attendance. One interesting aspect of the reporting was that the large Swiss media, who are very proud of the high quality and objectivity of their reporting, repeatedly took very clear positions on the Zentrum Paul Klee, but never once participated in a media conference or made an effort to contact the parties responsible for the project.

Special high points included the three exhibitions in Bern's Kornhaus, which were intended, on the one hand, to stimulate political dialogue and, on the other, to improve public acceptance of our project. In that context, one particular phenomenon is interesting: the Gesamtprojektausschuss, the Müller family, and the project management always sought to keep informed the residents of both the canton and the city, and especially the Schöngrün area, in a timely and thorough manner about the project's upcoming steps. Nevertheless, there was never any debate about the project. We took this silence to signal approval. The media, by contrast, repeatedly asserted that the political dialogue was being avoided. The members of the project can legitimately claim that we were always available for discussion, but dialogue can only take place when the offer is taken up. At the same time, we sensed broad approval among the populace, which pleased us very much.

There are other events that, though not essential to the story, provide anecdotal sidelights and comic relief, and therefore deserve to be told.

Once construction had begun, the director took it upon himself to inspect the state of project on site once a week. During the winter of 2001–2, when the excavation was

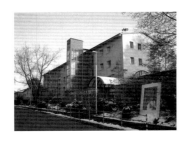

The temporary offices of the Zentrum Paul Klee administration were located in the former Bern Canton Teachers' College for Home Economics in Weltistrasse 40.

The management of the Zentrum Paul Klee at the media briefing on the state of progress one year before the opening, June 17, 2004: Adrian Weber, Tilman Osterwold, Andreas Marti, Ursina Barandun, and Kaspar Zehnder (from left to right)

in full swing and the hole in the North Hill intended for the auditorium was getting deeper and deeper, a driver got out of his dump truck after unloading twenty-five tons of earth, and asked the visitor: "What are you building here? A landfill?" The question was justified. At that time it was by no means clear what was supposed to be built there. The exchange led to all the participating construction workers being invited to Weltistrasse 40 at regular intervals for an aperitif, so that they could be shown what their construction work was about. We think that this contact reinforced the workers' commitment to the project.

One thing that participants in the topping-out ceremony especially appreciated was that they all, without exception, received personally from Professor Maurice E. Müller a certificate that documented their contribution to the construction of the Zentrum Paul Klee.

In summer 2002 the State of Berlin announced a competition for the Peter Joseph Lenné Prize. The challenge was to present ideas for the landscape design and space planning in the Wyssloch, as a western extension to the Landscape Sculpture of the Zentrum Paul Klee. That summer we were visited by many students who wanted to participate in the competition. One afternoon three more students had come from Germany, and they were led in boots across the site to familiarize themselves with the center and the Wyssloch for their work on the competition. As they were leaving, two of them shyly pointed out that their shoes, which they had left behind at Weltistrasse 40 for their site tour, had disappeared. A search turned up nothing, and we were just about to conclude that the Paul Klee-Zentrum would have to pay for new shoes to make up for the theft. At the last minute, however, we noticed that there were other visitors on the site. It soon turned out that our co-founder, Professor Maurice E. Müller, was showing former member of parliament Adolf Ogi our grounds. As active sportsmen will, they had looked about for the best shoes to wear to the site. The three young visitors from Germany naturally belonged to the running shoe generation, and so suddenly there were these enormous running shoes available. The two gentlemen helped themselves, thinking that these were shoes reserved for the site. The students could be consoled with the news that their shoes had served one of the greatest surgeons of the twentieth century and a prominent member of the Swiss parliament.

After the project had been awarded to Renzo Piano, the project management occasionally found itself in need of arguments when it was accused of lacking imagination—hiring for the construction of the Paul Klee-Zentrum the very architect who had built the most recent great art museum in Switzerland, the Fondation Beyeler in Riehen. At an opportune moment we called these accusations to the attention of Renzo Piano.

Renzo Piano at the building site of
the Zentrum Paul Klee

He smiled diplomatically and said: "I build functionally. Other architects cultivate
a certain style that always remains the same."

Far more important than amusing events on the margins of our planning work, how-
ever, are the effects that radiate from the idea of establishing a center rather than
just a museum. Three examples will illustrate this:

Professor Müller and his daughter Janine Aebi-Müller emphasized from the first day
that one could only do justice to Paul Klee if the teaching of art occupied an appro-
priate place in the center. To give this idea legs, they founded the Fondation du Musée
des Enfants auprès du Centre Paul Klee in summer 2002 and made the children's
museum an integral part of the architecture and operations of the Zentrum Paul Klee.[2]

Norberto Gramaccini, professor of art history at the University of Bern, was also in-
spired early on by the idea of the center. He encouraged the founding of a summer
academy that would give young artists an opportunity to continue their education on
a high level with renowned instructors. The Berner Kantonalbank became enthusiastic
about the idea and established the Stiftung Sommerakademie, which will offer a post-
graduate program for young artists at the Sommerakademie im Zentrum Paul Klee
every year, beginning in 2006.[3]

Finally, a third, completely different example: For several years there have been plans
to signpost the city for pedestrians. A group of Bern politicians (City Councilors
Urs Jaberg and Christoph Müller) and Theo Weber, then mayor of Ostermundigen,
proposed that the signage be supplemented with information about Paul Klee's former

presence in the city of Bern and in Ostermundigen. The result was the project "Wege zu Klee" (Paths to Klee), and the first step in anticipation of the center's opening will be a tour system from the quarries of Ostermundigen by way of the Zentrum Paul Klee into the city of Bern.

Paul Klee considered himself to belong to Bern even though he did not hold a Swiss passport. In summer 2005 Bern gains, on the eastern border of the city, in Schöngrün, a cultural center that preserves the work of one of its greatest artist for posterity and conveys it to an international public. For everyone involved, the planning and building of this center was a unique opportunity. We are grateful to the Klee and Müller families, and to the City, Canton, and Civic Community of Bern for providing this opportunity. May the center continue to fulfill, for decades to come, the task that its planners conceived for it.

Notes

1. See Andreas Marti's report at the topping-out ceremony on December 1, 2003.
2. See the foundation deed of the Fondation du Musée des Enfants auprès du Centre Paul Klee, dated June 10, 2002; on the children's museum, see Adrian Weber's essay in the present volume, pp. 94–8.
3. See the foundation deed of the Sommerakademie im Zentrum Paul Klee, dated January 8, 2004.

The Publicity

Ursina Barandun, Deputy Director and Director of Communication and Outreach, Zentrum Paul Klee, Bern

The founding families, the Klees and the Müllers, wanted the Zentrum Paul Klee to be a place where people, regardless of age or social and cultural background, could engage with art in a pleasurable and lasting way. To that end, the Zentrum Paul Klee was intended not only to make Paul Klee's artistic, pedagogical, and theoretical work accessible through scholarship and visual presentation, but also to cultivate intensively an interdisciplinary approach to communicating art. The founding families wanted to make the Zentrum Paul Klee a contribution to the quality of life, primarily for the population of the city, region, and canton of Bern, but also for art lovers throughout the world. The challenge was to give shape and definition to the vision of an interdisciplinary center for art and culture in Schöngrün, to give it an inimitable look, and to place it effectively. After all, both the politicians and the residents of the city and canton of Bern had to be won over to the project.

As with human births, in the case of the Zentrum Paul Klee, too, the communication about the upcoming happy event began at a time when it was not even clear what the "baby" would be called, what it would look like, and where it would grow up. Consequently, the communications strategy of the first hour deliberately dispensed with a comprehensive corporate design or a strong visual trademark or logo. The focus in establishing the brand had to be directed entirely at the Zentrum Paul Klee's future institution; any preliminary branding of the project would only have made that process more difficult. To ensure that communications had a lasting effect, the same illustrations and texts were used for every appearance in electronic or print media. This approach had the pleasant side effect that we were able to work in parallel with a variety of agencies and people without significant problems of coordination.

From winter 2001 to early summer 2004 the Zentrum Paul Klee organized hundreds of building-site tours for thousands of visitors.

The media and the public were kept informed about the project's development from the start, for the people responsible for the project considered an open information policy to be one of the fundamental rules of their work. This principle was contradicted somewhat by an agreement signed with the Renzo Piano Building Workshop, at its express request, that until the presentation of the preliminary design the architects'

331

LIVERPOOL JOHN MOORES UNIVERSITY
LEARNING SERVICES

Renzo Piano presents the preliminary designs on December 9, 1999, in the Kornhaus, Bern.

The media and the general public show a keen interest.

work would be handled in confidence and the master plan would not be published. The *Berner Zeitung* responded to the reserved approach to information with an article on September 1, 1999, titled "Weiteres Warten auf konkrete Information" (More Waiting for Concrete Information). This reaction demonstrates yet again the extent to which large projects are susceptible to criticism and what a hard time innovations have, even in Bern or perhaps especially in Bern.

The flipside of this coin was the unique opportunity to concentrate on a single day the events associated with "going public" with Renzo Piano's preliminary design and to stage them in a way that would be effective for the media and the public. That day was December 9, 1999. At five in the morning on that day, after a final hectic night shift, the exhibition was installed in the Kornhaus in Bern; the project was ready for its first encounter with the public. At 9:00 a.m. the Web site went online; at 9:30 a.m. the first copies of the architectural journal *Hochparterre* were delivered. The editorial staff of *Hochparterre*, who were the only outsiders to be informed in advance, published on that day a special issue on the Bern project by the Italian architectural star. At 10:00 a.m. Renzo Piano arrived; the media conference for the national media began at 10:30 a.m. At 5:00 p.m. the Müller family and Renzo Piano presented the project to the residents of Schöngrün; and at 8 p.m. an audience invited by the Architekturforum Bern heard in the maestro's own words what he had come up with for Paul Klee and for Bern. The Kornhaus was too small for the many hundreds of interested listeners.

So none of the things happened that had haunted us in our worst nightmares; all of the things we had hoped for came true. The first of an eventual three exhibitions in the Kornhaus in Bern on the project for the Zentrum Paul Klee launched the great history of the residents of Bern getting to know, growing to like, and coming to identify with the project. That process reached one in a series of high points on March 4, 2001, when the voters of the city of Bern in a referendum approved the project with a 78 percent majority.

In the months and years after December 9, 1999, the managers of the project and later, the center, intensively and systematically approached the task of publicity and kept records of that process. This documentation is called "Acta und Agenda," and it lists the thousands of activities leading up to the opening whose sole purpose was to raise public enthusiasm for the project. These activities included media conferences, media orientations, and interviews with members of the national and international media as well as countless articles for specialized journals in the fields of art, architecture, publicity, leisure, and tourism and for company and customer magazines and for the business media. For the cornerstone ceremony on June 20, 2002, and the topping-out ceremony on December 1, 2003, approximately thirty thousand informational brochures were printed and handed out for free. Three exhibitions in Bern's Kornhaus, an exhibition in the Bern town hall, reader campaigns with our media partners, reports and lectures for communities, companies, and service clubs all supplemented the PR activities. We helped schools plan and implement project weeks;

The exhibition "Das Paul Klee-Zentrum im Gespräch" (The Paul Klee-Zentrum under Discussion) took place in the Kornhaus and on the Kornhausplatz in Bern in February 2001 in the lead-up to the city's referendum on March 4, 2001.

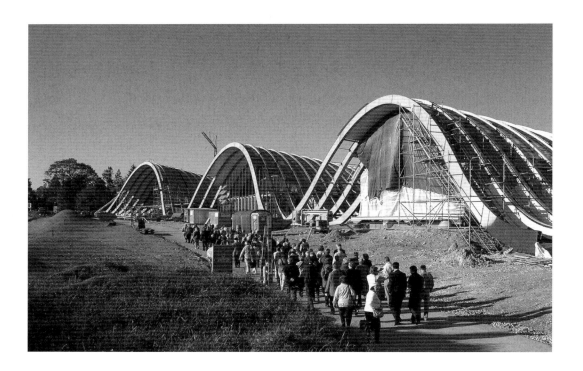

Impression from one of the many
building-site tours, which
the Zentrum Paul Klee offered
the public during the three-year
construction phase

Dimitri the Clown wrapping up the
pictures at the Paul-Klee-Stiftung's
"moving party"

planned long-term collaborations with teacher committees, an adult education course
for the Volkshochschule Bern titled "Das Zentrum Paul Klee im Gespräch" (The
Zentrum Paul Klee under Discussion), and walks with Pro Senectute (across the build-
ing site to the quarries in Ostermundigen); and sought and cultivated contact with
important mediators like Bern's hotels and taxi companies.

In the time between the groundbreaking on October 15, 2001, and spring 2004 we had
the privilege of taking several thousand men, women, and children through the
building site and introducing them to the project. Even the later introduction of an
admission fee did not affect the great demand, so that during the busiest times
we were guiding as many as three groups of forty or more people per day through the
building site. In early summer we had to cancel the offer of tours—construction
on the interior precluded entry into the building for safety reasons. With a few excep-
tions that could be counted on one hand, the reactions of the visitors ranged from
positive to enthusiastic. "Open to the public" was the credo of the project's and later,
the center's managers, and so the cornerstone ceremony in summer 2002, the topping-
out ceremony in winter 2003, and the move of the Paul-Klee-Stiftung (Paul Klee
Foundation) in winter 2004, as well as other big and small events, were always cele-
brated together with interested members of the populace.

The wider world also took notice very early on. Our Web site, which won international
awards, made a major contribution here. In 2003 we were already receiving queries
from Europe, Asia, and the United States about when the center would open, what

admission would cost, and how to get here. Japanese guests visited the Klee works in the temporary spaces on Weltistrasse and referred to Japanese fashion magazines featuring the Zentrum Paul Klee and Bern.

On December 1, 2003, the day of the topping-out ceremony, we had another big opportunity to attract the interest of the populace and the media. This was when our corporate design and logo were introduced and the new name, Zentrum Paul Klee, was announced. The name change from Paul Klee-Zentrum to Zentrum Paul Klee was intended above all to place more emphasis on the interdisciplinary approach. The name itself is a program.

The logo of the Zentrum Paul Klee describes in stylized form the three hills of the architecture: what we see as we approach the building. The movement and dynamics of the logo recall the formal language of Paul Klee, as do its colors, which were taken from works by Paul Klee and which, employed in a playful way, allude consciously to the center's varied offerings. The logo and corporate design were developed by Coande. Communication and Design. This Zürich-based agency works for museums throughout the world. Twelve renowned agencies from Switzerland and Europe were evaluated closely in a process that lasted a year and a half, and Coande was awarded the contract.

In the year leading up to the center's opening, the management coordinated its communications activities with various partners. Under the leadership of Bern Tourismus, the three large events of 2005—the opening of the Zentrum Paul Klee, the opening of the Stade de Suisse, and the exhibition in the Bernisches Historisches Museum on the Einstein year—all took place under the shared slogan "Bern³." The outstanding cooperation we received from the business world in the area of publicity was also invaluable. When, in spring 2005, the Zentrum Paul Klee train of BLS Lötschbergbahn AG took to the rails, the commemorative stamps had been issued, the new Web site had been launched, and the opening program had been published, we found ourselves in the home stretch.

Impressions from the 2004 Museums Night: Adrian Weber, director of the children's museum, Willy Athenstädt, building coordination, and Nathalie Gygax, Communication and Outreach Officer

Dr. Michael Baumgartner, Deputy Art Director and Curator of Collection, Exhibits, and Research at a presentation of the Zentrum Paul Klee at the Berner Kantonalbank

Cooperation with Our Business Partners

Ursina Barandun, Deputy Director and Director of Communication and Outreach,
Zentrum Paul Klee, Bern

An effective sponsoring program requires meeting three fundamental conditions.
The first crucial condition is an innovative, high-quality, and enduring project.
The second condition is project members who identify with the project and are pre-
pared to advocate its advantages to the outside world. The third indispensable con-
dition is partners from the business world who are not simply conscious of their social
responsibility but also prepared to acknowledge it generously. Our success demon-
strates that the initial situation of the Zentrum Paul Klee met these conditions.
The responsibility for the planning, building, and financing of the building was in the
hands of the Maurice E. and Martha Müller Foundation. The unusual preliminary
design of December 9, 1999, already made it clear that the thirty million Swiss francs
initially donated by the Müller family would not be sufficient to realize the ambi-
tious building, and so Professor Maurice E. Müller and his wife, Martha Müller-Lüthi,
made two additional donations totaling thirty million. But even sixty million francs
was not enough once the operating concept had transformed from that of a tradi-
tional art museum to that of an interdisciplinary cultural center. No extension to the
operating plan or the building was settled, however, before the follow-up costs
had been calculated and the financing arranged. It was decided, for example, to build
a separate, spacious area for the pedagogical activities of the museum—a central
concern both for the Müllers and the public authorities—that was in no way inferior
to those of the center's other core offerings. In order to provide a suitable platform
for music, theater, and conference activities, an auditorium that could fulfill these
varied demands was developed in the North Hill. For the changing exhibitions that are
to contribute to the center's long-term attractiveness, a basement floor was added

The flags of the founding partners on the visitors' platform abutting the A6 autobahn

in the Middle Hill, and to provide a wide range of communication opportunities, the Museum Street was outfitted with extensive multimedia equipment.

These expansions totaled fifty million Swiss francs. Deducting the eighteen million from the Lotteriefond des Kantons Bern, the financing needed for the initial project came to thirty-two million francs. Thanks to the procedure described above, there was never a financing gap of more than about five million francs.

From 2000 to 2004 financing totaling more than thirty million Swiss francs was generated from partnerships with private enterprises. It is undisputed, and it cannot be emphasized frequently enough to our partners and the public, that the Zentrum Paul Klee and its unique spectrum of offerings could never have been realized without the support of its partners from the business world.

Responsibility for fund-raising activities—both for conceiving them and for finding and cultivating partnerships—was in the hands of the president of the MMMF, a former member of the cantonal government, Peter Schmid, and the deputy director and the director of communication and outreach of the Zentrum Paul Klee, Ursina Barandun. They were supported by an advisory council comprised of the following

Jens Alder, Swisscom CEO, and Peter Schmid, President of the Maurice E. and Martha Müller Foundation, unveiling the Swisscom flag

public figures from Bern: Samuel Spreng, Dr. Rolf Bloch, Dr. Beatrice Gukelberger, Dr. Klaus Jacobi, Dr. Reto Sorg, and Professor Ulrich Althaus. Their activities were based on guidelines that defined not only the center's services and corresponding support from the sponsor but also the ethical and aesthetic framework of fundraising. Many personal conversations, one or more proposals tailored to the needs of the partner in question, and finally a written contract were part of every partnership. Although all the negotiations were confidential, and no information was released about the contracts, all of the partners were treated equally. The overall planning of the activities for the opening was discussed at a round table with all the founding partners and the management of the Zentrum Paul Klee.

What moved our partners to support the Zentrum Paul Klee with their money and their ideas? One important motif was our partners' connection to Bern the city, which for Paul Klee was a piece of home; another, his richly varied work, which stands for the ethical values of our society. Many of the partners see a parallel between Klee's willingness to set out on innovative paths and their own enterprises. As reliable and dynamic companies they identify with the Zentrum Paul Klee, which will have a

AO Foundation

AMMANN

BUNDESAMT FÜR KULTUR
SWISS FEDERAL OFFICE OF CULTURE

Lantal création baumann

HOFSTETTER

lasting and far-reaching effect in Switzerland and abroad. This will increase the value of the region, and the economy will benefit from that, as it already has. Investing in a vision rather than something existing attests to courage, just as it is an expression of courage to create a cultural project of this scope in times of austerity.

The Zentrum Paul Klee has never considered its partners from the business world as merely financial backers but as people from whom it can learn and who can offer it a great deal in many areas, including communication. Customer newsletters, some of which have more than two and a half million readers, contributed to making the Zentrum Paul Klee known throughout Switzerland even before the opening.

It is with joy and pride that we sincerely thank here once again all our founding partners and benefactors for their generous and by no means preordained commitment. Most of them committed themselves at a time when there were few or no indications of what might someday rise from the landscape. That innovations do not always have a hard time of it in Bern is demonstrated by the founding families and by our founding partners and benefactors.

The founding partners are: BEKB | BCBE, BKW FMB Energy Ltd., COOP, Fondation Maurice E. Müller, Galenica, Credit Suisse Group Jubilee Foundation, the lottery fund of the canton Bern, Schweizerische Mobiliar, Swiss Post, Securitas, Swisscom, UBS AG. The benefactors are: Ammann Holding, the AO-Foundation, the Swiss Federal Office of Culture, création baumann and Lantal Textiles, H. U. Hofstetter Kies und Beton AG, and the Mathys and Marzo families, Bettlach.

Even during the construction phase the Zentrum Paul Klee served as an attractive location for functions and festive events.

LIVERPOOL JOHN MOORES UNIVERSITY
LEARNING SERVICES

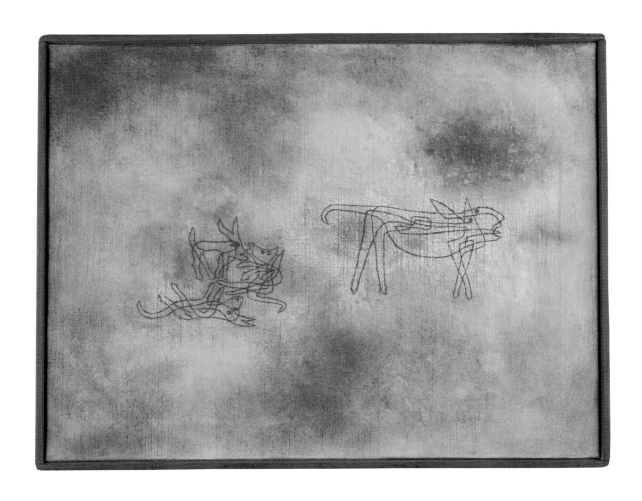

Paul Klee
Sie brüllt, wir spielen, 1928, 70
She Bellows, We Play

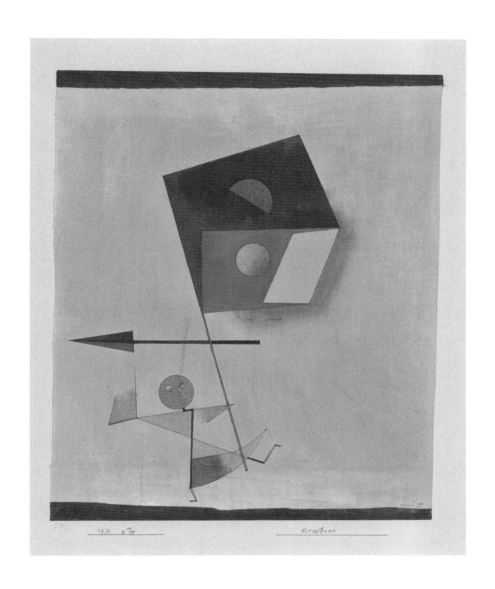

Paul Klee
Eroberer, 1930, 129
Conqueror

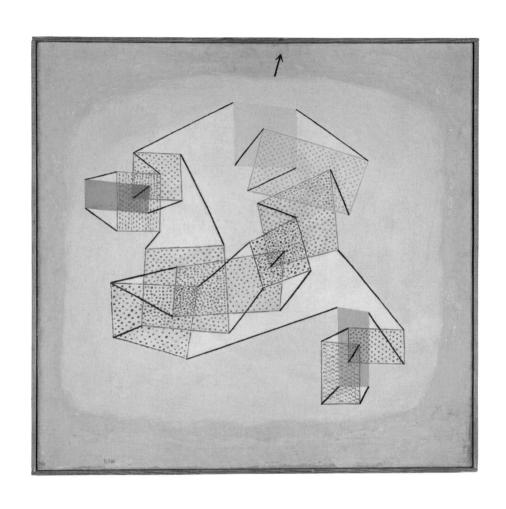

Paul Klee
Schwebendes, 1930, 220
Hovering

Paul Klee
Meerschnecken-König, 1933, 279
Sea Snail King

Paul Klee
Bauernzwerg, 1933, 394
344 Peasant Dwarf

Paul Klee
Büsser, 1935, 143
Penitent

Paul Klee
Tänze vor Angst, 1938, 90
Dances Caused by Fear

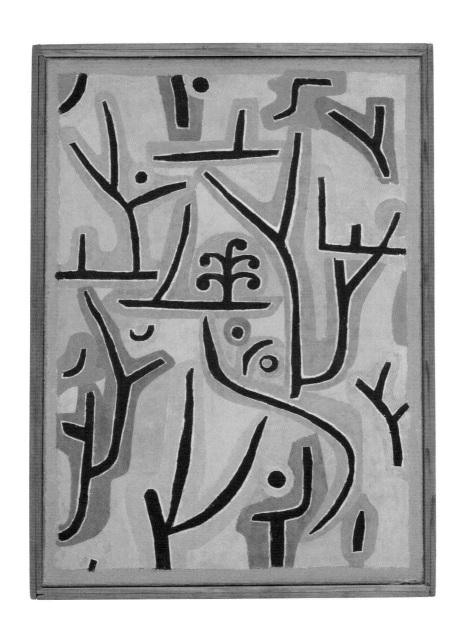

Paul Klee
Park bei Lu., 1938, 129
Park Near Lu.

347

LIVERPOOL JOHN MOORES UNIVERSITY
LEARNING SERVICES

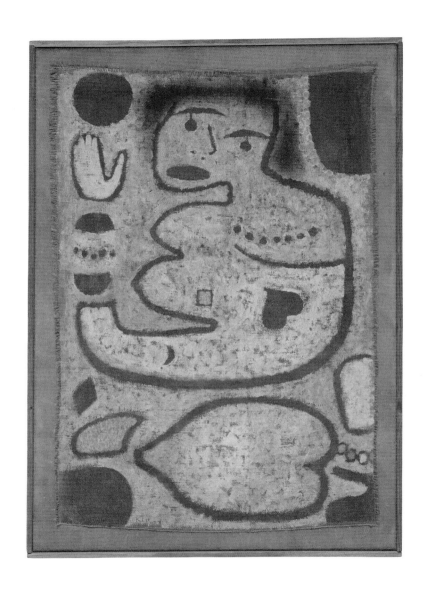

Paul Klee
Liebeslied bei Neumond, 1939, 342
Love Song at New Moon

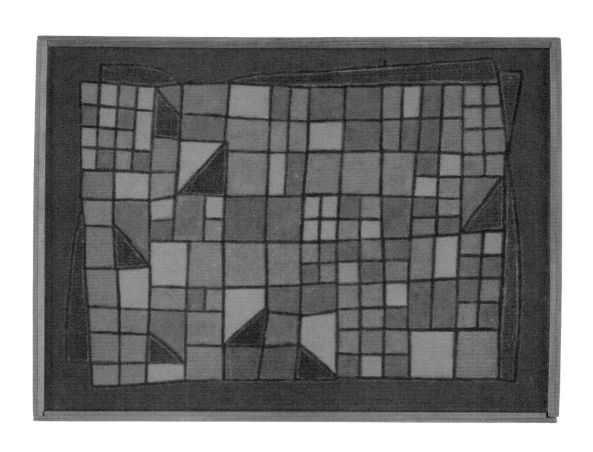

Paul Klee
Glas-Fassade, 1940, 288
Glass Façade

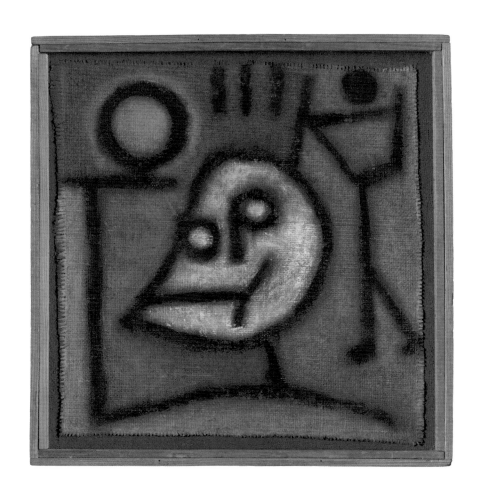

Paul Klee
Tod und Feuer, 1940, 332
Death and Fire

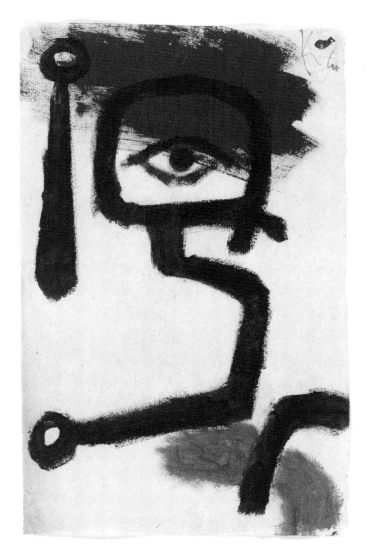

Paul Klee
Paukenspieler, 1940, 270
Kettledrummer

LIVERPOOL JOHN MOORES UNIVERSITY
LEARNING SERVICES

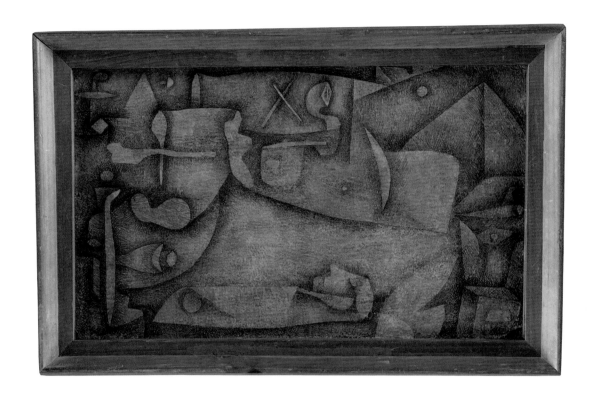

Paul Klee
Ent-Seelung, 1934, 211
The Soul Departs

Paul Klee
Menu ohne Appetit, 1934, 170
Menu without Appetite

Bern: Set in Motion by Klee

On Surges and Waves: Actions and Reactions to the Zentrum Paul Klee

Fred Zaugg, Art and Film Critic, Bern

Bern—Klee's city! If Bern has a right to call itself Klee's city, the opening of the Zentrum Paul Klee is the reason. For Bern, whose old city center is listed by UNESCO as a World Heritage site, it marks a leap into the future. The building Renzo Piano composed into the landscape has combined with a forward-looking, networked inter-action with Klee's art to become a source of hope for the culture of the city and region. Our heritage—Klee's legacy. Paul Klee's estate represents the cornerstone—art history, but with an uninterrupted transmission into the present. And again, only time will tell what the Zentrum Paul Klee will mean for the city of Bern when the days of celebrating its opening are past. What relationship will the populace and the media develop toward this new cultural focus with international ambitions?

By contrast, the reception of the Zentrum Paul Klee from the initial idea to its ultimate realization can be traced quite easily. But we should not lose sight of the artist Paul Klee, in whose name Renzo Piano's vision of waves has, after all, become reality. For it is only on the surface and in relation to the present that the Zentrum Paul Klee can be said to have made Bern Klee's city. In fact, it has earned that attribute for a long time. Klee's early work was produced here. This is where he wrestled with the decision of painting versus music. From here he set out into the world, and here he returned, stripped of his life's task, from Nazi Germany. It should not be forgotten that the artist himself chose Bern as his city. In his application for citizenship, he wrote in the early days of January 1940, the year of his death: "Because my good relations with Bern were never broken off, I felt too clearly and too strongly the attraction of this, my true home town. In the meantime I have returned to live here, and I have but one wish left: to become a citizen of this city." The one wish was not fulfilled. Nevertheless, Bern is still the artist's home town.

Despite his international reputation, it would be wrong to believe that Paul Klee was known beyond art circles when he returned to Bern. The exhibition institutions and the international art trade, however, had long since recognized him as a pioneering artist of modernism, as a painter, thinker, and teacher who would influence developments

worldwide. To use an expression from today's art business: Paul Klee was *made* in Bern. This is also where, following the death of the artist on June 29, 1940, committed advocates were at work: his widow, Lily Klee, and the collectors Rolf Bürgi, Werner Allenbach, Hans Meyer-Benteli, and Hermann Rupf. They saved his estate from confiscation by the Allies—and they did it for Bern. After Lily's death the Paul-Klee-Stiftung (Paul Klee Foundation) was housed in the Kunstmuseum Bern from 1952 on. Indispensable publicity work was conducted from there. It was not necessary to make Paul Klee famous when it was decided to create an adequate framework for the works concentrated in Bern by founding a monographic museum. The citizens of Bern already knew the treasures the city possessed. More importantly, they viewed Paul Klee as one of their own and developed a personal relationship to his works, which are at once complex and simple.

The First Vision and the Official Reaction

The main credit for this extraordinary degree of familiarity goes to Felix Klee, the artist's son and tireless ambassador, who presided over the Paul-Klee-Stiftung from 1963 to 1990. When he died on August 13, 1990, at the age of eighty-three, he was fully active in this regard. His son, Alexander Klee, and his wife, Livia Klee-Meyer, inherited his ownership of Paul Klee's estate. They made large sections of it available to the Kunstmuseum Bern as a loan. And in 1991 it was Alexander Klee who inspired Hans Christoph von Tavel, the director of the Kunstmuseum Bern, to create a Paul Klee museum.

His vision was adopted—one can even say gratefully and with enthusiasm. Six years later, an invitation from the state chancellery of Bern canton to a media conference on "The Creation of a Paul Klee Museum in the City of Bern," on September 19, 1997, illustrates that in Bern, even enthusiasm is a slow process: "Ladies and gentlemen, the idea of creating a museum devoted to the artist Paul Klee in the city of Bern has been around for a long time. We are thus pleased to announce that the first important steps toward its realization have been taken. The Canton, the City, and the Civic Community of Bern this summer signed an agreement that not only declared a fundamental readiness to create and operate the museum but also laid out how the costs and work would be shared; how the parties would work together with the Klee family, the Kunstmuseum Bern, and other interested circles; and finally, how the project would proceed in detail. To meet the operational tasks under the project, the three partners have appointed a joint management for the project."

The previous evening, art lovers in Bern had celebrated the fiftieth anniversary of the Paul-Klee-Stiftung with a lecture evening in the Kunstmuseum. In addition to an

Werner Luginbühl, Member of the Cantonal Governement and President of the Stiftung Zentrum Paul Klee, and the collector Christoph Bürgi (left) at the Paul-Klee-Stiftung's "moving party" at the Kunstmuseum Bern on November 21, 2004

Eightieth birthday celebration for Livia Klee-Meyer in the Cinématte Bern, June 5, 2002

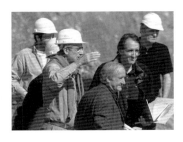

The architects from arb and the RPBW on the site and in the site office, 2004

appreciation of the "painter of the century," as Alexander Klee, then president of the Paul-Klee-Stiftung, rightly called his grandfather, a description of the foundation's extensive works, which includes scholarship, and setting the mood for its upcoming Klee exhibition *Die Blaue Vier* (The Blue Four) at the Kunstmuseum, another theme at the time was, of course, the Klee museum.

In the *Basler Zeitung* for September 20, 1997, to give just one example of the unanimously positive press coverage, Heinz Däpp alluded to Klee's unfulfilled desire to be naturalized and described, under the heading "Paul Klee—a Swiss, after all," the construction of a Paul Klee museum "as making amends to Klee . . ., who in his day was refused Swiss citizenship." He was referring to a statement by the then mayor of Bern, Klaus Baumgartner. Klee's heirs, however, seemed to feel no resentment at all; by that time Livia Klee-Meyer had already donated her portion of the estate, nearly 650 works by Klee and artists associated with him, to the City and Canton of Bern. Her only stipulation was that by 2003 a Klee museum would be opened in Bern, in time for the celebration of the artist's 125th birthday in 2004—a way of getting things going that clearly had an effect. In the contract the deadline was later extended to 2006.

In *Der Bund* Katharina Matter wrote: "The museum is projected to hold about 40 percent of Paul Klee's works. They are coming from the collections of the Paul-Klee-Stiftung, which has agreed to remain in Bern, although it is not tied to Bern by its deed of foundation. There are also works from the collections of Livia Klee. Authorities in the arts have described these works as being 'of the highest rank,' Regierungsrat Peter Schmid says, adding, 'Mrs. Klee has thus presented the Bernese and Swiss public, and indeed all the scholars and lovers of art in the whole world, with a gift of immeasurable value.' Klee's grandson, Alexander Klee, is in principle prepared to make his works available to a Klee museum."

Fred Zaugg commented in *Der Bund*: "Paul Klee was a visionary artist who knew how to combine music and painting and who saw a comprehensive picture of art, culture, and humanity as the basis for creativity and life. Today, in a city that is often accused of lethargy, the goal is to develop visions, realizable ones, and perspectives on the future, for Paul Klee was able to say something to everyone in his work, and he will also be loved by coming generations. The challenge now is to assume responsibility— for a cultural legacy, but also for a living municipal culture and a population that needs not just an intact old city but also an alert spirit of the sort Paul Klee possessed and implemented in his fascinating œuvre. Any hesitation would be inappropriate, any delay a loss. This calls for courage, generosity, and common will."

Old House and Flaring Emotions

At the first large media conference on September 19, 1997, the costs were already estimated at one hundred million Swiss francs, and the talk was of three bodies—the City, Canton, and Civic Community of Bern—participating with twenty million francs each. The community of Bern, which was then suffering financial difficulties, would provide the building. Designed by the Bernese architect Eugen Stettler in a historicist style, the former Progymnasium—also called "Proger"—was built between 1883 and 1885 as a secondary school. In the auditorium of this "future Paul Klee Museum" Paul Klee had received his school-leaving diploma on September 24, 1898. The subsequent surge of controversy around this building, located between Speichergasse 4 and Waisenhausplatz 30, was probably the fiercest in the history of the Zentrum Paul Klee. The building lies directly opposite the Kunstmuseum Bern.

Emotions ran high, so high that at a perhaps not entirely dry gathering of Bern's art and architecture scene, one established architect got so carried away that he declared, "I will personally burn this schoolhouse down if Klee's works are placed in those stuffy classrooms." They would probably not have remained quite as stuffy as the angry party recalled them to be, but at the time the preservationist Bernhard Furrer could promise very little room for maneuver if the Proger were to be repurposed for new use as a Klee museum. Despite opposing viewpoints, for a long time the necessary public discussion never took place.

That is why Bernhard Giger and Konrad Tobler raised the question very clearly and calmly in the *Berner Zeitung* of February 6, 1998: "Is Paul Klee really in the right place on Waisenhausplatz? Then why not a new building? Is Bern showing too little courage in the matter of a Klee museum? That is what politicians and architects are asking. They are thinking of a new building." The two journalists thus made the long-simmering debate public: "Not all of Bern's authorities are willing to use the example of a Klee museum to speak openly about Bern's future urban development. They are quick to bring up the proverbial bird in the hand and thus avoid questions and discussions. This defensive posture expresses resignation, suggesting that Bern is simply not a city for great plans. The proposal to construct a new building for the Klee museum could at least encourage an awareness that some courageous urban development goals would do the city of Bern good. An architectural venture could enliven the city both culturally and economically."

As an alternative to the controversial Proger, politicians, like Alexander Tschäppät, and architects preferred the bridgehead of the Lorrainebrücke as a location—a place for a striking architectural "gateway" to the city. City councilor and architect Urs Jaberg along with fourteen cosigners raised the question whether the Proger was the

The former schoolhouse on Waisenhausplatz in Bern, where Paul Klee went to school, was originally intended as the location for the new Klee museum.

Former Klee-Platz on Hodlerstrasse. To further honor the artist, in 2002 Bern's municipal government renamed eighteen streets and lanes in the immediate vicinity of the Zentrum Paul Klee with titles of works by Paul Klee.

right place for Klee in an urgent interpellation to the executive, thus forcing it to take position. Katharina Matter took a clear stand in *Der Bund* for March 12, 1998, and Fred Zaugg countered the undisputed talent of Bern architects in the art of repurposing with the remark that "the Lorrainebrücke–Schützenmatte–Kleeplatz area is fallow land in terms of urban development and conceals architectural potential that deserves our closest attention." Mayor Klaus Baumgartner warned against stopping the work in progress but said that the option of a new building for the Klee museum remained open. "We don't want the most practical solution but the best one—we owe that to the Klee family," said City Councilor Ursula Rudin-Vonwil, summarizing the majority position of the city council.

The young Bern architects of the firm smarch, Beat Mathys and Ursula Stücheli, had early on come out in favor of an open debate, of a new building based on a competition, and the key position at the head of the Lorrainebrücke. On the occasion of the Eidgenössischer Preis für Freie Kunst (Swiss Federal Award for Fine Art), they wrote a manifesto titled "Relationen" (Relations), which also referred to the Klee museum: "The buildings we have realized are seismographic reliefs of our intentions in wrestling with the context. Our context is anything but ideal. We create architecture in Bern, a city where intellectual and cultural engagement with architecture is regressive. In its narrow context the city clings to anachronistic values. In consequence, the suburbs are deteriorating to complete insignificance . . . The culture of architectural competitions is dying out. Vital forces are being blocked. A Klee museum is being stuffed into an older building. The matter is closed. Missed opportunities as a result of ignorance and complacency."

That manifesto formed the basis for diskurs für bern, a forum Mathys and Stücheli initiated with seven fellow architects that, in collaboration with the Paul Klee-Museum's project management team, organized podium discussions with key participants. The one held on March 30, 1998, in the Kunstmuseum Bern was a great success with the public: Christoph Reichenau, deputy director of the Swiss cultural agency, Bundesamt für Kultur (BAK), and a member of the project management team of the Paul Klee-Museum, moderated the debate between no fewer than eleven panelists, all men: "Everyone wants the Klee museum. But where it should stand and what should become part of this art center were issues on which the participants . . . could not agree" (Bernhard Giger, *Berner Zeitung*, March, 31, 1998).

The official, public, semipublic, and private discussions—and also quarrels—continued. In May it was said that a decision would be made in September, and an international competition would be announced in early 1999. Already those responsible for the project were focusing on a new building. When Bernhard Giger wrote "Klee

must interest the whole city" in the *Berner Zeitung* for June 4, 1998, he must have known that Klee had long since been an issue for the whole city. Nevertheless, he argued for reinforcing the idea of the bridgehead among the populace and among those who were to make the decision four months later.

A Great Gift with Clear Conditions

Suddenly everything changed. On the morning of July 8, 1998, the headlines on the newsstands read: "Bern Doctor Donates 30 Mil!" (*Blick*), "Klee Museum: New Turn Thanks to 50 Million Gift?" (*Der Bund*), and "Doctor Donates Klee Museum: He Listens to His Wife" (*Berner Zeitung*).

Just days before, a media conference had been held on short notice in the Erlacherhof. The world-famous Bernese surgeon and orthopedist Professor Maurice E. Müller, inventor of the artificial hip joint, caused incredulous astonishment: the project committee beamed as it reported the generous donation of thirty million francs, a building lot, and the offer to contribute half of the loan for operating costs for a Klee museum. The offer from Maurice E. Müller and his wife, Martha, and even more so the vision of a Klee museum behind it, pushed the ongoing discussions in an entirely new direction. Bern had never seen a donation like this. The result was a surge of media interest in all of Switzerland's regions and in neighboring countries as well. After the deadline attached to Livia Klee's donation, this was a second shot in the arm for a Klee museum in Bern and the second media event: the orthopedist Maurice E. Müller was mobilizing the city's "motor system."

But what about the location, what about the competition? "Now the donation from the Müllers, which is tied to the plot they offer on Freudenbergplatz in Schöngrün, forces a fundamental reorientation" (*Der Bund*, July 8, 1998). "Until now locations outside downtown have been rejected by the project management: they did not want to build the Klee museum in Murifeld, in Wankdorf, or in Ausserholligen. Now everything has changed: the couple's offer includes a nine-thousand-square-meter property and dozens of millions of francs. The new museum resulting from this private generosity so atypical of Bern would lie on the edge of the city" (*Berner Zeitung*, July 8, 1998). When Maurice E. Müller presented his vision on location in the Schöngrün area of Bern a few days later, it was clear that a patron with ambitious goals and demands was ready to donate, one who could say: "I saw that Bern was having difficulties with the planned Klee museum, so I thought, how can I best help?"

While those responsible for the project, the politicians, and the architects were quite cautious at first, it was soon clear to the populace that the Müllers' gift should be accepted with thanks. Maurice E. Müller is a thoroughly genuine person. He can even

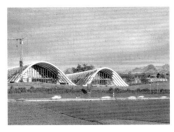

Views of the Zentrum Paul Klee
site after and before the beginning
of construction

admit to the press that he learned of Klee through foreign colleagues who made no secret of the fact that they would occasionally skip out of his medical conferences in Switzerland to go to Bern to see the Klee Collection in the Kunstmuseum. Curiosity tempted him to follow them.

The Meadow beyond the City and the Master from Abroad

The Müllers' commitment triggered an almost feverish activity in the planning of the Klee museum. It was repeatedly described as "atypical of Bern," because suddenly there was a determining force that was new, clear, and direct. Maurice E. Müller and his wife, Martha, a lover of the arts, did not simply want a museum but also a place of encounter, a research institute, a Klee academy. Unfortunately, these days it is a matter of course for the media to indulge in gratuitous mud-slinging. Anna Schindler wrote in *Cash* for September 18, 1998, of the "visit of the old gentleman," comparing the situation to Friedrich Dürrenmatt's play *Der Besuch der alten Dame* (The Visit of the Old Lady). She was not the only one. Others too thought the Bernese were being corrupted by unexpected wealth.

An important role in the debate on the site, now focused on the head of the Lorraine-brücke or Schöngrün, was played by the renowned architectural critic Benedikt Loderer when he argued for the Schöngrün site in the *Berner Zeitung* of October 22, 1998. In the public too, the possibility of "leaving the Middle Ages" and build-ing a Klee museum outside the historic city center was discussed in increasingly posi-tive terms. The establishment of the Maurice E. and Martha Müller Foundation (MMMF) on November 4, 1998, effectually decided the question and also concluded an extremely fortunate arrangement with Alexander Klee. The majority of the media applauded the long-anticipated decision regarding the site. There was no surge of protest. Perhaps Bern, whose real city walls had long been razed, had finally managed to knock down some walls in peoples' heads as well, clearing the way and view.

The third media wave would soon follow, however, and though it was not a tidal wave it was one that would carry things a long way.

The reaction of the media when the MMMF, now functioning very professionally, revealed it had commissioned the Genoese architect Renzo Piano to build the Paul Klee museum was moderately critical but still respectful and more surprised than anything else. The official release said he had been commissioned for the preliminary project. "By agreeing to a direct commission of Renzo Piano, the Müller's preferred candidate, the representatives of the public are turning themselves into bit players in this crucial planning phase of the Klee museum," fumed Bernhard Giger (*Berner Zeitung*, December 19, 1998). But even though the decision prevented the competition

that young architects in particular had championed, criticism was restrained. It was clear from the beginning that the "private foundation had the right to do this and was not skirting any regulations . . . Others . . . consider the decision of the foundation's board to be a courageous step. It is well known that art and quality cannot be judged on democratic principles" (*Der Bund*, December 19, 1998).

Calm prevailed. The journalists began, in interviews and visits to the studio and workshop in Genoa and Paris, respectively, to build a bridge to the Italian master architect; Bernese architects accepted the decision; members of parliament in both the canton and city had succeeded in their bid to make a splash in the sphere of culture; and the public expressed its enthusiasm in letters to the editor, full of expectation and rarely anxious. Among specialists and laypersons alike, general approval began to emerge.

After the Surges the Waves

Here was the breakwater between the three surges of public opinion, some quite high, washing against the Zentrum Paul Klee, and Renzo Piano's three waves in Bern's Schöngrün area, which have gradually, gently, and yet distinctly swept into our conscious. One might also say that the necessary discourse of the search was followed by information on the find.

The starting point, of course, was the creative act, the work of Renzo Piano and his Building Workshop. Renzo Piano's vision was engendered on site in Bern and then took shape in Genoa and Paris. The Zentrum Paul Klee leadership and office have done an impressive job in communicating the whole planning process to politicians and the population. One extremely important means to that end was the frequently updated Internet site at www.zpk.org, which included a newsletter to which one could subscribe and a discussion forum. It certainly deserved the gold and silver medals it won: a Web page award as Best of Art Category in April 2000 in Sunnyvale, California, and the Web award Standard of Excellence in Boston, Massachusetts, in November 2000.

Reports, media conferences, information evenings in the neighborhood and with the broader public, and a constant willingness to communicate produced outstanding results in the votes, too. In Bern's can-tonal parliament the project was approved with 132 votes and 7 opposing; in the city parliament, with 66 to 0 votes; the voters of the city expressed their enthusiasm when 78 percent voted their approval. Such a clear yes vote on a cultural project with considerable costs is extremely rare in Bern. The city's special connection to the visual arts had, however, already been evident years before in the clear approvals for the expansion and later the renovation of the Kunstmuseum Bern.

In the winter of 2004 the cantonal government and the municipal government of Bern invited the Swiss Federal Council to visit the building site; the photograph shows, from top to bottom, Micheline Calmy-Rey, Member of the Federal Council and Foreign Minister; Elisabeth Zölch-Balmer, Member of the Cantonal Government and Director of Economics; and Alexander Tschäppät, Member of the Municipal Government and Mayor of Bern (since January 1, 2005)

The plaque of the first international award for the best culture-related Web site, which went to the Web site of the Paul Klee-Zentrum

The Zentrum Paul Klee logo was designed by the Zürich-based agency Coande. Communication and Design.

A train called "Zentrum Paul Klee": Werner Luginbühl, Member of the Cantonal Governement and President of the Zentrum Paul Klee, christening a low-floor commuter train belonging to BLS Lötschberg-bahn AG on April 12, 2005

In Bern, of course, it was almost unprecedented for information about a project to be shared so openly. The media accepted the offer and participated in the campaign for the large project, though not without criticizing it, not without repeatedly giving the existing cultural institutions in Bern a platform for voicing their financial worries. They were right to do so, because the anxiety that the new Zentrum Paul Klee would result in smaller subsidies for others was not unjustified and could never be alleviated entirely. The Zentrum Paul Klee did all it could to clear the air of such fears. For example, it successfully found generous sponsors. Even on the political level it sought to avoid preferential treatment for the Zentrum Paul Klee, though misinterpretation of the figures caused panic again and again. Proving that the Zentrum Paul Klee will not be a burden to other cultural institutions but will instead fructify them in an ideal way will remain a necessary concern for the center's leadership and Bern's political leaders.

An Anniversary and a Second Gift

Another issue has simply been shelved. There is no more talk of closer cooperation among Bern's art institutions, of the cooperation necessary for Bern to assert itself strongly as a city of the arts.

At the celebration of the Kunstmuseum Bern's 125th anniversary Hansjörg Wyss offered in late August 2004 a gift of eighteen million Swiss francs to turn the much-discussed Proger into a museum of contemporary art. The Bern native, who made his fortune in the United States, wants to support a Kunstmuseum weakened by the departure of the Klee works. The way that trivialities can prevent collaboration in the service of the arts must give us pause. Bernhard Giger (*Berner Zeitung*, August 28, 2004) wrote that the agreement signed for the gift "intervenes, to a much greater extent, more or less directly in the future planning of the museum landscape in Bern . . . And then he [Hansjörg Wyss] spoke the words that make the true consequences of the agreement on contemporary art clear: 'The discussions on the fusion of the Kunst-museum and the Klee center are over.'" Marc Lettau quoted the patron of the arts in *Der Bund* for August 28, 2004: "Giving Bern a present, Wyss said, was decidedly painful and strenuous." What a strange notion of giving must lie behind this state-ment. No one disputes that Bern needs a museum of contemporary art. But Bern is a little too small for rivalries in the arts and between museums.

The broad enthusiasm for Renzo Piano's trilogy of waves in Schöngrün never flagged during the entire time of realization. Let us recall some of the highlights that caused ripples of applause in the media and among the public: the exhibitions in Bern's Korn-haus; the groundbreaking ceremony; the cornerstone ceremony; the topping-out

In fall 2004 the Zentrum Paul Klee sought volunteers to help in various service areas. The public resonance was great and very positive. Photo of the information session on October 30, 2004.

ceremony; and also Bern's Museums Night, in which the Zentrum Paul Klee took part as an illuminated construction site that could not be entered but nevertheless attracted a lot of admiration.

"Bern moves" was the slogan for a traffic-free Sunday in September 2004. Bern was moved, moved by Paul Klee, moved by art, moved by a vision and a shared will to make it reality. If it seems as if Bern were not moving or only barely so, waiting for someone to move it, then it is certainly Paul Klee who has moved the lethargic city most intensely in the past ten years. Perhaps the realization of the Zentrum Paul Klee is also a lesson for Bern in terms of discussion and information, deliberation and acceleration. Be that as it may, Bern is clearly a city that can be moved by art—for example, by the idea of building Paul Klee a museum.

The Role of the Bern Civic Community

Dr. Lorenz Meyer, President of the Paul Klee Foundation of the Bern Civic Community

From the very beginning, the Civic Community of Bern (Burgergemeinde Bern) was enthusiastic about the proposal made to it, along with the Canton and City of Bern, to build a museum dedicated to Paul Klee. The association appreciated the extraordinary importance and outstanding value a Klee museum would have for Bern, and felt its own mission predestined it to participate in this effort. It initially designated its president and vice president at the time, Rudolf von Fischer and Dr. Kurt Hauri, respectively, to be its representatives for the project. A year later it elected Dr. Lorenz Meyer, member of the Kleiner Burgerrat (Lesser Civic Council), its new representative. Dr. Kurt Hauri, by then the Civic Community's president, continued his commitment. Both of them represented the Civic Community on all the project's important committees.

On June 30, 1997, the Grosser Burgerrat (Greater Civic Council) approved an agreement between the Canton, City, and Civic Community of Bern in which the parties to the agreement declared their will to build a museum devoted to Paul Klee in downtown Bern. In that contract the Civic Community agreed to provide either a one-time contribution to the building costs to the amount of twenty million Swiss francs or an annual contribution to operating costs of one million francs. In September 1997 the three polities presented the plan publicly for the first time. The two councils of the Civic Community had, over time, repeatedly responded to specific questions and always took a very positive view of the plan.

In summer 1998, Professor Maurice E. and Martha Müller came to the Canton, City, and Civic Community of Bern with their offer to make a large contribution to the Zentrum Paul Klee, with the proviso that it be built in Schöngrün. This changed the situation fundamentally. Intensive negotiations among the partners led to a redistribution of tasks. The outline agreement between the Canton, City, and Civic Community of Bern and the Müllers stipulated that the building of the center would be the responsibility of the Maurice E. and Martha Müller Foundation, while the responsibility for operation would be shared equally by the City and Canton of Bern.

According to the same contract, the Civic Community would contribute, in the form of a fund or foundation, twenty million Swiss francs for specific operation tasks. In May 2000 the Civic Community decided to create a foundation. By doing so, it sought, on the one hand, to devote the promised amount, in law and in fact, to the goals of the center and, on the other hand, to demonstrate clearly the extent of its commitment.

Having created its own foundation, the Civic Community no longer needed to participate in the project's other committees. Its representative continued to be involved, however, as a member of the governing board of the operating foundation of the Zentrum Paul Klee, in order to ensure a connection between its own foundation and the center. On December 13, 2000, the voting members approved, with a vote of nearly 90 percent, a credit pledge of twenty million Swiss francs to the benefit of the yet to be founded Paul Klee-Stiftung der Burgergemeinde Bern (Paul Klee Foundation of the Bern Civic Community). This made the Civic Community the first of the three polities to commit itself to the center in a binding referendum. The city and canton had encouraged this approach, which gave them a tangible result to point to in their own referendums and the associated public discussion. The decision of the Civic Community met with strong support from the public. It was noted that the Civic Community's contributions for specific goals was financing the "optional," while the city and canton had taken responsibility for the "obligatory" by ensuring an orderly operation. With its contribution the Civic Community would help to "dust" the center now and again to keep it attractive.

On June 11, 2001, the Paul Klee-Stiftung der Burgergemeinde was established. Because the foundation intends to support the center over the long term, the deed of foundation specifies that the original donation of twenty million Swiss francs (including a gift of five hundred thousand francs from the DC-Bank) due on January 1, 2003, is to be kept intact in real terms. According to its statement of purpose, the foundation is supposed to contribute to the long-term attractiveness of the Zentrum Paul Klee by supporting it with the purchase of art objects, with changing exhibitions, and other projects, in the area of research, for example. Contributions to the routine operation of the center are ruled out. The foundation's first board was composed of Dr. Lorenz Meyer as president, Dr. Rudolf Stämpfli as vice president, and Professor Josef Helfenstein. The secretary of the Civic Community, Andreas Kohli, would also serve as the foundation's secretary. The board's first task was to invest the foundation's assets, which it did by purchasing from the Civic Community roughly half of the encumbered property with the service building Baumgarten-Ost, and investing the rest of its assets with the DC-Bank, under the same conditions enjoyed by the

Civic Community itself. After adjusting for inflation, the net returns should be several hundred thousand Swiss francs annually. On September 7, 2004, in the presence of the new president of the Civic Community, Franz von Graffenried, the foundation presented itself to the public on the occasion of a lecture by the center's artistic director in the Kulturcasino.

In the beginning, the foundation's board will decide in response to petitions from the center, but it will also be able to act on its own or in response to third parties. It wants to proceed carefully with the foundation funds. That is why the board has not yet responded to an offer from a Japanese collector to purchase paintings, because of differing ideas about the price. That is also why it carefully examined, but ultimately rejected, the purchase of the former dwelling of Paul Klee at Kistlerweg 6, which would have severely limited the foundation's financial options. The financing of the center's audio guide was not realized either. Yet the foundation did purchase, at the suggestion of the center, the drawing *Menu ohne Appetit* (*Menu without Appetite*), 1934, 170 (fig. p. 353), from a gallery in Bremen. It is an interesting work by Klee, in which the artist, not without irony, conducts a kind of concealed dialogue with contemporary artistic movements—in this case, with Surrealism. On that occasion, the board was able to approve the purchase within two or three days, even though the members are located in Lausanne, Bern, and the United States. The foundation's trim structure has, in part thanks to modern data transmission, proven its worth.

The foundation is pleased to be able to present the work to the Zentrum Paul Klee as a permanent loan, on the occasion of the center's opening in summer 2005. Finally, the foundation has financed the exhibition *Nulla dies sine linea* as an opening gift to the Zentrum Paul Klee.

Monument in the Fertile Country
On the Architecture of the Renzo Piano Building Workshop

Benedikt Loderer, City Wanderer, Bern and Zürich

The Zentrum Paul Klee is the fourth museum built by Renzo Piano. It was preceded by the Centre Pompidou, the Menil Collection, and the Museum Beyeler. These projects must be considered in any reflection on the design for Bern, since Piano learns something new from each of his buildings. But first: who is Renzo Piano? Le Corbusier emphasized whenever he could that his family was descended from Cathari, which was what made him so rebellious and unyielding. Renzo Piano does not miss an opportunity to remark that he is the son and grandson of master builders, which has given him his passion for making things: "From an early age, I would accompany my father to the construction sites. I was fascinated to see things arise from nothingness, simply through human hands. For a child, a construction site has something magical about it: today you see a heap of sand and bricks, tomorrow there's already a wall, and by the end there is an entire building, large and solid, and people are living inside. I have had the good fortune to spend my whole life doing what I had dreamed of as a child."[1] For Piano, it is obvious: equipped with this legacy from his father, no other path in life would have been possible. In conversation, Piano likes to invoke Brunelleschi. Sometimes he also compares himself with Robinson Crusoe—a man whom practical intelligence enabled to survive on unknown territory. The architecture critic Kenneth Frampton captured Piano's approach thus: "Throughout his entire professional career, Piano worked for an architecture free of myth, with a single exception: the mythos of the innate world-creating drive of the homo faber."[2]

Born in Genoa in 1937, Piano studied architecture in Florence and Milan. Ernesto Rogers and Giancarlo di Carlo were his most important teachers and role models. He calls Richard Buckminster Fuller and Pier Luigi Nervi his "teachers from afar;" Jean Prouvé, too, to whom he feels connected "in regard to a particular way of practicing this profession."[3] Prouvé, it should be noted, has his own relationship to Bern: he was advisor to the architecture firm arb, which, as Piano's representative in Bern, was responsible for overseeing the construction of the Zentrum Paul Klee.

Impressions from the Renzo Piano Building Workshop, Paris

LIVERPOOL JOHN MOORES UNIVERSITY
LEARNING SERVICES

After taking his degree at the Milan Polytechnic in 1964, Piano began to experiment. He worked with verve and gusto, built great things out of nothing, and developed lightweight constructions incorporating bars, cables, and membranes. He incorporated shells made from the then new material of polyester into his constructions, and assembled spatial structures from prefabricated components. The Robinson of the 1960s is an inventor who helps himself, as a matter of course, to the most modern technologies and the latest materials. His goal is lightness. The constructions must be light; the serious game of invention must also be light. Heaviness is alien to Renzo Piano. In a series of television programs, Piano communicated to the public what he learned through his lightweight constructions. Piano has always faced the public, since he is convinced that architecture is made for people—architecture for architects has never been of interest to him.

The City Machine

Piano's name is linked in the public consciousness to the Centre Pompidou in Paris. Along with Richard Rogers, his partner at the time, Piano won the international competition for the design, beating out 680 other project proposals. It was this success that put Piano on the map for international architecture. Since then, he has been among the recognized greats in his field.

With the support of engineer Peter Rice of Ove Arup & Partners, Piano and Rogers bet everything on a radically different museum design. They turned things around and made the interior into the exterior. The ongoing, unsupported usable floor space is inside; outside, the electrical wiring and plumbing have been placed in front of the façade.

When the Centre Pompidou was finished in 1977, it was acclaimed by the public and received by architects with grudging admiration, the sensation of the decade. It was not so much a building as a city machine; the cascade of escalators has become a mnemonic, an emblem. This city machine is perhaps what Le Corbusier had in mind when he spoke rapturously of a "machine à émouvoir," a sensation machine. Today, the Centre Pompidou still overwhelms through its monstrous presence. It stands among three public squares, like a modern cathedral in the body of the city of Paris. Terrible beauté!

It was Piano's first museum, but is not a museum so much as a percolator for culture consumers. An average of twenty-five thousand people flow through its escalator tubes each day, for a total of 180 million visitors to date. To these visitors, the building is just as important as the exhibitions. As a tourist, one goes to the Centre Pompidou as though by remote control, just as one goes to the cathedral of Notre Dame. Both

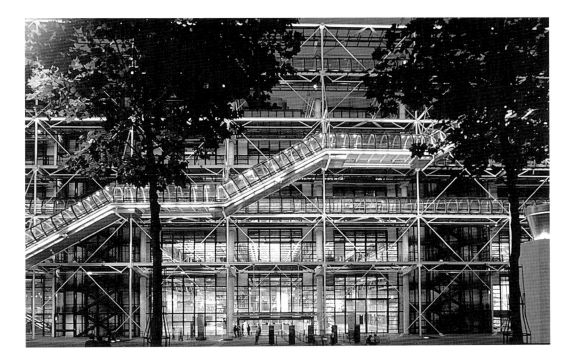

The City Machine:
The Centre Pompidou in Paris opened in 1977 and was the most influential building of its decade— acclaimed by the public, grudgingly admired by architects.

sights get four stars in the guidebook. Visitors climb up through the building and take in the view of the city—hardly noticing that everything that people find exciting about the Centre Pompidou takes place on the façades, the roof, and the surrounding city squares, and hardly at all on the building's interior: the breathtaking ascent, the traverse walkways in front of the exhibition halls, the terraces, and the fire-eaters on the plaza in front of the building.

Only on close inspection does it become clear what the Centre Pompidou really is: an enormous stack of artificially lit floor space, a multipurpose space distributed over six floors. On the inside, there is no architecture; the spaces are black boxes—plain vessels for ever-changing installations. The Centre Pompidou is an exterior construction; everything about the building that makes it exciting is concentrated in its façades. One must compare it to the Stuttgart Staatsgalerie by James Stirling, opened seven years later, in 1984, to see what is lacking in the Centre Pompidou, despite its ingenuity: the directing of light.

The Light Machine

In this regard, Piano has thoroughly caught up. Directing light is the central theme in the architecture of his building for the Menil Collection in Houston, Texas, opened to the public in 1986.

It sounds like a story from a cheap novel: A natural gas magnate leaves behind a fortune, an art collection, and a widow from the French financial nobility. The widow

The Light Machine:
The Menil Collection in Houston,
Texas, opened in 1986. The flat,
grayish-white art box stands in
a grid of roads in an expansive
suburb.

decides to build a museum to house the collection in a way befitting its rank. The
Menil Collection is in every way the opposite of the Centre Pompidou. Amidst a scat-
tering of suburban homes stands a low, white-gray suitcase for art. An entire city
block square has been turned into the lawn on which the museum stands. This is not
about educating and entertaining masses of tourists. Here, a site of contemplation
has been created. The museum's construction is simple. A large one-story rectangle con-
tains the exhibition spaces in which the changing exhibitions are located. Along one
of the long ends of the flat roof, Piano has added a slender horizontal member that
contains offices and storage for the approximately ten thousand art objects.

Piano is a modern architect, an inventive functionalist. He has reflected a great deal
on the relationship between art and technique, and is leading a "personal struggle for
liberation from the mythology of 'creation.' The artist is not blessed with a 'gift';
rather, he has mastered a tekné (technique) and knows how to apply it in the pursuit
of his goal: art."[4] The Menil Collection illustrates this approach.

Light is natural light, or none at all. In response to this, Piano designed the distinctive
component of the museum's construction, the transparent roof. Here, the light comes
from above, from the zenith. The layout and the inner organization of the museum
are intelligent and practical, ruled by the majesty of reason, treating its museum as
a merry temple to the religion of art. Madame de Menil, at home for visitors.

Yet Piano wishes to do more than cultivate ambience. He wishes to control the atmos-
phere, and to this end he must master light. To this end, he invented an ingenious

system of ceiling elements working in unison. Careful development produced his "light leaves"—concrete ribs in organic forms. Hung on a steel skeleton, they filter and distribute light, reduce brightness, protect from glare, and make up the undulating and turbulent ceiling of the exhibition spaces.

Solving the component problem, that of daylight, led to the solution of the central problem, that of the museum itself. Piano did not reach for the tried and true, for the glass roof with a dust sheet below that is familiar from the museums of the nineteenth century, from Stirling's Stuttgart museum, Gigon Guyer's Kirchner Museum in Davos, and Morger Degelo's Kunsthaus Vaduz. Piano always starts from scratch. Received ideas obstruct the view of better ones. Piano does not accept predetermined solutions; he works prototypically, deliberately, locates assumptions, tries out their consequences, changes the assumptions, works with variations, and approaches the solution by circling it. There is nothing he more decisively rejects than the myth of the genius architect in whose head, heart, and gut ideas flash like the divine spark.

Guiding Light:
As an imaginative functionalist, Renzo Piano developed an ingenicus system of repeating modular elements for the roof of the Menil Collection.

The Wall

Ernst Beyeler saw the Menil Collection. It won him over for Piano. At the Beyeler Museum in Riehen, near Basel, Piano presents an act of embedding. In an existing park, he has taken a great volume and made it disappear.

Piano, the master builder, has both feet on the ground. For him, there is no general solution; for him, it is always about the site: "I believe that project there is the best proof that we are deeply regionalist, bound to the earth, that we stay in a given place, that we do not move away at all."[5] For Piano, everything begins with a reading of the site: "We stand there and say: Aha! so that's how it looks here."[6] Piano found a narrow, gently rolling stretch of vineyard, bordered by a wall. The wall divided, indeed was built to divide, the country road from the land under cultivation. Yet this wall did more: it directed the gaze. It created an in-front-of and a behind. The wall turned its back to the street and gazed into the landscape, saw before it an undeveloped field, beyond that a plain and on the horizon the Tüllinger hill, its peak adorned by some vaguely medieval building. A picture postcard.

The wall was old, telling a tale of patrician country estates, of power, of erstwhile agriculture and its forms of production. The wall told of privileges and how they crumbled to bits. Walls protect, keep out, lock in.

The wall must have impressed Piano a great deal, since he made the wall into the generative element of his design. He built a museum from a sequence of four parallel walls. They extend into the park and anchor the building to the ground. They fix the horizontals and cut through the waves of the earth, which makes clear the movement

371

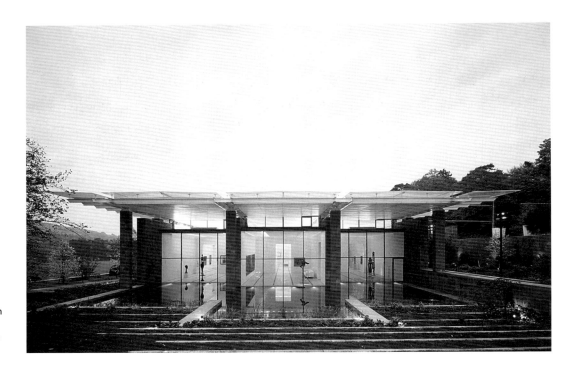

The Wall:
The Fondation Beyeler Art Museum in Riehen near Basel, completed in 1997. Four heavy, parallel sections of wall support a delicate roof.

of the terrain. The walls are heavy. Piano, the design engineer of lightweight construction, took particular pleasure in giving weight to his walls. He has clothed them in red porphyry from Patagonia. Porphyry, Piano explains, is age-old in the history of the earth, coming into being before the continents had even drifted apart. Will fragments of these four parallel walls some day be the only witnesses to the Museum Beyeler's existence? Piano says he never thought of future ruins. Whatever; these walls are the opposite of his first works. No longer is anything light and fleeting.

No, wait. The roof. Piano celebrates the contradiction between the heavy walls and the light roof, which has alit on the walls like a butterfly. Yet the connection between the walls and the roof is veiled. The construction is no longer turned inside-out. The technical demands may have increased—for ecological reasons—but the urge to show how things are put together, which was so unusually clear with the Centre Pompidou, has disappeared completely. Piano no longer has a need to prove anything: "I do not understand why we ... should not have used everything known now about directing light, preserving and securing artworks, and the use of glass."[7] Indeed, Piano took a significant step forward from the Menil Collection to the Beyeler Museum. It is the transition from heliography to computer printout. Or, the other way around: Piano has learned how to use the computer as an instrument for designing and drawing. And he is a master at it.

Renzo Piano has thought a lot about his profession: "A boundary profession hovering between art and science, on the cusp between invention and memory, between courage for modernity and respect for tradition."[8] He compares the inventor to discoverers: Columbus, Magellan, Cook, Amundsen. The architect, says Piano, makes journeys of discovery, and design is an adventure.

It is, to be sure, fraught with danger: "Incompetence, irresponsibility, arrogance, and contempt for craft are the things diminishing and ruining our profession."[9] He speaks against the architecture of least resistance as offered by resourceful service-sector architects. He distinguishes himself just as sharply from architects in ivory towers. They "are content with their actual or imagined social ineffectiveness. This is a classic point of view for avoiding responsibility, and it serves as a pretense for flight into pure form or into technology."[10] On receiving the Pritzker Prize, the Nobel Prize of architecture, in 1998, he remarked in his acceptance speech: "I thus see in it [architecture] curiosity above all, social expectation, the desire for adventure: these are the motives that have kept me away from the temple."[11]

The opposite of the temple is the stonemasons' lodge. Piano calls it the Renzo Piano Building Workshop (RPBW), which can be read as workshop for thinking and experimentation. In fact, there are two of them, one in Genoa with about forty and the other in Paris with about fifty bright people. The studio in Paris, where the work for the Zentrum Paul Klee was done, is located in the city center on the Rue des Archives. The shop window on the street provides a look into the model-building workshop. There is a method in this openness. Models—handicraft as such—are an essential component of Piano's design method. Architects are tactile visualists, they must touch what they see, and they must make visible what they think up. The Building Workshop is a humming beehive, stuffed full of models, presentations, books, and computers.

Calculate and work. Trial and error, first on paper, then in a model, and finally through prototypes on a 1:1 scale, this is the method of Renzo Piano, the practical scientist, and his workers. The design work oscillates between tinkering and calculating. The simplest freehand sketches and the most refined computer illustrations are used. There are always multiple projects coming into being simultaneously. There is a fascinating mix of playful approaches and computer precision. The questing path makes detours and goes in circles, it finds its way out of dead ends, but every step is one closer to a goal that is still unclear. Going off on the wrong track is necessary; it makes sure that no short-circuits, no supposed shortcuts will lead to a hasty outcome. Fixing in place too much too early locks one in. Piano's people approach their task like a research

Fred Zaugg, art and film critic (middle), in the Renzo Piano Building Workshop, Paris

Staff at the Renzo Piano Building Workshop, Paris

Bern is Big:
The city extends from the old town to the Alps. In the middle, on the meandering line of the autobahn, is the site of the future Zentrum Paul Klee.

team on thin ice. Their models are not meant to impress, but to reveal. The work process always includes its own representation. Every step is documented and is part of the workshop's growing exhibition, which is also used for internal office information. Pictures serve as a common language. The largely young employees, coming from all parts of the world, learn the Building Workshop's language of representation. Piano speaks in strong images.

The Building Workshop is an intellectual power plant. Piano says: "In architecture, everything gets mixed up and contradicts itself. But contradictions are the salt of life. Take, for example, the contradiction of art and knowledge. These are, for me, two dimensions that are not mutually exclusive, but instead exist alongside one another. Architecture is at once an art and a science. You cannot make art without knowledge, that's obvious. We have quite a lot of experience in our team. We have so much knowledge that we can forget about it at times, like a good pianist who no longer has to think about his technique, and can forget himself and play."[12]

The Hill

When Maurice E. Müller saw the Beyeler Museum, he was won over for Piano at once, and he commissioned the architect with the construction of a monographic museum for Paul Klee. Müller probably had in mind a building like the Beyeler Museum. But Piano reacted like Piano. When he and Bernhard Plattner, his project leader, first stood on the site, it became clear to them at once that one could not house Klee in

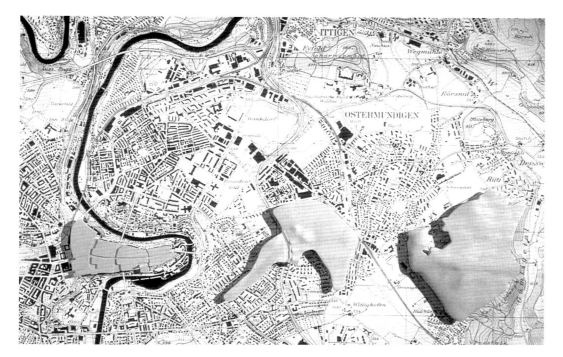

Three Green Spaces:
Renzo Piano contrasts the open
areas of Egelsee (and its continua-
tion into Wyssloch), Schöngrün,
and Ostermundigenberg with the
heavily built-up old town.

a "normal building." Klee needs a lot of breathing space, they realized, and then there
was this hill there, which they photographed at once. Not a very big hill, but a very
beautiful one. And naturally they took in the effect of the curve of the highway. Amidst
half-rural surroundings, the highway noise made clear to them where they were: in the
middle of the agglomeration of Bern and at the end of the twentieth century.

Shortly after his visit, Piano summarized what he had seen, experienced, and felt in the
winter of 1998 on the Schöngrün site in a letter to Maurice E. Müller: "Where to
begin? With Paul Klee, naturally. The dimension best suited to this artist is the dimen-
sion of silence: A poet of silence should make people reflect through a fundamentally
quiet museum."[13]

The design work began with a thorough examination of Paul Klee and the site. In this,
the highway did not represent a necessary evil to be driven out, but rather the flow of
the lifeblood of the modern city. The project was to be developed not against, but
along with the highway. The first design conceptions emerged from a precise observa-
tion of the site's movement. One of the discoveries was Klee's grave on the adjoining
Schosshalden cemetery. "Now, it displeases me not at all that the work of this artist . . .
will be preserved forever at a place of introspection not far from the cemetery where
he has been laid to rest. This, however, requires a distance from the noise of the city.
The plot of land must therefore be large. I think that the work that you ask of me
must encompass the entire site, from the Marti houses in the east to the highway in
the west," wrote Piano in the aforementioned letter.[14]

Genius Loci:
Lives in this hill, which was the first thing about the site to fascinate Renzo Piano. The hill became the central idea of the project.

The Landscape Sculpture:
Renzo Piano knows not to do things by halves. The idea of the landscape sculpture with the three hills arose in an early freehand sketch.

The Object:
A wooden landscape sculpture becomes an object of art. The grooves that were scratched on later represent early ideas about the visible steel ribs.

Schöngrün was a considerable tract of land in the building zone behind the highway and in the vicinity of the Freudenbergplatz. In a two-part private competition, Maurice E. Müller, who himself lives on the edge of the area, in 1982 set the course for its future development. The greater part of the land was subsequently built up, but one parcel was left open. Müller originally planned a residential and cultural center there that was never realized. A plot of land sought a new use. Müller wanted to give it to the public for a Klee museum.

Renzo Piano swiftly convinced all involved that the intended site was not suitable. He suggested constructing the new museum on the open field that had been set aside for the expansion of the cemetery. "Something small is out of the question; the whole has to be integrated into the planning. As soon as we had made the decision to take the totality as a starting point, we were no longer concerned with just a building, but instead with a site. And from that time on we saw the site as a sculpture, and we worked the field like farmers,"[15] Piano said in an interview. The newly claimed land belonged to the city of Bern and was situated in the agricultural zone. This shift abolished boundaries and created the basis for the core concept of the design, the hill: "As I have said before, I find that the genius loci of this terrain lies in the gentle movement of the hill,"[16] Piano wrote to Müller—the hill in Schöngrün as the spiritual brother of the wall in Riehen.

Castrum Lunatum

Where there are no hills, one must make them. Piano constructed a building shaping a landscape. Artifact and tamed nature hold one another in balance. These hills are two things at once: artificial structures in the literal sense and the articulation of terrain. They are the mark of the museum that imprints itself on the memory. The triple wave became the emblem on the Zentrum Paul Klee stationery, like the cascading escalators for the Centre Pompidou.

The snaking roof's three curves, a surprising figure announcing the extraordinary, appear for ten seconds when seen from the highway. Their message: the installation is significant, hidden inside must be something of value. Viewed from the park, the three mysterious hills create insecurity. What is being camouflaged? Piano believes in a mysterious connection of fantasy and landscape, one that gives the artificial a natural aura. Passing through the landscape sculpture, and even more so on viewing the model, one sees a crescent-shaped fortress, a sunken castrum lunatum, framed by a bank of terrain tracing, in enormous steel profile, the outline of a former city wall. The highway is the moat, the inclined façade the remains of the castle. Only a small part of the building's mass comes above the surface; what counts is what is buried.

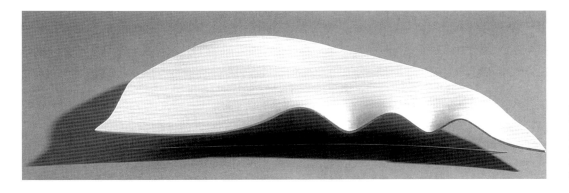

Flying Carpet:
The model of the site contours becomes an objet d'art in its own right. This multiple was given as a memento to those who made the Zentrum Paul Klee possible.

Another image: The ribs of the roof beams, sinking into the surrounding terrain, suggest that something has surfaced from below. An unknown animal with the technology of heavy industry has lifted itself up out of the earth to get some air. To the south of the castrum lunatum the sculpture garden forms a sort of suburb to it. Designed by the Zürich landscape architect Eduard Neuenschwander, this quiet garden is made for lingering and contemplation.

"We are building a house for Paul Klee, make no mistake, but a building is a building and not a work by Paul Klee,"[17] Piano says. Architecture is not simply handmaiden to art, nor does Piano see himself in the role of a servant whose work should be as invisible as possible. He places himself alongside, not beneath, Klee. His architecture never wishes to be neutral: "It is about viewing the work of Klee so as then to forget it and make a work of one's own."[19] The works of art, the painter's and the architect's, remain autonomous. The two are of course related, though not of the same family.

Where is Schöngrün? In the middle of the city of Bern, at its edge. The selection of the Schöngrün site was accompanied by a lot of background noise. For Bern's residents, the city runs from Zytglogge to Loebegge, and Schöngrün is far outside its limits, "im Gjätt usse" (out in the weeds), the Bern dialect has it. Piano admired the old town of Bern, to be sure, but he did not know where Bern ended. He saw the context of the landscape, not the hierarchy of city districts. He compared the densely packed old town to the green space of Schöngrün, which continues through Wyssloch to Egelsee and the forested hilltop of the Ostermundigenberg. The Bernese learned to see their city in a new perspective. It is larger than they had imagined. The focus on the upper old town is passé; the time has come to accept the city's agglomeration.

Schöngrün. The name is programmatic. In the beautiful (*schön*) green (*grün*) expanses, people stroll along a path through three hills. Like so many painters and landscape architects before him, Piano drew on classical principles of composition. The museum's hills are in the foreground, against the middle ground of the curtain of trees running

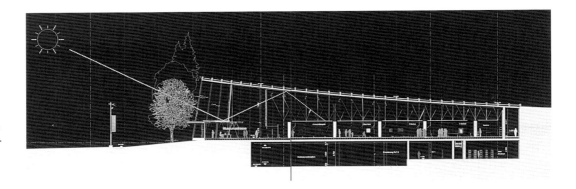

The Cross Section:
Step-by-step documentation of the
project is part of its development—
the Renzo Piano Building Work-
shop perfects its plans through
presentation.

along the gardens and the edge of the forest before it merges into the background pro-
vided by the surrounding hills' forested horizon. The gaze is directed so as to per-
ceive nothing of the agglomeration's jumble. The forest seems to fill all space up to the
horizon. Near and far come together, and the beautiful green has the character of
an island in a forest landscape. Piano creates a place that is mysterious and apart from
the world. Yet the tapestry of highway sounds makes clear where one still happens
to be: in the middle of the city.

Entering the museum itself, visitors are still confronted with a deliberately framed
landscape painting. The entrance is located in the hollow between the North and the
Middle Hill, and not, as one would have expected, on the central axis of the first
wave. Looking through the hollow, across the glass channel of the Museum Street, one
can see into the rising hill valley all the way to the Ostermundigenberg behind it.
This view also furnishes a look at the metamorphosis that Piano sees taking place as
the roof beams, covered in chrome sheet steel and sinking into the foundations,
melt into and merge with the artificial landscape. The three waves are not covered
with earth; instead, they grow up out of the ground.

The Functionalist

As far as inner organization is concerned, the project is purely functionalist, as is
always the case with Piano. There is no trace of green sentimentality about the bosom
of Mother Earth; here a highly mechanized structure has been realized—a work
of welding, not pottery. Nor are there geometric games with sharp angles or sloping
walls. Piano builds functional containers with right angles.

What is the main problem for museums today? Their overwhelming success. So one
must build for this success, i.e. for a huge mass of visitors. But what is the central
task of the museum? To preserve, to show, to research. In his ground plan, Piano solves
the contradiction between contemplation and the country fair by dividing up the
areas open to the public. There are two zones: the noisy, public Museum Street, about

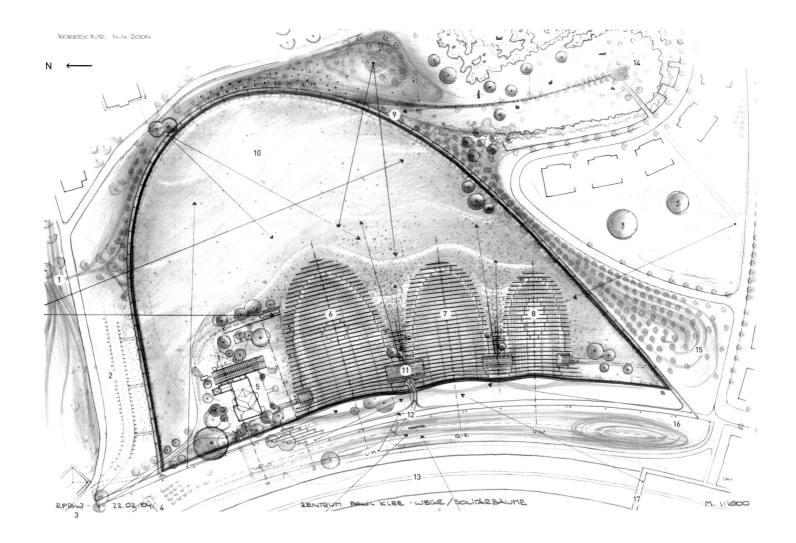

KORREKTUR 4.4.2004

ZENTRUM PAUL KLEE - WEGE / SOLITÄRBÄUME

RPBW 22.02.04

M. 1:1000

The Zentrum Paul Klee and
the Surrounding Area

1 Luft-Station
2 Parking lot
3 Bus station
4 Farmhouse
5 Villa Schöngrün and restaurant
6 North Hill
7 Middle Hill
8 South Hill

9 Pedestrian road
 Feld-rhÿthmen
11 Main entrance to
 the Zentrum Paul Klee
12 Pedestrian road
 Monument im Fruchtland
13 Autobahn A6
14 Sculpture Park

15 Hill and birch grove
16 Soundproofing embankment
17 Pedestrian bridge

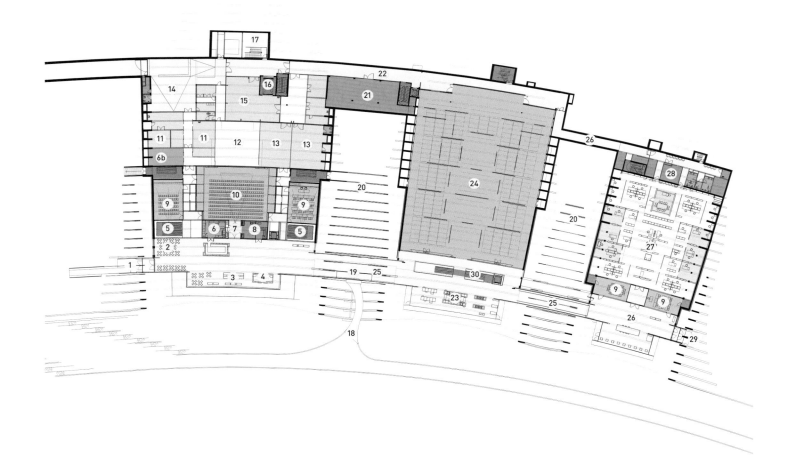

Ground Floor

1 North exit to Villa Schöngrün
2 Café
3 Information desk
4 Cash desk
5 Stairs to the auditorium and
 children's museum
6 Catering kitchen (café)
6b Catering kitchen (forum)
7 Entrance to the forum

8 Conference office
9 Seminar rooms
10 Forum (multifunctional hall)
11 Workshops
12 Atrium
13 Restoration workshops
14 Delivery area
15 Restoration workshops
16 Goods elevator

17 Building services
18 Access bridge
19 Main entrance
20 Valley garden
21 Storeroom
22 Internal service corridor
23 Shop
24 Klee collection
25 Museum Street

26 Reading area for visitors
27 Offices for research and
 administrative staff
28 Service rooms
29 South entrance
30 Stairway to temporary
 exhibitions area

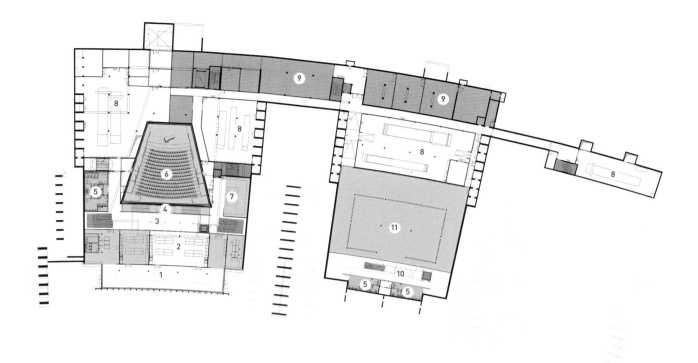

Basement (Lower Level 1)

1 Loft, children's museum
2 Children's museum
 Kindermuseum Creaviva
3 Foyer of the auditorium
4 Entrance to the auditorium
5 Toilets
6 Auditorium
7 Checkrooms
8 Building services

9 Museum storeroom
10 Foyer of the temporary
 exhibitions area
11 Temporary exhibitions area

LIVERPOOL JOHN MOORES UNIVERSITY
LEARNING SERVICES

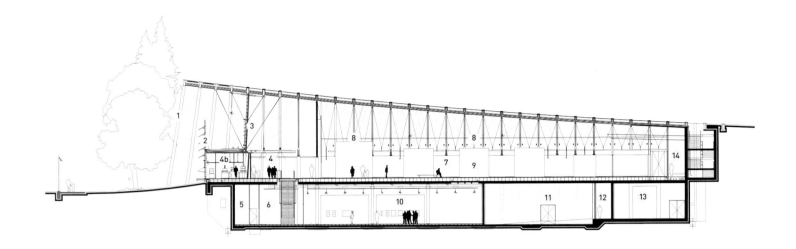

Cross-section of the Middle Hill

1 Steel girder
2 Awning
3 Main façade, suspended and
 set back
4 Museum Street
4b Shop
5 Toilets
6 Foyer of the temporary
 exhibitions area

7 Klee collection
8 Velum
9 Suspended walls
10 Temporary exhibitions area
11 Building services
12 Corridor
13 Museum storeroom
14 Internal service corridor

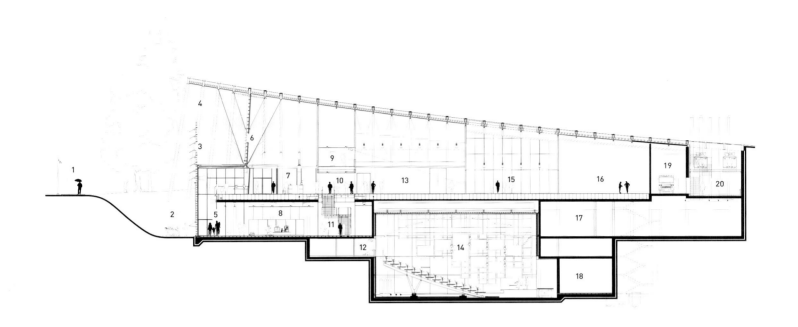

Cross-section of the North Hill

1 Pedestrian road Monument im
 Fruchtland
2 Garden of the children's
 museum
3 Awning
4 Steel girder
5 Loft, children's museum
6 Main façade, suspended and
 set back

7 Museum Street with
 cash and information desk
8 Children's museum
 Kindermuseum Creaviva
9 Forum control room
10 Entrance to the forum
11 Foyer of the auditorium
12 Auditorium control room
13 Forum (multifunctional

 hall)
14 Auditorium
15 Atrium
16 Logistic services
17 Building services
18 Backstage
19 Delivery area
20 Building services

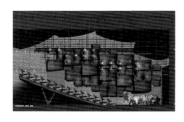

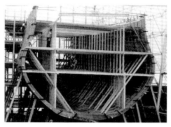

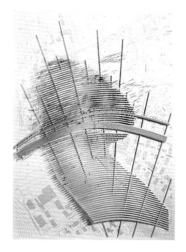

The Auditorium:
Lightweight elements fitted into hard concrete shell—the seating for the audience, the sound absorbers on the walls and ceiling, the stage for the performers.

The Ribs:
The image of a ship's hull at the docks provided inspiration from the very beginning. When the hull is turned over it forms a hill.

The Terrain:
The surrounding terrain was depicted—or rather, explored—using models. The view from the west shows the three hills rising naturally up out of the ground.

150 meters long, along which all the additional services, such as the cafeteria, the ticket desk, the book shop, the children's museum, and similar offerings, are located. Behind the Museum Street, separated by a continuous wall decorated in pale gray stucco, are the quiet workrooms and museum spaces, as well as the conference room and the concert hall. The building's depth is used as a filter. The dividing wall separates the noise of the country fair from the silence of contemplation and concentration. In the rearmost layer are situated the service rooms that are not open to the public, the workshops, and the storage space. A corridor free from visitors, hidden deep in the hills, connects these internal spaces.

Each of the three hills has its own function. The North Hill is dedicated to art education, music, conferences, and workshops, the Middle Hill is for exhibitions, and the South Hill is for research and administration—in sum, a clear, functional layout.

The new site for art is called the Zentrum Paul Klee, not the Klee Museum. Zentrum means more than museum—a site where there can and should be more than mere exhibition. This is why Maurice E. Müller attaches particular value to the children's museum; outreach offerings are a matter of some importance to him. Separated from the concert hall foyer by a glass wall, the children's museum is located in the lower level of the North Hill. It is fronted by the green "moat," and its façade is connected to the Museum Street on two floors. Everyone coming into the Zentrum Paul Klee will see the children's museum at once.

There is life after openings, one apart from architecture tourism, and so the lecture and concert halls in the North Hill are likewise a part of the Zentrum concept, offering a venue for conferences and musical performances. The Zentrum Paul Klee wants to be a lively place with a far-reaching presence. Renzo Piano has experience with concert halls. He built the IRCAM Project, an institute for the research of acoustics and music, next to the Centre Pompidou, for Pierre Boulez; he built the mobile music container for Luigi Nono's *Prometeo—Tragedia dell'ascolto*; and he transformed an unused Fiat factory into a concert and congress hall in Lingotto. The concert hall in the North Hill shows this depth of experience. In a concrete box, Piano placed a steel frame with about three hundred seats, which glow in the same orange-red hue as the back wall of the auditorium foyer. The walls are adorned with vertical grooves and tooled ribs. In front of this rough surface, wood elements hang like leaves from the ceiling, insuring outstanding acoustics and at the same time giving the hall a festive air.

Sturdy and Avant-garde

The building's execution is at once sturdy and avant-garde, as is always the case with Piano: sturdy, because meant to last; and avant-garde in construction. The image of the frame, the crosswise ribs of the hull of a ship, was the starting point. What was the right material and construction method for the wave-formed supporting beams? Wood, concrete, steel? The search ended with steel being chosen. Each arch is different from every other, varying in height, and cut from sheet metal with a gas cutting machine, pressed into its final form, and welded together by hand to achieve the sharp curvature. The assemblers have more than forty kilometers of welded joints under their belts.

The form of the wave was the basis for calculating the building's remaining components. In the ground plan, the façade stands on an arc with a radius of 460 meters. In cross section, the arc is cut from a cone with a slope of nine degrees. The waves follow a sine curve.[19] The flattened back of each hill corresponds to the surface line of a cylinder. Even a few years ago, a form like this, clearly defined but extremely complicated, could neither be planned nor produced. The advent of the computer has made it possible. The large 3-D computer model was the basis for determining the form and measurements of the individual parts, and for their manufacture. To gain some appreciation for the new architectural means of expression the computer makes possible, one must conceive of the façade as a straight rather than a curved front. Piano has always adopted technological innovations at once and used them for his architecture.

The Glass Wall

The lavish construction of the 150-meter-long glass façade is a result of the building's unusual geometry. The façade is divided along its entire length into an upper and a lower section. The two sections are separated by a space as wide as the Museum Street, and are connected above the Museum Street, at a height of four meters, by a horizontal roof strip. At its highest point, the façade is nineteen meters tall, the largest panes measuring 6 x 1.60 meters and weighing 500 kilos. The façade and the roof of the Museum Street are suspended by cables from four of the roof beams, which enables the construction to counterbalance distortions from wind and temperature fluctuations. The construction of the roof and the façade is not rigid, but instead moves freely and makes possible the Museum Street without supports.

With the façade, Piano once more displays his mastery of details. He makes visible the successive layers, celebrates the bracing cables, clamps, and the feet of the supports, and illustrates the distribution of forces, demonstrating its mechanics. This is Piano the

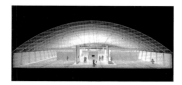

The Exhibition Hall:
A model to test what intuition suggests—trying out and adjusting lighting and fittings for the collection

Due to the roof's undulating geometry, no two meters of the total of 4.2 kilometers of steel girders are the same.
To achieve the sharp curvature, the arches had to be welded together by hand.

obsessive architect-engineer and engineer-architect. For him, perfection is not minimalism but visibility. Swiss German reductionism is not his business; he shows the individual parts and the combined operation of his façade machine. This façade gives the building a clear front and back, and, like the Riehen wall, it also directs the gaze: one looks towards the city, at Bern.

The Atmosphere

Yet atmosphere is the decisive element. Piano and his people know how to create an atmosphere: with space and light. The Building Workshop has given intensive thought to lighting and how to direct light. Even the models give an idea of the effect the large exhibition space will have. The Beyeler Museum offers no real basis for comparison. Klee's works, mostly watercolors, allow a luminous intensity of at most 50 to 100 lux, lest they fade. The paintings in the Beyeler Museum can bear 240 lux. Compared to the light machine in Basel, there is twilight in Bern. The consequence is artificial light. The main hall in the Middle Hill is lit purely by artificial light, which is likewise the case for the space for changing exhibitions on the lower level. This additional exhibition space confirms an old architectural truth: height matters. The relation between walls and floor defines the difference between a room and usable space.

The dividing wall between the Museum Street and the exhibition hall separates two atmospheres: the profane from the sacred. Piano does not hesitate to consecrate the hall; those who enter it spontaneously begin to whisper. Everything is light in this airy space of suspended gravity. One feels one's breath and hears one's heartbeat. The exhibition space is divided by partition walls hung by cables attached to the ceiling ribs. The partitions are purely linear elements, never bumping up against the walls, never forming corners with one another. Space flows uninhibited, uninterrupted by cabinets. That the partitions are four centimeters above the ground emphasizes the fact that they are hung from the ceiling. All of the fittings hover, lowered down from above. Fields of white gauze stretched across specially designed metal frames hang above the walls. Translucent but not transparent, these vela transform the halls into a museum in that they divide the space up above into two zones, yet let it be felt as a whole. One comprehends the entire space and even so experiences a certain intimacy with the paintings. After all of the sequences of closed rooms that followed the opening of the Staatsgalerie Stuttgart, Piano returns to the large, single space. The individual intimate sectors of space and the space as a whole, however, he holds in mysterious suspension. Piano mentions the "vaporeux" of the Impressionists as the key. The museum is white, the walls are covered in white gypsum plaster, the ceiling is made from chipboard painted white. Throughout the museum, there is the same

oak strip flooring as was used in the Museum Beyeler. Incoming air enters through narrow slits and is sucked out at the front end of the hall.

The basic lighting is cast onto the ceiling and reflected into the exhibition space, with spotlights emphasizing individual paintings. In the South Hill, a large skylight brightens the open-plan office space, while a light well admits daylight into the North Hill. In both cases, these are unspectacular arrangements with a high light yield. The Museum Street with its glass wall has bright natural lighting. Large screens prevent direct sunlight from entering through the west façade.

Villa Schöngrün, situated at the northern entrance to the site, before conversion

The Climate Chamber

A contemporary museum is a climate chamber. Inside, it is twenty-three degrees Celsius in the summer and twenty-one in the winter. The deviation permitted is one degree. Humidity is a stable 50 percent with a permissible deviation of 5 percent. These are the requirements that museums today impose on themselves in collaboration with their insurers. To question these limits is to give up art loans. Complying with them requires enormous air conditioners, hidden deep in the belly of the building, consuming vast amounts of energy. But there is method to the madness. The building is, of course, exceedingly well insulated, and heat recovery is an important feature. Put another way: the Zentrum Paul Klee is on the cutting edge of ecological sustainability. The building's annual energy consumption will be low in comparison with other museums. There is no balance sheet for its hidden energy flows.

La Campagne

The Villa Schöngrün, situated beside the museum, greets visitors at the northern entrance to the site. The house, which is a protected monument, has been carefully renovated, supplemented with a glass addition, and expanded into an elegant restaurant. Yet this is only one more chapter in the long history of the house, nor will it be the last.

The Villa Schöngrün recalls the country estates of the Bern patriciate, later of the *juste milieu*, the merry magnificence of summer homes. Schöngrün—this could also have been the name of a country house in Rudolf von Tavel's novels of German Bern. The artificial hill, called Schnäggenbühl, in the adjacent cemetery fits in seamlessly. Reached by a spiraling footpath, its top gives a superb view of the Bernese Alps. Here is a home from pre-industrial Bern. The villa is imbued with the scent of the ancien régime; Bern will never lose it.

Under the skin, the Zentrum Paul Klee is related to this villa, though unintentionally—because it has air, because it stands like a great house amidst a great garden, a garden

LIVERPOOL JOHN MOORES UNIVERSITY
LEARNING SERVICES

View from Schöngrün to the spiraling hill on the neighboring Schosshaldenfriedhof, the cemetery where Paul Klee lies buried

Paul Klee's grave on Schosshaldenfriedhof in Bern

spilling over onto peasant lands, because the building is not crowded in by property lines, because no privet hedges are needed to provide privacy—in short: because the Zentrum Paul Klee has been conceived on the scale of a great country house. "Something small is out of the question,"[20] Piano sensed. One cannot squeeze a museum for Paul Klee onto a leftover parcel of land.

The park, or rather the 2.5 hectares of landscape sculpture behind the museum hills, is bordered by a step in the terrain bridged by a steel rail. The step traces the boundary between the landscape sculpture and the surrounding area. Birch trees line the footpath alongside it. The entire grounds are once again farmland, as they were before. The plot of land will be used for agriculture, with the crops rotated annually. There will be a unified plan, to be sure, but the landscape sculpture will change continuously throughout the year: stretches of meadow, fields of grain and stubble, freshly plowed fields, sunflowers or rapeseed. Bern will be the first city to employ an art farmer.

Klee painted a watercolor with the title *Monument im Fruchtland* (Monument in the Fertile Country) 1929, 41 (fig. p. 146), and this is now the address of the Zentrum Paul Klee: Monument im Fruchtland 3, 3006 Bern.

Notes

1. Werner Blaser, *Renzo Piano Building Workshop, Museum Beyeler* (Wabern-Bern, 1998), p. 137.
2. Renzo Piano, *Mein Architektur-Logbuch* (Ostfildern-Ruit, 1997), p. 7.
3. Ibid., p. 264.
4. Ibid., p. 12.
5. Blaser 1998 (see note 1), p. 43.
6. Ibid.
7. Ibid.
8. Piano 1997 (see note 2), p. 10.
9. Ibid., p. 11.
10. Ibid.
11. Blaser 1998 (see note 1), p. 137.
12. Ibid., p. 47.
13. "Sonderheft: Paul Klee-Zentrum," special issue of *Hochparterre, Zeitschrift für Architektur und Design* 12 (1999), p. 4.
14. Ibid., pp. 4–5.
15. Fred Zaugg, "Ein Ort der Hoffnung, ein Gespräch mit Renzo Piano," in *Der Kleine Bund,* (January 27, 2001).
16. "Sonderheft: Paul Klee-Zentrum" (see note 13), p. 5.
17. Zaugg 2001 (see note 15).
18. Ibid.
19. "Sonderheft: Paul Klee-Zentrum" (see note 13), p. 16.
20. Zaugg 2001 (see note 15).

"We wanted a suspended space"

Benedikt Loderer Interviews Renzo Piano
Paris, December 16, 2004, at the Renzo Piano Building Workshop

What will the atmosphere in the large exhibition space be like?

One cannot talk yet of the results, though one can already discuss the first reactions. It is always a magic moment when an idea becomes reality at a building site. It is the moment of metamorphosis. In our profession, one draws for five years, one makes models—and then comes the moment when it all becomes reality.

The musician plays, and the sound is in the present. The sculptor, too, sees his work directly. But the architect does not see his building. For four or five years there is only a promise. This is why the moment of metamorphosis is so important, like the pupa that becomes a butterfly.

But to return to atmosphere, it will be abstract and light, which to me seems appropriate for a museum, since a museum is a place outside of time. The museum creates duration.

Museums in recent decades have been either architecture for the architects or humble handmaidens to art. What sort of museum is the Zentrum Paul Klee?

It's nonsense to say that a museum must be absolutely neutral. It is likewise nonsense when the museum is a work of art that overwhelms its own content. In Bern, we sought to create a cheerful and generous space. I have never believed that small works require small spaces. It was only the window through which Klee observed the world that was small; his world, on the other hand, was vast.

We wanted a suspended space, and yet the space is fixed, formed. The visitors perceive the space; it is in the present for them.

Is it a single space or a sequence of spaces?

The space is ambiguous, but in art ambiguity is not a bad thing, since it can also signify a multiplicity of meanings. It is at once a large space and a microsystem. When one enters, one senses the entire space; when one begins to observe the paintings, however, one begins to concentrate and find oneself in a much smaller world,

even though the larger whole has not been forgotten. In the middle is a lane, which is somewhat broader and gives some perspective. At the sides, lengths of fabric, which we call vela, have been stretched above the paintings. They enclose a zone of greater intimacy. Both take place at once, like cosmos and microcosm. I do not wish to theorize, since I am not a theorist, but in Klee's work there are also both—cosmos and microcosm. The interplay of large and small creates the suspended atmosphere.

Isn't that like a church, with nave and flanking aisles?
If you must seek an analogy, then yes, you're right. It's also like in an Italian palazzo, in which the smaller rooms are arranged in a hierarchy around the great hall.
The space in Bern follows from that in the Menil Collection. Reyner Banham has written that a well-tempered space was created there. One doesn't make architecture with plain walls and ceilings; one also works with atmosphere, with immaterial elements of space like light, transparency, tones, colors, surfaces. The Menil Collection was a project that took this into consideration. Banham wrote: "Piano brings back magic to rationalism." That made me very proud.
What is the space in Bern made out of? A floor, four walls, and the beams of the roof—nothing more. These are the only hard elements, the rest is suspended, actually nothing but air. Everything is white. Why? White is the color of dreams. It is no accident that Fellini's films are white. In short, there is a connection between the Menil Collection and the Zentrum Paul Klee.

Let's talk about the concert hall.
Yes, let's talk about music. Music is the other side of Paul Klee. He died and never knew whether he was a musician or a painter. Pierre Boulez, who has always held Klee in high esteem, took a title for a book from him. *Le pays fertile . . .*

. . . the fertile country . . .
. . . yes, but Boulez has always had contempt for the idea that there might be a direct connection between music and architecture, which I also think is nonsense. The world is full of fools who assert that there is a connection between music, painting, and architecture. I have to correct others over and over again: No, this building is not a painting by Klee, because Klee is Klee, and Klee is painting, but we, on the other hand, are doing architecture. Boulez studied Klee quite precisely, and he researched the poetry of Klee's work, that is, the inspiration behind it. He found many elements connecting music and Klee's painting, though never the same rhythm in both, nor other direct connections—no, it is about artistic inspiration.

During the construction phase, information boards were set up along the path skirting the Landscape Sculpture to inform the public about the project.

Music has been very much a part of the Bern story. The first person to call me about the Klee Museum was the pianist Maurizio Pollini. Maurice Müller had performed surgery on him and saved his life. Martha Müller loves music, Klee played music, music is close to my own heart. I always wanted to be a musician, and never became one. So it was a matter of course that an auditorium was part of the project from the beginning.

An auditorium is not a monument, it is an instrument for music lovers. A concert hall is not a chocolate box, it is a musical instrument, a little music machine, an instrument for hearing.

So I like the thought that this hall will not only celebrate Paul Klee, but also send out a musical radiance.

But what will the atmosphere be like inside?

In a concert hall, atmosphere, first and foremost, means acoustics. Everything depends on that, not on the shapes and colors. Are you interested in the shape of a Stradivarius? No, you judge a violin by the sound. Have you ever seen something as crude as a trumpet? But when it plays . . .

Sound can really spread out in the auditorium, since there are no parallel walls, but it is a fundamentally simple affair. We put a movable grandstand into a concrete box. But the hall has to be tall, otherwise the sound can't live.

Even so, you're the architect and make the decisions on shape and color.

Of course. That's why we decided to make the walls out of concrete so as to emphasize the massiveness of the shell. We didn't make the shell smooth; we used grooves and tooled ribs so that the acoustics would be right. The seats and acoustic panels are red. Red is the color of institutions. The red and the velvet remind us of music and of the performance halls in our memory. The sacred red runs up against the profanity of the concrete.

391

LIVERPOOL JOHN MOORES UNIVERSITY
LEARNING SERVICES

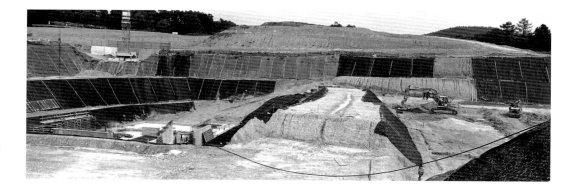

The museum's three hills may look big, but in fact a large part of its spaces are on the lower floors.

The sacred and the profane is a theme for you. What is its role in the exhibition hall?
It's sacred. One must have the courage for that. The Museum Street is profane; there you encounter noise, children, and the everyday, although already moderated. But as soon as you enter the hall, you're elsewhere. You will find yourself outside of time.

So there is a highly conscious difference between the Museum Street and the hall?
There is a threshold. It is a massive threshold simply for reasons of security and climate control, but it is a psychological threshold as well. You leave an active world behind and enter into the world of contemplation. It is as though you had taken off your shoes. When you observe a painting, it's between you and the artwork. This also happens to be why I hate people who want to explain paintings to me. Silence is the best language for speaking with a work of art. There are three speeds: outside on the highway, you drive in fifth gear, on the Museum Street perhaps second gear, in the hall in first.
The light changes, too. At first we had natural light in mind. Klee's paintings, however, cannot bear strong light, not more than fifty lux. Daylight is fifty thousand lux, so we had to kill off the light. We ultimately realized that we would have to build an artificially lit hall.

So it will be dark, like in a Gothic church?
Not at all. The eyes adjust. You can see very clearly after thirty seconds. It's the same with noise. In loud surroundings, you won't hear the soft sounds, but you will in a quiet space.
It's a mix, as always, of science and art. On the one hand, we speak of the holy, the timeless, the immaterial, on the other of decibels and lux. The architect is one part artist, one part technician—a curious mixture that has always amused me. When you've reached a certain age, you don't ask what you are anymore. You don't distinguish any longer, you just mix both identities.

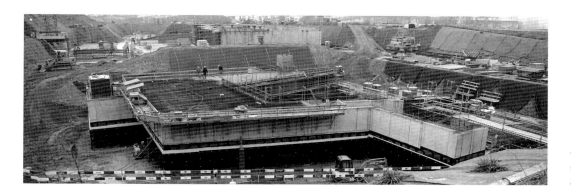

Top-quality insulation protects the highly sensitive museum and auditorium spaces.

A final question, what was the greatest difficulty with this project?

Let me say first that the clients were always pleasant to work with—Maurice Müller, the foundation, the city and the canton. We won the vote with 78 percent in favor—unbelievable! When the community of Riehen voted on the Museum Beyeler, it was only 65 percent. We got really spoiled in Bern. To succeed, every project needs an essential raw material: passion. That was there in Bern.

Naturally, the practical implementation of the project was complicated and difficult. Consider the geometry alone! One has to be kind of crazy just to choose so complicated a form. Yet had we made it all stubborn straight lines, then the magic of the curve moving through space would have been lost.

The greatest difficulty? The quiet fear, perhaps, of the scope of our dream.

And what was your greatest joy with the Zentrum Paul Klee?

There were many joys. It may be a little romantic, but even so: I have a five year-old son who grew up with the project. He always came along to the construction site. I have always compared my buildings to my children. In 1962, my daughter was born with the Centre Pompidou, and she, too, always came along to the construction site. It's said that one measures how time passes by one's children. For me, they were also the measure of the projects that we realized.

The greatest joy? It was a project realized in friendship and with passion. In the process, Maurice Müller and I have become friends; it has grown into a lasting relationship. It's always like that. If you're a businessman, you have customers. But if you're an architect, you have friends, "des compagnons d'aventure."

The Sculpture Park of the Zentrum Paul Klee

Master Plan: Renzo Piano Building Workshop /
Implementation: Eduard Neuenschwander, Architect

Werner Blaser, Architect, Basel

Around two hundred boulders were unearthed during excavation work and many subsequently used in the Sculpture Park.

The Sculpture Park at the Zentrum Paul Klee, an additional donation from Martha Müller-Lüthi, alludes to Paul Klee's love of nature. Many of his titles betray a close relationship to the garden or to nature—for example, *Familienspaziergang* (*Family Walk*) of 1930. Frequently his works play with symbols. The park stands for nature. Everything is about seeing and experiencing from mind and matter in order to reveal the symbols in art, because Paul Klee was also a philosopher and poet. The Sculpture Park combines the contemporary with the visionary, creating a synthesis of the world of the mind and a world to be formed. One of Eduard Mörike's poems says, "Was aber schön ist, selig scheint es in ihm selbst" (But what is beautiful seems blessed in itself). The viewer thus possesses the ability to experience the beautiful as healing. The Sculpture Park and the experience it offers, the adjacent pond with boulders from the excavation pit on the site, will have an effect on the region's genius loci that can scarcely be overestimated.

The 1998 master plan already situates the Sculpture Park on a rise on the eastern part of the Schöngrün site, in accordance with the wish of the donor, who envisaged a natural garden with sculptures. The place has since grown in significance, in part as a place for the people from the adjacent neighborhood to relax. In this natural setting the works of art create an effect of profound introspection. The conscious creation of art points the way to human well-being. That is why cultural identity is an active environment between sculpture and landscape. In the bronze-cast sculptures by the Argentinean artist Alicia Penalba, aesthetic modernism comes into its own. Oscar Wiggli from the Swiss canton of Jura and Yves Dana from Lausanne also seek the truth that signals what is outstandingly human. The process of oxidation turns the natural material—Cor-Ten steel—that Wiggli forges into time that has become nature.

In these sculptures Martha Müller-Lüthi has donated works from her collection by three artists who are experts in their execution and ingenious in their invention, and who thus show what is technically and artistically possible today. Shaped by an ethics of creativity, the works become icons in the public space.

The forged steel sculpture
Loaraden, 1993, by Oscar Wiggli,
in the Sculpture Park

The Sculpture Park has been developed in topographical relation to the characteristics of the site. Sensory order and sensory form express the spirit of the place. Visitors walk down a birch allée and encounter six sculptures that line their path in an organic arrangement. It is as human beings that the open-air museum speaks to them. They begin to react to nature and to the art, and their desire for quality and beauty is satisfied. They look beyond the sculptures and down to the museum's undulating roofs growing from the hillside; they gaze around the green garden bordering on the flowerbeds and coppices of the adjacent villas, along the rhythmically designed circular path, or up into the sky. The sculptures seem to speak to one another against this natural backdrop. How right August Endell was when he said: "We must teach ourselves receptivity to the beauty of the visible. And those who have tasted it will never tire of expanding and refining their feelings." The carefully selected quality of Martha Müller-Lüthi's Sculpture Park contributes to this.

"Where culture breaks off, violence breaks in."

August Everding, theater director

LIVERPOOL JOHN MOORES UNIVERSITY
LEARNING SERVICES

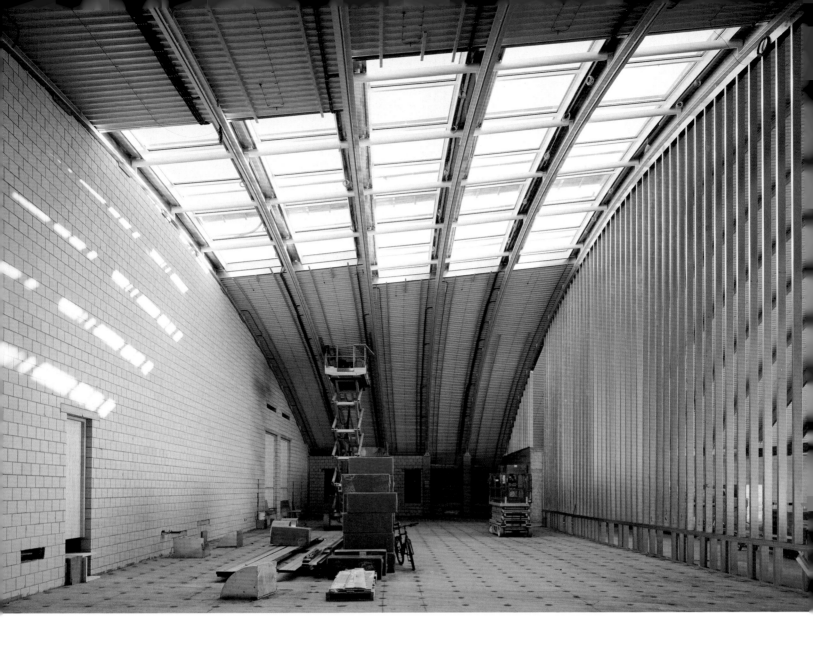

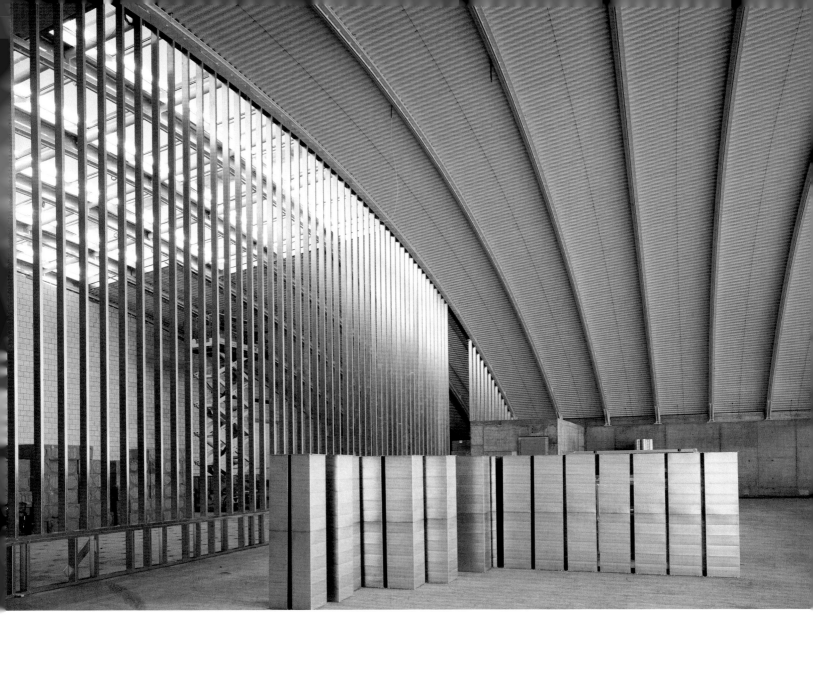

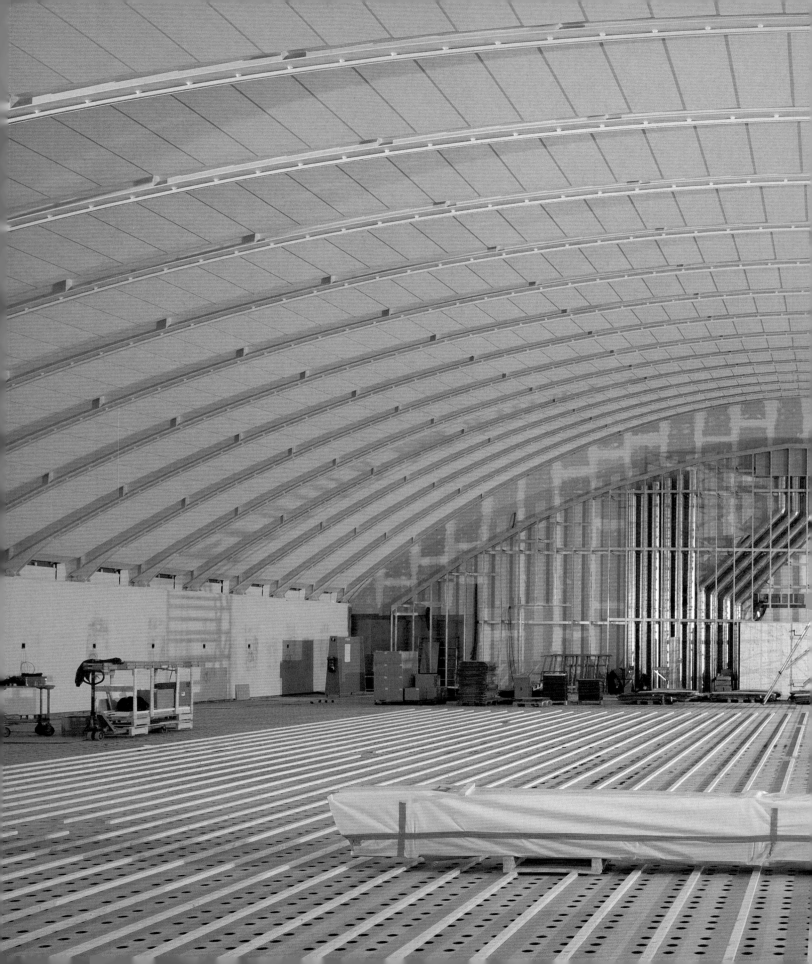

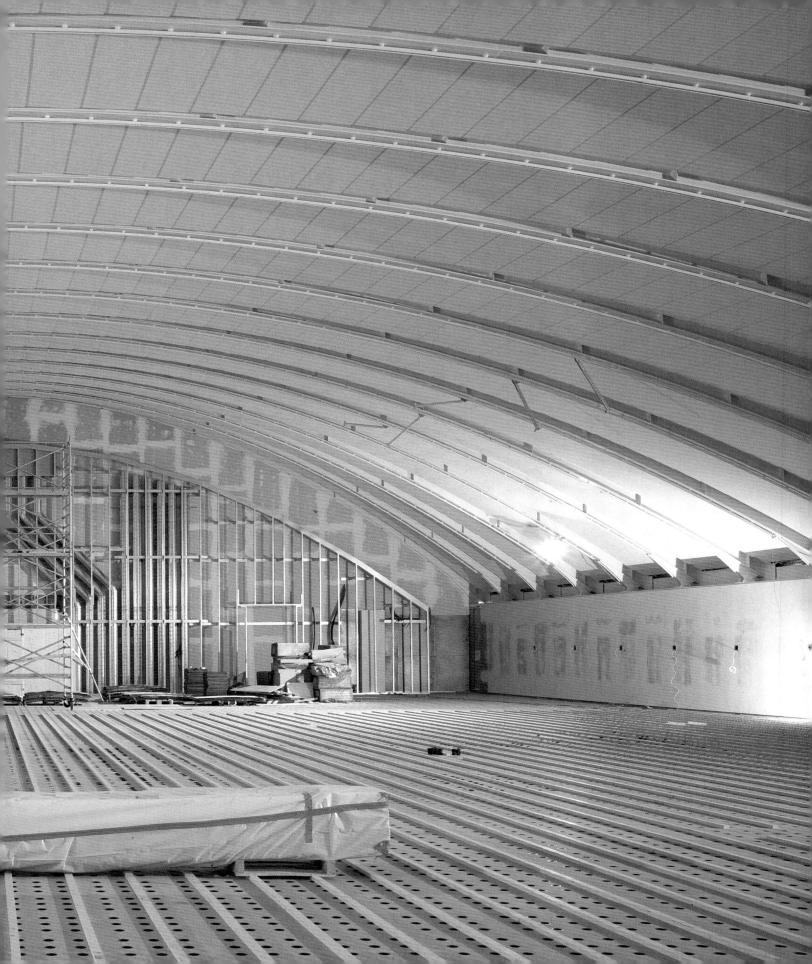

LIVERPOOL JOHN MOORES UNIVERSITY
LEARNING SERVICES

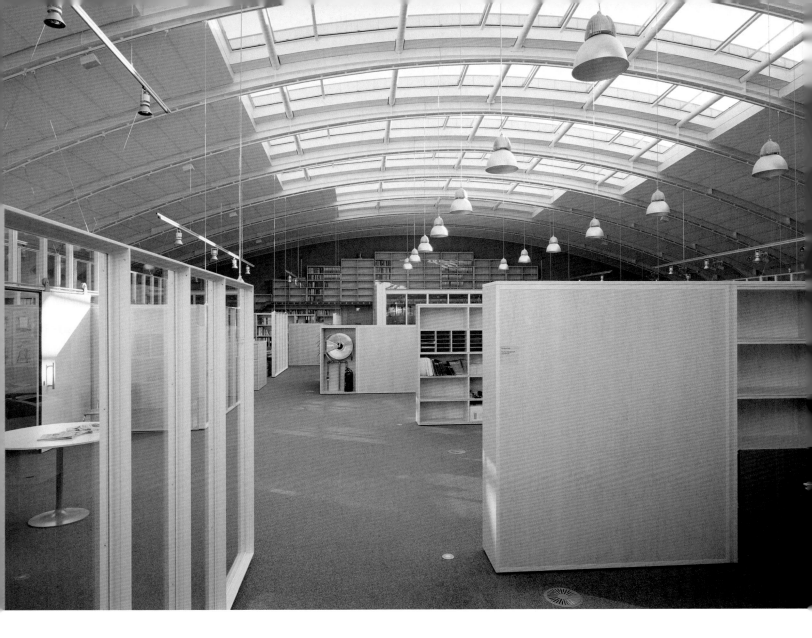

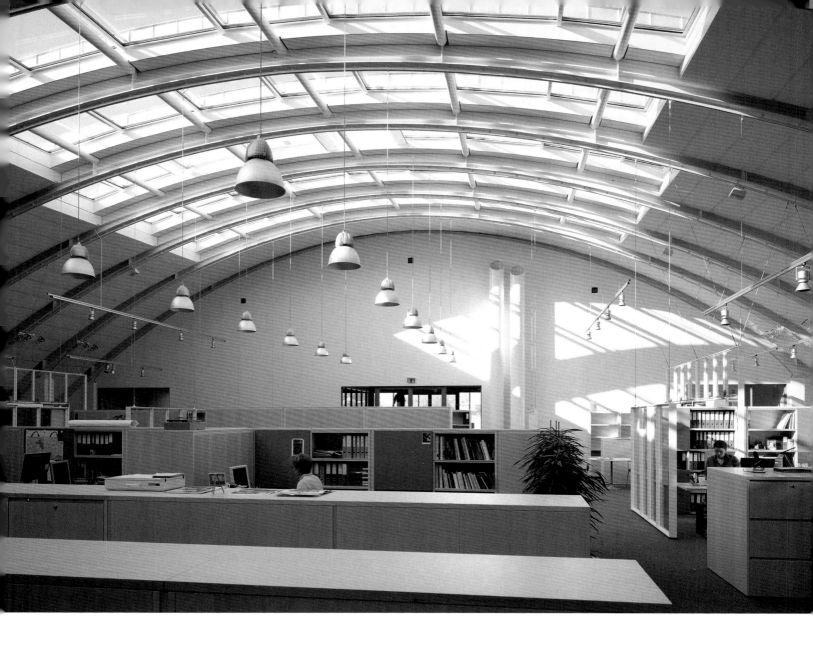

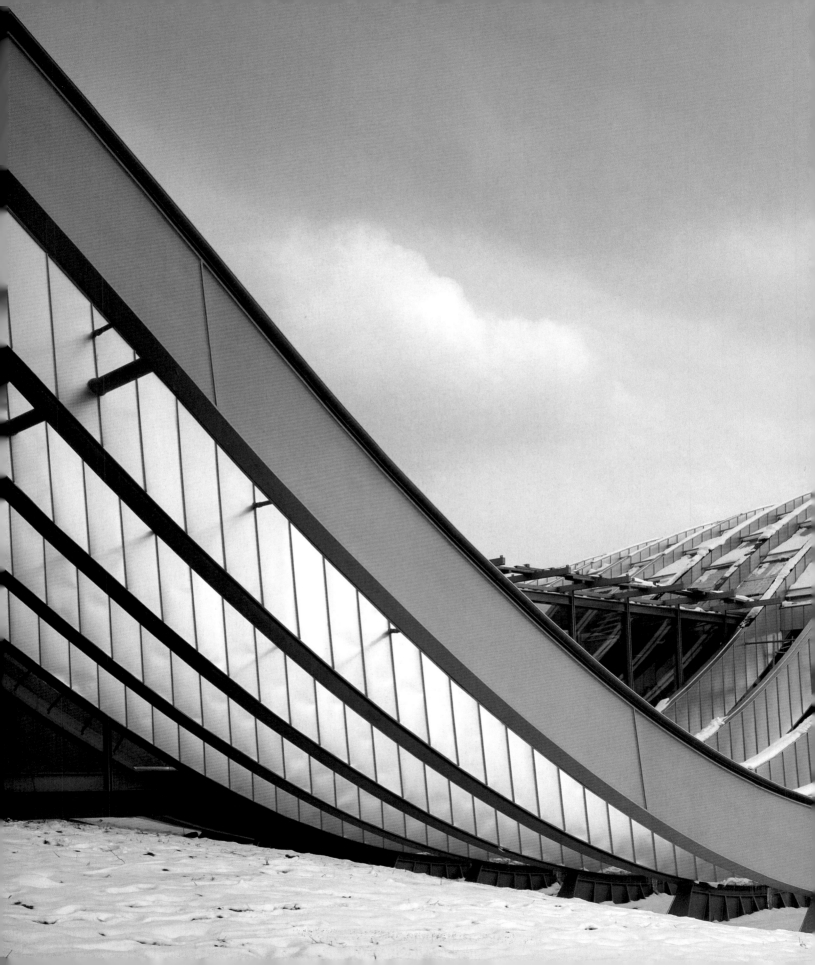

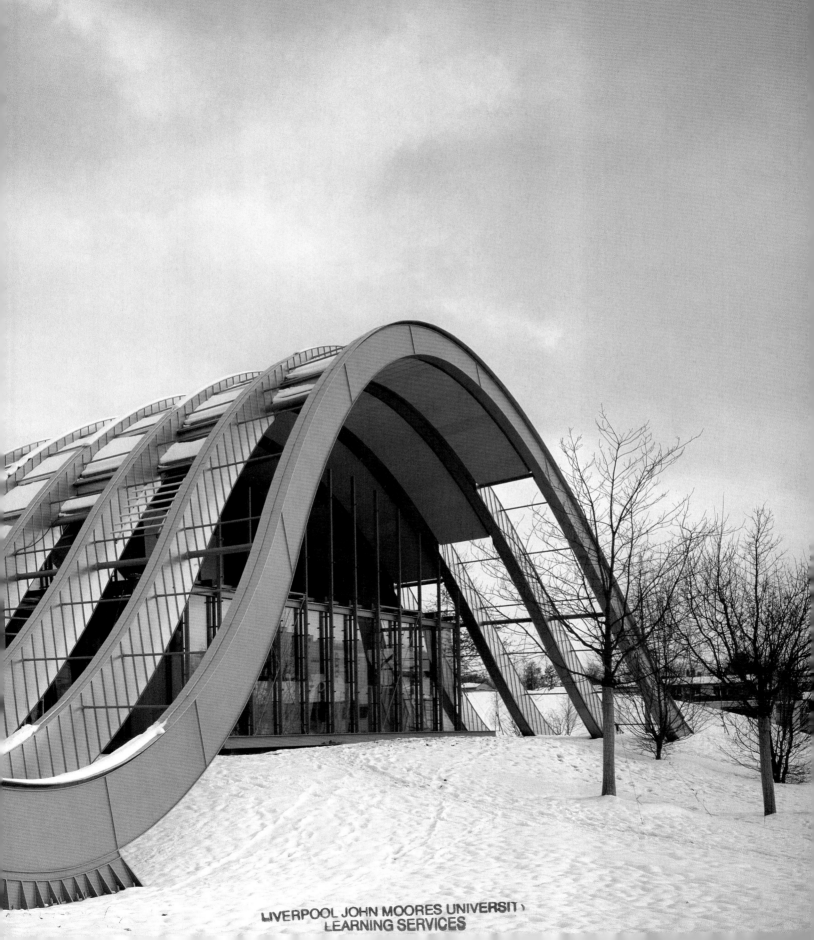

Paul Klee

The works are listed in chronological order,
following Klee's handwritten catalogue of
works (year, number).

Ohne Titel (Schnecke), 1883
Untitled (Snail)
Pencil on paper, from 1861 picture book,
p. 31
21/20.1 x 14.7/15.6 cm
Zentrum Paul Klee, Bern, private loan
Fig. p. 128

*Azor nimmt die Befehle der Mad. Grenouillet
entgegen,* 1883, 13
Azor Receiving Mrs. Grenouillet's Orders
Pencil on paper on cardboard
8 x 18.8 cm
Zentrum Paul Klee, Bern
Fig. p. 97

Droschkengespann, 1883, 14
Horse and Carriage
Pencil and grease crayon on paper
10.6 x 14.7 cm
Zentrum Paul Klee, Bern
Fig. p. 97

Dame mit Sonnenschirm, 1883, 15
Lady with Parasol
Pencil on paper on cardboard
11.2 x 6,4/8.2 cm
Zentrum Paul Klee, Bern
Fig. p. 97

*Gemeiner Wiedehopf, Zoologieheft II
(Vögel),* 1895
India ink on paper
7.5 x 14.7 cm
Zentrum Paul Klee, Bern, private loan
Fig. p. 226

Fitzliputzli, Wodan, Mohamed, Inri, Isis,
in *Handbuch der Geschichte für die oberen
Klassen des Gymnasiums und Realschulen,*
1897
India ink and pencil on paper, in school
textbook
20.4 x 13.4 cm
Zentrum Paul Klee, Bern, private loan
Fig. p. 227

Selbst, 1899, 1
Myself
Pencil on paper on cardboard
13.7 x 11.3 cm
Zentrum Paul Klee, Bern,
Livia Klee Donation
Fig. p. 198

Ohne Titel (Aarelandschaft), ca. 1900
Untitled (Aare Landscape)
Oil on canvas, originally on stretcher;
five-panel screen
Each screen 144.5 x 48 cm
Zentrum Paul Klee, Bern, private loan
Fig. pp. 230–31

*Schwebende Grazie (im pompeianischen
Stil),* 1901, 2
Hovering Grace (in the Pompeian Style)
Watercolor and pencil on paper
on cardboard
10.3 x 11.4 cm
Zentrum Paul Klee, Bern
Fig. p. 170

*Ohne Titel (Anatomische Zeichnung der
Oberschenkelmuskulatur),* 1902
Untitled (Anatomic Drawing of the Femoral
Muscles)
Pencil on writing paper; labels and
comments in pen
21.1 x 28.5 cm
Zentrum Paul Klee, Bern
Fig. p. 124

Ohne Titel (Porträt der Schwester Mathilde),
1903
Untitled (The Artist's Sister)
Oil and watercolor on cardboard
on a second layer of cardboard
27.5 x 31.5 cm
Zentrum Paul Klee, Bern
Fig. p. 156

Komiker, 1904, 10
Comedian
Etching on zinc
14.6 x 15.8 cm
Zentrum Paul Klee, Bern
Fig. p. 136

Komiker. (Inv. 4.), 1904, 14
Comedian
Etching on zinc
15.3 x 16.8 cm
Zentrum Paul Klee, Bern
Fig. p. 136

Mädchen mit Puppe, 1905, 17
Girl with Doll
Watercolor, backed with white,
reverse-glass painting
18 x 13 cm
Zentrum Paul Klee, Bern
Fig. p. 62

Akt, 1905, 34
Nude
Pencil and watercolor on paper
on cardboard
9.3 x 8.6 cm
Zentrum Paul Klee, Bern
Fig. p. 136

Empfindsame Jungfrau mit d. Maßliebchen,
1906, 21
Sentimental Virgin with Daisy
White paint and drawing scratched with
a needle, polychrome backing
23.7 x 20.4 cm
Zentrum Paul Klee, Bern, private loan
Fig. p. 229

*Mädchen, sich bückend, von einem
schlangenartigen Dackel gefolgt*, 1906, 22
Girl, Stooping, Followed by a Snake-like
Dachshund
White paint and drawing scratched with
a needle, polychrome backing, reverse-glass
painting
20.4 x 24.4 cm
Zentrum Paul Klee, Bern,
Livia Klee Donation
Fig. p. 266

m Vater, 1906, 23
My Father
Brush and drawing scratched with a needle,
backed with white, reverse-glass painting
31.8 x 29.3 cm
Zentrum Paul Klee, Bern,
Livia Klee Donation
Fig. p. 265

Kinderbildnis, 1908, 64
Portrait of a Child
Watercolor on paper
29.9 x 23.4/24.2 cm
Zentrum Paul Klee, Bern,
Livia Klee Donation
Fig. p. 253

Der Zeichner am Fenster, 1909, 70
The Draughtsman at the Window
Watercolor and chalk on paper
30 x 23.5 cm
Zentrum Paul Klee, Bern, private loan
Fig. p. 64

Mädchen mit Krügen, 1910, 120
Girl with Jugs
Oil on priming on cardboard
35 x 28 cm
Zentrum Paul Klee, Bern,
Livia Klee Donation
Fig. p. 267

Candide, 9 Cap, Il le perce d'outre en outre,
1911, 62
Candide, Chapter 9, Il le perce d'outre
en outre
Pen on paper on cardboard
15 x 25.2 cm
Zentrum Paul Klee, Bern
Fig. p. 137

Maske, 1912, 57
Mask
India ink and watercolor on paper
on cardboard
11.8/11.4 x 5.5 cm
Zentrum Paul Klee, Bern,
Livia Klee Donation
Fig. p. 254

Angst, 1912, 155
Fear
Lithographic pen, lithographic chalk,
and pen on transfer paper on paper
10.6 x 9.6 cm
Zentrum Paul Klee, Bern,
Livia Klee Donation
Fig. p. 248

In den Häusern v. St. Germain, 1914, 110
In the Houses of St. Germain
Watercolor on paper on cardboard
15.5 x 15.9/16.3 cm
Zentrum Paul Klee, Bern,
Livia Klee Donation
Fig. p. 256

Teppich der Erinnerung, 1914, 193
Carpet of Memory
Oil on chalk-primed linen, bordered with
watercolor, on cardboard
37.8/37.5 x 49.3/50.3 cm
Zentrum Paul Klee, Bern
Fig. p. 65

Tunesische Scizze, 1914, 212
Tunisian Sketch
Watercolor and pencil on paper
on cardboard
17.9 x 12.2 cm
Zentrum Paul Klee, Bern,
Livia Klee Donation
Fig. p. 255

vor den Toren v. Kairuan, 1914, 216
Before the Gates of Kairouan
Watercolor on paper on cardboard
20.7 x 31.5 cm
Zentrum Paul Klee, Bern
Fig. p. 63

Steinbruch, 1915, 213
Quarry
Watercolor and pencil on paper
on cardboard
20.2 x 24.6 cm
Zentrum Paul Klee, Bern
Fig. p. 66

Ohne Titel (Herr Tod), 1916
Untitled (Lord Death)
Hand puppet; head: painted plaster;
costume: linen
Height 35 cm
Zentrum Paul Klee, Bern,
Livia Klee Donation
Fig. p. 279

Einst dem Grau der Nacht enttaucht . . .,
1918, 17
Once Emerged from the Gray of Night . . .
Watercolor, pen, and pencil on cut up paper,
on cardboard
22.6 x 15.8 cm
Zentrum Paul Klee, Bern
Fig. p. 164

Tiergarten, 1918, 42
Zoological Garden
Watercolor on plaster-primed paper
17.1 x 23.1 cm
Zenrum Paul Klee, Bern
Fig. p. 204

mit dem Adler, 1918, 85
With the Eagle
Watercolor on chalk-primed paper
on glazed paper on cardboard
17.3 x 25.6 cm
Zentrum Paul Klee, Bern
Fig. p. 67

Sexuelle Erkenntnis eines Knaben, 1918, 111
Sexual Discoveries of a Boy
Watercolor and India ink on plaster-primed
linen on cardboard
22.8/22 x 24 cm
Zentrum Paul Klee, Bern, private loan
Fig. p. 221

Vogel-Flugzeuge, 1918, 210
Bird-airplanes
Pencil on paper on cardboard
21.7 x 27.4 cm
Zentrum Paul Klee, Bern, private loan
Fig. p. 137

Abwägender Künstler, 1919, 73
Pondering Artist
Oil transfer drawing on paper on cardboard
19.7 x 16.6 cm
Zentrum Paul Klee, Bern,
Livia Klee Donation
Fig. p. 246

Junger Proletarier, 1919, 111
Young Proletarian
oil on cardboard
24.4 x 22.7 cm
Zentrum Paul Klee, Bern,
Livia Klee Donation
Fig. p. 268

nach der Zeichnung 19/75 (Versunkenheit),
1919, 113
Copy of the drawing 19/75 (Meditation)
Colored lithograph
23.6 x 16 cm
Zentrum Paul Klee, Bern,
Livia Klee Donation
Fig. p. 247

"Felsenlandschaft" (m/Palmen und Tannen),
1919, 155
"Rocky landscape" (With Palms and
Fir Trees)
Oil and pen on cardboard, nailed to
a wooden frame, original frame strips
41.8 x 51.4 cm
Zentrum Paul Klee, Bern,
Livia Klee Donation
Fig. p. 171

Komposition mit Fenstern, 1919, 156
Composition with Windows
Oil and pen on cardboard; original frame
50.4 x 38.3 cm
Zentrum Paul Klee, Bern
Figs. pp. 192, 205

Der grosse Kaiser reitet in den Krieg,
1920, 68
The Great Emperor Rides to War
India ink on paper on cardboard
31.8 x 23.6 cm
Fig. p. 240

Der Weg von Unklaich nach China,
1920, 153
The Way from Unklaich to China
India ink on paper on cardboard
18.6 x 28.2 cm
Zentrum Paul Klee, Bern
Fig. p. 68

Zimmerperspective mit Einwohnern,
1921, 24
Room Perspective with Inhabitants
Oil transfer drawing and watercolor
on paper on cardboard
48.5 x 31.7 cm
Zentrum Paul Klee, Bern
Fig. p. 69

Fuge in Rot, 1921, 69
Fugue in Red
Watercolor on paper, bordered with paper
strips on left and right, on cardboard
24.4 x 31.5 cm
Zentrum Paul Klee, Bern, private loan
Figs. pp. 89, 166

Choral und Landschaft, 1921, 125
Chorale and Landscape
Gouache and pencil on oil paint on paper
on cardboard
35 x 31 cm
Zentrum Paul Klee, Bern, private loan
Fig. p. 70

Der grosse Kaiser, zum Kampf gerüstet,
1921, 131
The Great Emperor, Armed for Battle
Watercolor and oil transfer drawing
on plaster-primed linen on paper, bordered
with watercolor and pen, on cardboard
42.4 x 31.2 cm
Zentrum Paul Klee, Bern,
Livia Klee Donation
Fig. p. 252

Scheidung Abends, 1922, 79
Separation in the Evening
Watercolor on paper, bordered with
watercolor and pen at top and bottom,
on cardboard
33.5 x 23.2 cm
Zentrum Paul Klee, Bern,
Livia Klee Donation
Fig. p. 257

betroffener Ort, 1922, 109
Affected Place
Watercolor, India ink, and pencil on paper,
bordered with watercolor and pen at top
and bottom, on cardboard
30.7 x 23.1 cm
Zentrum Paul Klee, Bern
Fig. p. 71

Schwankendes Gleichgewicht, 1922, 159
Unstable Equilibrium
Watercolor and pencil on paper, framed in
watercolor and pen, on cardboard
31.4 x 15.7/15.2 cm
Zentrum Paul Klee, Bern
Fig. p. 163

Ohne Titel (Selbstporträt), 1922
Untitled (Self Portrait)
Hand puppet; head: bone and painted
plaster; costume: wool
Height 38 cm
Zentrum Paul Klee, Bern,
Livia Klee Donation
Fig. p. 278

Puppen theater, 1923, 21
Puppet Theater
Watercolor on chalk priming on two pieces
of paper, framed in watercolor and pen,
on cardboard
52 x 37.6 cm
Zentrum Paul Klee, Bern
Fig. p. 152

Zaubertheater, 1923, 25
Magic Theater
Watercolor and India ink on paper, bordered
with watercolor and pen, marginal stripe
at the bottom with watercolor and pen,
on cardboard
30.6/31 x 21.2/21.7 cm
Zentrum Paul Klee, Bern
Fig. p. 202

Schauspieler, 1923, 27
Actor
Oil on paper, bordered with oil color
and pen, on cardboard
46.5/45.8 x 25 cm
Zentrum Paul Klee, Bern, private loan
Fig. p. 225

Feuerwind, 1923, 43
Fire Wind
Oil transfer drawing, oil and watercolor on paper, bordered with watercolor and pen, marginal stripe at the bottom with watercolor and pen, on cardboard
43.2 x 30.2 cm
Zentrum Paul Klee, Bern
Fig. p. 72

Assyrisches Spiel, 1923, 79
Assyrian Game
Oil on cardboard on a second layer of cardboard
37 x 51 cm
Zentrum Paul Klee, Bern, private loan
Fig. p. 74

Bildarchitectur rot gelb blau, 1923, 80
Pictorial Architecture Red, Yellow, Blue
Oil on black primer on cardboard; original, painted frame
44.3 x 34 cm
Zentrum Paul Klee, Bern
Fig. p. 144

Städtebild (rot/grün gestuft), 1923, 90
Picture of a Town (Red-green Gradated)
Oil on cardboard nailed to plywood; original frame strips
46 x 35 cm
Zentrum Paul Klee, Bern,
Livia Klee Donation
Fig. p. 269

Der Seiltänzer, 1923, 121
The Tightrope Walker
Oil transfer drawing, pencil, and watercolor on paper, marginal stripe with pen at the top, on cardboard
48.7 x 32.2 cm
Zentrum Paul Klee, Bern
Fig. p. 165

Sternverbundene, 1923, 159
Connected to the Stars
Watercolor on paper, bordered with watercolor and pen, marginal stripe with watercolor and pen at the bottom, on cardboard
32.4/32.8 x 48.3/48.7 cm
Zentrum Paul Klee, Bern, private loan
Fig. p. 222

Harmonie aus Vierecken mit rot gelb blau weiss und schwarz, 1923, 238
Harmony of Rectangles with Red, Yellow, Blue, White and Black
Oil on black priming on cardboard; original, painted frame
69.7 x 50.6 cm
Zentrum Paul Klee, Bern
Fig. p. 145

Requisiten Stilleben, 1924, 112
Still Life with Props
Oil on muslin, bordered with gouache and pen, on cardboard
35.2/36.3 x 43.8/44.2 cm
Zentrum Paul Klee, Bern
Fig. p. 201

buntharmonisch, 1925, 256 (Z 6)
Colorful Harmonious
Pastel on black glue sizing, on paper, bordered with pastel, on cardboard
22.2 x 28.8 cm
Zentrum Paul Klee, Bern, private loan
Fig. p. 75

Ohne Titel (Breitohrclown), 1925
Untitled (Wide-Eared Clown)
Hand puppet; head: painted plaster; costume: linen
Height 48 cm
Zentrum Paul Klee, Bern,
Livia Klee Donation
Fig. p. 281

Ohne Titel (Zündholzschachtelgeist), 1925
Untitled (Genie of the Matchbox)
Hand puppet; head: matchboxes, feather, wire, plaster; costume: wool and linen
57 cm
Zentrum Paul Klee, Bern,
Livia Klee Donation
Fig. p. 280

ein Garten für Orpheus, 1926, 3
A Garden for Orpheus
India ink on paper on cardboard
47 x 32/32.5 cm
Zentrum Paul Klee, Bern
Fig. p. 73

Fisch=Leute, 1927, 11 (K 1)
Fish People
Oil and tempera, partly sprayed, on plaster priming on canvas on cardboard
28.5 x 50.5/51 cm
Zentrum Paul Klee, Bern
Fig. p. 76

Harmonie der nördlichen Flora, 1927, 144 (E 4)
Harmony of the Northern Flora
Oil on chalk priming on cardboard, nailed to plywood; original frame strips
41 x 66/66.5 cm
Zentrum Paul Klee, Bern,
Livia Klee Donation
Fig. p. 270

italienische Stadt, 1928, 66 (P 6)
Italian Town
Watercolor on paper; at top and bottom marginal stripes with gouache, pencil, and colored pencil; on cardboard
33 x 23.4 cm
Zentrum Paul Klee, Bern, private loan
Fig. p. 77

Sie brüllt, wir spielen, 1928, 70 (P 10)
She Bellows, We Play
Oil on canvas on stretcher; original frame strips
43.5 x 56.5 cm
Zentrum Paul Klee, Bern
Fig. p. 340

Monument im Fruchtland, 1929, 41 (N 1)
Monument in the Fertile Country
Watercolor and pencil on paper, on cardboard
45.7 x 30.8 cm
Zentrum Paul Klee, Bern
Fig. p. 146

Wachstum auf Stein, 1929, 258 (Z 8)
Growth on Stone
Watercolor on plaster on gauze; on wooden strips; original frame strips
32 x 30.5 cm
Zentrum Paul Klee, Bern, private loan
Fig. p. 224

Eroberer, 1930, 129 (W 10)
Conqueror
Watercolor and India ink on cotton, at top and bottom marginal stripes with gouache and pen, on cardboard
40.5 x 34.2 cm
Zentrum Paul Klee, Bern
Fig. p. 341

polyphon gefasstes Weiss, 1930, 140 (X 10)
White Framed Polyphonically
Pen and watercolor on paper on cardboard
33.3 x 24.5 cm
Zentrum Paul Klee, Bern
Figs. pp. 90, 167

417

LIVERPOOL JOHN MOORES UNIVERSITY
LEARNING SERVICES

gewagt wägend, 1930, 144 (Y 4)
Daringly Balanced
Watercolor and India ink on paper
on cardboard
31 x 24.5/23.5 cm
Zentrum Paul Klee, Bern
Fig. p. 162

Schwebendes, 1930, 220 (S 10)
Hovering
Oil, partly stamped, on canvas on stretcher;
original frame strips
84 x 84 cm
Zentrum Paul Klee, Bern
Fig. p. 342

abstracte Schrift, 1931, 284 (Y 4)
Abstract Writing
India ink on paper on cardboard
8.4 x 21.9 cm
Zentrum Paul Klee, Bern
Fig. p. 135

Ranke, 1932, 29 (K 9)
Tendril
Oil and sand on wood; original brass frame
38 x 32 cm
Zentrum Paul Klee, Bern,
Livia Klee Donation
Fig. p. 271

tote Puppen, 1932, 150 (R 10)
Dead Dolls
Chalk on paper on cardboard
42.9 x 32.2 cm
Zentrum Paul Klee, Bern
Fig. p. 138

durch ein Fenster, 1932, 184 (T 4)
Through a Window
Oil on gauze on cardboard
30 x 51.5 cm
Zentrum Paul Klee, Bern,
Livia Klee Donation
Fig. p. 272

Garten=rhythmus, 1932, 185 (T 5)
Garden Rhythm
Oil on primer on canvas on cardboard;
reconstructed original frame strips
19.5 x 28.5 cm
Zentrum Paul Klee, Bern, private loan
Fig. p. 142

Kleine Felsenstadt, 1932, 276 (X 16)
Small Town among the Rocks
Oil on canvas on stretcher;
original painted frame
44.5 x 56.5 cm
Zentrum Paul Klee, Bern
Fig. p. 158

Meerschnecken-König, 1933, 279 (Y 19)
Sea Snail King
Watercolor and oil on priming on muslin
on plywood; original, silver plated and
painted frame
28.4 x 42.6 cm
Zentrum Paul Klee, Bern
Fig. p. 343

Kopf eines Märtyrers, 1933, 280 (Y 20)
Head of a Martyr
Watercolor on plaster priming on gauze
on cardboard; original gold frame
26 x 20.5 cm
Zentrum Paul Klee, Bern,
Livia Klee Donation
Fig. p. 172

geöffnet, 1933, 306 (A 6)
Opened
Watercolor, pen and pencil on muslin
on plywood
40.5 x 55 cm
Zentrum Paul Klee, Bern, private loan
Fig. p. 232

eilen nach Schutz, 1933, 389 (E 9)
Running for Shelter
Chalk on paper on cardboard
21.7 x 29.8 cm
Zentrum Paul Klee, Bern,
Livia Klee Donation
Fig. p. 249

Bauernzwerg, 1933, 394 (E 14)
Peasant Dwarf
Colored paste on paper on cardboard
44.1 x 26.7 cm
Zentrum Paul Klee, Bern
Fig. p. 344

von der Liste gestrichen, 1933, 424 (G 4)
Struck from the List
Oil on paper on cardboard
31.5 x 24 cm
Zentrum Paul Klee, Bern,
Livia Klee Donation
Fig. p. 258

Geheim Richter, 1933, 463 (J 3)
Secret Judge
Colored paste on paper on cardboard
41.3 x 28.9 cm
Zentrum Paul Klee, Bern,
Livia Klee Donation
Fig. p. 260

Lumpen gespenst, 1933, 465 (J 5)
Ragged Ghost
Colored paste and watercolor on paper
on cardboard
48 x 33.1 cm
Zentrum Paul Klee, Bern
Fig. p. 203

landschaftlich-polyphon, 1934, 88 (N 8)
Scenic-polyphonic
Pencil on paper on cardboard
48.4 x 62.4 cm
Zentrum Paul Klee, Bern,
Livia Klee Donation
Fig. p. 134

Menu ohne Appetit, 1934, 170 (S 10)
Menu without Appetite
Pencil on glue sizing on paper on cardboard
20.9 x 32.8 cm
Zentrum Paul Klee, Bern, Paul Klee-Stiftung
der Burgergemeinde Bern
Fig. p. 353

Die Erfindung, 1934, 200 (T 20)
The Invention
Watercolor, partly sprayed, on cotton on
plywood; reconstruction of original
frame strips
50.5 x 50.5 cm
Zentrum Paul Klee, Bern, private loan
Fig. p. 223

Ent-Seelung, 1934, 211 (U 11)
The Soul Departs
Watercolor on primed cardboard; frame
30.5 x 49.3 cm
Zentrum Paul Klee, Bern
Fig. p. 352

Landschaft am Anfang, 1935, 82 (N 2)
Landscape in the Beginning
Watercolor on plaster priming on gauze
on cardboard
33.5 x 58.5 cm
Zentrum Paul Klee, Bern, private loan
Fig. p. 147

Büsser, 1935, 143 (R 3)
Penitent
Watercolor and India ink on plaster-primed
burlap, on second layer of burlap on
stretcher; original, painted frame strips
85.5 x 35.5 cm
Zentrum Paul Klee, Bern
Fig. p. 345

das Tor zur Tiefe, 1936, 25 (K 5)
The Gate to the Depth
Watercolor on priming on cotton on
cardboard on stretcher
24 x 29 cm
Zentrum Paul Klee, Bern, private loan
Fig. p. 148

labiler Wegweiser, 1937, 45 (L 5)
Unstable Signpost
Watercolor on paper on cardboard
43.8 x 20.9/19.8 cm
Zentrum Paul Klee, Bern, private loan
Fig. p. 126

Katastrophe der Sphinx, 1937, 135 (Qu 15)
Catastrophe of the Sphinx
Oil on oil priming on cotton on stretcher
50 x 60 cm
Zentrum Paul Klee, Bern,
Livia Klee Donation
Fig. p. 273

Ueberschach, 1937, 141 (R 1)
Super-chess
Oil on burlap on stretcher;
original frame strips
120 x 110 cm
Kunsthaus Zürich
Fig. p. 192

blaue Nacht, 1937, 208 (U 8)
Blue Night
Pastel on cotton on colored paste on burlap
on stretcher
50 x 76 cm
Kunstmuseum Basel
Fig. p. 192

Blick aus Rot, 1937, 211 (U 11)
Glance out of Red
Pastel on cotton on colored paste on burlap
on stretcher; reconstructed original frame
strips
47 x 50 cm
Zentrum Paul Klee, Bern,
Livia Klee Donation
Fig. p. 143

Schwefel-Gegend, 1937, 255 (W 15)
Sulfur Region
Paste-based tempera on paper on cardboard
29.3/31 x 55.3/52.7 cm
Zentrum Paul Klee, Bern,
Livia Klee Donation
Fig. p. 261

Tänze vor Angst, 1938, 90 (G 10)
Dances Caused by Fear
Watercolor on paper on cardboard
48 x 31 cm
Zentrum Paul Klee, Bern
Fig. p. 346

der Graue und die Küste, 1938, 125 (J 5)
The Gray Man and the Coast
Colored paste on burlap on a second layer
of burlap on stretcher
105 x 71 cm
Zentrum Paul Klee, Bern,
Livia Klee Donation
Fig. p. 275

Vorhaben, 1938, 126 (J 6)
Intention
Colored paste on newspaper on burlap
on stretcher; original frame strips
75.5 x 112.3 cm
Zentrum Paul Klee, Bern
Fig. p. 159

Park bei Lu., 1938, 129 (J 9)
Park Near Lu.
Oil and colored paste on newspaper on
burlap; original double frame strips
100 x 70 cm
Zentrum Paul Klee, Bern
Fig. p. 347

Früchte auf Blau, 1938, 130 (J 10)
Fruits on Blue
Colored paste on newspaper on burlap
on stretcher; original frame
55.5 x 136 cm
Zentrum Paul Klee, Bern
Fig. p. 155

Mutter und Kind, 1938, 140 (J 20)
Mother and Child
Watercolor on priming on burlap
on stretcher
56 x 52 cm
Zentrum Paul Klee, Bern, private loan
Fig. p. 233

Alpha bet I, 1938, 187 (M 7)
Alphabet I
Colored paste on newspaper on cardboard
53.9 x 34.4 cm
Zentrum Paul Klee, Bern
Fig. p. 168

Alphabet II, 1938, 188 (M 8)
Colored paste on newspaper on cardboard
49 x 33 cm
Zentrum Paul Klee, Bern
Fig. p. 135

Anfang eines Gedichtes, 1938, 189 (M 9)
Beginning of a Poem
Colored paste on newspaper on cardboard
48.3 x 62.8 cm
Zentrum Paul Klee, Bern
Fig. p. 169

das Auge, 1938, 315 (T 15)
The Eye
Pastel on burlap on cardboard
45/46 x 64.5/66.5 cm
Zentrum Paul Klee, Bern, private loan
Fig. p. 199

Insula dulcamara, 1938, 481 (C 1)
Oil and colored paste on newspaper
on burlap; original frame strips
88 x 176 cm
Zentrum Paul Klee, Bern
Fig. p. 197

dieser Kopf versteht die Gleichung nicht,
1939, 67 (J 7)
This Head Does Not Understand
the Equation
Chalk on draft paper on cardboard
23.1 x 26.9 cm
Zentrum Paul Klee, Bern
Fig. p. 130

Landschaft in A dur, 1939, 91 (K 11)
Landscape in A Major
Pen on paper on cardboard
27 x 21.5 cm
Zentrum Paul Klee, Bern
Figs. pp. 90, 134

Landschaft in C dur, 1939, 92 (K 12)
Landscape in C Major
Pen on paper on cardboard
27 x 21.5 cm
Zentrum Paul Klee, Bern
Fig. p. 134

Fall-Bäume, 1939, 280 (U 20)
Descending Trees
Colored paste on paper on cardboard
20.9 x 29.7 cm
Zentrum Paul Klee, Bern,
Livia Klee Donation
Fig. p. 263

alter Geiger, 1939, 310 (W 10)
Old Violinist
Pencil on paper on cardboard
20.9 x 29.7 cm
Zentrum Paul Klee, Bern, private loan
Fig. p. 89

Liebeslied bei Neumond, 1939, 342 (Y 2)
Love Song at New Moon
Watercolor on burlap on a second layer of
burlap on stretcher; original frame strips
100 x 70 cm
Zentrum Paul Klee, Bern
Fig. p. 348

Zerstörtes Labyrinth, 1939, 346 (Y 6)
Destroyed Labyrinth
Oil and watercolor on oil priming on paper
on burlap on stretcher; original frame strips
54 x 70 cm
Zentrum Paul Klee, Bern
Fig. p. 149

ein Kinderspiel, 1939, 385 (A 5)
A Children's Game
Colored paste and watercolor on cardboard
43 x 32 cm
Die Sammlung Berggruen in den
Staatlichen Museen zu Berlin
Fig. p. 128

Scham los, 1939, 416 (B 16)
Shame Less
Pencil on paper; reverse: drawing,
on cardboard
29.7 x 20.9 cm
Zentrum Paul Klee, Bern,
Livia Klee Donation
Fig. p. 250

Näherung händlich, 1939, 453 (D 13)
Approach to Handy
Pencil on paper on cardboard
43 x 27 cm
Zentrum Paul Klee, Bern
Fig. p. 131

ein Kind träumt sich, 1939, 495 (F 15)
A Child Dreams
Watercolor on paper on cardboard
27 x 21.5 cm
Zentrum Paul Klee, Bern
Fig. p. 139

tief im Wald, 1939, 554 (CC 14)
Deep in the Wood
Watercolor and tempera on oil priming
on canvas on stretcher
50 x 43 cm
K 20 Kunstsammlung Nordrhein-Westfalen,
Düsseldorf
Fig. p. 129

blaue Blume, 1939, 555 (CC 15)
Blue Flower
Watercolor and tempera on oil priming
on cotton on plywood
50 x 51 cm
Zentrum Paul Klee, Bern,
Livia Klee Donation
Fig. p. 154

falscher Kopf am falschen Ort,
1939, 587 (EE 7)
Wrong Head in the Wrong Place
Pencil on paper on cardboard
29.7 x 20.9 cm
Zentrum Paul Klee, Bern
Fig. p. 135

Klippen im Fahrwasser, 1939, 668 (JJ 8)
Cliffs in the Channel
Colored paste on burlap
45 x 42 cm
Zentrum Paul Klee, Bern,
Livia Klee Donation
Fig. p. 276

hungriges Mädchen, 1939, 671 (JJ 11)
Hungry Girl
Colored paste and pencil on paper
on cardboard
27.1 x 21.3 cm
Zentrum Paul Klee, Bern,
Livia Klee Donation
Fig. p. 262

Mister Kin Lade, 1939, 684 (KK 4)
Mr. Jawbone
Pencil on paper on cardboard
27 x 21.5 cm
Zentrum Paul Klee, Bern,
Livia Klee Donation
Fig. p. 251

Kohl-Teufel, 1939, 714 (LL 14)
Cabbage Devil
Colored paste and grease crayon on paper
30.7 x 21.3 cm
Zentrum Paul Klee, Bern, private loan
Fig. p. 151

der wandernde Kopf I, 1939, 742 (NN 2)
The Wandering Head I
Pencil on paper; reverse: drawing,
on cardboard
27 x 21.5 cm
Zentrum Paul Klee, Bern
Fig. p. 125

Schema eines Kampfes, 1939, 1012 (CD 12)
Diagram of a Fight
Chalk and pencil on priming on paper
on cardboard
26.9/27.3 x 27.1/27.5 cm
Zentrum Paul Klee, Bern, private loan
Fig. p. 161

Wellenplastik, 1939, 1128 (JK 8)
Wave Sculpture
Tempera, chalk, colored paste, and oil
on cotton on burlap on stretcher;
reconstruction of original frame strips
70.2 x 70.5 cm
Zentrum Paul Klee, Bern,
Livia Klee Donation
Fig. p. 274

Gebärde eines Antlitzes I,
1939, 1176 (LM 16)
Expression of a Face I
Oil and colored paste on paper
59.5 x 44.3 cm
Kunsthaus Zürich, Schenkung der
Klee-Gesellschaft, Bern
Fig. p. 206

Kämpft mit sich selber, 1939, 1189 (MN 9)
Struggles with Himself
Chalk , pencil and watercolor on paper
on cardboard
29.5 x 20.6 cm
Zentrum Paul Klee, Bern, private loan
Fig. p. 160

Engel, noch tastend, 1939, 1193 (MN 13)
Angel, Still Groping
Chalk, colored paste, and watercolor
on paper on cardboard
29.4 x 20.8 cm
Zentrum Paul Klee, Bern, private loan
Fig. p. 200

KOP, 1939, 1225 (OP 5)
Head
Chalk, colored paste, and watercolor
on paper on cardboard
29.5 x 20.6 cm
Zentrum Paul Klee, Bern,
Livia Klee Donation
Fig. p. 150

la belle jardinière, 1939, 1237 (OP 17)
Oil and tempera on burlap on stretcher;
original frame strips
95 x 71 cm
Zentrum Paul Klee, Bern
Fig. p. 157

Uebermut, 1939, 1251 (PQu 11)
High Spirits
Oil and colored paste on paper on burlap
on stretcher; original frame strips
101 x 130 cm
Zentrum Paul Klee, Bern
Fig. p. 120

Ohne Titel (Ineinander Gefügtes), ca. 1939
Untitled (Joined Together)
Colored paste and watercolor, partly
sprayed, on drawing paper
29.8/30.3 x 46.6 cm
Zentrum Paul Klee, Bern,
Livia Klee Donation
Fig. p. 264

Kinder spielen Angriff, 1940, 13 (Z 13)
Children Playing Attack
Watercolor, encaustic paint, and pencil
on paper on cardboard
20.7 x 29.5 cm
Zentrum Paul Klee, Bern, private loan
Fig. p. 153

Engel, noch hässlich, 1940, 26 (Y 6)
Angel, Still Ugly
Pencil on paper on cardboard
29.6 x 20.9 cm
Zentrum Paul Klee, Bern
Fig. p. 140

woher? wo? wohin?, 1940, 60 (X 20)
Whence? Where? Whither?
Watercolor, chalk, and red chalk on paper
on cardboard
29.7 x 20.8 cm
Private loan, Switzerland
Fig. p. 132

Stilleben am Schalttag, 1940, 233 (N 13)
Still Life on Leap Day
Color paste on paper on burlap on stretcher;
original frame molding
74.6 x 110.3 cm
Zentrum Paul Klee, Bern
Fig. p. 173

Paukenspieler, 1940, 270 (L 10)
Kettledrummer
Colored paste on paper on cardboard
34.6 x 21.2 cm
Zentrum Paul Klee, Bern
Fig. p. 351

Schlosser, 1940, 274 (L 14)
Locksmith
Colored paste on paper on cardboard
48 x 31 cm
Kunstmuseum Basel, Kupferstichkabinett,
gift from the Klee-Gesellschaft, Bern
Fig. p. 206

Glas-Fassade, 1940, 288 (K 8)
Glass Façade
Encaustic paint on burlap;
reverse: oil on priming; on stretcher
71.3 x 95.7 cm
Zentrum Paul Klee, Bern
Fig. p. 349

Tod und Feuer, 1940, 332 (G 12)
Death and Fire
Oil and colored paste on burlap on a second
layer of glue-primed burlap, on stretcher;
original double frame strips
46.7 x 44.6 cm
Zentrum Paul Klee, Bern
Fig. p. 350

Flora am Felsen, 1940, 343 (F 3)
Flora on the Rocks
Oil and tempera on burlap on stretcher;
original double frame strips
90.7 x 70.5 cm
Kunstmuseum Bern
Fig. p. 196

dieser Stern lehrt beugen, 1940, 344 (F 4)
This Star Teaches Bending
Colored paste on paper on cardboard
37.8 x 41.3 cm
Zentrum Paul Klee, Bern,
Livia Klee Donation
Fig. p. 259

Ohne Titel (Komposition mit den Früchten),
ca. 1940
Untitled (Composition with Fruits)
Colored paste and chalk on packing paper
103 x 148 cm
Zentrum Paul Klee, Bern,
Livia Klee Donation
Fig. p. 175

Ohne Titel (Letztes Stillleben), 1940
Untitled (The Last Still Life)
Oil on canvas on stretcher
100 x 80.5 cm
Zentrum Paul Klee, Bern,
Livia Klee Donation
Fig. p. 277

Other Artists

Alexej von Jawlensky
Kreolin, 1913
Creole Woman
Oil on cardboard
69 x 50 cm
Zentrum Paul Klee, Bern, private loan
Fig. p. 228

Franz Marc
Ohne Titel (zwei Pferde vor blauem Berg),
1913
Untitled (Two Horses by a Blue Mountain)
Postcard to Lily Klee (no date, no stamp)
Mixed technique and collage (silver foil)
14 x 9.2 cm
Zentrum Paul Klee, Bern, private loan
Fig. p. 228

Photo Credits

Renzo Piano Building Workshop, Genoa and Paris: pp. 6/7, 367, 369, 370, 371, 372, 373, 374, 375, 376, 377–385, 388

Dominique Uldry, Bern: pp. 17–45, 51 (bottom), 57, 103–117, 283–301, 337, 356 (bottom), 357, 361, 362 (bottom), 397–413

Peter von Gunten, Bern: pp. 48, 49, 50, 51 (top), 91, 304, 306, 308, 309, 314, 315 (top), 316, 319, 324, 325, 326, 327 (top), 329, 333, 355 (bottom), 376/1, 386, 387, 388, 392, 393, 394, 395

Willi Kracher, Bern: pp. 79, 80, 81, 82, 83, 327 (bottom)

Erhard Hofer, Lützelflüh: pp. 95, 338

Adrian Weber, Zentrum Paul Klee, Bern: p. 96

All photos of Paul Klee's work, with the exception of pp. 129, 132, 192 (top and middle), 206, 240: Peter Lauri, Bern, and Abteilung für Bild- und Medientechnologien, Basel University: pp. 62–77, 89, 90, 97, 120, 124, 125, 126, 128, 130–131, 134–140, 142–173, 175, 192 (bottom), 196–205, 221–225, 229–233, 246–281, 340–353

K 20 Kunstsammlung Nordrhein-Westfalen, Düsseldorf: p. 129

H. Humm, private collection, Zürich: p. 132

Photographer unknown, Zentrum Paul Klee, Bern, Klee Family Donation: pp. 88, 176, 177 (top), 178, 180, 190 (top and middle), 235, 236 (top and bottom), 237 (top)

Karl Schmoll von Eisenwerth, Zentrum Paul Klee, Bern, Klee Family Donation: p. 177 (bottom)

Louis Moilliet, Westfälisches Landesmuseum für Kunst- und Kulturgeschichte, Münster: p. 179

Felix Klee, Zentrum Paul Klee, Bern, Klee Family Donation: pp. 84, 181, 188 (top and bottom), 245

Photographer unknown, Musée National d'Art Moderne, Paris, Centre Georges Pompidou, Fonds Kandinsky: p. 182

Franz Aichinger, Zentrum Paul Klee, Bern, Klee Family Donation: p. 184

Charlotte Weidler, Zentrum Paul Klee, Klee Family Donation: p. 185

Photographer unknown, Staatliche Museen zu Berlin, Berlin: p. 186 (top)

Presumably Franz Henn, Bern, Zentrum Paul Klee, Bern, loan from the Archiv Bürgi, Bern: p. 187 (top and bottom)

Lily Klee, Zentrum Paul Klee, Bern, Klee Family Donation: pp. 189 (top), 190 (bottom)

Robert Spreng, Basel, Zentrum Paul Klee, Bern: p. 189 (bottom)

Max Wagner, St. Moritz, Zentrum Paul Klee, Bern, loan from the Archiv Bürgi, Bern: p. 191 (top)

Photographer unknown, private collection, Switzerland: pp. 191 (middle and bottom), 193 (top)

Maya Allenbach, private collection, Switzerland: p. 193 (middle)

Photographer unknown, private collection: p. 193 (bottom)

Kunstmuseum Basel: pp. 192 (top), 206 (top)

Kunsthaus Zürich: pp. 192 (middle), 206 (bottom)

Karl Nierendorf, Zentrum Paul Klee, Bern, Klee Family Donation: p. 194

Photographer unknown, Kulturarchiv Oberengadin, Samedan, estate of Max Huggler: p. 207 (top)

Franco Cianetti, private collection, Zürich: p. 207 (bottom)

Presumably Sybil Rosengart-Dülberg, Angela Rosengart, Galerie Rosengart, Luzern: p. 208 (top)

Photographer unknown, Galerie Vömel, Düsseldorf: p. 208 (bottom)

Kunstmuseum Bern: pp. 211, 212 (top)

Hansueli Trachsel, Bern: pp. 212 (bottom), 318, 320, 321 (bottom), 322

Albert Winkler, Kunstmuseum Bern: p. 213

The Menil Collection, Houston: p. 214

Renate Joss, Bern, private collection, Bern: p. 216

Alexander Klee/eclipse, Zürich, Zentrum Paul Klee, private loan: pp. 219, 227 (bottom)

Abteilung für Bild- und Medientechnologien, Basel University: pp. 226, 227 (top)

Peter Lauri, Bern, Zentrum Paul Klee, Bern, private loan: pp. 186 (bottom), 228 (bottom and top)

Jens-Erik Nielsen, private collection, Bern: p. 237 (bottom)

Photographer unknown: private collection, Bern: p. 238

Photographer unknown: private collection, France: p. 240

Jürg Spiller, Zentrum Paul Klee, Bern, Klee Family Donation: p. 244

Peter Friedli, Bern: p. 307

Felix Klee, Zentrum Paul Klee, private loan: p. 310

Erwin Schenk, Zentrum Paul Klee, Bern: pp. 321 (top), 328, 331, 334 (top and middle), 335, 339, 362 (top and middle), 363, 391

Christine Blaser, Bern: p. 332

Anita Schürch, Ueberstorf: pp. 334 (bottom), 355 (top)

Peter Leuenberger, Bern: p. 356 (top)

Documenta natura, Roger Huber and Hans Kobi, Bern: p. 360

This catalogue is published in conjunction with the opening of the Zentrum Paul Klee, Bern, June 20, 2005.

Issued by
Zentrum Paul Klee, Bern

Editorial direction
Ursina Barandun and Michael Baumgartner

Copyediting
Nina Hausmann

Translations
Will Firth, Jim Gussen, Ben Letzler, Steven Lindberg

Graphic design and typesetting
Atelier Sternstein, Stuttgart

Typeface
Sabon, FF DIN

Reproductions
Pallino cross media GmbH, Ostfildern-Ruit

Paper
Printed on Furioso 150 g/m² from m-real Biberist, Switzerland

Binding
Kunst- und Verlagsbuchbinderei GmbH, Leipzig

Printed by
Dr. Cantz'sche Druckerei, Ostfildern-Ruit

© 2005 Zentrum Paul Klee, Bern, Hatje Cantz Verlag, Ostfildern-Ruit, and authors

© 2005 for the reproduced works by Peter von Gunten, Alexej von Jawlensky, Paul Klee, Louis Moilliet, Kurt Schwitters, and Hansueli Trachsel: VG Bild-Kunst, Bonn; Renzo Piano Building Workshop, Architects; the artists, authors, photographers, and their legal successors

Published by
Hatje Cantz Verlag
Senefelderstrasse 12
73760 Ostfildern-Ruit
Germany

Tel. +49 711 4405-0
Fax +49 711 4405-220
www.hatjecantz.com

Hatje Cantz books are available internationally at selected bookstores and from the following distribution partners:

USA/North America – D.A.P., Distributed Art Publishers, New York,
www.artbook.com
UK – Art Books International, London,
sales@art-bks.com
Australia – Towerbooks, French Forest (Sydney), towerbks@zipworld.com.au
France – Interart, Paris,
commercial@interart.fr
Belgium – Exhibitions International, Leuven,
www.exhibitionsinternational.be
Switzerland – Scheidegger, Affoltern am Albis, scheidegger@ava.ch

For Asia, Japan, South America, and Africa, as well as for general questions, please contact Hatje Cantz directly at sales@hatjecantz.de, or visit our homepage www.hatjecantz.com for further information.

ISBN 3-7757-1533-9
Trade edition: Hardcover with dust jacket
Museum edition: Hardcover

This catalogue is also available in German and French
ISBN 3-7757-1532-0 (German)
ISBN 3-7757-1534-7 (French)

Printed in Germany

Frontispiece
dieselbe Gekrümmte führt zu variabler Form, 1931, 19 (19)
The Same Curvy Line Leads to
a Variable Form
India ink and watercolor on paper
on cardboard
61,1 x 48,8 cm
Zentrum Paul Klee, Bern

Zentrum Paul Klee
Monument im Fruchtland 3
3006 Bern
Switzerland

Tel. +41 31 359 01 01
Fax +41 31 359 01 02
www.zpk.org

LIVERPOOL JOHN MOORES UNIVERSITY
LEARNING SERVICES